Praise for *Weak in Comparison to Dreams*

Weak in Comparison to Dreams is unlike any book I have ever read: a fascinating mixture of introspective realism and dreamlike surrealism, of text and image. Although the novel's exuberant use of visual stimuli is reminiscent of the experimental works of Jonathan Safran Foer, Steve Tomasula, and Lance Olsen, Elkins has created a highly original, unique literary work. —**Wojciech Drag, author of** *Collage Literature in the Twenty-First Century*

Weak in Comparison to Dreams is an extraordinary arthroscopic view into a man whose life is liquefying, becoming a chrysalis. The images imprison, haunt, warn, and liberate the imagination. I think of photographers who deal in borders, scars, animal and human pathways, memory, and traces — Stephen Gill, Colleen Plumb, Robert Adams, Sofie Ristelhueber, John Gossage — coupled with Proust, Murdoch, Musil, Kafka, Casares, Beckett. Reason is on trial. We are told the world is not a maze or a puzzle, but Ariadne's string unravels until the labyrinth is only a faint wiggle along bars of piano music.… *Weak In Comparison To Dreams* is a story full of wit, tragedy and surprise about mental health and making sense. —**Kate Joyce, author of** *Metaphysics*

A stunning achievement, framing profound questions of memory, meaning, and moral responsibility within a highly inventive literary structure. Fundamentally, this is a book about being lost. Indeed, it can be read as an evocative reworking of Dante's *Inferno*, in which we descend into the narrator's deepening realizations of self-estrangement but without exiting Dante's disorienting woods. As Elkins's narrative unfolds, it keeps folding back on itself, lacking any secure Dantean perspective from which to explain the meanings of one's experiences, the orientation of one's journey, or its correspondences to larger cosmic orders — but without diminishing life's ineluctable call for some such explanation. The innovative visual and musical logic of *Weak in Comparison to Dreams* beautifully complicate not only what a novel is but how a life coheres. —**Jonathan Anderson, coauthor (with William Dyrness) of** *Modern Art and the Life of a Culture: The Religious Impulses of Modernism*

The unraveling narrator dreams of fire and destruction, trapped in the inescapable confines of his own subjectivity. *Weak in Comparison to Dreams* is a lucid account of a sleepwalking soul becoming increasingly lost as he wrestles with unresolvable conflicts, symbolized in the pathetic fate of animals. —**Johanna Drucker, author of** *Subjective Meteorology* **and** *All The Books I Never Wrote*

Elkins enters the field with an exhilarating, surefooted, and profound book. —**Charles Green, artist and author of** *Peripheral Vision* **and** *The Third Hand*

The dreams interwoven in James Elkins's intricate novel are not the hallucinogenic variety of Burroughs, nor are they the fever dreams of Breton: rather they are lucid dreams that slow down the world, allowing the dreamer to consciously examine their contents and potential meanings. The novel is a philosophical inquiry into the fundamental question: Can one truly know the self? While the novel's narrator, Dr. Samuel Emmer, confesses that the book serves to gather his memories before he is "lost to himself," the chapters that follow reveal that this is an elusive and perhaps naïve ambition.... Elkins presents a series of nested boxes, knowing full well that none will provide a pat explanation of the self, for it is the quest for understanding itself that is offered for us to contemplate. —**Anna Arnar, author of** *The Book as Instrument: Stéphane Mallarmé*

James Elkins, a celebrated, imaginative and sometimes controversial art historian, has written a brilliantly experimental novel—a contemporary allegory of paths in life taken, not taken, or impossible, with brooding episodes of despair and zoochosis, punctuated by a succession of non-surrealistic, lucid, hypnopompic dreams.... Never unequivocally symbolic, the meta-referentiality of the book will thrill readers who admire Nabokov or Pynchon, the bleak atmosphere those who love Kafka, the narrative flow of naturalism those who like Don DeLillo. —**Mark Staff Brandl, artist and author of** *A Philosophy of Visual Metaphor in Contemporary Art*

Weak in Comparison to Dreams tells the moving story of Dr. Samuel Emmer's life, his concerns about animal welfare, his dreams about fire and the instability of his self. There is a great generosity of imagination in Elkins's writing.... This is an intriguing book, which can't be compared to anything except perhaps the enormous projects of writers such as Marianne Fritz or Arno Schmidt. —**flowerville, author of fortlaufen.blogspot.com**

Weak In Comparison To Dreams introduces entirely new language games. What first appear as illustrations of zoos turn out to be the labyrinths of our own human behavior, by which we pursue our daily lives and cling to the allegories that make us believe in our own ascendency. Manifold dialogues between pictures and words line the verges of the protagonist's path, ultimately pointing to the few remains of a life. —**Lukas Schmutzer, author of "Between Word and Work: On Marianne Fritz's** *Whose Language You Do Not Understand"*

Elkins's novel breaks down the boundaries between word and image, celebrating the intertwining of text and pictures, inviting readers to engage in a new form of storytelling that aligns with our contemporary experiences of the online realm. —**Si Han, author of** *A Chinese Word on Image*

In this encyclopedic novel innocent zoo inspections spiral into a bubbling maelstrom of madness, lethargically engulfing kaleidoscopes of scientific lore, sheet music, and photographs of dreams. —**Evelina Domnitch, author of** *Orbihedron*

Backed by an uncanny soundtrack of impending doom, *Weak in Comparison to Dreams* unfolds a virtuoso game of memory and oblivion. With great ease and playfulness the author takes us on a verbal as well as visual journey through remote landscapes of knowledge, finally dissolving the supposed coherence of a life into music. A mesmerizing synesthetic experience and great intellectual pleasure. **—Philipp Weiß, author of** *Am Weltenrand sitzen die Menschen und lachen*

Weak in Comparison to Dreams is an extraordinary synthesis of natural history, travel literature, oneirocriticism, and musicology.... his uncannily sensitive ear for the plaints of the human and non-human creatures implicated in the process imparts to it a poignancy and humor that is all his own. The constellations traced in the reader's mind by Elkins's novel in the course of its exhilaratingly irregular orbit through manifold registers of genre and tone will remain fixed there long after the glare of lesser literary fiction has faded. **—Douglas Robertson, translator of** *The Rest Is Slander: Five Stories by Thomas Bernhard*

Stories can be slow or fast, storylines can be linear or in disorder, simple or complex, narratives may contain more or less descriptive or nonnarrative material, they can even include images and sounds, but roughly speaking there are only two ways to do it: the text is either mainly a flow (that is the Dionysian way) or the verbal shaping of an underlying structure (that is the Apollonian way). The exceptional achievement of *Weak in Comparison to Dreams* is that this book succeeds in doing it all, while at the same time offering a truly moving story about time and memory, human agency and relationships as well as the multiple crossings of nature and culture in what can only be defined as a new model of the encyclopedic novel. **—Jan Baetens, author of** *My Life to Live*

For years I have learned from and enjoyed the essays of James Elkins. But this novel goes further than anything he has written. It's a fascinating journey between places, times, mental states, and ways of understanding the world, a book that overflows the limits of genres, but is traversed by an exciting narrative drive that links Raymond Roussel's surrealism, Sebald's archival exploration of reality, Agustín Fernández Mallo, and Tom McCarthy's anthropology of the contemporary world. It's quite a challenge! And an endless literary feast. **—Miguel Ángel Hernández, author of** *Escape Attempt* **and** *Anoxia*

Every now and again, a book presents a new type of narrative that alters the way we see literature. James Elkins's *Weak In Comparison to Dreams* engages memory, photography, and music to paint a picture about a 90-year-old pianist recalling his past. The text is unexpectedly interspersed with surrealist landscape photography, diagrams, and sheet music, which animate the prose in a manner that surprises as much as it intrigues. While this may be Elkins's first venture into experimental literary fiction, I would expect nothing less from the man whose ground-breaking writing about art, painting, and photography changed the way a generation of artists view their own media. **—Kimberly Brooks, artist and author of** *The New Oil Painting*

Do we own our mental images? Are they comparable to thought? In this intriguing novel, James Elkins imagines a life without images while realizing that evoking such life is possible only through the imagination. The art historian-turned-novelist directs his inquisitive gaze from pictures made by others to the image-producing and yet always wandering mind. Reveries, dreams, reflections and memories drive this Sebald-inspired narrative through combinations of word and image: the text is speckled with photos, diagrams, and even musical scores. The reader is invited to not just look at them, but act with them, by mimicking a walking pattern of a diagram, or playing the music. These acts draw up new images in the mind, or rather, pictorial thoughts. What makes us think? Where do we go when we think? Can any mental activity ever be called "ours"? Elkins's novel offers a profoundly provocative exercise in visual thinking. —**Hanneke Grootenboer, author of** *The Pensive Image: Art as a Form of Thinking*

Photographs, tables, diagrams, notations – various means of coming to terms with the world? Not in James Elkins's masterful novel *Weak in Comparison to Dreams*, where images propel a mesmerizing story of losing touch with reality. Yet they are far more than mere melancholic ciphers, for Elkins brilliantly knows how to mobilize their constructive and operative functions. The result is a moving and profound contemplation on images in relation to dreams, memory, and music…. it is an unbelievably rich and haunting story. —**Charlotte Klonk, author of** *Terror: Wenn Bilder zu Waffen werden* (*Terror: When Images Become Weapons*)

I'm delighted this book has finally appeared! Elkins's novel is experimental in the best sense of the word, because it puts new ways of imagining and representing to the test. Like the first generation of Nouveau Roman writers, Alain Robbe-Grillet, Michel Butor, and Nathalie Sarraute, or like the filmmaker Alain Resnais, Elkins creates a dynamic constellation of memories, dreams, and life. Samuel's wandering mind, and his life's paths, are reenacted by photographs and sheet music: the book shows what it is like to think with images, and not only about them. —**Eva Schuermann, author of** *Seeing as Practice: Philosophical Investigations into the Relation Between Sight and Insight*

WEAK
IN COMPARISON
TO DREAMS

A NOVEL

JAMES ELKINS

THE UNNAMED PRESS
LOS ANGELES, CA

Table of Contents

WEAK IN COMPARISON TO DREAMS

That winter ruined any hope I had of experiencing my life as a story, beginning with a cry in a hospital and developing right up to the latest click of the plastic second hand on the large wall-mounted, battery-operated clock that I bought because, as I once said to Adela, I need to keep better track of time: that year I lost the capacity to manage my days, keep my mind on my job, keep on good behavior, keep hold of my family, attend to what people were actually saying, distinguish animals from humans, day from night. That winter tore me from myself and pushed me into a world of dreams.

What I learned that year:

Reason is like aspirin. Everyone takes it because it's supposedly a wonder drug. But if your headache is serious enough, aspirin won't stop it.

Reason is like a child who won't stop crying. You know you love it, you can't live without it, but it's intensely annoying and you wish it would just sit there and slobber.

Reason is like a runner who does not know when the race is over, she runs for days, without food, without water, until she collapses. As soon as she recovers, she gets up and starts running again.

Reason is like Penelope undoing at night what was done during the day. She is canny. She knows the real work is done when people are asleep. Anything that takes place during the day is nonsense.

What happened that year made me into something different. I felt like a caterpillar winding myself into a cocoon, settling in, losing my appetite for leaves, forgetting my fear of birds, contracting my soft green body into a hard brown shell, erasing my caterpillar memories, saying goodbye to the sun and rain, becoming a pupa. Soon I will be lost to myself, and before that happens, I want to write this book.

1

That Rhyme About Magpies

On the way out of the airport rental car lot in Tallinn, Estonia, I saw the sign for the city, pointing right, and then I spotted another road, unmarked, leading into the countryside. In one direction, the hotel. In the other, basically anything else. Off I drove into the empty landscape.

It was a chill late afternoon, with those furtive clouds that drop a sudden deluge on you and then evaporate into an innocent blue sky. The land was thickly forested with cyan colored pine trees.

I drove at speed through a small village. Only a few people were out. Two children in plastic space helmets clambered over a brick wall. Roofs came down at steep angles, nearly hiding dark windows. Walls were made of outsize wooden planks, as if they'd been repurposed from barns or ripped from factory floors. Some houses leaned, like people falling asleep on a bus. I passed a car dealership and a petrol station, then I was out in the country again. Billboards in spectral colors advertised cell phones. There seemed to be an unending supply of those bluish trees. What kind of color is that for a tree, anyway? They looked like the sea in children's books, or that blue liquid people put in toilet bowls to make them seem clean.

I passed a farm truck going 90 kilometers an hour, then a new Nissan going 120. My rental car wasn't fragrant like they're supposed to be. People had been smoking in it.

On I drove, vaguely in the direction of nowhere in particular. I slowed behind a rattling tractor, then sped around a tight corner. I could spend the

rest of my life like this, I thought. Towns like the one I'd driven through must continue all the way to Russia and on into Siberia. *Forty Years of Random Driving in the Baltic,* that's what I'd call my memoirs. Fluorescent forests were interrupted by straw colored fields. The sun was low in the sky, but it wasn't in a hurry to rise. Maybe in midwinter it didn't rise at all. The road meandered, like my thoughts, curiously at the exact speed as my thoughts, mainly in one direction, but then turning, left, then right, unexpectedly swerving, then straightening.

I decided to see what it was like in the woods. I parked, pushed through the thickets at the roadside and walked into the pine forest. It wasn't like the woods where I'd grown up. There were no old-growth trees overshadowing peaceful cathedral spaces sliced by dusty sunbeams. The trees looked stunted. They were closely packed and continued evenly into the distance, like a house of mirrors. Just thirty feet overhead their feathery tops made a sort of thatched roof.

The twigs were wet and prickly. They bent like stalks of celery gone soft. I crushed some of the needles in my hand and they produced a sickening smell, like body odor. The ground was nearly impossible to walk on, because trees had fallen in haphazard directions and been smothered by a thick mat of moss and heather, as if someone had thrown a soaking wet shag carpet over a brush pile. I walked unsteadily, holding the rubbery trunks for balance. The bark was friable and resinous. Every few steps I broke through and my foot snared in moldering branches.

A soft thrum of droplets fell from sodden branches into soaking moss. A bird, somewhere off in the hazy mesh of trees, sang a rising note. It was a peculiar call. I stopped to listen, and that was when I realized I had lost sight of the road. The forest was all around me, symmetrical in every direction.

When you lose your place in the world, you suddenly wake up, as if your normal life had been a dream. At that moment I was the man who came to his senses midway along his life's journey, in the middle of a dark forest.

I stood perfectly still. If I set out in the wrong direction, I might walk for miles without finding anyone. In one direction was the road, just a couple minutes away. In the others were miles of forest, ending in the arctic or in Siberia. If I panicked and started walking at random, I'd probably choose the wrong way, and I wouldn't survive.

I twisted around to see if I could retrace my steps, but the moss had sprung back, and I couldn't see my footsteps. I couldn't climb a tree to get a view, because the branches were too spindly to support my weight.

The forest was both intimate and endless. I felt a special kind of panicked stillness, perhaps the sort a rabbit feels when it runs from a wolf, veers into a thicket and suddenly freezes, hoping it will be invisible. The rabbit is absolutely motionless except for its heart.

With each breath the zipper of my coat rasped against a twig, singing a tinny counterpoint to the faint sounds of the thousands of droplets falling all around me, pelting the weak needles, dropping into the moss at my feet and for countless miles through the soft forest. I thought of lakes lost in the woods, their water perfectly still, their dark mute depths under the luminous gray sky. The bird sang again, a couple of notes, rising like a question.

I became drowsy, as if somehow I'd found my destination and I should just sit down and rest a while. It occurred to me this was like a trial run for another kind of stillness. A rehearsal for the passive acceptance my body will fall into when I sense my life is nearly over. I'll be listening, hoping to see which way to go next, and something will tell me it is time to keep still and wait.

After a few minutes, a truck came down the road, and I knew which way to go.

I made a U-turn around a village square and headed back to Tallinn, where I'd chosen a hotel in the historic district. As I drove past the intersection by the airport, I pictured the poor confused driver from an hour earlier. As soon as he'd seen that road going out into the countryside, he'd been helpless to stop himself. He'd wanted to escape the appointment at the zoo, but it hadn't occurred to him that he'd drive back through

the same intersection and remember the moment when he'd turned the wrong way, and see how it'd come to nothing, and feel the usual disappointment.

The landscape on the city side of the airport was especially empty. It had been raining. A soggy cloud lowered over a sodden field. Five magpies stood senselessly on a patch of bare ground.

I wondered why I had turned back just where I did, or for that matter why I'd turned back at all. There is something secret about me. I don't really know myself, at least not well enough to get a sense of what I might do in the next minute, and that is probably unusual. Isn't a person supposed to know, more or less, when they want to do something? Don't most people have an idea of what they want? What kind of lunatic rents a car in a country he has never visited and then just drives at random?

I passed a sign for a place called LÄÄNE-VIRUMAA. Nice name, I thought, maybe I'll go there. It'd be an adventure. There probably wouldn't be any hotels, or if there were, they wouldn't take credit cards. I'd find a way to keep going, on through Petrograd, away into the taiga or tundra or whatever they call it out there.

The land was splotched with islands of snow and pools of rainwater. Most of the year it must be snowed under. Summer was probably a brief reprieve. The sun seemed weak, as if it wanted to set.

For long stretches there were no cars on the road. A single magpie sat on a cellphone tower. What was that rhyme?

> One for sorrow,
> Two for joy,
> Three for a girl,
> Four for a boy...

I know my intentions, but only at the precise moment I do something. That's how I had ended up going out with Rosie. I was running off somewhere and all of a sudden I turned around and stopped in front of the little office where she works. For a minute I had nothing to say. When I'd gone the wrong way out of the airport, I turned too quickly and nearly hit a car behind me. When those sorts of things happen, I am impassive, like I am

watching someone else's life. It happened over and over the winter I am going to describe in this book, and the last time it was a disaster.

When I visited Estonia, my life with Adela was almost back to zero. When we first met, we were at zero, naturally, because we didn't know each other. Then we felt some love, +1, and we added more, +3, +5, +9, and soon we were adding up to something. There was incrementally more love each day, 32, 36, 47, it surprised us, 50, 60, 70, building like one of those pressure meters on submarines in old movies, and suddenly it was much more, 100, 150, jumping to 300, say (when Adela was pregnant and we were too nervous to know how happy we were), then up to 500 (the year Fina was born, a year of continuous smiling), even 900, unprecedented, wonderful (that would be the last summer we were really in love, a great summer, long days when nothing much happened). Then the meter started to fall. At first, we didn't notice it, because of course we weren't counting, although maybe we should have been, because even though you can't count love you can pretend to count it, but we didn't, so we failed to notice when the numbers started to slip. If there had been a happiness barometer on our wall, we could have watched the needle move down the scale: 540, 310, 90, 20…

By the time I went to Estonia we were approaching zero. We were doing it carefully, or at least I was. I didn't want to actually hit zero, because that would be painful. Adela had moved back to Bratislava and Fina had gone off to college, and I had been thinking less and less of her, of them. The needle was hovering just above zero.

Happiness is when things simply are. You can ask yourself if you deserve to be so happy, and you can try to figure out how to keep yourself happy, but you won't get very far, because your mind is flooded with happiness. At first Adela and I went everywhere together. If I needed to go to the pharmacy, she went along. We went grocery shopping together, we walked together to the dry cleaners. I suppose like everyone who's just fallen in love. When we noticed we were drifting apart we let it happen, because we'd been drifting together, and that had been great, so why not drift differently, provided we kept each other in sight? But that letting go

was the start of unhappiness. We got too far apart to hear each other. One time I looked to see where she'd gone, and I saw only brush and hills. That was when I realized what sadness is, it's the landscape with its trees and fields and no one in them. Managing the speed of separation, that's the key. Rosie, too. Around the time the zoo trips started, our relationship decelerated quickly, and I had a hard time adjusting. It's like when you're speeding along the highway and you come up on a traffic jam, and you brake suddenly in order to avoid a crash, and then you can't get used to the slow speed of the traffic, so you go too fast, and then you brake, and then too fast, and then brake, until finally you calm down and settle in, even though you're always craning your neck to see when you can go fast again.

Seven magpies were marching around a mud puddle. What did that mean?

> One for sorrow,
> Two for joy,
> Three for a girl,
> Four for a boy,
> Five for silver,
> Six for gold...

I'd never wanted to go on these trips, but after Catherine volunteered me for the Zoo Feasibility Committee, I didn't have a choice. My task was to gather information on problematic animals, especially disturbed ones, that's how they put it, so that the zoo they wanted to build wouldn't have issues. No lions that pace endlessly or elephants that twitch and stomp or chimpanzees that pull their own fur out and scratch themselves raw. It wasn't impossible Catherine had given me that assignment on purpose, just to irritate me.

— Come on, she'd said, you'll love the travel.

I told her I'd never liked zoos, not so much because the animals suffer, everyone knows that, but because I don't like mammals in general, including not only lions and tigers and bears but also dogs and cats and even puppies and kittens, including even the youngest, sweetest, cutest kittens that topple each time they meow. I preferred the animals I encountered in my day job in Water Management in Guelph, Ontario, where I was paid to keep an eye

on the city's water supply, to make sure there weren't too many fecal bacteria in the drinking water, the kind that turn your intestines into liquid, and above all to ensure that there was on average less than one *Naegleria* amoeba per million liters of drinking water, because those are the ones that climb up your nose into your brain and cause a spectacular hemorrhaging death, complete with bloody tears and screaming hallucinations.

— Large warm animals make me uncomfortable, I told her. I like small animals. They have no minds.

— Yeah, she said, dogs and cats actually look at you, and you can't stand that. They might even love you, wouldn't that be awful?

She was right: an amoeba can't fix me with a loyal gaze, full of love and longing, and it can't stare me down with a doleful expression full of recrimination and hatred, like a panther had done on the first zoo visit, or like Catherine did when she realized she had not convinced me she'd ever actually thought I'd enjoy traveling to zoos to see unhappy animals.

— Also, I said, I like microscopic animals because no one else does. No one cares if some kind of amoeba goes extinct, or even if they all do. No one even knows if any amoebas have become extinct.

— A little like employees of Water Management, she said.

On I drove, glumly attending to the morose countryside.

Something was going wrong with me. I took wrong turns without knowing why. I drove into the void. When I got lost, I stayed in place, wondering at the world that mirrored itself endlessly around me. I watched bemused as my relationships faltered. I thought if I could lose control, I'd find myself, although I couldn't have said how that would happen, and I was dimly aware that the idea was a weird kind of nonsense because I had in fact entirely lost control of my life already. It was February 2019. A year earlier I'd had my small but apparently contented family and my unambitious but occasionally useful job inspecting the city water supply. Adela was working in Agourec Pharmaceuticals and Fina was still in high school. Now we were dispersed. My family wasn't broken, exactly, in the sense

that there hadn't been any trauma, no demanding or abusive or alcoholic or self-destructive behavior, no so-called irreparable differences. And yet we were falling away from each other, and I had fallen away from Rosie, and I was falling away from myself.

Those days I had a strange feeling, like I was slipping off the path I was supposed to be following. Slowly veering to one side. Like a plane coming down to land, lining up with the white stripes on the runway, wheels squeaking on the tarmac, big puff of dust, speeding down the runway, but then leaning off to the side, crossing the white stripe, at first slightly, then disastrously. A delicious feeling. Like eating rich food, knowing that your arteries are slowly calcifying, but the food is so good you can't resist it. Or like a person suspecting he has dementia, enjoying the freedom of not remembering a painful past. Or like someone free to go anywhere because he has no family—that's it, I thought, that last one, and suddenly it wasn't fun to analyze myself anymore.

Closer to Tallinn there were more signs, each one a potential detour. The places kept calling to me. Kangru, Saue, Kumne, Saku. Places I could go for a couple of days or a couple of decades. Jõhvi, Rapa, Risli, Hullo.

— Hullo, I said out loud.

I was free to go anywhere but knowing that took away my interest in actually going somewhere. I didn't yet know how to make a wrong turn and just keep going. At the time, I remember thinking, well, there are only five more zoos, and after that I can figure out where I really want to go. I knew that wasn't an especially clear way to think about it, but it was the best I could do.

> One for sorrow,
> Two for joy,
> Three for a girl,
> Four for a boy,
> Five for silver,
> Six for gold,
> Seven for a secret,
> Never to be told.

— May the road rise up to meet me, whatever that means, I said, out loud.

— May the sun shine warm on my shirt, I said, trying to remember the proverb. May the wind push me along, may it rain on my feet, may I hang my heart in the trees. May I list and bob, I babbled. May I always make sense, if only to me.

On I drove into the city.

The hotel was a cement building, painted orange. Sodden flags of different nations hung solemnly over the entrance. The receptionist was busy with something, so I stood there in the warmth, looking at the usual clocks set to different cities: Tallinn, Paris, London, New York. She seemed untroubled by the somewhat clouded person standing in front of her. At last she finished, looked up at me, and smiled as if she hadn't noticed I'd been standing there. I shivered as I filled in the registration.

— Chilly, isn't it? she said.

— Winter darkness. In places like this, in the winter, the sun never rises.

— It rises, yes.

I told her I doubted it.

— It rises. I live here.

— In the summer it dims, I told her, without really knowing why I was objecting. It seeps.

— Seeps?

— The sun seeps, it doesn't set. It creeps along the horizon.

I made walking gestures with two fingers, up one side of the registration card and across the top. She shrugged.

As I filled in my home address, making it up as usual, I thought: in the summer months the sun around here doesn't set, and as the summer wears on, it weakens as if it has lost heart, like the long decline of a great country into a forgotten backwater, like a man who has less energy each year until finally he just wants to sleep, like a person falling slowly out of love. That last one especially.

— It spills out on the horizon, I said.

— It sets, she replied. White nights, we call it.

— I know, I said, I live here.

She didn't look up. Perhaps something was wrong with her monitor.

— I was born here, I said.

She looked at me with a worried expression and I flinched. Why was I arguing with her? She hadn't done anything except ignore me for a minute or two.

— Room 31, she said. Please enjoy your stay.

She went back to her computer. I glanced at her as I waited for the elevator. Poor woman, I thought.

— I won't, I said as the elevator door closed.

My room was trapezoidal. The walls converged away from the bed, forming a narrowing corridor. They'd put a standing lamp and chair at the far end. The walls were painted bright orange. There was a small round side table with a vase of plastic flowers. I took off my shoes and lay on the duvet, which smelled of chlorine and bleach-resistant apple perfume. A pillow was palely stained with what I hoped was coffee.

I'd been nervous before the first zoo visit in January. I hadn't even been to a zoo since I was a child. It all felt fake, not only my assumed expertise, but my supposed interest. It didn't help that Abigail Meuron, the Director of the Bronx Zoo, met me wearing a gray business suit.

— Doctor Samuel Emmer! she said, welcome to New York. It is a genuine pleasure to host you.

I almost told her I didn't know anything about zoo animals, that it wasn't my normal job, that I never visited zoos, that I felt like I didn't belong there, that if she didn't mind could we just call the whole thing off.

— It's chilly today, I said. Maybe a short tour would be best.

— A full tour is scheduled, she said. We are delighted to have an expert here.

I was anxious she'd ask me something about animal welfare, or which species I was interested in, or what our projected budget was, or how we

were going to get licensed, or basically anything. Luckily, she had lots to say. They had a panther that paced all day long, she told me, and bovids with issues. I tried to say as little as I could. Nightmare scenarios played out in my head. I'd make some ridiculous mistake, and she'd say "you're not really a biologist, are you?" and I'd have to explain that I was, more or less, but just not the right kind, and I was only here because my sadistic supervisor Catherine had put me up to it, but none of that would sound right, and things would just get worse from there.

She took me around, showing me their new aviary and talking about budget projections based on the crowds that would come to see their baby hippo.

— We're doing what we can with our budget, she said. We know it's not optimal.

— Why not? I asked.

— We're in trouble with the Bronx Commission. There are expectations. People don't realize we need to be certified, we have to comply with the breeding programs. I just wish our big animals would stay healthy at least through the end of the fiscal year.

She stopped to talk to someone who was inside an empty cage, scrubbing the walls with wire brush.

— If only we had money for an accountant and a personnel director.

— Are the animals in there okay? I asked.

— They are prone to infections. Again that's a budget issue, because Detromol—that's the disinfectant—it's a hundred dollars a case. We love the animals, you know. We just can't always show it.

She took me to see their rhinos, which she said had iron overload, and their orangutans, one of which had air sac disease, and probably also orangutan respiratory disease syndrome.

— Suzy, she called out. How are you today?

Suzy tipped her head one way, then the other, listening.

— I could use some advice, Doctor Emmer. Our girl's not in good shape.

— Poor thing, I said, looking at Suzy but thinking of Abigail. There's not much we can do.

Halfway through, we were joined by a frightening person named Suhruda, an expert in mammal welfare, with a PhD in behavioral neuro-biology and a postdoc in affective mammalian neuroscience. He wore a suit and tie under a long, out-of-fashion gentleman's coat. Again I was anxious, and again I didn't have to be, because he was entranced by his own knowledge, and he talked continuously as we watched a herd of cows gnashing their teeth.

— Cows, in a zoo? I asked.

— Not cows, Doctor Emmer, gaur.

I looked again. The animals were hulking monsters, bulging with muscles. They had curving horns like parentheses. Two stood near an empty feed trough. Their pelts glistened purple. One licked the metal flange of the trough. A second lurched forward, sniffed inside the trough, then curled its lips and gingerly bit a rusty bar. They were like weightlifter cows with metastasized heads.

— Persistent licking and biting, Suhruda said. That is behavior you need to monitor, Abigail. It is neuroaffectively negative.

He went on, lecturing us about chemical pathways in the brain, and the many ways they could go wrong. Abigail listened, but I could see she was tired. The cold air smelled of manure.

We had attracted the herd's attention, and they lumbered down to see what was happening. I found myself the object of a dozen stares, each bulging pair of eyes bracketed by a parenthesis of horns. A third gaur came up behind the one licking the metal rim. Abigail and Suhruda were talking about something, hopefully not me.

A gaur in a snowy field, tentatively licking the rim of a metal feeding trough with its bloated pasty tongue.

A second gaur in a snowy field, curling and uncurling its lips, baring its clunky teeth and biting a bar.

A third gaur, standing right behind the one that's biting, in fact stand-ing so close that the flesh hanging down from its throat, whatever that's called, rests on the rear of the gaur that's licking.

A herd of gaurs, staring.

A worried woman, pondering ways to keep the zoo running, patiently listening to a man hypnotized by his own science.

A cold Canadian man watching uncomfortably, wishing he could help and wondering how bad a gaffe it was to think gaurs are cows.

One for sorrow

Two for sorrow

Three for sorrow...

When we got to the bears and the big cats, I thought it would be easier, but I realized there are different kinds of bears and lots of medium-sized cats. I tried to steal glances at the labels.

Abigail pointed out their panther. It stopped pacing and turned to face me. It looked directly into my bleary primate eyes. Its eyes were enormous, incandescent, and frighteningly empty. Charred by some emotion I couldn't name.

At the exit gate Abigail thanked me for coming.

— We look forward to visiting your zoo, Suhruda said. It'll be in the AZA, right?

— What?

— The AZA.

— Sure.

— Well, see you next October.

— For what?

— The annual meeting. Are you a member?

— Of course. We all are.

Except for that blip and my mistake about the gaurs, things seemed to have gone fairly well. At the time I thought maybe I can make it through these six zoos by keeping quiet, and just saying things to encourage the staff. But I was in a delicate frame of mind.

When it came to Adela and Fina, I thought way too much, even though my thinking never seemed to do me much good. When it came to this new job, I couldn't think, because I didn't know the subject I was supposed to think about. It didn't help to have a fake job. A job isn't supposed to be something you like, but it is supposed to be something you can do. At

least I still had my ordinary work, my microscope, my amoebas, my little bacteria. They did what I expected, which was scooting around minding their own business, unless of course they were busy infecting someone and sending them on to a spectacular hemorrhaging death.

Lying on the duvet, thinking how wandering might actually be the thing I did best, wondering when I'd decide whether to show up for my appointment, or if I'd just drive away instead, pondering how I seemed to be reaching a state of perfect indecision, I saw that my imagination was not working properly: and that's when I noticed, noticing myself note the fact, falling into the old familiar thoughts about thoughts, helplessly watching as my drowsiness shut down the wobbly machinery of my mind, like the last worker in a factory going around switching off the machines, with the darkness growing behind him, that's when I realized I was thinking again of something other than my life.

First Dream

That night I slept a strange, illuminated sleep. I watched, enchanted, as my mind showed me images. Pictures shone on my closed eyes, gleamed in my imagination. Clearly, I thought, as my bemused sleeping mind contemplated the images that kept arriving, this is from my childhood. Somewhere near Watkins Glen, New York, nearly forty years ago.

I was standing in a reedy place next to an overgrown field, looking back toward drier ground. A chalky summer haze powdered the air. A weak wind tousled swamp grasses. It would have been stifling hot.

Trees stood around in the landscape, like men on Second Street in summer. I could almost hear their idle talking. Their voices were lost in the scorching breeze.

I turned around, in my mind, and saw I was at the edge of a swampy pond. Like the one I'd played at as a child. Mats of exhausted cattails lay on brackish water. Beyond them rafts of green algae. In my dream they had lost their color. Most people dream in black and white, and in their dreams they know they're missing something, but they just can't keep their minds on what it is. The idea of green lingered a moment, then faded.

The water stank of methane and mud, like the pond behind our house in Watkins Glen. The far bank buzzed with flies. A pair of dragonflies zoomed madly up and down, back and forth. Beyond the swamp were pine woods. They'd be a little cooler. There was something in the tall pines I wanted to see, but I couldn't think what it was.

This was the sort of place I loved as I child. The sun was warm on my shirt. Let me wander in my sleep, I asked, as if I were asking someone else, let me see it through the eyes I had as a child, little Sam's eyes, as if little Sam was someone else, and of course he was.

Farther into the swamp. I was wading. My shoes were soaked, the mud gummy. My jeans black with it. Reeds cracked and rustled as I walked. There was a drone of uncountable insects, clinging to every leaf, hovering, swarming.

I was heading toward the remains of an ancient tree, shipwrecked in the swamp. Beyond it was a scrim of thin wet woods, roaring with the sirens of cicadas.

A deerfly bit me on the hand, or else a thorn pricked me. In the dream I didn't look at my hand. Sometimes in dreams it's impossible to do the simplest things, like look at your own hand.

I sloshed on into the swamp. Insects whirred and fluttered. The flat water reflected the flat sky. Sometimes in dreams impossible things are simple, like walking while standing still.

At the water's edge I crouched down. Willow saplings were growing in the muck. Their stems trapped leaves in the slow current. On the bank were swamp milkweeds, a plant that grows quickly at the end of summer. They wither at the first frost and shrivel down into the earth.

The viscid soil near the water, the tangled sodden roots and stems, last year's leaves coated in slime, reminded me of something in my real life, my waking life. The rotted black mud at the edge of the swamp meant something, but I couldn't quite recall what it was, because the images kept arriving, unexpected, unasked.

I looked up at a bank of milkweeds. Beyond were some trees killed by the swamp. In Watkins Glen the swamps always expanded. Year by year they grew, and the woods around them died. The swamps created wastelands, hollows where dead trees stood knee-deep in water. Those were also places little Sam loved, because no one ever visited them.

The leaves of swamp milkweed have a velvety feel. Soft like small animals warm in the sun. There was something wonderful about weeds. No one attended to them. They were always a mess. When they got tired, they leaned on each other.

I watched the scene carefully, gratefully. There was the sound of a woodpecker back in the swamp, chipping at a soft trunk. The milkweeds moved ever so slightly in the breeze. Just a few millimeters one way or the other. Gentle, minimally alive.

My sleeping mind's eye watched, bemused, as the landscapes came one after another. I had an idea I was looking for something, maybe a particular tree. I walked through woods soundless as a ghost. The delighted eye of my memory regarded one thing and then another.

I saw a vase of ferns, then a young tree that had died and half-fallen on a cushion of stems and vines. Brilliant daylight poured down. Leaves shone softly. There was darkness underneath.

I had no fear of getting lost, because I was a little boy again, and somehow whatever I looked at was home.

2

Life with Maria-Kristiina Tank

At eight fifteen the next morning I was in the hotel lobby, thumbing through a copy of *Life in Estonia,* waiting for Dr. Maria-Kristiina Tank.

— Hello? she said loudly, behind my back.

She was in her forties, with a knotted, diffident expression and a blunt nose that might have looked adorable on a little girl's face.

— Dr. Samuel Emmer, she said, using that odd custom in which people identify themselves by announcing they know the name of the person they are meeting. She stretched out her hand for an American-style handshake. Her fingernails and hair were funeral black.

— We must go. It is eighteen minutes by tram.

It was a chill dark day, with a buffeting wind. Our shoes clattered and slid on the outsized paving stones.

I told her I was interested in the new mountain goat enclosure. My assistant, Vipesh, had given me a heavy folder of documents for my trip. I hadn't read them, but I'd noticed a newspaper clipping that said the Tallinn Zoo had the world's largest collection of mountain goats and mountain sheep.

She made a sound, possibly yes, but possibly also eh or yeh, and probably meaning I didn't catch that, but I'll pretend I did.

We walked on in silence. My eye was caught by a shop with the sign WOOLENS, GOLD, SILVER, AMBER, ESTONIAN NUKUKUNST DOLLS. In the display, dolls of anorectic young women with enormous eyes and fairy

wings walked on a landscape made of wool blankets, against a backdrop of silver, gold, and amber clouds. One had a wool shawl and held a gold brick. Another had a ruff collar, a miniskirt, and lace-up boots. A third had an enormous wig with an amber egg on top. She was pushing a wheelbarrow full of gold and silver. Rosie would have liked that one, I thought. When I looked up, Dr. Tank was about to disappear around the corner.

The tram was cramped. For some reason the seats at the windows were six inches farther forward than the seats on the aisles, so I sat a bit behind her. I was grateful for that, and for the tram's dizzying swings and lurid screeches, because they made it impossible to talk. The howling of the tracks was at odds with the complacent faces of the passengers. The tram was like one of those old wooden roller coasters, straining against the clamp that holds each car to its tracks, the clamp that's probably grimy with machine oil and grit, eroded from decades of grinding, crisscrossed with hairline fractures, fatigued from the crushing pressure and the lurches and the percussive rattling, the clamp that's somehow kept holding on even though it should have broken years ago, but it's down there somewhere, unnoticed by anyone, never inspected or even cleaned, but that's life, everything falls apart, no one's accountable, the clamp that finally snaps, releasing the car into the air, sending its ecstatically horrified occupants sailing into silent zero-gravity space for just exactly one unmeasurable eternity before they come crashing down onto the amusement park parking lot, smashing brutally, exploding in blood and bones and rusted nails, like in *Amusement Park Horror Ride* or whatever that movie is called where the last scene is the girl's hand holding the teddy bear, sticking out from underneath the red-painted rim of the overturned roller coaster cart. At every ill-engineered turn in the street, I absorbed the juddering electric feeling of swelling danger, followed by the sad, draining return to the steel track, safety, and more traveling. The tram and the wheelchair, I thought. Vehicles that take us dependably on into our uninteresting futures.

We got out in a mixed-use neighborhood and walked down a wide street guarded by dirty concrete medium-rise apartment buildings. There was a mist of rain. It was the kind of street where you might find a furniture

wholesaler or a specialty shop to fix cracked windshields, the sort of neighborhood a lost tourist would drive right through, never dreaming of asking directions from any of the undoubtedly surly monolingual shopkeepers. Estonia, I decided, is a particularly inhospitable place for tourists hoping for friendly chats with surprisingly North American people who only betray their nationality in their endearingly light accents.

We stopped at a restaurant across the street from the zoo entrance.

— I live there, Dr. Tank said, pointing to a wretched-looking five-story Soviet-era apartment building overlooking the zoo.

She chose an outside table with a blue vinyl parasol that shivered in the breeze. The menu, she said, offered dishes made with local wild mushrooms. She ordered for both of us: soup made from smoked cheese and mushrooms, and a glass of kama, which she said was a national drink.

— Your city has a special interest in mountain sheep?

For the first time I picked up on the U.K. accent in her speech.

— We might.

"No" would have been more honest, but I was on the edge of the runway. It was fascinating to watch myself swerve. The straight path used to be the easy one, I thought. It's the one that's marked on the runway, after all. It's smooth, it doesn't end in a spectacular burning crash. But straight lines had become difficult.

I thought of telling her the whole zoo project was just the City Council's idea to attract regional tourists, that I didn't know what I was doing, that I didn't care about her mountain sheep. That would be interesting. But then she'd probably write to Catherine or Agathe and I'd be in trouble.

— You are from the University of Emory?

I guessed that the name of the university I had once attended meant as much to her as the name of her university, which her email signature identified as Tartu Ülikool, meant to me.

— No.

— Okay.

She was wearing a black-and-white striped blouse and black velvet pants, which together with her black hair and nails gave her the appearance

of a pantomime actor portraying a zebra. Her glasses had oversized plastic tortoise-shell frames. I wondered if zoo directors often dress like animals. I guessed she was fifteen years out of university, earning something like 30,000 Euros a year, probably supporting a child or two.

She was looking at me like I was an idiot.

— So, she said, unfurling a brochure, this zoo is the largest in Estonia and we cannot see everything.

She pointed to several features, but the brochure was in Estonian, and it was upside down. Her accent meant either she'd had a teacher from the U.K., or she'd lived there. If I were Estonian, I would definitely want to get out, maybe just to see trees that aren't blue.

She was saying something about mountain goats.

I wanted to ask about another thing I'd seen in Vipesh's folder, concerning a man who lost his right hand to one of the zoo's polar bears. He had been drinking and fell asleep behind some bushes. After the zoo closed, he woke up and wandered around in a stupor. At some point he offered a cookie to a polar bear. The bear took his hand along with the cookie. The hand was never recovered.

When Dr. Tank finished her explanation my mouth was filled with kama, which turned out to be a curious blend of powdered dried peas and berry-flavored kefir yogurt. The polar bear's snack would have been creamy and crunchy like that, but with a different flavor profile. Perhaps the bear got the man's watch, too. That would have been especially crunchy.

— This is not really a local soup, she announced. We do not really have a cuisine here. The country is too small. This is just a Russian soup.

Was I meant to console her for the continuing hegemony of Russian culture, or to praise her for her honesty in acknowledging her country's lack of cuisine? There were enormous distances between Guelph and Tallinn: culinary, linguistic, climatological, economic. In Canada, we have an actual sun, I thought. Tallinn has a pale thing that lingers somewhere off in the sky. Around Guelph there are reasonably prosperous farms with late-model cars parked in paved driveways, and the farmhouses are nestled in the shade of mature trees whose leaves are generally a good

healthy green. Tallinn is surrounded by an endless forest of toilet brushes. In Guelph people speak that slight Canadian drawl that Americans have such fun making fun of. The Estonian language is related only to Finnish, which is said to be one of the world's most difficult languages. Silly to think some Russian soup could possibly bridge those gulfs.

Suddenly she brightened.

— Do you have children? she asked.

— A daughter.

— How old?

— Eighteen, she's gone to college now.

— And your wife, she is also a scientist?

— My wife lives in Bratislava.

I sighed to indicate I was sad, even though I wasn't. Or not exactly, anyway. Whatever had once been sadness was overwhelmed by anxiety that the sadness might come back, and since it hadn't, the result was more like relief.

— Unfortunate. I believe Bratislava is very beautiful. I have no time to travel. My position at the university is part time, and my position at the zoo is also part time. This is how things are.

— So sorry. But you're not missing anything. For me, it's kind of depressing to come all this way to study animals trapped in cages.

— Please, Dr. Emmer, our animals are very good. Our welfare compliance rating is exceptional plus. Eighty-three percent of our animals are born in captivity. They are used to it.

I hadn't always been so thoughtless to blameless people. I felt for the interns in the lab when they were hardly able to learn what they needed for their certificate, and I knew a number of waiters, waitresses, and coffee shop employees who would have said I was perfectly cheery. But when my apartment emptied out, I lost interest in what other people felt, not because I had more problems or worse ones, but because I'd lost that natural connection with my own feelings that we all take for granted. My feelings weren't working right. Either they arrived a minute or a day too late, as if they had their own schedule and no longer cared about mine, or

they didn't appear at all, leaving me in a vacuum, where all the oxygen had gone out of the air and yet I was able to keep breathing.

I wanted to say I felt trapped like the animals, but not by iron bars, walls, and moats. What had trapped me was an intricate thready thing that had assembled over me as I sleepwalked through my life, like those filmy cocoons that enmesh sleeping people in *Invasion of the Body Snatchers*. I wanted to tell her that the threads of my cocoon were spun from the guilt I felt at not spending more time with my wife when it might still have mattered. Some especially tough strands were made of the shame I felt when I saw that by letting Adela go, I'd caused Fina a pain she hadn't yet begun to measure. It was one thing that Adela and I let our lives drift apart: that was our own business, and despite what we'd anticipated, it'd been going fairly smoothly. Fina was another matter. For some reason I wanted to tell Dr. Tank all that, and then I'd tell her that my cocoon was also fabricated from my own low-level, entirely ineffectual ambition, an ambition that wasn't strong enough to help me resist this whole zoo project. For a long time, I'd tell her, I've known I don't have any special hunger or aptitude for success. My field, protozoa, is a small, low stakes subject. Its objects are tiny, and it attracts people who don't want to scale the steep cliffs of more competitive specialties. And really, I'd say, I'm not a specialist in those things anymore, I'd quit even that diminished arena, and gone for my secure job as a water inspector.

And wait, I'd tell her, there's more. Some especially hurtful threads are woven from my acidic relation to my corrosive mother. Those threads probably started forming when I was quite young, and they became visible the decade before she died, when I learned to dislike her, almost to hate her, because I saw, finally, how poisonous she was to herself, and how she didn't notice when other people saw that, or care about the discomfort or pain it might cause them, especially when such people had loved her for many years in the natural, unreflective way that children love their parents, a feeling that can persist into adult life and even into old age, and is probably best left that way, unexamined and undoubted, because it corresponds to the natural order, an order that was ruined, slowly, nastily, by

her incapacity to tolerate herself. Lots of threads, I'd tell Dr. Tank, hard to count, hard to disentangle, hard even to breathe through them, what do you think of that?

She was chattering on about the exemplary treatment of animals at the Tallinn Zoo. Second to none in Europe, I heard her say, nearly a standard deviation above the EU line for median mammal health. It was what she thought I needed to hear. But I wanted to find out who was at home behind the zebra suit and turtle glasses. At the least, she needed to know I was not some commuting Canadian government rep easily distracted by borrowed Russian cuisine. I could feel a needle in my mind, thin, sharp, ready to pick at the cottony confusions that had been swaddling me so long.

— I saw a report in *Life in Estonia,* I said, interrupting her. It seems last year was a record summer for mushrooms.

I fixed her with what I imagined as a friendly gaze. She winced instinctively, subtly, and then returned my stare with a composed and distant look.

— Yes.

She seemed annoyed, possibly because I had interrupted her.

— I guess many people in this country find mushrooms interesting.

— Some, yes.

I'd said that awkwardly. I was trying to compensate for her less-than-perfect English by speaking clearly, but I was only capable of speaking clearly when my thoughts were clear, as they were when I had informed the Commissioner's panel about the clearly statistically insignificant presence of brain-eating amoebas in the city's drinking water, but at the moment I didn't really know exactly where I was headed, except that there was a connection between Estonia and mushrooms, and another between the wild mushrooms in the soup and mushroom-hunting when I was a child in Watkins Glen, and another between the musty smell of the soup, or perhaps its woody taste, and the woody taste or musty smell of mushroom soups I'd had years ago, especially soups made with a particular species of Boletus that I couldn't bring to mind just then, even though I could hear my mother sighing at my incapacity to learn to ident, which in turn re-

minded me of our long walks through the forest searching for mushrooms, a forest that felt especially lovely and fragrant, as if I'd just seen it yesterday and not forty years ago, and then there was also a connection, or rather a contrast, between the composted smell of this Estonian mushroom soup and the watery tinned quality of the mushroom soup in the Yellow Hat diner on Lorck Street where I had my weekly lunches with Catherine, which reminded me that I hadn't come very far in life, just from Watkins Glen to Guelph, a four hour drive, and really, now that I thought about it, how watered-down my life had become, falling from its original richness, when mushrooms smelled of fresh mulch and the smoke from a pinewood fire, and each specimen had its exact Latin name, to my life's present state, where the only mushrooms I ate were farmed and canned by Campbell's and tasted like warm water that has been poured over mushrooms and lightened with fat-free milk.

Somehow Dr. Tank needed to know all this. I tried again. I told her that when I was young my family had been obsessed with mushrooms. I cast a distant look out across the street in order to signify dreamy pensiveness. This was a lie; it wasn't the family. It was only my mother, but for some reason I needed to make a connection with this Tank person.

Her eyes had lost their focus. What was her problem, anyway? She didn't dislike mushrooms, because she'd ordered that soup. Maybe she was tired of talking about mushrooms. Probably everyone in Estonia talked about them. Chances were every other person was a mushroom hunter. Maybe she was worn down by her life. Maybe she really did want to talk about her zoo.

— It's tricky, I continued. Poisonous species look a lot like delicious ones. I'm sure it's the same here.

She didn't say anything. Her expression may have become even a touch more severe. She leaned forward.

— To tell you the truth, Dr. Emmer, I never have time to get out into forests, ever since my son—

She waved at someone behind me. Two people in their thirties came up to our table.

— Samuel Emmer, meet Tüüne-Kristin Vaikla and Joonataun Alatalu, our old graduate students. We call them old because they haven't graduated.

The two were dressed in suits and trench coats, as if they thought the lunch might possibly result in employment. Joonataun, who pronounced his name Unit One, had long unkempt hair and looked guilty of something. He told me he was an expert on veterinary economics. Tüüne's hair was pulled back tight against her skull. She'd had her eyebrows done into sharp angles, giving her a hawklike expression. Joonataun handed me a spiral-bound report.

— It is a pleasure to give this to you. Our report about animal health issues, compiled especially for your visit.

— Last year, Tüüne said, sitting down next to me, we had 130 cases requiring care, including gynecological issues and infections, and twenty-seven injuries, however please note this is in an animal population greater than 1,700 individuals.

— During the same year, Joonataun said, we required only nine euthanasias, nearly all from the aging mammal population. That's well below the curve.

— First, we surveyed stereotypical pacing behavior, because we understand it is the purpose of your visit, Tüüne said.

Joonataun consulted his copy of the report.

— This behavior has been recorded in zoos in our country in the following species: Sumatran tiger, Asiatic lion, North American black bear, Alaska brown bear, European wildcat, Amur tiger, spectacled bear---

— Fennec cat, African leopard, slender-tailed meerkat, Barents seal.

— In the case of the seal, it is stereotypical swimming. So-called pacing while swimming.

Dr. Tank was watching them. She must have supervised the report, and maybe even rehearsed what they'd say.

— No pacing behaviors are currently observed in Tallinn zoo. Next, we made a tabulation of other stereotypies. We will send you our spreadsheet, which includes all zoos in Estonia. Our tabulation includes about thirty kinds of non-pacing stereotypical behaviors. Several chimpanzees

recently exhibited self-plucking of body hair. A gorilla in this zoo exhibited regurgitation and reingestion. A sun bear in Tartu practiced tongue extruding and excessive paw licking. At present those behaviors are absent.

Dr. Tank apologized. She had to make a call. She left the table. I leaned in toward Joonataun and Tüüne.

— Tell me, I whispered, do you consider her a good Director? Is it good to work with her?

— She is wonderful, Dr. Emmer, Joonataun said.

— She is a little strict, Tüüne said. I begin to wonder will I ever graduate? Joonataun shook his head.

I told them my report was absolutely confidential.

— She keeps this filing cabinet in her office. We know what she keeps in it because—

— It doesn't matter how we know, Tüüne. We know. The filing cabinet has notes on her meetings. "Met Dr. Maeda today. Short, ugly person," like that.

Joonataun giggled.

Dr. Tank was standing at the curb, talking on her phone.

— "Short, ugly. Unconvincing. Turn down application." Or here's another one: "Called Florina today. She's—"

— Florina Ifscher, she works at the regional zoo in Tartu.

— Yes. "Called Florina today. She's lost funding for tigers. She's upset, does not understand what happened. Excellent prospect for us."

— "Excellent prospect for us!" Tüüne said, mocking Dr. Tank's voice. Can you imagine?

— You know, I said, it's funny her last name is Tank. In English it sounds…

— Hallo troops I am Doktor Tank! You know, Doctor Emmer, Joonataun and I have read the filing cabinet. In this way we know there is no escape.

He raised his glass and flipped his long hair out of his eyes.

— I may be a student forever.

— We will be students forever!

They touched glasses and sat back in unison. It seemed they'd made this toast before. I thought of my interns back in Guelph, looking for jobs, finding none, pondering going back to school.

— What about the university? I asked. Can you complain to the rector?

— No, she knows him.

— Dr. Tank is supervisor. She has final say.

— Say about what? Dr. Tank said. She had suddenly reappeared.

— Whether we can ask Dr. Emmer, in future, for a letter of recommendation.

Dr. Tank surveyed her two perpetual students with a mistrustful expression.

— I don't think that's a question for me. What did you say about the rector?

Two young women came up to the table. Dr. Tank greeted both in Estonian. They brought chairs from an adjoining table.

I listened to their language. Not a single word came through. This is the strange loneliness of the cocooned mind. The certainty that the world is out there, free of the threads that crisscross the cocoon and entangle every thought. Their incomprehensible talk gave me a writhing feeling, which is the uncomfortable wriggling of the soft larva inside its hard-spun shell. That is how I experience the world: whatever sounds reach me are refracted by the silk threads of my own misapprehension. I don't always hear people properly. Things I say are sometimes misaligned with what people say to me. It is hard to see out of the cocoon. I make out lattices and lines, and if I'm lucky I get a glimpse of an eye, or of someone's meaning, or a thought other than my own.

— Doctor Emmer, this is Miss Merike Lepp, she is volunteering at the zoo.

I stood halfway up and shook her hand. She was dressed attractively, in a dark blue skirt and cerulean windbreaker. She started to say something, but thought better of it.

— And Miss Sirje Kukk.

— Hello, she said, I am a doctoral candidate in History of Science. I am definitely not a biologist.

She was almost punk, with a 1950's flip haircut, done in such a way that it appeared to sit on top of her actual hair, which was shoulder-length and emerged from underneath the flip cut's set curl. She reminded me of two things at once: a party where everyone tries on wigs, and a Tolkieny

movie populated by peaceful forest creatures. She put her phone down in front of me.

— Mind if I record you? I am doing research on the history of zoo management.

— Sure, I said, but then they all started talking Estonian again.

After another minute of conversation, Tüüne and Joonataun said goodbye, telling me I could write them anytime, with any question, any question whatsoever, on any subject, and they hoped I would find their paper useful in my study; it had been a pleasure to work on it, and they hoped to see me again perhaps at some conference or maybe even in Guelph, Ontario, Canada, and they would send me the spreadsheet and the full report in case I did not want to carry the printout in my luggage, and possibly also, at some point in the future, they might send a request for two letters of recommendation, if that was approved by Dr. Tank and the rector. Joonataun winked at me as they left.

— Welcome to Estonia, Doctor Emmer, Sirje said. If I may ask, what do you hope to accomplish in this research?

— Well, I said, speaking into the phone, I am here to study best practices for keeping animals.

— Of course, a fascinating research, she said quickly. But what specifically in our zoo?

She probably knew all about the project, and also how little I knew about zoos.

— Well, I read about the polar bear.

— Yes! Our hungry polar bear. It ate a man's hand!

— I wonder if it intended to attack the man, or just grab the cookie?

Dr. Tank had apparently gone deaf, because she was staring at a man who was adjusting something on his bicycle.

— Oh, it totally wanted revenge. It thought, Hey, I can get some sweet revenge on these people who have kept me prisoner all the years, and also I will have a nice lunch. A lovely warm hand sandwich featuring a cookie filling.

— Ooh, horrible, Merike said. I wonder too, does the bear like the tasting of a man's hand?

Dr. Tank sipped an espresso abstractedly. Perhaps she knew people who had witnessed the event. She might even have been there herself.

— Revenge has a taste! Sirje said.

— Sweet revenge! Merike yelled, pretending to chomp down on Sirje's hand.

The bicyclist was adjusting his panniers, which were loaded with boxes. That was apparently a fascinating and unusual sight because Dr. Tank was fixated on it.

— Bears are accurate feeders, I said, trying to exercise some authority. They eat snowberries and blueberries, and they catch fast things, like Alaskan salmon. Your bear knew exactly what it was aiming at. The question is: Was it carnivorous behavior? Or anger?

The students stared at me, expecting the answer.

— Or was it an intelligent choice, where the bear figured no one would blame it for taking the man's hand, because everyone would think it was aiming for the cookie?

— Our bear was dangerously intelligent, Sirje said, playing along. They had to kill it.

Merike gasped.

— Oh no! They didn't kill the bear! Did they kill the bear?

— They did not kill the bear, Merike, Dr. Tank said. It was relocated.

— Where? Can we see it?

— No.

Sirje was delighted, Merike was distressed, and Dr. Tank was presumably bored, as we headed across the road and up a steep driveway. The entrance gate was a concrete tent shape with a muscular bronze wolf on top. Sirje pointed out that the LOST AND FOUND window displayed a single infant's shoe. One, she signaled with her finger.

— I propose we proceed to the principal attraction of our zoo. It is world's largest collection of mountain sheep. It is at the far end of the zoo.

We walked a while in silence. Why didn't Dr. Tank like talking about the bear? Maybe it wasn't real science. They probably saw right through me. I should have read the papers Vipesh had given me.

The cages were empty, and the long avenue leading to the back of the zoo was nearly deserted. In the far distance, a mother pushed a pram.

— Welcome to Tallinn Zoo, open for business! Sirje said.

— It is winter now, Dr. Tank explained, and most of the animals are retreated into their enclosures.

— Tourists also, Sirje added.

It was hard to see if there were animals inside the darkened cages. For some reason the zoo was in a forest, and more of those depressing Estonian trees shaded the displays.

— Our zoo is not the largest one in the Baltic region, Dr. Tank said. That honor belongs with Helsinki. But we are leaders in the study of sheep and goats. We also have tahrs, turs, and markhors. And gorals and serows.

I nodded perfunctorily as if I knew. Sirje walked backwards in front of us.

— I hope you are enjoying our deserted zoo, she said, gesturing right and left. The animals are quite happy even though for technical reasons they are invisible.

— Not technical reasons, Sirje. It's cold.

— The animals are technically cold, Sirje said.

We paused by a sculpted concrete pool, drained for the winter.

— For otters, Dr. Tank said. They are being kept indoors.

She pointed at a dark wall beyond the pool area.

Sirje stepped between us and the empty pool.

— Here you see the end of the life of otters in Estonia, she said, holding her phone up like a reporter's microphone. This is a happy place for the little creatures. They are away from wolves. They are protected. They are fed fairly fresh fish. Even now they recline in their concrete otter bunker, watching otter television.

— Sirje, please, it is not a bunker.

— Sorry, I meant lounge. Otter lounge.

Dr. Tank walked off.

— Please follow me, Sirje said, there is much more to see.

I peered into a high enclosure, draped with black steel netting. Something for monkeys or birds. What would life be like under a sky like that? The heavens captured in a net.

— Isn't the sky supposed to be empty? I asked, without quite meaning to.

Sirje considered the cage.

— This is a grade-A Protected Sky from Charlottenstrasse SkyMesh, featuring the latest in Despair Repellent technology.

— For lemurs, Dr. Tank said. And companion birds.

Sirje nodded at me as if she and Dr. Tank were co-hosts on television.

— You will never doubt the existence of god again, if you live happily under our Protected Sky.

— Oh, for heaven's sake, Sirje, Dr. Tank said, and added something in Estonian.

We walked on, past another row of enclosures that looked abandoned. Resilient weeds grew in the yards. Vines climbed the fences. A service alley ran along behind the cages. The animals' small metal huts were dark and hopefully empty. The place had the look of a village somewhere in the developing world. I felt sorry for Dr. Tank, because she must know how her zoo looked.

— Here we have the pens of the dispossessed, as they are called, Sirje said, stepping around in front of us again. This is where the zoo keeps animals that have been the objects of racial or gender discrimination. Also many transgender animals live here, shunned by their fellow animals and sadly marginalized by the international zoo community. Even today many animals are conservative and prone to reject other animals that do not conform to their old-fashioned standards. Camels are especially racist. Asian or Bactrian camels despise dromedaries, because dromedaries only have one lump on their back, and Bactrian camels have two. The Bactrian camels are horrible snobs, and they think that camels with a single lump are probably idiots. There are many similar cases, all heartbreaking.

— Sirje, you're being ridiculous, Dr. Tank said.

— And what's worse, Dr. Emmer, is that many zookeepers are deeply complicit. Not Dr. Tank, of course. But they actually believe some animals are inferior. The animals interiorize this prejudice, and they are ashamed to show themselves.

Down a side path there were enclosures for exotic birds. A Chinese golden pheasant stood in the back of its cage. Its outrageously gorgeous tail, the color of pale oranges and pink sparklers, shivered in the cold air. It hopped up onto a feeding platform, and its fancy feathers dangled town, their ends tickling the dirt. It regarded me with opaque emerald eyes flecked with silver. The ground in its cage had been groomed with a finely toothed rake.

There was a jittering movement in the next cage. A small bird, perhaps a quail, was there in the shadows, shaking its head at the fencing. No, it seemed to say, No, you don't exist. It ran up and down, shaking its head, No, no, no.

— A Chinese quail, Sirje announced. It feels sad because the Chinese pheasant is so much more beautiful.

— That's ridiculous, Dr. Tank said.

— The poor quail is mostly brown. She looks at the magnificent plumage of the wonderful pheasant, and she despairs. Such a wonderful bird, so regal, so decorative. The quail feels her small body is inadequate. She has a bad body image. Her name is Winifred, and she's embarrassed about that too. The exquisite pheasant is named Wallace. Wallace is especially famous for his fire-fangled feathers, and occasionally he plucks one out and drops it in front of Winifred to taunt her. There is a regrettable lack of counseling in this zoo, so this quail is left to work through her issues on her own.

— What nonsense, Dr. Tank said.

Some pens were half-flooded with standing water. I said the mud would be perfect for pigs. It seemed like a safe thing to say.

— Our choice of animals is a balance, Dr. Tank replied. We specialize in the boreal forest. It is our local ecoregion. However, we also need the state

sponsorship, therefore we stock limited numbers of charismatic megafauna. A giraffe lives here. In this weather naturally it prefers its shelter.

— Ah, no, said Sirje, in a great booming voice, I certainly prefer the opportunity to wallow in muck, since I am so grievously deprived of that possibility where I come from.

— And where is that? I asked.

— Sir, thank you for asking. I am from the distant desert clime of Nubia, known to you as the Sudan, and I can assure you most resolutely: I enjoy my romps in the cold, unpleasant, sticky mud of this, my adopted home.

— That is enough, Sirje, Dr. Tank said, and went on ahead.

— Why are you inside, then? I asked.

— Ah, sir, you are so solicitous! Sirje boomed. I am inside because I am afraid of Dr. Tank. You see, she is jealous of my lovely long legs, but I cannot help the way I was made, now can I?

She made a pouty expression.

— Sirje is only an historian, Merike said. I actually work here. You can also ask me questions.

I stopped by a pool of stagnant water.

— And this enclosure will be of special interest to our honored guest Dr. Samuel Emmer, because for some reason he specializes in microscopic animals such as the humble common amoeba.

She held out her phone to me.

— Yes, there will definitely be amoebas at the bottom of this pool, I said. Rare ones, maybe. And anoxic bacteria.

— Oo.

I warmed to my subject.

— See in the back, where the water looks dull? That is a film of bacteria. Hundreds of millions of them.

— Mm.

She panned her phone over the enclosure. She had a nice mixture of happiness and insincerity.

— Millions of bacteria, she said. You heard it. This is the terrible scandal of the Tallinn Zoo: it has big warm animals, but also uncounted hundreds of millions of these anxious bacteria. Consider, ladies and gentlemen, the gross injustice and rank prejudice of the Tallinn Zoo. Not one of these many, many sad little creatures is labeled. The zoo is full of cold ponds and mud. Clearly it is principally designed to host anxious bacteria. It is even possible that they might be happy, since they multiply in outrageous numbers. And yet the management continues to act as if there is nothing on the premises except pretty mammals and birds. I am with the Canadian scientist Dr. Samuel Emmer. His bold proposal is to rename our zoo the Tallinn Collection of Endangered Pond Scum. And he calls for the immediate resignation of Dr. Tank.

I gave Sirje a what-the-hell look, but Dr. Tank hadn't heard.

The rains had turned a turtle pen into a cauldron of mud, twigs, and leaves, undoubtedly mixed with animal excrement, hair, skin cells, and more amoebas and bacteria. Sirje was right, no one appreciated the things that actually lived in these enclosures.

— Rare Estonian cold-mud turtle, Sirje announced. Lives in stinky mud, sticks out its rear end every spring solstice. If it poops, six more weeks of misery.

— Ms. Kukk, the Russian tortoise, is of course in its winter pen.

— Right, Sirje said, and grinned at me.

I shot her a look that said she probably saw that, and she shot me a look that said who cares; and Dr. Tank gazed into the turtle pen with an expression that said my life is fairly hopeless, because Sirje is pretty much right, this place is a dump, but it's mine. I have tethered my withered career to this zoo, it is what it is, jokes can't tear down what's already stomped into muck, and besides, I am as secure as the Russian tortoise, we both live in warm concrete houses, the tortoise has free rent but I have a pension, and I looked at Dr. Tank with an expression that Sirje knew right away meant,

I could live her life, I know those feelings, and Merike also looked at Dr.
Tank, probably wondering if now was a good time to ask again about the
polar bear.

— Pit! Pit!

Merike ran ahead and stood at the rim. I leaned over, wondering what
might live down there. Pits: emblems of despair. If I lived in this one, I'd
look up and see only sky and a hateful sandblasted tree trunk, my ladder
to nothing.

Sirje gave me two pats on the shoulder. There's something cruel, I thought, in the easy sympathy of someone who doesn't know you, especially if she basically doesn't care. She was smart, so she probably knew that. She'd been trying to cheer herself up as much as me.

Farther on, a row of low buildings turned out to be barns for ruminants. In front were scruffy pens, stocked with different sorts of antelopes. An odd one with a bent neck and a beard like a goat pressed forward curiously, rolling its enormous waxy eyes, stretching its head upward as if it wanted to howl or vomit. It looked at me, or rather its rolling eyes rotated around me, as if I were a shirt in a front-loading washer, tumbling in the suds.

The path to the end of the zoo ran along the edge of the property, and we glimpsed the main road through patchy woods. There was Dr. Tank's building, and beyond it, enormous electric power lines.

— My god, this place is unbelievably sad, Sirje said, lowering her imaginary microphone.

— It is just winter, Merike said. The zoo is lovely.

We came to a small, cleared area with two amusement park rides for children. One was a teacup ride, fenced off, rusted, and apparently long broken, and the other was a metal octopus painted enamel red, with little wooden chairs hanging from its arms. Crows stalked around. Sirje made a video. Mushrooms had sprouted in front of the octopus ride. They looked like a crowd of tiny children waiting for the operator to let them on board.

— Clitocybe, she said, the sweating mushroom. Looks nice, but one bite and you sweat until you faint.

— Edible, Dr. Tank said. *Clitocybe nuda.*

— Incredibly rude name, Sirje said. Also causes painful wrinkled shrinking of the hands and certain other parts.

— Oh my god, Sirje, Dr. Tank said.

— This is nature's way, Sirje continued, walking back and forth on the mushrooms. If you ate the animals and plants in this zoo, you would get sick. Amoebas make a delightful silky soup, but you will be sorry afterward. Millions of bacteria can be compacted into an excellent burger patty, but

it is full of poison. These mushrooms have an effect that can't be mentioned on TV. The only things that taste good in our zoo are the giraffes, and they are notoriously stringy.

The mountain sheep and mountain goat area turned out to be a landscape of rounded dirt hills, like enormous, overturned salad bowls, protected by a high fence topped by five electric lines. Some animals stood awkwardly on the slopes, uphill legs bent, downhill legs reaching for purchase. Mountain goats gathered on the puny summits. The landscape was bare except for boulders that had been added for decoration. Between the hills there were low shelters with feed troughs. The zoo ended there, with a high brick wall. Beyond it, Dr. Tank's building looked down on the animals like a guard tower in a low-budget movie of a prison.

Merike and Dr. Tank went to talk to a zoo worker who was raking animal waste.

— It's like a gulag, I said.

One of the mountain sheep lost its footing and skidded down the slope. It stayed rigid, like a toy animal being pushed by a child. When it reached the bottom it hopped sideways and fell over.

— Holocaust kitsch.

— Imagine living like this, Sirje. You get a hill of compacted dirt, a boulder or two, and a hut with a straw floor.

— I would be insanely happy, she said, filming around with her phone.

— Happy, happy, she said, holding her phone out toward the sheep.

Dr. Tank probably looked down on the gulag each morning from her apartment. Mountain sheep have sharp eyes: they'd all know she lived up there.

— See how the animals walk around their bald hills, Sirje said, narrating again. They go in spiral patterns, up and down.

She was right: their landscape was bare, so they spiraled their way up and down. Their paths made lovely intersecting arcs, like a potter running a fingernail up and down a pot while it spins on the wheel.

— Would you say, Dr. Emmer, that those are normal animal paths?

— They're orbiting their spherical hills like planets, I said, like moons.

— That is so true, she said, panning back and forth to follow the goats' paths. If we could all follow paths so celestially perfect, our lives would be one single perpetual joy. As Bob Dylan says, our lifetime would be like a heavenly day, each moment of our life like a line in eternity.

She backed away to get an overall shot.

— Thank you, Dr. Emmer. We see here that absolute joy is possible in this life. These animals live in an ideal habitat. They are content, therefore they walk in perfect geometrical paths. Their lives are as perfect as the celestial bodies above us. So here you have it, my friends. Despite the scandal, in spite of the stench, this is the famous best of all possible worlds. And by the way, dear listeners, please do not hold Dr. Emmer to account for his error. These are of course not mountain goats, because there is no such thing in Eurasia. These are our blissful West Caucasian turs.

A tur looked down at me from an adjoining hill. It licked its puffy lips and yawned.

Dr. Tank and Merike came back.

— So you see our sheep area. The largest in Europe. The largest space per animal. No evidence of welfare issues, no stereotypical behavior.

A misty rain fell as we began the long walk back. Dr. Tank and Merike shared an umbrella, and Sirje offered to share hers with me.

— I have a book I want to send you, she said. On orbits.

— Of sheep?

— Of planets. Very beautiful. Dreamy.

She photographed me in the zoo's evil-smelling overheated reptile house, between a lethargic fat saltwater crocodile and some plastic leaves.

— You look horrible, she said.

What a life Dr. Tank must have, I thought, in this blank neighborhood, shopping for winter vegetables at the corner grocery stand, taking her son to some run-down city park, or maybe to that octopus ride. If her son was a child, that is. It was possible he was in his teens or even his twenties. Maybe she lived alone, like I did. In another life I might have been her husband. We'd have been the Emmer-Tanks. We'd look down, out of our claustrophobic apartment, right onto the blighted mounds where the poor animals scratched and fed. We'd really have to be in love to make that work.

Or maybe I'd end up with Sirje. She was younger than me, but not scandalously so. We'd be the Emmer-Kukks. She'd entertain me as much as she could, until she gave in to her own unhappiness.

A breeze came up and it began to rain in earnest. We walked quickly back to the entrance gate. I'd made it through without humiliating myself, but I'd missed my chance to hear about Dr. Tank's life, to show her I sympathized. By the time we arrived my pants were clinging to my legs. Merike called me a taxi, and after a few minutes waiting under the entrance gate, with the bronze wolf stalking out of sight above us, a small Soviet-era

taxi arrived. I squeezed into the tiny back seat. As the taxi pulled away, I looked back and saw the three of them huddled like beetles in the rain.

The hotel lobby was deserted. Over the bar a television fizzed with static. I sat in a chair covered with a plaid wool throw rug. If today had been a movie, I would have gotten a chance to talk to Dr. Tank. She would have come back with me, and we would have sat in this empty lobby talking about our children. Who knows, we might have fallen in love, I might have started an odd but rewarding life here in Tallinn.

I walked up an insanely steep flight of stairs to my trapezoidal room.

Or maybe I would have fallen in love with Joonataun, despite his silly name. That would make a good movie. We'd live together in his cramped eighth-floor walkup, and we'd be happy enough until one day a picture of Fina would fall out of my wallet, and I'd realize I had to go back home, and Unit One, as I'd call him, would sit there weeping, but he'd realize I was right, and we'd have a sad kiss goodbye and I'd get a taxi back to the airport.

I undressed and tested the water in the shower, which came out in needles of hot and cold.

Or today could be made into a thriller. I'd get a phone call while I was in the shower. Wait outside, the caller would say, ten minutes. It'd turn out to be someone you wouldn't expect, like Tüüne. We'd go to a bar. She'd tell me she'd had been looking forward to my visit, and she'd propose a marriage of convenience: she'd get a Canadian passport and escape her life here, and I'd get access to her family's money, and it would sound preposterous at first, but the longer she talked the more interesting it'd sound, and I'd keep thinking really, why not? until finally we'd go to her place for the night and I'd sign some documents without looking. The next morning there she'd be, dead, and someone else you wouldn't expect—like Merike—would come in and beat me with a kitchen chair, and I'd be arrested, and after some tedious scenes involving my Estonian lawyer, it'd turn out I was framed by someone else you'd never expect—that guy Dr. Tank talked to in the mountain sheep area, who was also the guy who'd called her at the restaurant—and I'd exonerate myself with the help of the person who'd seemed least sympathetic—of course Dr. Tank.

Round and round I turned in the cramped shower. The plastic shower pan wobbled back and forth.

Or maybe today could be turned into a horror movie. The day would end just like it was ending. I'd be in the shower, thinking well, that wasn't a very satisfying day, I didn't manage to get to know any of them, and I didn't see anything for my report, but at least no one had said "wait a minute, you're not really a scientist, are you? Who are you, really?"

So I'd go to bed, and then late at night I'd be visited by two shadowy figures who'd make ethereal and slightly creepy love to me, and the next morning I'd be in a kind of fog. I'd be lightheaded and my vision would be blurred. I wouldn't be able to remember who the people were—Merike and Sirje? Joonataun and Tüüne?—until the moment when I'd be back at the restaurant to say goodbye to Dr. Tank and she'd look across the street at someone on a bicycle, and I'd see she was looking at a woman who looked exactly like her. Or maybe two women, I wouldn't really be sure, because my vision would be blurred. The possibly twin Dr. Tanks would disappear into a shop with the sign ESTONIAN NUKUKUNST DOLLS, and the original Dr. Tank would smile in a totally demented way and say "welcome to our little community, Samuel. You'll be happy here," and I'd say, "I have to go, I've got a plane to catch," but then I wouldn't be able to stand up because I'd be so dizzy. My vision would get worse, and I'd see two Dr. Tankses at the table and two phones in my hand, but somehow I'd manage to call a taxi. There'd be some anxious minutes while I waited for it, during which the Dr. Tankses would tap their twenty black fingernails on the table and say more unsettling things like "you love NukuKunst dolls, don't you? I saw you looking at the Vampire Fairy," but finally the taxi would come, and I'd get in and say "Airport!" but as soon as we pulled away I'd say "change of plan, take me back to the zoo," because I'd hope to run into Merike or Sirje, or even Joonataun and Tüüne, surely they'd know the secret of the double succubus Dr. Tankses, but of course at the zoo I'd be greeted by the double succubus Dr. Tankses, all four of them, and they'd turn me into two West Caucasian turs, and they'd herd me, or us, out into the pasture, and the other turs would gather around and we'd

all stare at one another with sad waxy wide-open eyes because we'd all recognize one other, and the two turs who were once me would stare at each other with especially perplexed expressions.

I toweled off and went straight to bed. The starched sheet didn't quite protect me from the scratchy duvet.

Or maybe, I thought, today could be made into a crime drama, where the hero is a famous detective, a real brainbox, laser-focused on solving problems, and he's concerned because things just aren't adding up: Why, he wonders, was Dr. Tank always so distracted? What game was Sirje playing, exactly? And wait a minute, didn't Joonataun and Tüüne break into Dr. Tank's office? What was going on there? And what was it they were saying about the woman at the other zoo? And for that matter, why mushroom soup? And why wild mushroom soup? And why hadn't Samuel been shown the gorilla that vomited or the chimpanzees who plucked out their own hair, not to mention the bear that ate the man's hand? Those could all be clues, he thinks. Something's afoot here and I'm going to get to the bottom of it. So the detective goes back to his office and sets up one of those bulletin boards with pictures of everyone he's met. His head is swimming. Anoxic bacteria, octopus rides, racist camels, rural Estonian architecture, that little quail shaking its head No, no, no... until Eureka! in the middle of the night, it comes to him: those details were distractions, intended to pull his attention away from the fact that Dr. Tank was covering up her mismanagement of the zoo. The detective unpins her photo and puts it in the center of the bulletin board. She'd sold the polar bear to that other zoo, or she'd had it killed for its pelt. He puts a pin into a newspaper clipping of the polar bear incident, and another pin into Dr. Tank's face. He runs a red thread between the two pins and turns the thread around the pin in Dr. Tank's face to anchor it there. He leaves the end dangling, making her look like she has a nosebleed. She'd probably taken money from that other zoo, and she was keeping her students as unpaid workers. He writes INFORMANT on the photos of Joonataun and Tüüne. He tacks up a picture of a silhouetted man, because detectives always have stock pictures of mystery men to put on their bulletin boards. He sticks a

pin in the throat of the silhouetted man. He picks up the thread dangling from the pin he'd stuck in Dr. Tank's face and attaches it to the picture of the silhouetted man. He draws two question marks on the picture of the silhouetted man. He taps it twice and says "I'm going to get you."

The camera pans back and forth across the photos. The hero is thinking vigorously: I've got to solve this. I just have to, I can't sleep until I do. He moves pictures from one side of board to the other. He grabs the photo of Sirje and tears it down. She's innocent, and besides, he likes her. He puts up more string. He circles some photos, X's out others. He moves faster and faster.

He's frantic, and then suddenly he stops. He's got it. He picks up his phone and calls the chief inspector of the Tallinn police. "You do not know me," he says. "But if you meet me tomorrow morning at the entrance to the zoo, under the bronze wolf, I will explain everything. And bring along the mayor. Yes. The mayor. Yes, I know what time it is. No, I'm not a lunatic. No, you don't know me. Be there tomorrow morning at eight sharp, and I will take you to a polar bear and a box with more money in it than you have ever seen. I just told you, you don't know me. Look, have you ever wanted a promotion? Ever wanted to be mayor? Right. I thought so. Just be there. If I'm wrong, no problem, throw me in jail. Oh, and bring a pool scoop, you know, the kind with the long metal handle. It's what they use to pick up stuff that's sunk to the bottom of a swimming pool? Okay, right, a pool net. I'll explain everything tomorrow. Just bring the net and the mayor." The hero puts the phone down and smiles.

Movies and books make us happy because they say: don't worry, everything has its place. There'll be closure, justice will be served. You haven't wasted your life. Everything adds up, all the threads hang together, things make sense, families heal, people love each other, and no one's neglected. You'll be okay. Just keep going, a happy ending is not ruled out.

Even an unappealing pool in a nearly deserted zoo in Tallinn, Estonia has its significance. In fact, as the hero will soon tell the police chief, as he uses the pool net to bring up a box of money from the bottom of the anoxic pool, and Dr. Tank blanches in surprise and relief, and the mayor

tries to escape but is held by two policemen, in fact, as the hero will say, the little things in life mean a great deal.

That's books and movies. Really, most things that happen don't mean much, and plenty of things don't mean anything. *Life in Estonia,* for example.

It wasn't likely I'd see any of those people again. This is real life, I thought, not like movies and books, where the world is tightly woven like one of those improbable knots sailors supposedly tied. Our lives are almost random. We run through the world like children: our shirts are untucked and our laces unraveled, and there's snot hanging off our noses. People who make films and write books are like mothers who call their children in from the yard, tuck their shirts back in, tie up their little shoes, and wipe away their snot. Without mothers, kids would run around until they got exhausted, and then they'd get hungry and scared and start to cry, like in the film *Post Tenebras Lux* where a little girl walks back and forth in a rain-soaked pasture, with horses galloping around, and dogs barking and running, and it's getting dark, she calls but no one hears her, it gets darker, a rainstorm is coming, but no one answers her. She just runs back and forth and cries and looks at the clouds.

I switched off the lights. The sun had set but the sky was not dark. The window formed a grayish rectangle in the black wall.

I was slated to visit four more zoos. I'd meet dozens more people. Each place would have a new cast of characters. Some quirky and sweet, like Sirje. Or weepy, crazy, or funny. It wouldn't matter because I'd never see them again. I'd never drive through the Estonian countryside again, or return to this unsettling orange room. Life's a mess, pretty much. Paths splay. The whole thing is unraveled. Loose ends dangle down.

Dr. Tank might be depressed or even desperate. She might also be perfectly content. Sirje sensed I need to have a little fun, and that was thoughtful, but what does it matter? People forget each other, they turn their backs and walk away. When Adela was finished with her time in Guelph, she went back to Bratislava. Blue forests and orange hotels are strewn across our lives. We ourselves are spattered over the world. Our thoughts are disarranged. Disconnected and meaningless events: that's

what optimistic people call memories. Actually, the world makes as much sense as the goggly stare of that antelope: we look at it, but we can't focus. We just don't understand.

A small television on the dresser showed local news. There was nothing in English. A bridge somewhere had apparently collapsed.

Second Dream

As soon as I fell asleep my perplexing life washed out of my mind and my eyes filled with images.

I stood in a wet field, the kind with hidden sumps into which your shoes unexpectedly sink. Somewhere a dog barked. I knew without stepping up close that the tree branches were hung with spiders and the leaves swarmed with aphids. Sumac bushes decorated the water's edge. They would have been the color of pomegranates.

I knew, in the dream, that my mind was full of pictures of my childhood. Part of me lived in these images. In some way I even lived thanks to these images.

What would life be like without pictures of the past in your mind? I wondered about that for a moment, but I was asleep, staring at the lovely field, and it was hard to keep my mind on thoughts. I was enraptured, the humid air warm on my face. What would life be like without images? The question lingered in my mind, but it lost its meaning. I thought of it without taking in the words, without knowing quite what it meant. What would life be like without pictures? Life was like an image, it simply was, like an image.

I was awake just enough, in my sunken sleep, to wonder where these places were. They must have been places in Watkins Glen that I'd forgotten. I knew that kind of lily pad, where a few leaves curl above the water. I recognized the scruffy shapes of the trees, their tops nibbled by insects. And the open space in the water, with its silted reflection of the sky.

I know all those things, I said, and this time I heard my voice while I said it, and wondered for a moment if I was talking in my sleep. I know those trees, those weeds, because they came into my memory when I was little Sam. They were gone for a long time, but they're back now.

There were pines in the distance and dry bushes on the near bank, the kind that leave burdocks tangled into your socks.

Life becomes pictures, I thought, snuggling down into my dream like a child with a picture book. After the chaos of an ordinary day—the usual shock of your older face in the mirror, an unpleasant flash of sunlight off a window, rain soaking your pants, ugly buildings, the sounds of animals— after all that irritating, loud, bright, random stuff that days are made of, when that is all over and you're quietly asleep, that's when images arrive. In sleep, I thought, dully noticing I was sleeping while I thought it, in sleep the frantic careening of things slows and settles. Sounds die down. Bright colors just agree to leave, and in that way the world becomes still, becomes visible.

Life calms into pictures, doesn't it, and the pictures live in your mind, patiently, without thoughts.

Later I stood by a flooded stretch of river, where there was no place to walk along the bank. Like the inlet in Watkins Glen, close by Seneca lake. Prickly bushes hung out over water that was glossy and dead like oil. The place was still, except for an occasional burp of methane or flop of a sunfish. The light, too, was flat and constant.

Another forgotten scene from deep in my childhood. I just had seen things, and the images went in and stayed there. Waiting in my mind all these years.

Then came an image of a garden path. I wondered where it was, when I'd been there. It looked untended. A garden lamp, tilted, stood at the end. The place should have been easy to remember.

Where have I seen that, my sleeping mind wondered. When did I walk down that path? Perhaps as a very young child, maybe on a visit to the grandparents. But the image had strangeness written across it.

A cold feeling washed over me. Like when you smile at someone you think you recognize in the street, but he returns your friendly look with a blank stare, because he doesn't know you.

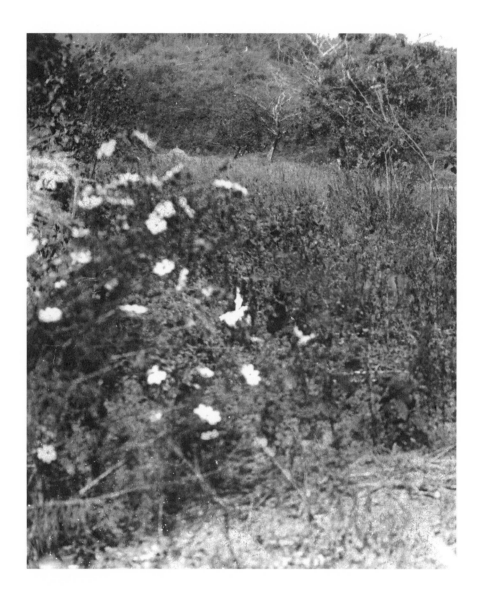

Then a different garden. Scruffy weeds, flowers tossed in the wind. The place had an end of summer look. Baked dead grasses lay underfoot, rangy summer plants choked an untended meadow. The land was hilly. In the distance was a house, maybe a barn. But I couldn't reach it in my imagination: there was no path to get there. Somehow I knew this wasn't Watkins Glen.

My sleeping mind struggled to understand what I was seeing. Aren't your memories supposed to be your own? A person can't dream images

from outside their own experience. That happens in science fiction. These images weren't like that. Maybe they weren't places at all, but glimpses assembled in my mind. White wildflowers from some stray moment in my life. An odd-looking barn I'd seen in Estonia. A path I may have walked down as a toddler, embellished in my defective memory with overgrown honeysuckle and weeds. Dried summer twigs from anyplace. Instants assembled in my middle-aged mind, brought here to divert me, keep me asleep. Puzzles for my sleeping brain.

Images of childhood are supposed to be comforting. You're supposed to say I remember that! It was so long ago, I haven't thought of it for years. It's wonderful to think of it again. Those were perfect summer days, so precious.

But these places were not my childhood. I stared unhappily, in the grip of the dream, at images of a life I may never have lived.

The longer I looked, the more the images said you do not know me.

You have never seen this.

You have never walked here.

3

The Story of Monika Woodapple

In the morning I was on the ferry from Tallinn to Helsinki, to see the next zoo. The schedule said the trip was two and a half hours, enough time to read the papers Vipesh had found for me. I settled myself in a vinyl recliner on the top floor lounge with a view of the sea. Brilliant light streaked the windows. Seagull shadows flashed across my chair.

READINGS

FOR ZOO TALLINN IN TALLINN, ESTONIA

AND FOR

KORKEASAARI ZOO IN HELSINKI, FINLAND

COLLECTED BY VIPESH PIBULSONGGRAM

"Dear Dr. Emmer," he'd written, "here is your READINGS. The project supervisor, Dr. Catherine Sounder, has instructed me to find essays on the subject: 'stereotypical movements of zoo animals.' As she said to me, using her own words, 'please collect scientific papers for Dr. Emmer on the stereotypical movements of zoo animals.' Also, she has instructed me to find information about the zoos you will visit. One zoo is called Zoo Tallinn, because it is in Tallinn in Estonia and also the other is known as Korkeasaari, I have no idea why. Also I have also added a SUPPLEMENTARY PACKET of additional readings. I feel you must enjoy it. These SUPPLEMENTARY readings I have just discovered employing my OWN RESEARCH. I wish you happy travels! Signed, your Intern Vipesh Pibulsonggram, พิบูลสงคราม."

Lovely curving letters, I thought. The first one had a little cloud floating over it. The second looked like a *U*, with a tiny *U* like a child following along below it. Under his name he'd written: "P.S. my surname is pronounced Phi būl šngkhrām in case you wish to pronounce it to me."

I practiced it under my breath. It sounded like Feeble Sink Ramp.

The first papers on Helsinki were fiscal documents. It looked like their zoo had its share of unhealthy animals. One page broke down the costs of a plastic mask they'd fabricated to anesthetize a sea turtle in order to remove a tumor from under its shell. The operation cost 900 Euros. Overall, the zoo had spent 23,000 Euros on pharmaceuticals in the last fiscal year. In 2017, they'd euthanized an Amur tiger. It had tuberculosis and developed spine and liver problems. It was clearly in pain, and visitors expressed concern. They moved it out of sight, and eventually it was transitioned to palliative care. One morning the zoo staff gathered around and fed it a fresh water buffalo steak infused with fentanyl. When it fell asleep, they euthanized it with a Dan-Inject Model JM dart gun. The total cost over and above routine maintenance was 3,570 Euros. Another paper was on expenses associated with stereotypical behaviors. An Asian black bear spent its days running back and forth, resulting in adverse visitor reactions. It was put on a course of animal Haldol and Bearaware, at a cost of 90 Euros per month. Currently, the paper concluded, the bear appeared adequately sedated, and visitors reported positive experiences.

Then came a stack of essays on stereotypical movements of confined animals. These were the things I was supposed to have read before I met Dr. Tank. The first was just two pages stapled together: the library's blue cover sheet, and a page scanned from a battered old book. "The very first record *ever* of animal stereotypic movements," Vipesh had written in red pencil.

A man named Markus Eipper had watched a wolf in the Schönbrunn menagerie in Vienna in 1877. "The she-wolf did not see the piece of flesh in the corner of its cage at all," Eipper wrote. "Its tongue lolled on one side, and it panted continuously. It paced with a fast rhythm. Back and forth it went. In this way, it paced over fifty kilometers every day." Eipper then moved on to a discussion of molting pea hens.

Why did people care so little back then? Zoos had been around, but for some reason no one paid attention to how the animals were doing. People must have been callous. Maybe life was harder back then, and animals seemed unimportant.

The next paper was by someone named Urban Schtuhlenmiller. In 1893 he made a list of stereotypical movements he'd observed in the Jardin des Plantes in Paris. "I have discovered many different habits," he wrote. "Wriggling the body, whipping the tongue around the mouth, stamping the feet, nodding in agreement, blinking very fast, jumping in place, pawing at the dirt, scratching the wall. Pacing was the most prominent wrong behavior. I discovered five kinds.

"1. Rotating. This is when the animal stays in place, and spins on its own axis, a motion familiar in trained dressage horses and performing elephants.

"2. Circling. This is when the animal rotates with a larger radius. It is especially marked in the Asian wild asses. They run in a circle, very quickly, for as long as I have patience to watch. In this they resemble dogs, which will circle a pole to which they are chained.

"3. Pacing. This I saw in a tiger and a lion. The animal walks back and forth near one wall of its cage, like a businessman pondering a risky venture. It appears that if the animal was free, it would continue to walk in a perfectly straight line, like a falling star, indifferent to cliffs, rivers, or other natural impediments, impelled by its nature to trace a perfect line."

"4. Figure eights. This is when the animal runs in figure eights. I have seen this in hyenas, jackals, dingoes, and wolves in the ménagerie in the Jardin des Plantes and also in the Amsterdam Zoological Garden. The animals resemble ice skaters who compete to trace perfect figure eights. The animals do this for longer than I have patience to watch.

"5. Weaving. This is a peculiar kind of walking. The animal follows the path of a sine wave. Sometimes this is done in an irregular or drunken manner. Often the animal moves very quickly. The animal's head may swing from side to side as it moves, as if it is hunting for mice or other small prey. This I have seen in a wolf. The motion resembles a skilled waiter walking between tables in a crowded restaurant.

"Those who maintain that animals share many traits of their inner or imaginative lives with humans are not wrong. I passed the better part of two weeks in these observations, and it was a delight to see these animals so occupied with their interests and concerns, whatever they might be."

The next paper was by someone named Monika Woodapple. It was Xeroxed from the *Zeitschrift für Tierpsychologie*, volume 2, 1939. Apparently Woodapple was not a scientist, because she didn't list her institution or her degrees. There was an editorial note that her essay had been received on April 20, 1938, postmarked from Bern, Switzerland. She thanked some very professional-sounding people: a Professor Dr. J. A. Barend de Hühl, director of the Zoological Garden of Berlin and founder of the Animal Psychology Laboratory in Bern, and Mr. Inspector A. F. J. Portielje, Director of the Zoological Gardens in Amsterdam.

The first thing, Woodapple began, is to determine the animal's "flight distance," which is the nearest you can get before it will panic and run. Most zoo enclosures are narrower than an animal's flight distance, which means the animal is in a perpetual state of panic. "It is important to know the flight distance," she wrote, "if we are to understand how animals behave in cages. I illustrate this with a diagram of a fox cage, seen from above. The cage is wire mesh on three sides, and in back there is a door, labeled *TK*, which is kept closed."

"Say that an observer stands at the point labeled a at the upper right and looks at the fox. The fox will retreat to the far end, labeled with the number 1. It will run madly back and forth along that side of the cage. Its fear will be palpable.

"Then say the observer goes around to where the fox is, and stands at point b. The fox will run to the closed door and go back and forth along line 2.

"Now say a second observer arrives and stands at point a, while the first observer moves to the left until he stands at point c. Then the fox runs along the diagonal line marked 4.

"Now say a third observer arrives and stands at point b. In that case the fox will move to point x and remain frozen in place. This behavior is because the *flight distance* is greater than the length of the cage. There is no place where the fox can be calm.

"The fox sits at point x and looks fearfully back and forth at the three observers. Let us call this *flight in place*. The animal wishes to run. Each observer frightens it, but it has nowhere to go. Forces impinge on it from all sides. *Flight in place* is a crushing fear that results in no movement whatsoever. If we look closely, we observe the animal is not actually sitting still. It is in motion, because all its muscles are working at once. It shakes and trembles, but it does not move.

"Let us now return to the initial case. A single observer stands at point a, and the fox runs back and forth along the line number 1. At the end of each brief run it will turn as rapidly as it can and run back along the same straight line. Its path, seen from above, will describe a straight line segment.

"Now say the observer steps back one meter. The fox will continue to run, but less frantically. Its path will no longer be a line segment but a segment with a small loop at each end, resembling the cotton swabs that are used to clean the ears of infants, or the batons, padded at each end, which are thrown by twirlers in parades.

"Now say the observer steps back two meters. The fox relaxes, and the turns at each end of the segment will open out into larger loops. The

straight line segment between them will diminish, and the loops will meet. Voilà, the stereotypical figure eight is born. This may be observed in many animals. I am, as far as I know, the discoverer of this *figure-eight repetitive path*."

A few pages later there was a dark black and white photograph of an animal's pen, with bare trees and fences. It looked like the photo had been taken from the roof. It was a frigid morning, or perhaps an evening, and the zoo appeared to be deserted. The photo was captioned "Hyena paths in the snow, October 1937, Berlin."

"This photograph," Woodapple wrote, "shows portions of *figure-eight repetitive paths* produced by a male hyena. The photograph shows the farther loops. The nearer loops, closer to the animal's bedding station, are not visible."

Then there was a diagram of the hyena's pen.

"This diagram depicts the hyena's enclosure, and the paths that it chose during the second week of October, 1937. The principal *figure-eight repetitive path* is on the right. It consists of two loops. The outer loop is larger on account of the segmental form of this animal's cage. A trapezoidal cage will result in larger loops at the wider end. If the cage is rectangular, and there no obstacles, the path will tend toward a perfect figure eight.

"The hyena completed a circuit of this *figure-eight repetitive path* in an average of sixteen seconds. It woke and began pacing between five-thirty and

six-fifteen in the morning, and continued for an average of seven hours each day, until feeding time. For the first five hours, the hyena completed each circuit of its path in exactly twenty seconds, plus or minus a fraction of a second. After five hours, as feeding time approached, the hyena ran, completing a circuit in as little as seven seconds. Occasionally it took the alternative paths indicated by interrupted lines, but it quickly returned to the principal path."

I ran my eyes over the diagram. Out from the inner cage, winding between the trees to where people would be, then back, hugging the fence. Out then back. Hour after hour. In the photo there were no tracks at the far end of its pen. It never went there, and why should it? There wasn't anything to discover. The point was just to remain in motion. Its path was the shape of its unhappiness.

Under the heading EXPLANATION, Woodapple wrote "my studies indicate these *figure-eight repetitive paths* are not related to mental states. The hyena ran at the constant pace of twenty seconds per lap for an average of five hours per day before it sped up in anticipation of its dinner. During the five hours of constant pacing, the hyena required thirty-three strides (of four steps each) to complete the circuit. In approximately eighty percent of those figure-eight circuits, the hyena took exactly thirty-three strides, and it never took more than thirty-six nor fewer than thirty-two. The constant speed and gait indicate the hyena's motion was dictated by the dimensions of its cage, obstacles such as trees, and its *flight distance,* and not by any psychological factor such as boredom or unhappiness, because such mental states are incompatible with constancy of movement."

The paper then concluded with a NOTE ON METHODS: "In the autumn and winter of 1937, I spent a total of 210 hours of observation time in the Berlin Zoo, gathering the data for this study. My field materials included a folding chair, plans of the animals' cages, pencils and notebook, stopwatch, pocket watch, hand and foot warmers, and a pair of opera glasses. In inclement weather I covered myself in a felt blanket. I do not believe my presence or appearance influenced the behavior of the animals be-

cause I remained well back from the edges of the roofs, and as far as possible I remained motionless for many hours at a time. In the case of the hyenas and dingo, I arrived before the animals were released from their pens to the open enclosures, so they were accustomed to the presence of my silhouette and seldom looked at me. Children pointed at me, but I did not move or answer. I thank the curators and staff of the Zoological Garden of Berlin for graciously providing me with access, and also for giving me Gestetner copies of the floor plans of the cages. The diagrams in this paper were drawn by Wolfram Pichler, Potsdam Observatory."

I stopped at the name, Wolfram Pichler, and felt a shock of recognition. My mother had studied in Potsdam in the mid 1950s, not that long after Monika Woodapple wrote her essay. Tee and I had found a packet of letters signed Wolfram Pichler on our mother's nightstand after she died. At the time, we decided they were private, and we threw them out. Whoever he was to her, he was part of her life that she never intended to share with us. When she was in Potsdam, she would have been about twenty. Wolfram and Monika would have been twenty years older, maybe less.

I pictured Monika getting up before dawn in her one-room apartment somewhere in the city, in the winter, and making her way to the zoo. The early morning trams would have been nearly empty. A watchman must have let her in. Then walking through the zoo, still in the dark, and up onto the roof of the hyena enclosure. Sitting there as the sun rose and the hyena was released to its outdoor pen.

Then all day in silence. The keeper who came by and threw in the horsemeat probably didn't even glance up and wave hello. She'd sit in her folding chair as the sun made its way around behind the trees, until the zoo closed again. Then she'd make her way home, or perhaps to a café to see Wolfram.

Either she was independently wealthy or so poor she had time to spare. Meanwhile Berlin was gearing up for war. Perhaps she just couldn't bear the noise, the violence. Things were especially bad in the years she observed that hyena. A month after she sent her letter to the editor, Germany and the Soviet Union sent their armies into Poland.

A second essay followed. It was titled "Obsessive Fixation in a Dingo." There was the same photo, this time with a second one taken from another angle.

This photo was brighter, but it may have been the same shadowless winter day. There were spruce trees on both sides. The hyena's paths seemed to be the same. Again there were no animals or people.

"The Berlin zoo," she wrote, "keeps a dingo in the cage next to its hyena cage. The dingo enclosure is on the right in the photographs. The dingo was fascinated by the hyena. It spent all day pacing up and down the fence that separated it from the hyena. The dingo made a mud path. It can be seen in the second photograph. Its flank brushed against the wire mesh. The dingo required between four and a half and five seconds to walk out, and the same amount of time to return. It made no difference if the hyena was present. There was no variation, on any day I observed it, until an hour before feeding time.

"The dingo provides an example of *fear-induced fixation*. In an environment full of fear, an animal can become attracted to just one thing. That thing becomes precious to it. Like an infant with its blanket or a little girl with her doll, the dingo tried to stay as close to the hyena as possible. The hyena ignored the dingo. Although it was difficult to determine, I believe the hyena seldom glanced at the dingo even when the two animals were less than a meter apart. The hyena maintained its *figure-eight repetitive path*, as I have documented in a previous essay."

She provided a diagram of the dingo's paths, showing how it preferred to stay close to the fence separating it from the hyena, labeled C. It doubled back as quickly as it could, following the loops at H and H. She observed from the roof T.

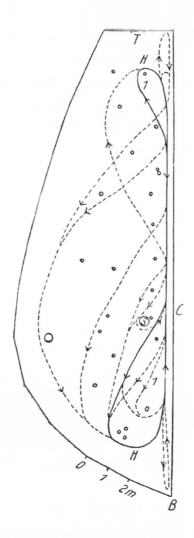

"This back-and-forth path marked *H-H* is characteristic of *fear-induced fixation*," she wrote. "Along half of its length the figure eight is compressed into a single straight line."

"In mid-February, 1938," she continued, "the dingo began to pace over more of its enclosure, as shown by the interrupted lines. Its strict back-and-forth route relaxed into figure eights resembling the hyena's figure eights. By February 21, 1938, the loops had enlarged so that the dingo was using approximately three-quarters of the area of its cage.

"My first conclusion was that the dingo had become acclimated to its enclosure, and its *fear-induced fixation* on the hyena had diminished. On

further study it became apparent that the dingo's figure eights did not represent relaxation. Comparing the two enclosures side by side, I conclude that the dingo was emulating the hyena. In the following diagram, the hyena cage is on the right, and the dingo cage is on the left. This is a composite of all the paths followed in a week beginning February 26, 1938. The two sets of paths are highly correlated, allowing for the different sizes of the animals, the different shapes of their enclosures, and the uneven distribution of saplings and trees, indicated by small and large circles.

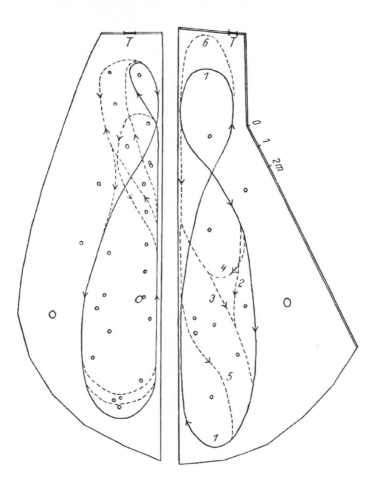

"I propose that the dingo was trying to associate itself with the hyena by mimicking it, and possibly attempting to attract its attention. Such behavior is not unknown in the animal world in mating 'dances.' For exam-

ple, the male magpie goose bows its head in imitation of the female, and the male blue-billed duck swims back and forth in imitation of the female. The dingo's figure eights may be understood as an attempt to communicate with the hyena. It is also possible the dingo thought it was a hyena or wanted to be accepted as one.

"The dingo was focused entirely on the hyena. Yet the hyena's behavior never altered. It paid no more attention to the dingo than to the saplings, the fences, or the zoo visitors. I call that kind of behavior *blind pacing* because the world has in effect vanished and the animal is only aware of its neuro-motoric calculus, i.e., its pacing."

If I were that hyena, I thought, I'd hardly notice where I was. I wouldn't see the parents and children beyond the fence, I wouldn't care about the animals in the other cages. I'd keep my eyes on the trail, on my own paw prints in the cold mud. I'd follow my track like a streetcar on its rails. If I was the dingo, watching that hyena, I would be doubly heartbroken. Once for the hyena and again for myself.

A man came in from the deck and my left side was doused by chill air. He stood a moment with his back to me, looking out to sea. His bald head had a bump on it.

"I define the dingo's behavior as *telescopic pacing* because the animal is focused, like a telescope, on a single object that stimulates its behavioral responses. *Telescopic pacing* and *blind pacing* are superficially similar, but are actually strongly opposed. In *blind pacing* (the hyena) the animal is impelled by the need to avoid obstacles while maintaining a constant high speed. *Telescopic pacing* (the dingo) is determined by the desire to mimic the object of fixation as perfectly as possible, and it requires constant attention both to the object of fixation (the hyena) and to potential obstacles.

"These distinctions may be useful for zoo managers. *Blind pacing* and *telescopic pacing* are abnormal. Neither exists in wild nature, except, significantly, in the mating 'dances' of certain animals. Both sorts of pacing are reductions of the animal's behavioral palette to just one color. The animal is living at the edge of behavior. Each path is the animal's solution

to specific constraints: the fear of the environment (people), the physical limitations of the cage, and attraction to another animal.

"It is possible that these paths might be modeled by mathematical equations. There are several figure-eight curves in mathematics that fit the data I have observed. One figure-eight is called the Devil's Curve. Its equation is as follows:

$$y^2 \left(y^2 - a^2\right) = x^2 \left(x^2 - b^2\right)$$

For

$$-1 \leq x \leq 1.$$

The nearest fit to the hyena's path is when $a = 2$ and $b = 4$.

"This ideal figure-eight is also called the Devil on Two Sticks, because there is an Italian children's game called *Diabolo,* which uses two sticks and strings to manipulate a figure-eight toy. If animals who pace follow this curve, it means they are manipulated by forces outside the curve. This is compatible with *telescopic pacing.*

"There is also the lemniscate, a figure eight that has the beautiful equation

$$\left(x^2 + y^2\right) = a^2 \left(x^2 - y^2\right)^2$$

The product of the distances of any point on the curve from the points

$$(-a, 0) \text{ and } (a, 0)$$

is a^2. If animals that pace follow this curve, it means they instinctively manage their distance from two fixed points that they avoid, one in each of its loops. I leave this for others to explore.

"It has been suggested to me that the closest parallel in the natural world is the figure-eight pattern known as the analemma, a slender figure eight that is traced by the sun over the course of a year. On each day at noon, the sun occupies a slightly different place in the sky, and if all of its

positions at noon are plotted on a sheet of paper, through all four seasons, they produce an analemma. It is possible, therefore, that the behavior of confined animals and the 'behavior' of celestial objects might be linked. I am not competent to explore this possibility, and I only record it here so that others might consider it.

"These studies were completed in December 1938. The author thanks the astronomer Wolfram Pichler, Potsdam University, for assistance with the mathematics and for preparing the diagrams."

The article ended with a letter from the journal's editor.

"We have received from our correspondent, Miss Monika Woodapple, August 24, 1939, postmarked Bern, Switzerland, the following addendum: 'The next spring, the hyena died from infections following from a foot inflammation, and its pen was empty from March to June 1939. The dingo continued to pace in the form of the hyena's figure eight paths. Its *telescopic pacing* continued even when the object of its mimicry was no longer present. It did not settle, and showed aversion to its keepers. On June 12, two African wild dogs were introduced into the empty hyena pen, but the dingo was indifferent to them. It continued its pacing until June 27, 1939, when it was transferred to a smaller concrete enclosure.'"

The dingo must have loved the hyena, I thought. When the object of its love died, it kept going, even though there was no reason to. Just no reason not to. Same with people. Imagine loving nothing in the world except an animal as hideous as a hyena. Then being spurned. Then being abandoned. You'd have nothing. You wouldn't know what to do with yourself. People who visited the Berlin zoo after the hyena died would have seen the dingo running. They wouldn't have suspected its life wasn't its own, that it was thinking of a creature who had died.

The same could have been true of the hyena: even at the beginning of Monika's study, it might have been remembering some other animal Monika hadn't seen. Maybe stereotypical pacing is a kind of memory, a trauma that has no end. Each despairing animal learns from the ones before it. Their paths are diagrams of their memories. Going all the way back through the generations to some ancient despairing animal.

It didn't seem that Monika really cared. She spent several years with animals in the zoo, but her writing was cold. Say the observer at *a* is joined by a second observer at *b,* and they gang up on the poor fox and frighten it even more. She didn't comfort the hyena or agitate to change its enclosure. She just counted its steps. She didn't mention feeding the animals or befriending them. She was trying to be a scientist. She certainly liked diagrams and numbers. Perhaps the science made her feel she was accomplishing something. She liked inventing expressions like *telescopic pacing* and *fear-induced fixation.* All that must have made her feel better about what she was seeing, and maybe about herself and the way she was running her life. Or maybe she was just drawn to zoo because the streets of Berlin were full of people marching and running.

I imagined Monika on the rooftop, speaking to the hyena.

— I study you, she'd say, I know you as well as any creature ever will, even though you've never noticed me. Your figure eights are beautiful, as Wolfram's diagrams demonstrate. They're your signature, your diary, the story of your life. Your paths are what you're accomplishing in your life. You don't know it, but I am recording you. I'll be publishing your paths, you're very lucky. Your inner life may be decoded by some future scientist who can read the language of your figure eights. After you've died, your paths will still be there in my article. People will think of you even in the far future. They'll trace your steps with their fingers. You are immortal! The first immortal hyena, first to leave an indelible record of its every step. Before you, for millions of years, hyenas ran wild, and no one saw what they did. They ate, defecated, mated, and died, like all animals. They left nothing but bones. You'll leave bones too, but you'll also leave these diagrams. And good morning, little dingo. I'm recording your paths too. The diagrams Wolfram inks for me are exquisite, if I say so myself. They are all that matter about your lives.

I scolded her, in my imagination, for the speech she'd made in my imagination.

— But Monika, I said, sitting next to her on the roof, surely you know the hyena and the dingo are as heartbroken as any living creatures can be.

As far from help as anything with a mind. They're much worse off than you, because you go back to your apartment, wherever it is, and dream about starting a family, maybe after the war, or finding a job, maybe in France or England, or going to the university. You sit at your kitchen table and warm yourself with tea and picture your future, and meanwhile, it gets darker and colder, and the poor dingo and hyena stay in the zoo and pace. And now the hyena has died, and the dingo is in some concrete enclosure, probably still fixated on the thing it loved, feeling in its lost animal way that the hyena is gone, not knowing what to do. You'll find other animals to observe and papers to write, but the dingo won't forget the hyena, even if it lives a dozen more years in its concrete enclosure.

— I am a scientist, she said, looking at me for the first time. Who are you?

I adjusted my seat back. The wind had come up, and sea spray flecked the windows.

— You must know how the animals suffer, I said, ignoring her question, just as you know your diagrams will persist in the pages of an obscure German journal on the shelves of a half-dozen libraries scattered across the world, even though you could never guess that a sycophantic and misguided Vietnamese Water Department intern in Guelph, Ontario will find your essay and copy it in hopes of earning the admiration of his employers, and maybe even of getting an entry-level job, even though he's never been given the slightest encouragement and no one has mentioned any such job opening, and you could never guess your essay will be read by someone like me, a person not even in your field, who tends to think of everything in terms of himself and his own wandering life, whose thoughts run in tangles far messier than figure eights, and most especially you would never guess that your reader is the son of a woman who knew Wolfram. Maybe you know my mother, her name was Martha. I think Wolfram was in love with her. I hope that's not a shock, or maybe you know he loved her, anyway Martha must have been happy back then. I hope she was, but I'll never know, because there's no one left to ask. And how surprised and delighted you would be to know that your diagrams, so

fastidiously inked by Wolfram, would someday be superimposed, by your improbable reader, on the loops and spirals of gulls flying in a serrated sky above a gleaming enamel white ferry in the Gulf of Finland. That is how history and memory crash together, Monika, how they become sharp, strange, and meaningless.

I imagined her pulling her hood up over her head and turning away. That would be natural. It was a lot to take in.

The last folder in Vipesh's readings was labeled SUPPLEMENTARY PACKET. The first page was an obituary.

"Monika Woodapple, born 1920, curator of mammals for the Dählhölzli Zoo in Bern, Switzerland, from 1945 to 1957, died October 2, 1969, of an infection of the lungs. Woodapple was also on the Board of the Bärengraben Association, which managed the Bern bear pits. She was unmarried and leaves no immediate family."

The other item in the folder was a newspaper article, from the *New York Herald*, dated December 3, 1943.

DESTRUCTION OF ANIMALS AT THE BERLIN ZOO

"Allied Command has released a final count of the destruction of animals in the Berlin zoo. Of the zoo's 3,715 animals only 91 have survived. Most were killed by the extensive Allied bombing, made necessary because the Germans intentionally placed one of their principal flak towers in the middle of the zoo. Many animals burned to death or were crushed in rubble. Several dozen escaped during the raids and were killed by German soldiers. Allied Command reports that among the animals hunted and killed outside the zoo were two lions, an Asian bull elephant, ten Hamadryas baboons, a Pallas's cat, a baby chimpanzee, a bull hippo, a dingo, and a black stork. The zoo is closed to the public indefinitely."

Third Dream

That night images flooded my eyes with a cold light.

I saw first a swamp, like the ones in the dreams before, but everything was dead. It was a shadowless day in late winter. Storms had torn off the lingering leaves. There was frigid standing water. The place had the smell of winter floodplains in Watkins Glen: acid, sterile.

On the far hill was a bare field, possibly covered in snow.

The stalks of reeds, empty of water and living tissue, rattled from time to time in the cold breeze.

A person called, in the dream, from somewhere out of sight.

I wandered into the woods, looking. It was a high forest at the top of a hill. There were piles of lumber, roughly stacked, like they used to do in the forest preserve at Franklin. A working forest, owned by someone, but seldom visited.

The calling stopped. I stood there, listening. The wind made that soft roaring sound that makes you wish you were home in front of the stove. A few leaves crackled and clicked on a sapling.

Somewhere in the forest a pine tree creaked in the wind. Maybe that's what had sounded like a person calling.

I followed a quiet stream down through the woods, walking softly on new snow. Some trunks were striped with white, scars from a recent blizzard. There was a broken skin of ice on the stream. A slow current jostled ice platelets, making small sounds like salt being sprinkled into a glass bowl.

My eyes teared in the freezing air.

Then I came out of the woods and saw a long way, into a gorge, down the stream to a lake. At first, I thought: I am high above Seneca Lake. Somewhere north of Watkins Glen but near home.

I was half awake within my dream, enough to know this was another childhood memory. I was seeing through little Sam's eyes. This was some great adventure I had forgotten. But I didn't recognize the gorge, and those weren't the woods of home.

It is a mixed memory, my sleeping mind reassured me, it comes from parts and passages of your life, it is mingled with dreams, it is mingled with dreams.

I stood still on the cold height, staring. The hill across the lake was large, wild. The banks were too steep for Seneca Lake. There was no town. And where were the farms? The fields and pastures?

I kept looking, and the scene became frightening. The water looked deep and still.

I wrestled, in my dream, trying to change the image. If I just walked down through those woods, there'd be railroad tracks by the shore, like in Watkins Glen. I would turn right and follow them home. But somehow I knew there was no railroad. This wasn't near home. It was some lost place in the Arctic. It wasn't my childhood, it wasn't my memories, it wasn't what I needed.

A chill seeped down inside my head. I stood and looked at the image, my own image, in my own dream, of another place I had never seen.

4

Arguing with Pekka

Helsinki's zoo is on an island. Driving out from the city, I had been expecting a bridge, but the map directed me to a parking lot surrounded by forest, no sea or island in sight. A sign at the end of the lot said KORKEASAARI ZOON. From there, a footpath led into the woods. It was colder than Tallinn. Perhaps it'd be better just to go back to the hotel and wait to be called.

I was still standing there staring at the woods and wondering indistinctly about escape routes when a bus pulled up and thirty noisy school children dressed in cerulean coats poured out and streamed down the path. I followed them into the forest.

After a few minutes of walking, we came to a decorative gate painted green and purple, with the word KORKEASAARI in raised white letters. I saw the island across a stretch of water. It was a kingdom of cages, a prison island like Alcatraz. ABANDON HOPE, the gate should have said.

My guide, Assistant Director Pekka Stserispaa, was standing at the ticket counter. He said his name with a pause in between the *k*'s, as if he'd never learned how to pronounce it. He was wearing a loud red Gore-Tex winter coat and a pair of baggy white cargo pants. I hadn't seen those since college. Tomato and peach colors on his cheeks complemented his light blue eyes, giving him a somewhat idiotic baby-like appearance.

We started across the long footbridge to the zoo island. The wind was sharp. We let the mass of children flow around us.

When Monika Woodapple and Wolfram Pichler worked together, my mother was just a baby, two or three years old when Monika published that first essay. A couple decades later, he was writing her letters, maybe love letters, at least letters she kept when she'd discarded so many other things in her life. It was a puzzle I could probably never solve, and it was my fault for throwing out the letters. And how strange that now I was spending time in zoos just as Monika had. As the plot of a mystery, it was all wrong.

Pekka pointed to a place where a black net had been draped over some trees.

— The sea eagles.

I looked the other way, out to the Gulf of Finland, and beyond it, the Baltic, and beyond it, the Atlantic.

— Cold today, he said. Wind is blowing from the arctic.

I remembered seeing an old map decorated with pictures of the heads of chubby-cheeked men, one in each corner, blowing winds onto Europe. Winds were thought to be giants' breath. A disgusting thought. If it were true, pleasant summer breezes would be suffused with droplets of saliva and mists of buccal amoebas and bacteria. On a day like this, with a steady gale blowing from the sea, a person could accumulate a film of skin cells that had worked loose from the giants' mouths and throat linings. I pictured Pekka as a colossal head planted far up in the arctic, blowing a gale of fragrant icy air onto the inhabited world. Or four of them, mountain sized Pekka heads, their necks frozen onto the horizon, rosy cheeks puffed out, eyes bulging from the effort, turning all sorts of fruity colors, raspberry, black cherry, blowing and blowing...

— Did you see the Tallinn Zoo? Pekka asked.

— It has issues. Do you know Dr. Tank?

— Yes, she is a clever person.

— Clever intelligent? Or clever devious?

— Clever clever. She is good at sourcing discount providers for charismatic megafauna. Also good at finding host institutions for specimens with behavioral issues. Her zoo is small, like a regional zoo. By

comparison we are one of the EU's highest-rated institutions. We participate regularly in the European Zoo Association, that's the EZA, and the World Zoo Association, that's WAZA, and the Southeast Asian Zoo Association, that's SEAZA, and of course the North American Zoo Association, that's AZA, and even the Japanese Zoo Association, that's JAZA, and also we work with the Species Survival Plan, that's SSP, and the International Species Information System, ISIS, and the European Endangered Species Program, EEP, and the Taxon Advisory Groups, TAG, and the Association of Animal Aging and Assisted Living Protocols, AAAALP. As far as I am aware Dr. Tank works only with EZA and AZA. She is cowboy.

— Is she married?

— Her life is the zoo. Also, Mister Emmer, we have one of the lowest per-animal pharmaceutical costs—

— But a high pharmaceutical budget.

— But low per-animal costs. For large mammals an average of only 200 Euros per mammal per year. Later I will take you to the large animal clinic and you will review the numbers. Only 100 average per mammal per year in geriatric support, 200 average in biologics, 100 average for de-worming, which includes roundworms, heartworms, whipworms, pinworms, tapeworms, and hookworms, also de-ratting and de-mousing, de-lousing, and de-ticking.

— I don't want to talk about worms and numbers, I said. I didn't fly all the way to Europe to talk about worms and numbers.

Something about Pekka offended me. At the time he seemed competent, probably boring, but well informed and friendly, and those were qualities I'd once had. Afterward I thought maybe it wasn't Pekka who'd set me off, but the world he lived in, that cold island where a babylike animal imprisoned other animals.

He just kept walking as if the wind had drowned out what I'd said. I wondered what might happen if I was even ruder. Did it matter how I came across, if I never saw him again? He wasn't part of my life, and neither was Abigail Meuron, Dr. Tank, or those grad students. They

weren't people. They were shards that pierced my life for no reason, like meteorites into the moon or Pluto, leaving craters and rubble, ruining the planet's perfect sphere with pointless scars. Sirje had the right idea: just say what you want.

As we walked onto the island I looked back toward the forest on the mainland. For a moment it seemed familiar, like the woods of home.

The sea eagle enclosure turned out to be a high tent of black wire mesh, supported by struts and cables, like the one in Tallinn. It hung over a dirt and concrete landscape pocked with shallow pools. There were two dead trees, stripped of small branches and bark, their naked trunks stuck in metal collars secured to the concrete flooring with bolts. On top of each tree perched an enormous sea eagle. Three feet above the two eagles the intricate wire sky shimmered and shook in moiré patterns. The whole ensemble looked like a medieval coat of arms of some forgotten northern kingdom. Kingdom of the Dead Trees, Principality of Nets, Duchy of Sea Eagles. King and Queen Metal Collar are in residence on Royal Prison Island.

— I'm sorry they are red, Pekka said.

The eagles had ochre stains running down their white breasts, as if they'd been gorging themselves on rabbits or sheep, or perhaps children from the neighboring Kingdom of Humans. The pools at the feet of their dead trees were scored by the wind.

— It's because they eat oxidized earth. No one knows why they do that.

— Boredom. Protest.

— No one knows.

— Bloody-mindedness. Insanity.

— No one knows.

— Can they fly in there?

— When there is a strong wind from the Baltic Sea.

He pointed at the open ocean, in the direction of one of the giant Pekka wind heads.

— Then the eagles can soar in one place. Just so.

He held a flabby hand palm down and rocked it back and forth to simulate a bird trying to balance in the wind.

When the wind rose enough, the two enormous creatures would lift off and hang in the air, showing their bloody breasts, gazing out to sea, feathers trembling at the tips of their wings. The wire mesh would shake and whistle just above their heavy heads.

One of the sea eagles shuddered. It puffed up and its feathers vibrated as if it had been shocked, and then, just as quickly, its feathers flattened and it was still.

— A displacement reaction.

I told him the sea eagle looked like a porcupine.

— A displacement reaction. Like when chicken pecks at the ground when there is nothing there, because it is thinking of feeding. This bird is thinking of flying. There are a number of other examples. Some birds sing in the night.

— I think birds sing in the night because they're anxious. They can't sleep.

— Well, we don't say that birds get anxious. They see street lights and that triggers them. They sing automatically.

— I think they're too nervous to sleep. Especially in the city. It's night time, but it's bright. The sun won't rise, they get worried, they sing to calm themselves. They pretend nothing is wrong. Like when I sing "Amazing Grace" in the middle of the night.

— Mister Emmer, singing at night, I mean birds' singing, I think it is caused by an excess of energy that cannot be directed to a goal. A displacement reaction.

— Sometimes I whistle "Sittin' on the Dock of the Bay," even though I hate that song. It's because I can't sleep. I'm anxious, like everyone. I think your sea eagles are nervous. They're twitchy.

A Pekka giant in the far north was blowing cold air under my coat. Maybe it wanted to move me along, but I preferred to stand and argue.

— I'm sorry, Pekka said, I don't know what you mean. Soaring is sea eagle behavior. If the wind picks up this afternoon, they will soar in place. What you see here when the eagle ruffles its feathers, that is a displacement reaction. It is common in many animals. The animal attempts a behavior

that it cannot complete. In this way, flying becomes shivering. Displacement reaction is from Tinbergen.

— Yes, I know, I said, although I didn't. But look, I get anxious and drum my fingers on the table. Or I flick at the corners of the page of the book I'm reading, know what I mean? Just picking at the edges of the pages? That's nerves. And also, a lot of people can't sleep, a lot of people sing at night. Don't you?

— I sing in the day. You know that experiment with the American robin and the toy American robin? The robin thought the toy was a rival, and it attacked the toy, and then they took away the toy, but the robin kept attacking the air where the toy had been.

The sea eagle shuddered again, more violently. For a moment it seemed it might lift off its perch, then it settled, motionless as before. Maybe it wanted to go eat more bloody dirt. This place was more like the *Island of Dr. Moreau* than Alcatraz.

— Yes, I lied, a famous example.

— Later, it forgot where the model robin had been, and it attacked different places in the empty air.

Pekka's blond hair curled around the edges of the hood of his Gore-Tex jacket, making him look like an overfed Red Riding Hood.

— Pekka, I told you. I know. The robin was desperate. It was frantic and angry, it was furious. It was out of its tiny little mind.

— Not really. The robin had an excess of directive energy. Its energy was displaced.

— The robin was insane. Like your birds, they're probably insane.

— Not really. The American robin was over-stimulated by the toy American robin. The toy was a supra-normal gestalt.

— Oh, of course, I said, as sarcastically as I could.

— The robin's brain was overloaded. It was a behavioral deviation, not a sign of emotion. Our eagles are not nervous.

— Your eagles are in despair.

— Look, Mister Emmer. There are many examples of behavior displacement. Do you remember the study of ostriches with their heads in the sand?

— Yes.

— So?

— So what?

— So, what do you think?

— Sorry, what was that study?

— People used to say ostriches put their heads in the sand because they want to hide. I have seen that behavior. They spread out their wings and put their heads down on the ground, not in the ground, on the ground. Actually, it is one of their sexual behaviors. It's part of courting. But they also do it when something frightens them, like a low-flying airplane. So, why do ostriches exhibit sexual behavior when they are frightened? It is displacement behavior. Over-excitement releases mating actions. When people look at them, they say, foolish ostrich, it thinks it's invisible, or, idiot ostrich, it is worshiping an airplane. But the ostrich is simply displaying a wrong behavior because of overstimulation. It does not think it is hiding. It does not have a religious mania. It is not foolish. It is not an idiot. It is not suffering or insane, as you say.

— Isn't it insane to be aroused by an airplane?

— This story is in the same book that reports on the American robin. David Lack's book *The Life of the American Robin.*

— Doesn't sound like a scholarly source.

The two of us stood motionless, looking up at the two birds. They were dreaming. Waiting for the wind to come up so they could fly in place. And we were dreaming. Dreaming about arguing and winning. At least I was.

Pekka took me around the periphery of the island. The empty stone enclosures looked like ruins of some ancient culture. Maybe they kept trolls there, or small ogres.

On the far side of the island the horizon was interrupted by smaller islands. Beyond them was the unimaginable arctic. So hopelessly vast, so sorely empty. Populated with stupendous Pekka heads. The stumps of their necks frozen onto the ice, sealed in place with rivers of frozen gore. Their cavernous mouths exhaling frozen smelly air. Their girlish blond hair fluttering ridiculously in the desperate wind.

Then I realized I was turned around. The sea view faced south, so the animals on this side of the island were actually looking back in the direction of Tallinn, where other captive animals were probably looking out toward them. Still, if a long view calms the mind, a cage on this side of the Korkeasaari zoo would be as good as any place to spend your life. On the other hand, if a long view makes you think of places you'd like to go, seas you can sail over, then this place would be torture. Sea eagles probably have tremendous vision. They could choose particular pine trees on distant islands where they'd like to roost, or inaccessible clifftops

where they'd perch and survey the turbulent waters for sea-eagle sized fish, or maybe particular Pekka heads where they'd land and chisel off a few choice pieces of frozen Pekka scalp. They'd relish those too—so oily, so full of fat.

We stopped at an enclosure labeled ROE DEER. It seemed empty. A small stockade of branches had been erected, probably to protect a plant. Trees had been felled and left where they lay.

I told Pekka I didn't see any deer.

— There are no deer. This place is infected. We hope to have a speckled hyena move in. They are slightly more resistant to infestations.

I told him I had no idea what he was talking about.

— Deer ticks, he said, the enclosure is swarming with them.

I told him I didn't see any.

— You can't, not from here.

I asked him what he meant by slightly more resistant.

— They can usually stand the ticks, he said, looking sad.

I asked him if we could move on.

— Okay, Mister Emmer. I know you are here to see stereotypical behaviors. We have none, but you might say our brown bears are uncomfortable.

— You might?

— No, *you*. I think we do very well with them.

— I'll be the judge of that.

He led me around a high wall.

Talking with Pekka about animals was like one of those sci-fi movies where a person tries to talk to a cyborg about the human soul. The cyborg stands impassively in the middle of an empty windowless room lit by banks of fluorescent lights. The improbably young and beautiful woman who designed it checks something on a futuristic transparent tablet. She removes the cyborg's wig of curly blonde hair, revealing its synthetic skull, within which colorful lights are softly blinking. The cyborg looks at her with vacant pearly eyes and says, in a lightly synthesized voice, "what is a soul?" She strokes the peanut-like but oddly attractive cyborg's translucent plastic head and says, "I can't tell you exactly what a soul is, PEK-KA-14, but it makes us human." The cyborg regards her with a possibly friendly but disconcertingly empty expression. "I think I understand," it says. "You never will," she sighs, and plucks out its eyes for reuse in model PEKKA-15. She leaves with a handsome young lab assistant. Close-up of the cyborg's eye sockets, to show a few droplets of liquid pooling inside. The cyborg is a perfect match for her. It is exquisitely sensitive, because she built it that way, and it's warm, on account of the colorful lights inside it, and it's soft, because its skin is synthetic cellulite with a nanofilm of white mineral oil, but she prefers her men smelly.

The brown bear enclosure turned out to be a steep slope of earth and concrete, ending beneath our feet in a trough. Dead trees were sheathed in steel, like the ones in the sea eagles' cage.

— We know this enclosure is problematic. But that is normal. It has been demonstrated that it is impossible to keep bears without producing aberrant behavior. Confined bears tear at their environment. They scratch doors. They dig up trees unless we put steel around them. They try to burrow under walls. If we give them live trees, they pry the bark off and the trees die. If we plant bushes, they tear them up or rip away the leaves and the bushes die. See how we have put an electric fence around the bushes? Bears go on wrecking things until they have nothing but rocks and mud.

I leaned over the balustrade. The wall below us was studded with rows of electric wires to stop the bears from trying to climb.

— Did you hear about the polar bear in the Tallinn zoo?

— Of course.

— And?

— And what? If you have drunk people wandering around your zoo at night, they are likely to be less healthy in the morning.

Pekka laughed in little chirps.

A sawn-off section of a tree trunk had been fitted with an iron collar and a chain, which was attached to a spike driven into the rock. Pekka saw me looking at it.

— The log is chained because otherwise the bears throw it at the observation windows. On the other side of the enclosure the bears dug pits. They only stopped when they exposed the concrete substructure.

— Escape tunnels?

— Tunneling is one of their behaviors in the wild. They hibernate in tunnels. They dig for root vegetables.

— Escape tunnels. They want to get at people, they want to kill people.

— Bears have a dozen officially recognized behaviors. We encourage as many as we can. Tunneling. Walking. Loping. Sleeping, which is what they're doing now—

— Digging to get out, to kill people.

— No.

— Desperately digging, trying to get out, to kill people.

— They are curious creatures. Also snuffling, pouncing.

— Killing trees, tearing out bushes.

— Hibernating, fishing, rummaging. Foraging.

— Throwing logs at people. Destroying everything in a blind rage.

— Mister Emmer, there are EU regulations for bear enclosures, and we follow them. Bear landscapes must possess key elements including a pool, hill, and habitat furniture, that means logs and boulders. And bear landscapes have to include views. We do that.

— And bear landscapes have to include dead stripped-down trees planted in metal necks and bolted onto fake rocks made of concrete?

— How would you do it? I think we have done quite well.

Pekka regarded the desolate enclosure with an expression of simple and sincere contentment. His curly blond hair fluttered in the breeze. I thought of throwing him over the wall, into the pit. The squeaky sound he'd make when he landed would be delightful, and it would attract the bears. His rosy cheeks would turn red with surprise and anger, but it'd be too late.

On we walked, past an area where animals lived on artificial islands. Island prisons on an island prison.

— For monkeys that do not swim. They don't need fences. They could swim, but they don't know it. So, they don't try. I am the same: I don't know how to swim. I am not unhappy that I can't swim. Swimming is simply not one of my behaviors.

— And how do you know the monkeys can swim?

— An experiment. Someone dropped a monkey in the water.

— That's hard to believe. If I dropped you in the sea you would drown.

— Perhaps. My wife says I have a lovely padding.

The place really was like the *Island of Dr. Moreau*. Pekka was the faithful Dog-Man, barely human, vivisected out of a St. Bernard, carrying out the orders of the evil Doctor Moreau, who secretly ran the zoo from his House of Pain, which he'd cleverly disguised as the large animal clinic. But how could I be sure? Maybe, I thought, if I pick up a stick and throw it and yell fetch? Pekka will go running after it before he realizes his mis-

take. Of course, if he is human, he'll just stare at me. At that point the tour will be over. But if he is the faithful Dog-Man on the *Island of Dr. Moreau,* then I'd have to get away, because he would go to find the evil Doctor. I'd run madly along the zoo paths, but I'd get lost, and soon I'd hear the Doctor and the Pekka Dog approaching. I'd look desperately for a place to hide, but you can't hide in a zoo, because everything is locked. I'd stand at the edge of the bear enclosure, out of breath, thinking of actually jumping into it to hide from the evil Doctor, and that's when a bear would come out of its artificial cave and walk toward me, on two legs, just like a person, and look at me with eyes full of compassion, eyes I'd swear were human, and the bear would gesture with its head, come around the back. And I would realize oh my god, the bear is human, the result of unnatural operations; oh my god, all the animals in this zoo were once people. I'd follow the bear's gesture and run around behind the enclosure. The bear would let me in. There I'd stand in humid semidarkness, and the bears would all stand up on two legs and circle around me, looking at me with eyes half pleading and half hungry. Outside, on the path, we'd hear the horrible Pekka Dog yelping and squealing. He's here somewhere, master, we'll find him, I promise. Oh please stop beating me, please stop!

Meanwhile Pekka was walking along, looking innocent. He asked if I knew the story of the eagle owl.

— Of course not.

— It is a famous moment in Finland. There was a very important football match. We were playing Belgium. This was 2008. A Eurasian eagle owl came down onto the playing field. It landed on the Belgian goal post. The Belgians had never seen such a large bird, and they lost their confidence. We won, and the owl was named Bubi. It's from bubo. It means owl. Bubi became a celebrity. At the zoo we get many requests to see Bubi, but of course we do not have Bubi, or any Eurasian eagle owls.

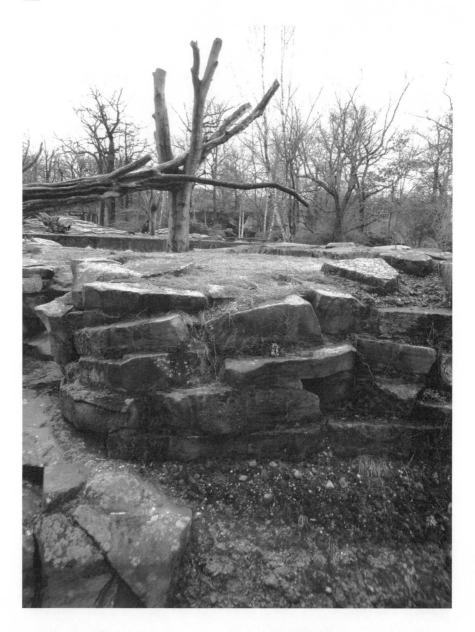

It wasn't a very interesting story compared to the one I was imagining, which was about to end very badly for the hapless Pekka Dog.

— And then a pair of them came and nested on the zoo island.

— In a cage?

— In a small part of forest near the bridge.

— Why did they want to live in a zoo? That would be like buying an apartment overlooking a jail.

— Perhaps they experienced Korkeasaari Zoo as a wilderness full of animals.

— Maybe they liked to see other birds locked up. They were sadists, and they loved watching other birds suffer.

Pekka allowed himself a squeaky little laugh. In my remake of the *Island of Dr. Moreau,* that's all it would take, because it would remind the bears of their hours of torture on the vivisection table in the House of Pain, and they'd all turn, their bear blood boiling, and fling open the door of their cage, which had been somewhat mysteriously open the whole time. The expression on the Pekka Dog would be priceless. He'd be just like a dog caught peeing on the floor. The bears would surround the trembling Pekka Dog and shatter his bones with their massive yellow teeth. Doctor Moreau would escape, probably, but he wasn't really part of the story anyway, and that was definitely a flaw in the plot. I'd take advantage of the bears' moment of savage revenge to sneak away. I'd run back over the footbridge and through the woods to the parking lot, and it wouldn't be until later that night, safe in the airport lounge waiting for my flight out of the country, that I would realize there was no Doctor Moreau, it was only the Pekka Dog. He'd created all the creatures in Korkeasaari Zoo. That's why the bears had attacked him. They'd heard that squealy laugh before, it was when they'd been blindfolded and tied to the operating table in the House of Pain. The Pekka Dog used to giggle while he cut them open. And then I'd realize the Pekka Dog had been intending to vivisect me too. He wanted to turn me into a spotted hyena, a particularly long and painful process involving shaving down my limb bones, breaking and binding my ribs so my rib cage would have the lanceolate shape of a hyena's thorax, clamping my skull until the brain was suitably elongated, sawing my jaw into a carpenter's joint and sliding it forward, filing my teeth down into points, extruding the canines, hammering out my ears until they are large and flat, trimming them with scissors into nice points, bruising and dying my nose until it became soft and black, injecting my corneas with brown

dye, implanting clumps of hair over my entire body, stapling claws into my fingertips, and forming a tail out of skin cut from my inner thighs and rolled into a cylinder, all of which the Pekka Dog would do without losing his sense of humor, his fruity cheeks radiating health and puffing with little burps of pleasure.

It was probably best to pay attention to what the actual Pekka was saying.

— And so, he concluded, every year the Belgians bring us a crane's nest, as a symbolic gift for Bubi. Wonderful story, isn't it?

— I suppose. Look, Pekka, do you know Nora Amazing's paper "Some Starlings are Pessimistic"?

— What is it?

I wondered if I could remember anything about the paper. Catherine had described it to me once, saying I really needed to read it, but I'd never gotten around to it. The person's name wasn't Amazing, it couldn't have been, but I couldn't think just then what it was.

— It's a standard in the literature. It's about European starlings. Amazing showed them playing cards, one at a time. If they pecked at a black card, they got a mealworm. If they pecked a white card, they got a rotten mealworm. Then she showed the starlings cards that were shades of gray, so the starlings weren't sure what they would get.

— I see. And what is a European starling?

— It's not important. So Doctor Amazing did this with two groups of starlings. One was normal, the other had issues in stereotypical behavior. The ones with stereotypical behavior pecked hugs and kisses.

— What?

— They pecked X's, four pecks to make the X, then one more for the center. Over and over. Peck peck peck peck, and then a big peck in the middle.

— Odd.

— Typical. And they pecked O's. Peck peck peck peck peck peck peck around the circle. They call those hugs. So XOXO, hugs and kisses. Children and sentimental people put that on their letters. Thanks for the tour, Pekka, signed Samuel, XOXO.

— Lovely, delightful.

— Why would you say that? It's pathological.

— I mean—

— Just listen. Doctor Amazing proved that starlings who peck hugs and kisses don't like to take risks. They take longer to decide what to do. They took so long deciding what to do with gray cards that some of them actually fainted. They "interpreted the choices pessimistically," that's what she said. Hesitation and risk aversion are clinical symptoms of depression in humans. The hugs and kisses starlings were pessimistic because they were depressed.

— There might be other explanations?

— When they cured the hugs and kisses by giving the starlings more Purina Cat Chow—

— Cat chow?

— It's standard food for birds in captivity. I'm surprised you don't know that. It empowers them because they imagine they are cats. When they cured the hugs and kisses starlings, they made quicker decisions and took more risks. They ate more. They were no longer depressed.

Pekka shook his head. His ringlets trembled in the wind.

It was surprisingly easy to lie. The language gap helped, because an American would have said, "doctor Amazing? *Really*?" And I would have had to say, "it *is* amazing, right? Amazing name, ha ha." And then I'd feel uncomfortable, so I'd bluster on. I'd say, "funny, names are funny. I once knew someone named Brilliant, and another guy named Spectacular." But that would only make it seem like I'd been lying in an especially brazen way, so I'd have to keep going. I'd say, "wouldn't it be great to be named Amazing? People would laugh at you, sure, but they'd really be jealous. They'd be thinking why the hell couldn't my family have a superhero name like that? I could have been Doctor Amazing! Instead, I'm just Feeble, Doctor Mark Feeble. I'd try to stop talking, but I wouldn't be able to. It'd be horrible. Everything would unravel. The American would just stand there shaking his head, thinking Jesus, I hope I don't end up like that. I may not be Doctor Amazing, but at least I'm not a wreck, at least I have

some dignity. I'm not a twitchy, sweaty pathological liar, like this Mister Emmer person, what is the deal with him, anyway?

But Pekka didn't have a clue, so I decided to try again.

— How about the study by Carole Furieux and Lea Landsler on depressed horses?

— I do not know it.

— Really? Hmm. It shows that horses exhibit what they call "behavioral despair."

That sounded good, and those names were a real improvement, but for a moment I wasn't sure where to go next.

— That's what they call it. They say that if you stop exercising a horse, and you don't let it out, and you don't pay attention to it, then it can fall spontaneously into a state of despair. The horse stretches its neck out and hangs its head. Its ears turn backward. It becomes unresponsive. Its blood pressure rises, like people with depression. It doesn't sleep well. Its serotonin levels drop. The study is conclusive. The two authors, Fury and Landslide, they show beyond doubt that horses suffer from measurable depression.

— Landslide?

— I think that is her name. So they did a trial where they took two sets of horses, one depressed, the other not, and they put them in stables that had been decorated with pictures. One group of stables were full of pictures of depressed people, moping, with their heads in their hands, eyes red from crying, looking up at heaven, streaming tears, wringing their hands, contemplating skulls, holding onto gravestones, and the other group of stables were full of pictures of people looking laughing insincerely, actors pretending to be happy, nervous people smiling at policemen, people laughing because they are embarrassed, people laughing anxiously at stand-up comics, people being tickled—

Suddenly I was inside a hollow metal drum, and a hundred boys were banging metal bars on the outside.

I clapped my hands instinctively over my ears. It was a lion, in an enclosure twenty feet away. It had roared at nothing I could see. It was stand-

ing sideways to me, looking into empty space. It roared again. The noise reverberated in my stomach, in my head. The air itself was throbbing, as if the lion was all around me, inside me. I realized, numbly, that I had never heard a lion roar. No wonder animals are transfixed when they hear a lion. If I were an antelope, my thin legs would fail, my desperate eyes would barely be able to turn.

— He is still smelling the young male lions that were in the next enclosure. He has been marking his territory.

Pekka walked toward the lion, which walked away from him. It made some grunting sounds, like it was revving up to roar. Then it stood still, looking into the pen where the young lions had been.

— He will mark his territory.

I hoped it wouldn't roar again. I felt stupidly weak. If the lion somehow got free and came toward me, I'd buckle. I'd offer up my neck. The lion had made me passive. It'd turned me into a meal without looking at me, without even thinking of me. It grunted and glared at the empty cage next to its own. The grunting noise was rude, like a fat man belching. It didn't mark its territory. It went and lay down behind some bushes.

— You were saying about horses?

— Never mind. You can just read it sometime.

The horse story had been going okay, but I was out of material, and the lion's roar rescued me. In another minute I would have started making up stories about people named Fury and Landslide.

A short way down the path, we saw a black leopard pacing madly, inches from the front of its cage. It went to one side of its enclosure, folded itself, and came back instantly, surging from corner to corner. This was the stereotypical pacing I'd been sent to find. The leopard's turns were loops, so its path was shaped like a Q-tip, exactly as Monika said. The main path, the stick of the Q-tip, was compressed smooth dirt, just two inches wide.

— Aadolf! Pekka called. How are you?

There were other loops, fainter, also just like in Monika's diagrams. Some were half-hidden by sticks and leaves. It looked like the leopard hadn't walked on some of them since the summer. I timed its circuit: seven seconds.

— This is what you are looking for? Leopards always pace. There is no way to prevent it. It is one of their behaviors. Aadolf had a companion, Emma, but we determined he was unsuited for mating because he is from genetically compromised stock. His sperm count is low. So, we put Emma behind that wall. Aadolf needs to live by himself.

— But Emma's healthy?

— We have to take the entire population into account. They are IUCN red listed. We can't get sentimental about the sex life of just two animals.

— The love life.

— It is just mating, okay?

— Maybe you could put him with Emma, but I don't know, use contraceptives? Or maybe sterilize him once his sperm has been collected. You could put up a sign: OUR LEOPARDS PRACTICE SAFE SEX, SO SHOULD YOU!

— Are you joking?

— I don't think so.

Aadolf glided back and forth. His paws did not make a sound. Dark, powerful, entirely fixated on his pacing. Like a boulder falling sideways through space. Poor Aadolf, I thought, as he passed by in a blur of black. You smell Emma in the air. Other things too, lions and antelopes. You know they're out there. But there is a lot you don't know. You won't ever be traveling. You won't ever mate with a female leopard again. You're inbred. There was some unfortunate mating in your background, sorry to be the one to tell you. Your sperm count is low, and everyone knows it, even I know it. And your name is Aadolf. Sorry, it's a creepy name. You pace at seven seconds per circuit. You are very exact, but you probably do know that. Good luck in life, Aadolf, I'll never see you again.

From the leopard's pen, the path led up to unprotected slopes where the animals were exposed to winter winds. We came over the crest of the zoo island. The wind was stronger, and snow had started to accumulate.

A powerful animal paces back and forth at exactly seven seconds per lap while two weak animals watch it. One of the weaker animals is immunized by science against any sad feelings. The other has already seen too much. He had been feeling a little lost, but now he's seeing what lost really is. He imagines a conversation between the strong and weak animals: "We imprison you, but we care for you." "I want to bite you in the back of the neck, but I can't get to you." "We're doing our best; we're keeping you healthy." "I don't care. I see only my footprints in the path, my bars."

"You know, in the end, mind is superior to might." "Nope. Let me out and I'll show you."

—It's colder up here, I said.

— This parka also functions as a raincoat, Pekka said unhelpfully.

He tapped me on the shoulder.

— Look, the Pallas's cat.

It was in a stony enclosure, resting on a branch that lay on the ground. Apparently, Pallas's cats are monstrously overweight house cats. It stared at us with an expression I couldn't help but interpret as extreme distaste. Like it was about to howl in dissatisfaction, or vomit at us. The Catherine cat, I thought.

— It is unusual to see the Pallas's cat at all. We are close to its feeding time, and I am dressed similarly to the attendant who feeds it.

The supposedly secretive cat stared at us brazenly. Then it began to move, almost imperceptibly. It turned in increments from face-on to profile, as if it were demonstrating the phases of the moon. Slowly it flowed along its log, low on its legs like a millipede. Presumably, it was trying to get out of our sight.

— They seldom move faster than that. It is running away.

The cat's front paws barely emerged from under its fuzzy belly. It chose each step with fastidious delicacy, as if its feet were blistered. An unpleasant animal. Like a hairy larva.

— Mushka! Sometimes she comes if I call. Mushka! Mushka!

I asked if it crept along in stereotypical paths.

— I do not know. Pallas's cats are native to high elevations, and when they come to sea level, they are prone to infections. Many die. Mushka may be under the weather. She hasn't been eating her mice.

The cat made a wheezing sound, as if it was blowing its nose, then carefully poured itself down behind its log and disappeared. The ground was scattered with frozen mice, their little black feet tangled like wire twist wraps.

— Mushka, dear! Mushka! Pekka puffed his lips out. Please come back!

— Do you have webcam footage?

— Yes. No. I do not know.

— You don't keep very good records here, I see.

— Perhaps. Mushka! Oh, Mushka, please come back so the nice Canadian scientist can study you.

— Pekka, I have to say this is a really depressing zoo.

— I am sorry you feel that way. The zoo is actually exemplary, by EU standards.

It's easy for Pekka, I thought. He looks at an animal and sees a to-do list.

Pallas's cat: feed frozen mice, three per day.

Frozen mice: break block into individual portions, scatter in pen.

Pen: hose down once a month.

Pallas's cat that wheezes: thaw mice, insert antibiotic tablets, scatter in pen.

Pallas's cat that wheezes and disturbs visitors: call it Mushka, pretend it's an ordinary cat.

Pallas's cat that wheezes and disturbs visitors then dies: replace. Name the new cat: Mushka.

For Pekka, taking care of animals was like maintaining your garage. You sweep it out, fix a shingle, paint it every couple of years. You don't hope for much from it because it's only a garage.

We lingered a moment at the enclosure, staring at the branch. I thought: animals are much stranger than Pekka thinks. They don't have names. They stare into space. They feed in the dark. They swarm through the world. The smallest ones, like bacteria, drink the clear serum in our veins and the saliva in our mouths. Some slide along the neurons in our brains. The larger ones see us. We irritate them. If we get nervous, they notice.

We came downhill and rounded a corner, and I saw we'd made a circuit of the island and arrived back at the footbridge.

— Well, Mister Emmer, I hope this tour has provided some of the information you are seeking.

— Not really.

— My wife and I would be delighted to invite you to dinner this evening and a sauna, if you have no other plans.

That was disappointing. I hadn't managed to annoy him at all.

— A Finnish sauna, if you are not busy.

I pretended to think.

— My wife told me to warn you I take the extreme sauna. I am a member of URESS, the Uusimaa region Extreme Sauna Society. The sauna is quite hot. Perhaps you will not want to go.

He grinned, and his rosy cheeks streamed with purple, like heirloom tomatoes.

As we walked back across the bridge, he told me how the spotted hyena was going to have two cubs. I pointed out they would be infested by deer ticks. He said both cubs would probably survive. He told me the zoo store was going to carry Bubi dolls.

In the face of such good will, such relentless obliviousness to my increasingly wretched frame of mind, I was mainly silent.

— Oh, and we just had two births, a Zanj elephant shrew named Lijiji and a Peruvian hairy long-nosed armadillo named Purutu. Lijiji that's a word in the local language in Tanzania. She is not very cute, but visitors love her. She has a long wiggly snout like a tiny elephant. Elephant shrews are monogamous. That's very rare in the animal world, the whole animal world, including people. But elephant shrews only love each other, and

they are terrible parents, so we took Lijiji away and she lives in a sterile container. Visitors love to look at her. She is a little frightening, like a deformed premature baby, but then people see how helpless and cute she is, and they love her because she can't help how ugly she is. They cheer when she sucks up conehead termite larvae with her tiny tongue. Purutu the hairy long-nosed armadillo baby is definitely not cute. She has long hairs growing through pores in her armor, but people love her even more and she is going to be featured in the "Births and Hatchings" section of the EZA *Bulletin*. Her mother is Axomamma, an ancient Incan name, and Purutu is also an Incan name, we chose it because it means "chewed up" in Finnish, because when Axomamma gave birth to her child she attacked her and bit off one of her legs. But Purutu is fine. The zoo store is going to carry baby Purutu dolls with crutches, and Bubi dolls, and baby Lijiji plush toys. We will probably also have hand puppets of the two hyenas, which we are going to name Screech and Spike, those are popular hyena names. Births and hatchings are very good to raise awareness for the zoo.

The wind was strong on the bridge. The sea eagles might have been hovering, but I couldn't make them out through their black net. The Pekka heads in the arctic were at full blast, trying to rip the bridge off its foundations, scour the Korkeasaari Zoo island, grind it down to the smooth ice that once covered the world and would cover it again soon enough. The Pekka Dog was pretending everything was fine, but I knew that as soon as he dropped me off in the parking lot, he would hurry back to the zoo, chain the bears up to a massive dogsled, and set off into the arctic to destroy the monstrous Pekka heads. It would be a titanic battle. The bears would snarl and snap as they struggled forward into the full-force gale of one of the Pekka heads. The bears' muzzles would be coated in comical ice goatees formed of sputum sprayed from the gullet of the giant Pekka head. But the Pekka Dog would triumph! He knew that if he could only get close enough, the giant Pekka head would recognize him. It would see that the little creature racing to attack it had its own face! And it would see the little creature had a body, and it would realize it

did not have a body, something it'd never really thought about before, and it'd gasp in shock, and its gasps would reverse the wind, and the Pekka Dog and his infernal bear team would be inhaled into the monstrous gullet of the Pekka head, and the Pekka head would choke, and die, and freeze in place with its mouth open. And in its mouth, peering out from between its icicle teeth, there would be the Pekka Dog's face, also frozen, and maybe, this would be a nice disturbing touch, there'd be a Pekka puppy inside the Pekka Dog's mouth, raising the nauseating possibility of an infinity of Pekkas, one inside the other, or maybe not, whatever.

In the parking lot, the ordinary Pekka stood by as I got in a taxi.

I realized the sauna was going to be his revenge. I told him I'd go.

— So, Mister Emmer, I will see you soon, I'm delighted. Just please remember the extreme sauna group is used to heat, and perhaps you are not. If you leave the extreme sauna early, before other people leave, you will be laughed at. Afterward, we will have dinner, but I have to warn you also my wife is not a good cook. Also, my son is just visiting from the Finnish army, and he is sometimes aggressive.

An ordinary person would like Pekka. He was like a snowman, encased in cold padding, hard to hurt.

Later that evening at the gym, Pekka paid my entrance fee. We left our clothes in skinny lockers and made our way, without towels, to the men's shower room, which had the usual antiseptic odor. After a lukewarm shower, we walked down a stuffy corridor to the extreme sauna. Pekka stopped in front of a dark wood door. He handed me a folded paper napkin.

— For hygiene. You sit on it.

The door opened onto a cramped ill-lit vestibule, and from there we went into the extreme sauna. Inside the heat was astonishing, frightening. Four men were in the tiny space, sitting on raised wooden benches. I unfolded my napkin and took my place next to Pekka.

He said something to one of the men. It seemed they all knew one another. A middle-aged man with a salt-and-pepper beard and a deep

orange artificial tan threw ladle after ladle of water on the hot rocks, filling the room with suffocating steam.

— You have to throw like a boar pissing, Pekka said, tossing a ladleful so sloppily that half the water went on the floor.

— Like this, he said, throwing another ladleful that hit its mark.

I braced for the burning heat, which arrived a second later.

He consulted a large thermometer on the wall.

— Ninety degrees Celsius. You are almost boiling.

My skin prickled. I took shallow breaths. It felt like the heated air would burn my lungs. I might gag or choke. My arms and legs stung. I scratched, trying to be inconspicuous. I was resolved not to panic. I was breathing fast, taking half breaths. I felt I had to keep the air out of my lungs. Just when I thought I'd have to risk embarrassment and run out, Pekka nodded to me and we went out to the vestibule. I took a deep breath of chlorinated air. He led me past the shower area and down another corridor to a room with a small pool. A concrete staircase led down into the pool, which wasn't more than four feet square.

— The refrigerated pool, Pekka said, and stepped in, holding the steel railings.

He backed down the steps, inhaled sharply, dunked his head, and came charging out.

— Ice water. You dip, you come out. Then we sit a while.

I went in quickly, without thinking. It was like that woman in the *Saw* movie who swims in a pit filled with hypodermic needles. I gasped and jumped out. My body was shaking, reverberating, worse than after the lion's roar. I was both electrified and liquefied.

We sat in blue plastic chairs as if we were lounging in the back yard. From the safety of my chair I considered the pool I'd just been in. There were pieces of ice floating in it. A misted window in front of us looked out onto the ordinary swimming pool where overweight swimmers bobbed and flopped.

— For years, I have been in the extreme sauna group. We do not know each other's names, because it is a custom not to know. One is called "The

Pastor" because another of us saw him on a street corner passing out Seventh Day Adventist brochures. There is also a man who might be a member of the Cabinet; we are not sure. Everyone is equal, Mister Emmer.

Back we went into the sauna for a second round. I stole a glance at two old men who were sitting, heads bowed, elbows on knees, on the highest and therefore hottest bench. Without clothes they looked as all old men look: bony and flabby, and hopefully wise about something. The one on the left looked down at me, as if to say: you'll never know who I am.

Pekka doused the stove.

— One hundred ten. Above boiling. Not yet the high temperature record of the World Sauna Championships, but they don't hold them anymore, not after Ladyzhensky died.

I was too intent on monitoring my ability to breathe without choking to ask Pekka about that. We sat in silence a few more minutes while Pekka tossed far too much water on the stove. Panic began to close in on me.

— Time for a dip, he said, and we grabbed our sodden napkins and went back out.

This time I took careful notice when Pekka went in the ice pool, to see how he gripped the steel railing to get out as fast as possible. When it was my turn I walked quickly down the five steps, dunked, and jumped out, hardly registering anything except animal self-preservation. A second later I felt the very painful shock. I was shaking—or no, I was vibrating, like a cartoon character who has grabbed an electric wire. After a few minutes the trembling damped down. The hypodermic needles dropped off my skin. I felt done, like a vegetable that's been over-steamed until it's pretty much mush. Then it was time to go back to the sauna. I followed placidly, like a prisoner, like an addict.

After several more rounds of painful heat and piercing cold, during which the oversize thermometer on the wall registered as high as a hundred and twenty Celsius, we went back to the showers, which I could hardly feel. As if the water were air. My skin had gone numb. It felt soft and lifeless like damp cardboard.

— Well, I deserved that, I said, as we walked down a darkening street.

— I hope you enjoyed it, he said, looking at me with genuine concern.

His apartment was in an old building. The echoing stairwell was rotten with water damage. His wife and son greeted me in the kitchen. She was short and had a grayish-white ponytail that went down to her waist. We sat at a cramped table ornamented with green and white knitted bears.

Dinner was a watery dish of boiled mincemeat, with a side plate of boiled potatoes. Ordinarily, I would have picked at it and made some excuses about jet lag, but my body needed help and I drank tap water and ate everything quickly without tasting anything. As advertised, Pekka's son seemed angry. He was dressed in camouflage, and he sat in sullen silence. Pekka and his wife took turns telling a long, complicated story about Pekka's Estonian cousin who had recently died. She was a great patriot, Pekka said. Pekka's uncle Jaagup, also Estonian, had been captured during the war and taken to Azerbaijan, although it was hard to make out why. The cousin was married to a concrete manufacturer.

— Luckily, Pekka said, crushing a potato with his fork and shoveling the hamburger mush into a pile as if it were a pallet of wet concrete, there was a concrete shortage in Azerbaijan, and Reet managed to persuade the local government to trade war bonds for concrete stock.

— For concrete commissions in Baltic states, his wife corrected.

— So Jaagup was rescued by a trade deal, and he came back to Estonia and worked in the open mining industry here, selling shoring equipment for mine shafts.

I made listening gestures and paying-attention noises, but I was thinking of my life, how it was unraveling, and my mind, how it was behaving erratically, and my body, how it seemed to be made of water and yet it needed water. Pekka must have known that last part, because he poured me another glass.

The story continued over dessert, and I felt increasingly uneasy over how long I hadn't been listening and how little I'd understood. What if they asked me a question?

The rosy puffy part of Pekka's cheeks was a lace of broken capillaries. Was it the effect of a lifetime of saunas, or the mottled flush of a heavy

drinker? It no longer looked obnoxiously healthy, as it had out in the sunlight.

— Jaagup was pretty amazing, Pekka said. He could stand in a mine, feel the rock, and tell if it was going to collapse. He tapped the rock with a little hammer, ping ping—Pekka tapped his glass with his fork—and then he'd say "this is hollow behind," or "this has fault lines." He guided the miners where to dig.

— He used to stare at trees, Pekka's wife said.

— He had amazing powers of observation. They would call him in when they wanted a new shaft head, and he would say "dig here," or "don't touch this wall," just from feeling the stone.

— He stared at trees, Pekka.

— Actually, I learned so much from him. He used to study the oak tree in back of our house in Jõhvi, where we lived near the mines.

I remembered that name from my drive in Estonia. It was at the far end of the country, near the Russian border.

— Sometimes I stood outside with him, looking at the tree. Of course, Reet thought he was insane, and okay, he was. He talked about the pattern in the bark. He taught me how bark has shapes floating in it, like islands. Between the islands are channels. They all connect like strands of a net. Each kind of tree has its own bark map.

I remembered something I'd told myself years ago, when I used to play in the woods in Watkins Glen. I'd told myself trees meant more to me than people.

— He taught me different trees. How each has a different pattern. He tried to teach me the mathematics of it, but I could never understand.

There was a connection forming in my mind between Pekka, his uncle, and my family. Jaagup's fascination with bark was like my mother's interest in mushrooms. The gills on the undersides of mushrooms were sometimes patterned like bark, with interconnected folds. Martha used to tell me to look closely at the gills, to pay attention to them. I never really did, because they were boring and disgusting at the same time.

— He was completely crazy, Pekka's wife said. Reet said so too.

— He was crazy, we have to say that. But there was science in it, because there were never any collapses in the mine in all twenty-four years he worked.

I wanted to tell them about mushrooms and trees I remembered from my own childhood, the bark of hickory trees, shagbark, shellbark, beech bark, birch bark, but my thoughts were too diluted, washed out by the sauna. I needed to understand why Pekka was telling me this story. I wanted to ask him what trees had to do with his job, and what I was doing there, in his apartment, whether it was still part of his revenge, or just his idea of proper hospitality. For that matter probably the whole zoo thing was Catherine's revenge, that was actually fairly likely, although I didn't know if she had signed me up because she was mad at me for something in particular, or if she was just being her irascible self, annoying everyone because she was annoyed, jabbing people because she felt jabbed, or whether I'd done this to myself, letting Catherine sign me up for this zoo project, which was either waking me up and showing me my life, or pushing me over some edge. It would have been nice to know, but I couldn't concentrate because Pekka was still talking.

— He studied an elm tree that was at the far end of our garden, Pekka was saying, just in front of the mine tailings. The trunk was hung with vines. He trimmed them off. Some pieces still clung onto the bark. At his eye height there was a knot in the trunk, and he used to stand so close his nose almost touched it. He looked very insane, as you say, dear.

— He did. Like the tree was his wife. When I saw that, I almost didn't marry you. I thought: do I want this in my family?

— I admire him, Pekka said.

Their son stared dully at them, from one to the other, expressionless. Was it hatred? Or had he given up on them?

— He told me that knot in the bark was like an entire continent.

The little broken capillaries in Pekka's cheeks were flushed, and there were round branched veins on his temples. One of them might burst, and then he'd have a little rosy explosion on his face. Enough of those, and he'd be a horror show.

— He showed me how ants climbed across the knot, around the base, and then up to the top. It is sideways to us, he said, but it is like a mountain to the ants. They circle like a highway around a mountain, and they switch back and forth when they climb, like cars on mountain roads. Study this, he told me, and you will understand bark.

Pekka's wife shook her head.

— Study ants, she said.

— Look and never stop looking, that was his motto. I memorized that knot. I think I knew it was crazy, what we were doing, and I never told my friends at school. But I also thought: Jaagup is a genius, he is the genius of the family.

— He had terribly bad taste. He made my mother cry when he bought that huge end table, with the twisty legs and the cracked top.

— She cried because he couldn't afford it.

— She cried because it was so ugly.

— But he had high standards.

— He frightened people.

— You see, Mister Emmer, Jaagup would look at your face, at the wrinkles, if you have wrinkles, your gray hairs, if you have gray hairs. He would stand up close to you, as if you are bark or stone. Or if you invite him to your house he would examine the foundations, he would ask to see your basement, he used to do that, and then he would go down into the basement as if he was a government official, and he'd stay down there for hours. Then he would come up and say, Thanks, Mr. and Mrs. So-and-so, I very much enjoyed your basement. It will last fourteen years and then the east wall will collapse.

— He dressed very strictly, Pekka's wife said. Always like Sunday.

Their son was regarding his parents as if they were potentially dangerous combatants. His right hand moved back and forth across his shaved head.

— He was really a sweetie pie, Pekka's wife said.

— Later in his life, after he retired, he used to go into the forest around the Jõhvi mines. He studied bark in the forest. He got interested in the old Soviet graffiti on the trees. Sometimes I went with him. He read the Russian graffiti. ANATOLY LOVES SERGEI. ANASTASIYA LOVES PAVEL. Some trees there also have German graffiti. He said they were Nazi collaborators, an enormous scandal in that generation. And later Soviet collaborators.

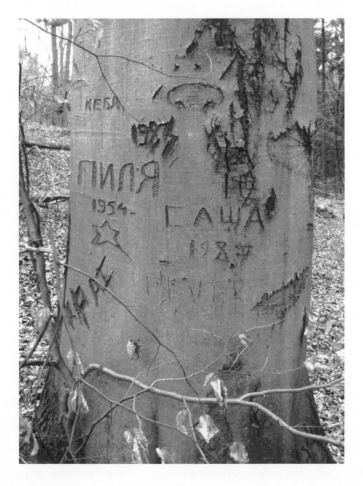

— He got mixed up. He told me the trees know what was written on them. The trees are hurt by the knives, he said. They never heal. He showed me how the graffiti travels up their trunks as they grow. Eventually they take their scars up into their treetops. That part was true at least. Beech

trees know the most, he said, because they are naked. He showed me old beech trees where the bark looked like old men's skin, flaccid like in the sauna. The crotches of the trees, he said, are like men's crotches, their branches are like old men's legs. The old trees in the Jõhvi forests are like old men, he told me.

Some of that did sound crazy, but when I was young, I spent a lot of time in the woods, and I could no longer say exactly what I was thinking. I didn't fail to distinguish trees from people, but I probably did fail to value them less than people. And my mother, at the end of her life, may have thought more about mushrooms than her family. If I hadn't been so diluted by the sauna, I might have found a way to mention some of that.

— He was a honey, but he was scary in his old age, Pekka's wife said. Full of nonsense.

— In the end.

— He was the psychotic of your family, Pekka's wife said.

— I am not as wonderful as my uncle, Pekka said.

He was red and glistening now, like a maraschino cherry.

Pekka's son slammed his fork down, hard, on the table.

— You two are assholes, he said.

Pekka and his wife stared, and then they got up and started clearing the plates away.

— You are fucking assholes. I come from a stupid and deranged family.

— You are being the asshole, Pekka said quietly, with his back to his son.

— *Pilu,* his son said.

— Ah! Pekka's wife said.

She turned away.

— *Ime mun munaa,* Pekka's son said.

Pekka turned around and yelled at his son in Finnish, a ferocious stream of words. He screamed, arms at his sides, face deep purple, hair trembling. His son glared at his plate. Pekka shrieked, shouted, spat on the table. Then he finished. His mouth was turned down, the tips of his Pekka teeth were showing. His breathing was irregular. His hands were at his sides, rigid, fingers stretched out. His wife remained at the sink.

His son got up slowly and stood looking at Pekka. Then he walked very deliberately around the table, brushed shoulders with his father, and went upstairs.

— My son is a monster, Pekka said to me. Sorry, I didn't plan it this way.

He called a taxi for me, and I sat while Pekka and his wife talked quietly at the sink. She cried a little, but then she took a sponge and began cleaning the dishes.

At the doorstep Pekka put his hand on my shoulder.

— Mister Emmer, it was a great pleasure to host you for one day. I really hope you enjoyed your extreme sauna, just as I enjoyed your conversation. You are a remarkable observant and intelligent person. Like my uncle. I fervently hope we can meet again. When we do, I will demonstrate for you another great Finnish custom, swimming in the ocean in winter.

It would have been right to say something in return, but I couldn't, because his sauna had dissolved my insides, and his stories about Jaagup had confused me. I turned and got in the taxi.

Back in the hotel, I was transfixed by the sight of myself in the bathroom mirror. My arms were covered with a webbed pattern of soft red burns. I stripped to my underwear. My legs had those marks too, back and front. Raised curving red lines wrapped around my entire body from the shoulders down, branching, like rivulets, around in back of my knees, into my armpit, like in one of those alien movies where a parasite moves around under the spaceman's skin. I traced the red lines with my finger, but there was no sensation. Nothing hurt. After a few minutes I decided not to go to a hospital.

I sat on the edge of the bed. It was hard to know what to make of the day. I had spent hours seeing things I wished I hadn't, arguing with a person who was actually perfectly nice. He probably had all the same sorts of challenges Dr. Tank had. But I'd behaved really badly, and then he'd attempted to kill me by boiling and freezing. And he'd given me an uncanny inflammation.

As I lay in bed with my eyes closed, trying to forget just enough to fall asleep, trying not to think about the odd parallels between me and Jaagup, and how Pekka could have sensed them, or the parallels between Jaagup, my mother, trees, and mushrooms, which Pekka never could have known, as I tried to push those thoughts away, the eyes of animals played on the screen of my mind, rolling, peering.

It was late. The sea eagles out on the zoo island slept on their perches, eyes shut tight against the wind. Mushka the Pallas's cat lay in its concrete cave, paws oozing over the ledge. Aadolf the black leopard slept in the middle of its Q-tip path, facing forward, ready to begin pacing in the morning. Lijiji the baby elephant shrew rested in her sterile container, tired from a day eating conehead termite larvae, wondering in some infinitesimal corner of its little mind where its mother might be. Somewhere in Estonia, the polar bear that had eaten the man's hand scrunched into its straw bed. Somewhere else in Estonia, the man who had lost his hand scratched absentmindedly at his dressing as he fell asleep. Pekka's son lay in his bed, running his hand over his shaved head and muttering obscenities in Finnish. Pekka slept on his back, snoring loudly, while his wife

read a book to calm herself. All was right in the unpeaceable kingdom. The world's tortured animals were as happy as they could be. The universe was beset by a restive peace.

The bed had a down comforter, and the weblike burns felt warm. You'll be gone by tomorrow, I said to the inflammation. Sleep well, disappear overnight.

Fourth Dream

That night the fires began to burn.

I was driving, in my dreams, through unpromising countryside. It wasn't Watkins Glen, because somehow I wasn't allowed to drive there any more. The landscape had the familiar restless hills, but I sensed my hometown was far away, not just over the next hill but gone, in the logic of the dream, off the face of the earth. This was my new life. I knew, because something in me had said so, that this would be my life from now on. The unsatisfying landscape unfurled endlessly.

On some unmarked country road, at the top of a hill, I stopped the car and looked out over the sameness and stillness. That was when my mind fixed on a puff of white smoke in the distance.

It was a fire, probably a farmer burning brush. In Watkins Glen they used to burn off last year's marsh grasses. Out in the country they burned straw and corn husks, sometimes tires and garbage.

It was an ordinary fire, but my sleeping mind snapped to exact attention. I stood at the side of the car, in my dream, for several minutes, which might even have been an hour of dreaming, staring at that distant puff of smoke. As I watched the fire play out in the silent afternoon I tipped my head to the right, and then to the left, like you do when you're pondering.

Later that day in the dream, or some other day, or some other year, I again noticed fires in the distance.

This time it was a plume of smoke on a hill. I parked the car on a high ridge in a forest. Someone might have been burning timber to make a clearing. But the hillside beyond the fire was veiled in white. An entire hill was burning.

It was a humid summer day, so it was hard to tell what was happening in the distance. The smoke blended with the haze. A distant valley was on fire, and possibly a mountain beyond it.

A part of me thought: there is a road leading into the distance, and if I follow it, I will come to the fires. Then another part, less sunk down in sleep, a remnant of my waking self, thought: no, this is not a place, but a state of mind. It is a feeling of disturbed calm. Something is going wrong. Up here, at the top of the hill, beech and oak trees are in full dark foliage. A warming wind is blowing. It is midsummer, as it should be throughout a person's life. But down there, in the distance, something small is going wrong.

I stopped by a lake, at one of those small beaches where there's a concrete boat launch, a picnic table, and a couple of charred pits where people have made campfires. No one was around. Maybe it was early in the day, or late in the season.

I sat at the weathered table and drank a beer and watched a fire burning fitfully on the far shore. I couldn't see exactly what was burning. Perhaps the forest was more smoldering than burning. The place reminded me of other spots by lakes where I'd stopped, drank or ate something, read a book or the paper for an hour or two between destinations, between obligations. Yet I couldn't clearly remember any of those other times or places, and this time I had no deadline, no reason to leave, so I sat at the weathered table and waited.

The smoke rose, and then fell again. It drifted across the lake, hiding the far shore.

I knew, in some waking corner of my sleeping mind, that my dream of driving was not normal, that it isn't common to travel endlessly, either

in dreams or in life. Dreams, I remembered, are usually strange, or else they're sexy or frightening. Dreams have people or monsters in them. They are full of events, threats, desires. This dream unspooled in silence, continuously, just as one road leads to the next, forever. Nothing interrupted me: I never needed gas for the car, I drove by every hotel. I never saw people, but that didn't concern me.

For several years I drove away from the hills and lakes that reminded me of home, and up into higher hills and mountains.

Once, I was driving down one of those long straight roads that match themselves to railroad tracks. The rail and the road turned around a slow bend, and I saw a fire off in the distance. White smoke rising off a ridge, exactly where I was headed.

At first it seemed the road would lead directly to the fire, but it wound up and through the mountains, and I saw the fire from another angle, still many miles away.

I parked, and spent an afternoon in a high meadow of ferns, under a perfect sky. It was a large fire now, but so far away that the smoke seemed stationary. When I looked patiently and attentively, I could see the billows changing shape, but over the course of several hours the fire hardly changed, as if it were painted onto the landscape, as if those mountains had always been on fire, as if the entire scene was a picture hung in my imagination.

As the afternoon went on, the clouds shifted, but the fire didn't seem to move.

This is what life is like, I thought. Most is sunny, and there are high fields where you can look out across great distances and up into the deep sky, but there is also something wrong. In the background of life there is a fire, I thought, in that indistinct way we think in dreams, and that fire is quiet and actually quite lovely, it looks like cotton, delicate and soft.

Is there a difference between dreams and waking life? In both, things happen slowly while we watch.

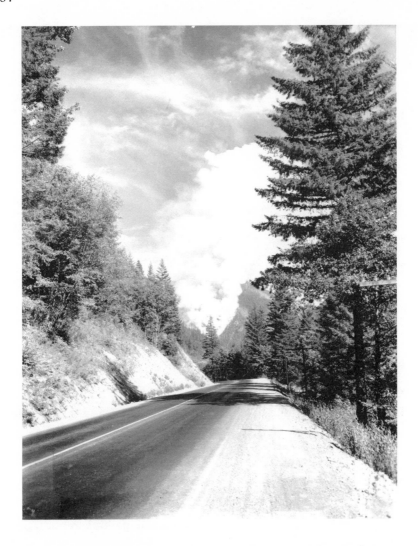

I followed mountain roads to see if I could get closer to the fire. It was burning on a steep mountainside, like a volcano.

Soon, I thought, I'll have a better view, and I'll know what the fire means, not for the earth, or for the forest, but for me. That didn't make perfect sense, I knew, because fires don't have things to tell us, a fire isn't a fire for someone, given to someone, calling to someone.

As I drove, the mountain kept receding. It seemed to have the same size and distance no matter how far I drove. The smoke tarnished as I stared, like an afterimage of the sun.

Even while we're dreaming we struggle to make sense of things in dreams, and we always fail, because part of us knows that if we try too hard to make sense of what we see, if we really fight to understand, then we'll break the dream and wake up.

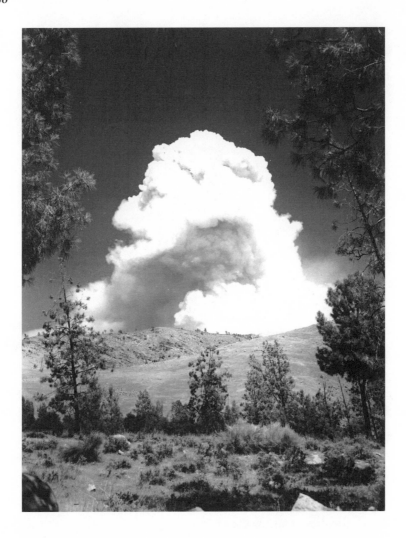

I drove along a high road that went around the back of the mountain, and there was the fire, just over the ridge.

A thick billow of smoke was growing like a tumor. Churning around itself, like an enormous cave, like a mouth, like a gigantic hand.

I stood fixed in place, trying not to see the cloud as a monster, trying to picture the place without the fire, to think only of the ordinary landscape, the peaceful sunlight on the dry hills. The cloud continued to swell into the dark empty sky.

I realized that I was trying not to think about illness, but I was watching it, following it.

5

Twitching and Punding

The apartment had been quiet since Fina and Adela left, and especially since the TV and refrigerator stopped working. I'd gotten into the habit of escaping the silence by staying late at work. It wasn't an especially successful idea because the Water Department was actually quieter than the apartment. It was sheltered on one side by the massive windowless power plant, and won the other by the river and the woods. Every forty minutes there was a bellowing moan from the power plant's steam vents. At seven in the morning, and then again at nine and eleven in the evening an especially lonely-sounding whistle announced the Everal bridge was opening for barges. It was if the world had been reduced to a few giant machines.

Before the zoo project disaster, I'd had a wonderfully routine life. I sampled drinking water all around the city, with stops at McDonald's for coffee, the Yellow Hat Diner or Mikuya for lunch, and occasionally the grocery on Adams for a second or third coffee. Back in the lab, I analyzed the samples, letting the water drip through a one-micron yarn-wound polypropylene filter, concentrating it, adding antibodies, dyeing it with fluorescein and examining it under the microscope, and then, almost inevitably, ticking the same fourteen boxes certifying that Guelph's citizens were reasonably safe from distressing and even potentially fatal bacterial and amoeboid infections. In the fall, Wednesdays were set aside for the Water Management lab class, in which Vipesh and the other interns strug-

gled to keep themselves awake for three hours in order to earn a certificate and hopefully go on to disappointing jobs with the city.

Once the lab ended and the zoo trips started my weeks were pinched by trips out of town and my imagination was pressed on all sides by the faces and sounds of animals. When I wasn't collecting water samples, my time in Guelph was taken up writing reports about the zoos I'd just visited and reading about the next ones.

It was eight o'clock, an hour before the first evening bridge opening. I got a bag of stick pretzels from the vending machine and sat at the wobbly folding table in the tiny rec room, with a sheaf of readings Vipesh had given me for the next zoo trip.

READINGS

FOR ZOO KNOXVILLE IN KNOXVILLE, TENNESSEE, U.S.

COLLECTED BY VIPESH PIBULSONGGRAM

AND VIPERINE PISTOURIEC

Apparently Viperine was still around, insinuating herself into the Water Department's business even though the lab was over and she had no position.

"Dear Dr. Emmer, here is your READINGS for your trip to Knoxville to see the Zoo Knoxville. I must continue to give you papers on the subject of the stereotypical movements of zoo animals. Here enclosed are four more papers for your knowledge. Viperine and I have also added a new SURPRISE SUPPLEMENTARY PACKET of additional readings. Please, you must enjoy it. I wish you happy travels! Signed, your intern Vipesh Pibulsonggram, พิบูลสงคราม and my collaborator, Viperine Pistouriec."

Viperine had added her own note, written in flowing cursive script. She had been educated in France, and her writing was lovely and confident, with enormous loops blossoming from the f's and g's.

"Dear Doctor Emmer, I hope you won't mind my contributing to your readings. Please feel free to disregard whatever you think you don't need. It occurred to me that after your lab class, and your really exemplary tol-

erance of my sometimes insistent ideas, that I could contribute some material to your current zoo project that would provide diversion, if not instruction, and would certainly augment if not materially correct Vipesh's enthusiastic but often somewhat less than rigorous contributions. I hope to see you in September, when I will return to Guelph to begin a three-year programme in ecology with a special focus on parasitology, which will make us neighbors for the foreseeable future. Yours very sincerely, Viperine."

I was not looking forward to Viperine's many unpleasant fascinations or her disturbing habit of telling me about things like parasites in the intestines of hairless bats or animals that eat their own shit, all in a quiet breathy voice like Marilyn Monroe. Maybe she'd gotten over her desire to shock me now that she'd been accepted into the university.

The first paper, "Stereotypical Paddling in Harbor Seal Following Forelimb Amputation for Giant Cell Sarcoma," described the case of a harbor seal in SeaWorld Orlando that had been diagnosed with cancer. Veterinarians amputated its right foreflipper at the humeroulnar joint. After a period of recovery, it was reintroduced to its pool. It developed a way of swimming using a corkscrew motion, but on land, it exhibited a repetitive stereotypical movement, squirming and slapping its healthy forelimb against the rock in a manner that disturbed zoo visitors. This was not an attempt to move along the ground, the author said, but either an expression of frustration or a neural tic. The seal was successfully treated with an NDRI (norepinephrine-dopamine reuptake inhibitor) manufactured by Sun Pharma, which caused it to stop slapping the rock, lose weight, and become more active. The NDRI had no effect on the seal's corkscrew swimming. The author noted that the unusual swimming motion was not considered a stereotypical, and it was greeted favorably by SeaWorld guests, who nicknamed the seal Torpedo.

"Managing Forest Elephant Depression Following Outbreak of Elephant Haemorrhagic Disease (EHD)" was about two young forest elephants in the Moukalaba-Doudou Elephant and Rhino Nursery in Gabon, orphaned when their mothers died suddenly of EHD, a viral disease specific to ele-

phants, caused by a proboscivirus. EHD, the author wrote, causes rapid hemorrhaging of all major organs, and leads to death within twelve hours of the onset of symptoms. The two orphaned forest elephants were offered surrogate mothers but did not accept them, preferring to stay with each other. Both developed stereotypical behaviors including trotting in figure eights, rocking, and over-dusting. They refused to eat and lost weight. One had high indicators of anemia. The nursery used blow guns to administer packages of vitamins and the mood stabilizer Efalith. After six months the orphans returned to normal diets and behaviors. They still rejected their surrogate mothers.

"Alzheimer's Disease-like Pathological Lesions in the Brain of an Aged Bottlenose Dolphin" was written by a team of Greek veterinarians. It concerned a case of a dolphin that had stopped swimming with four other dolphins around its pool in the Attica Zoological Park in Athens. It floated on its side or upside down, and occasionally it swam into the sides of its pool. It was sedated and examined in an MRI, and pathological lesions were detected that are characteristic of human Alzheimer's. The veterinarians proceeded on the assumption that the bottlenose dolphin had a form of dementia, resulting in mild cognitive impairment. It was returned to its pool and given a beta-generation derivative of Aricept (donepezil). After three weeks of medication, it no longer swam upside down or sideways, and it seldom swam into the sides of the pool. Later, the symptoms worsened, and the dolphin had to be euthanized.

"Box Elder Tree (*Acer negundo*) Intoxication and Poisoning in Fallow Deer (*Dama dama*)" described how four fallow deer in the Ouwehand Zoo, Rhenen, Netherlands, had to be euthanized after ingesting box elder cuttings. The day after they were given box elder cuttings, they began exhibiting stereotypical teeth-gnashing, shaking, and stomping. A week after eating the box elder, they developed signs of colic, anorexia, and behavioral damping involving a reduced range of motion and lack of interest in external stimuli. They seldom slept; their eyes were open and not fixed on anything in particular. Twice every day they were herded into stockades and treated with three triaged courses of paroxetine (Paxil) and imipramine (Tofranil),

along with appetite stimulants and antacid packages, but they did not improve and had to be removed from public display and euthanized.

Viperine had appended a note.

"The four papers in this week's reading were all found by my industrious colleague Vipesh. I believe his intention is to show you a wide range of stereotypical movements, beyond the ones you may have encountered on your zoo visits. Vipesh is enthusiastic, but I am afraid he is also limited in his research capacities. Therefore, with his full consent, I will suggest alternative interpretations for several of these papers.

"First, may I please dispose of the papers that are irrelevant? The harbor seal study does not belong here. It is not clear that animal had any stereotypical behavior, and indeed there are many cases of peripheral neuropathies that result in involuntary movements such as fasciculations. Our surprise additional collection of readings will address this point.

"Second, can we agree the fallow deer were simply poisoned? I tried to convince Vipesh of this, but he was so delighted with his discovery that he would not allow me to omit the paper. The fallow deer were poisoned by boxwood, which contains a chemical called bebeerine. Vipesh thinks this is humorous, because he believes the word derives from 'beer,' but it comes from an unknown and possibly extinct language in Guyana. Bebeerine is an isoquinoline with the formula $C_{36}H_{38}N_2O_6$. It causes vomiting and seizures, and it can kill deer. So this essay is just a sloppy and ignorant description of gradual poisoning, resulting in paresis or -plegia.

"This leaves us with two papers that may appear to be good examples of stereotypies. They are, but they are not what Vipesh supposes. I believe in fact that I can connect the elephants in Gabon to the dolphin in Greece. Recent research has identified one of the human herpes viruses as a cause of Alzheimer's disease, and there are several species of Herpesviridae that are endemic to dolphins. The dolphin's stereotypical movements may therefore have been a result of a virus. In the case of the elephants, probosciviruses are also members of Herpesviridae, and it has been shown that they are endemic in elephant populations. Trunk washes and saliva sampling of bush elephants, forest elephants, and Asian elephants routinely turn

up most of the eight elephant probosciviruses. One virus in particular, a member of the Deltaherpesvirinae, lowers the production of certain antibodies, IgG and IgK (and by the way those are pronounced I g Big G and I g big K, which again Vipesh finds very amusing), and that allows the viruses to gain mass until they reach saturation at about fifty virus particles in every cell of the elephant or about two hundred billion virions per elephant (which incidentally amounts to slightly less than the weight of a poppy seed, which Vipesh finds marvelous). The Deltaherpesvirinae gain sufficient viral mass to challenge the animal's neural network and alter behavior.

"I am not heartless, Doctor Emmer, and I have no doubt the two orphan elephants were depressed because they had lost their two mothers. But whatever they truly felt was locked in their brains, because their figure eights, rocking, and over-dusting were caused by their viral load, which made it impossible for them to do anything else."

Viperine's stories always seemed to end with viruses or bacteria in control and animals reduced to robots. She wasn't heartless, exactly, but she was resolutely unwilling to be reasonable where there might be a chance to see feelings instead of pathology.

Vipesh had also included the Knoxville zoo's veterinary report. There was a table titled "DISEASES, FISCAL YEAR 2018":

Condition	Animals affected	Medical costs	Pharma costs
Digestive diseases	47	$18,514	$3,042
Respiratory diseases	9	37,036	4,526
Metabolic diseases	1	6,078	459
Gynecology and ob.	13	52,925	512
Surgery-related	37	90,520	31,953
Injuries	26	524	403
Parasitic diseases	384	54,402	98,820
Other	45	20,492	942

And another titled "ANIMAL BEHAVIORAL WELFARE, FISCAL YEAR 2018":

	Animals affected	Pharma costs
Antidepressants	226	$131,054
Stimulants, mood stabilizers	29	4,709
Pain management	19	1,392
Appetite control	12	1,495
Hormonal regulation	635	97,305

And a third on "DEATHS, FISCAL YEAR 2018":

Cause of deaths	Mammals	Birds	Reptiles
Deaths among diseased animals	14	10	0
Euthanasia of diseased animals	11	5	0
Euthanasia in hospice care	10	0	0
Cardiovascular events	7	0	0
Deaths following medication	8	9	8
Unexplained deaths	3	17	72
TOTAL DEATHS	53	42	80

That would be good conversation material for my tour. I practiced: Your animals have an unusual number of hormonal issues, don't they? I understand many of your animals are quite old. Ten died in hospice, for heaven's sake. You seem to have some rather severe psychological issues here. What do you mean, no? Over two hundred animals on psychotropics? And that is a lot of parasitism for a first world zoo. Oh my god, look at those euthanasia rates. I'm afraid that will require a formal investigation.

At the bottom of the packet was a red folder.

"Dear Professor Emmer, welcome to your new SURPRISE SUPPLE-MENTARY PACKET. This is additional material my friend Viperine and I

have discovered. This PACKET is different. The contents are useful for you I hope! We have discovered wonderful material truly. It is not known to your colleagues Dr. Catherine Sounder or Dr. Agathe Desmarais or Mr. François Aucoin. (I promise this is true.) Signed, your intern, Vipesh Pibulsonggram, พิบูลสงคราม and his collaborator, Viperine Pistouriec. We are V.P. and V.P.!!"

The first few papers were about people with drug problems. "'Got the Twitches Bad, Doc': Twitching Behavior in Opiate Withdrawal Sequences." "Squirming: An Indicator of Approaching Detoxification." "A Statistical Arc of Squirming and Twisting Motions Observed in Stage 4 Alcohol Withdrawal." "Shaky Hands Syndrome in Combined Alcohol and Methamphetamine Dependency."

It seemed like a joke, but Vipesh was too obsequious to contemplate a prank, and Viperine was far too serious.

There were dozens of papers. "Systemic Uncontrolled Shaking Limbs as a Pre-Seizure Indicator in Advanced Alcohol Toxification," "Panic Attack or Panic Disorder? New Diagnostic Criteria," "Darting Eyes and Tapping Fingers: Nervous Conditions in Methamphetamine Dependence," "New Correlation between Arrhythmia and Shaking Hand Syndrome," "Tongue Tremors: Low Predictive Indicator of Parkinson's Disease, High Predictive Indicator of Chronic Anxiety Syndrome," "Permanent Involuntary Facial Tics a Consequence of Antipsychotic Medication," "How to Grade Your Schizophrenic Patient on the New Abnormal Involuntary Movement Scale," "Essential and Intermittent Tremor in Obsessive Compulsive Disorders," "'My Leg Just Won't Stop!' Patient Reports of Loss of Limb Control," "Jaw Gnashing, Jaw Retraction, Jaw Joint Popping, And Other Repetitive Dyskinesias," "Disease or Symptom? Psychopharmacological Status of Eye Tics and other Blepharospasms," "Tardive Dyskinesias: Permanent Involuntary Jaw, Neck, and Face Movements in Patients Treated with Antipsychotics," "Progress of a Neuromotor Affective Disorder: Progression from Eye Tic to Wince to Flinch," "Loss of Hand Control in Alcohol-Related Depression," "Trembling Lips and Rapid Blinking in Early-Onset Parkinson's Disease," "Development of Generalized Corporal Shaking in Cases of Ad-

vanced Stuttering," "Loss of Eye Tracking and Compulsive Swallowing in Late-Stage Dissociative Psychosis," "Repetitive Swallowing Correlated with Non Anxious Dissociative Disorders," "Knocking Knees as an Indicator of Social Anxiety Disorder (SAD)," "Aggressive Social Disruptive Behavior: Finger-Tapping, Knuckle-Cracking, Ear Cleaning, Nail-Biting, Spitting, Hacking, and Propulsive Ejection of Phlegm," and "From Trichotillomania to Baldness: A Report on Compulsive Hair-Pulling."

That last one turned out to be a pinch-by-pinch analysis of a patient who pulled her hair out. She told her doctor she had developed a system to remove her hair in slow stages. The author, Albert Pecs, reproduced a diagram his patient had drawn, showing how she had gone from having a full head of "flowing glossy brunette hair" to "stage 9 baldness," following her own self-imposed rules.

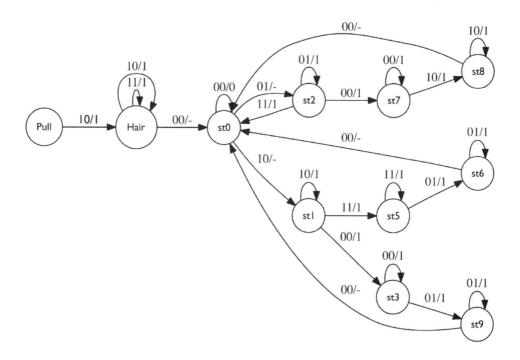

Pecs's patient was a computer programmer, and she had developed an elaborate game of chance involving three pennies stolen from her father's coin collection: an ordinary one, a wheat penny, and an Indian head penny.

She flipped them to get combinations of heads and tails, and moved them along her diagram as if it were a board game. That way, she explained, "I am not responsible for my hair. I do whatever my father's pennies tell me to do."

When Pecs's patient first came to his office, she had already achieved what she called "stage 9 baldness," which meant the top of her head was entirely bald, with hair left over the ears and in back so she could look normal with a cap on. They settled on a treatment program in which the patient had to play the game using a diagram Pecs drew, which called for the same three pennies. When she played using Pecs's diagram, she had to let her hair regrow in stages, from 9 back to 1. Pecs says he designed his diagram so it worked like the patient's diagram: as she played, the pennies were often trapped in place on the board, or turned back toward the beginning so that it seemed that she was not making progress, but eventually she would get the right combination of heads or tails and the game would continue. After six months of treatment, Pecs's patient was on her way to recovery. But he could not report a positive outcome, because during one of the patient's final visits he noticed she had started pulling the "short, fine, and often white hair" that had begun to regrow on her scalp. Soon after that the patient stopped making appointments. On her last visit she produced a third diagram. It was played with nine pennies, so that the game would go faster, and it was designed to end with the total depilation of her body. She demonstrated the new game and offered to show Pecs how she pulled hair from other parts of her body. "It was clear to me," he wrote, "that she was attracted to the repetitiveness, the frustration, and the irrational rules of the games she had devised. The diagrams were her real interest, and not her hair or her father."

I tore out the diagrams and put them in my notebook. They'd also be handy for talking to zoo curators. Apparently Vipesh, or more likely Viperine, thought I need to know that people also exhibit stereotypical behaviors. She could have just written me about it instead of going to the trouble of printing so many articles. When I saw her again in September, she'd probably explain human stereotypies in exquisite detail, in that

uncanny soft voice she had, which always made it sound as if science is obscene.

Toward the bottom of the pile were papers on something called punding: "Punding in Autism," "Punding and Adult-Onset Schizophrenia," "Punding and Obsessive-Compulsive Behavior," and "Punding Behavior Distinct from Methamphetamine Usage." That one was written by four Japanese authors, GAN Akiko, JI Masami, GAI Souta, and KUSO Hachiro, all of them working at the Tokyo Matsuzawa Metropolitan Psychiatric Hospital. "Punding," they wrote, "is a human stereotypic behavior. It typically occurs in two forms. Either the patient obsessively and repeatedly assembles and takes apart and reassembles a mechanical object such as a clock, a doorknob, a pepper mill, or a mechanical pencil sharpener, or else the patient obsessively and repeatedly arranges objects, such as coins in straight lines, pebbles in spirals or concentric circles, shells in the shape of giant shells, flowers in floral patterns, toothpicks in rows, napkins in helical stacks, playing cards in 'ribbon spreads,' or silverware in 'diagonal displays.'

"Patients who assemble and disassemble objects," they wrote, "are referred to as *robot punders*. Patients who arrange objects are called *artistic punders*. We present evidence against recent proposals that punding is pathological behavior indicative of substance abuse. This hypothesis was originally stated by Undeutsch (2010) and is therefore known as the Undeutsch-hypothesis (Steller, Mankiewicz, and Kanishvili, 2012.) According to the Undeutsch-hypothesis, punding is to be considered a pathology because it is statistically correlated with a range of high-dopamine producing conditions including certain psychotic states and the habitual use of methamphetamines, cocaine, and cocaine analogues.

"It is true that punding is associated with the abuse of methamphetamines. It is also true that punding can be correlated with the release of dopamine. In clinical situations, punding has been corrected by administration of dopamine inhibitors. However, the Undeutsch-hypothesis has been conclusively overturned by several of us (GAN and JI, 2016). We therefore name our finding the Anti-Undeutsch-hypothesis.

"A thorough review of the pertinent clinical literature indicates that normal-range levels of dopamine are compatible with punding effects in the general population. According to our Anti-Undeutsch-hypothesis, punding is a normal-spectrum behavior, and can be considered as a healthy response to stress, worry, and anxiety. The punder derives pleasure from the temporary arrangement of objects into satisfying geometric patterns, or the temporary disassembly and reassembly of mechanical devices. This is to be considered normal and characteristically human behavior. Examples of non-pathological punding arrangements are glasses in china cabinets, stamps in stamp albums, and patterns in flower beds and gardens."

Viperine cared for me in her weird way, so if she'd chosen the essays, it was probably to alert me to the fact that my minor punding behaviors, like lining up glassware in the lab or keeping a row of sharp pencils upright in a foam board, are harmless and normal. Vipesh was hopelessly sycophantic, so if he was the one who discovered these papers, the message would be something like: Doctor Emmer, please accept these papers in the collegial spirit in which they are given, since we are both scientists, and besides, your secrets are safe with us.

The next paper was "Toward a General TRU Theory of Punding," written by ten scientists working at several universities in Japan. It was published in the *Papers of the Nakisha Institute of Neurological Studies* in Osaka.

"The word 'punding,'" they wrote, "comes from a Swedish slang expression 'dumbom,' which means 'blockhead.' It is used in drug addiction communities in Sweden. Punding is also known as 'stimming,' which is an abbreviation of 'self-stimulating.' In the methamphetamine community in North America, it is known as 'tweaking.' In Japan it is known as *hikitsuri* 引攣り, which in this context means 'twitching.'"

I looked at the Japanese. Very like twitches, those little marks. A zig-zag spasm, then a straight line, then a really messy shaking shape, and ending with a hook. Maybe the four characters were syllables: hi, ki, tsur, i.

"Punding is broadly defined as a constellation of iterated sterile behaviors. The behaviors are 'sterile' because they are either undirected, for example

sitting at a table and rapidly moving one knee up and down, or else they are unrelated to ordinary functions, for example pacing, because it does not move the person forward.

"We follow other researchers in dissociating punding from various addictions (Gan, Ji, and Kuso, 2017). However, there is still no general theory of punding, which can account for people expending significant time and energy on activities that are both iterated and sterile. We propose that punding can be understood in the framework of a general theory of the psyche as it has been developed by Laplanche and Pontalis following Freud, Adler, Klein, Lacan, and others beginning in the 1920s (Laplanche and Pontalis, 1967; Laplanche, 1981, 1985, 2011). In this theory, which we will denominate the revised general Copernican theory of the repressed unconscious (RGC-TRU, or TRU for short), the self-alienation of the unconscious possesses no originary or central individuation that can account for itself using the epithet 'I' (that would be a 'Ptolemaic' orientation), thereby generating a continuous irresolvable conflict of desires with the conscious self. Among these conflicting desires is the one Freud first identified as the *Todestrieb* (death drive), which manifests itself in 'sterile' and 'iterated' repeated thoughts and actions (Freud, 1920; Laplanche and Pontalis, 1973). A person in the normal spectrum who manifests punding can be said to participate in the same complex of behaviors first identified by Freud as *Wiederholungszwang* (repetition compulsions) and more recently studied as 'stereotypies.' These derive, both in classical psychoanalysis and in the revised TRU theory, from manifestations of the death drive. This is the organism's preparation for its own death, its rehearsal of the permanent state that will follow its life, as well as its acknowledgment of the seductive nature of the primitive states that preceded it, first in the embryo, and ultimately in single-celled life. At the level of somatic existence, the *Todestrieb* (death drive) is a regressive instinct that draws the mammalian body, with its complex systems of organs and orifices, toward the protozoan body, with its simple interior protoplasm and continuous enclosing membrane. The death drive manifests itself in destructiveness, both the aggressions of war and also

self-destructions, the so-called 'primary masochisms.' A person who exhibits punding is also manifesting the instinctual drive to self-mutilation, both psychic and physical, tending unconsciously toward the simple state of single-celled organisms, and ultimately toward self-annihilation, where we all, in the end, wish to be."

Another paper, "Computer Addiction and Punding," was about a man who "developed an unusual and severe attachment" to his computer. He spent up to ten hours a day arranging hundreds of icons on his screen into diagonal rows and offset columns. The paper included a photo of the man's computer screen, which didn't look perfect to me. A couple of icons were clearly out of place. Maybe those were ones he opened just before he broke down and presented himself for treatment "in a state of agitation and despondence."

"Excessively Neat Sandcastle Crenellations: Punding Behavior in Sports" was from *La Gazzetta dello Sport e Medicina*. It was written by three Italian sports doctors. Their patient was a sand sculpture competitor, specializing in sandcastles. His wife had asked him to see a doctor because his castles were taking up so much of his time. He made and remade the crenellations on his castles, trying to form them perfectly, even though the judges of the contest, the *Concorso Internazionale di Castelli di Sabbia*, repeatedly asked him to stop, so that they might judge his efforts. Eventually, the patient had been persuaded to go home, and the judges discovered that his five entries in the *Concorso* were identical. The three Italian doctors counted the castellations and ramparts in the patient's five sandcastles and discovered each castle had exactly thirty-five turrets and 305 crenellations. Shortly afterward, the patient was briefly institutionalized.

"The behavior of Paolo (not his real name) is entirely typical of constructive punding," the authors wrote. "Paolo (not his real name)'s sandcastles were intended to be perfect, but in his judgment, each had small flaws. He attempted to refine them until he was prevented from doing so. He developed a ritualized method, in which he visited each of the thirty-five turrets in each of the five castles, to inspect and adjust each of the 305 crenellations in the same order.

"Our patient permitted one of us (Meriggi) to visit his home near Porto Venere, where it was determined that his house was in an average state of order. In the back, however, the patient had a large empty factory building he called his 'laboratory.' In it were thirty-five identical model castles made of K-FOAM polystyrene cubes.

"A finding of abnormality is indicated. However, repetitive actions are entirely normal in other sports. One of us (Udinese) is completing studies of punding behavior in professional race car driving. He reports race car drivers at the *Autodromo dell'Umbria* complete up to 600 laps of the racetrack in an average week of training. These laps are intended to be run at the exact same speed, so that each lap is within three seconds of the others. One of us (Udinese) is also working on a study of professional swimmers. An international-caliber swimmer will practice a given stroke for an average of 200 laps in two two-hour sessions. These laps are intended to be within one second of each other. A coach can instruct an international-caliber swimmer to swim a lap 0.5 second faster than the one before it, and the swimmer can accomplish that without looking at a clock. One of us (Piccio) has studied repetitive stress disorder in tennis. Repetitive stress injuries do not occur unless a motion is exactly repeated. Two of us (Udinese, Piccio) consider punding as an important component of sports medicine, because athletes specialize in repetitive behavior. One of us (Meriggi) dissents. He considers the behavior of Paolo (not his real name) to be pathological and not properly an example of sports. One of us (Meriggi) also dissents from our majority view (Udinese, Piccio) that international-caliber athletes should be considered normal. We (Udinese, Piccio, Meriggi) recommend further study to determine which sports activities may be considered as examples of punding."

Apparently Viperine and Vipesh, or one or the other, had noticed some mildly compulsive things I've done around the lab. Pencils are one, and glassware. They might have noticed that I always fold the lab coats into neat piles instead of just hanging them up like in other labs, or that I like to arrange the cloths for the eyewash station in helical stacks like napkins. All the interns had seen the neatly arranged remnants of the old

wind-up lab clock, which I'd disassembled mainly out of curiosity and haven't been able to put back together. There are probably other things. So they both wanted to tell me that I exhibit features of the animals I'm supposedly studying. For Viperine that would be clinically interesting. How, she'd ask, can you study animals afflicted with stereotypies when you have them yourself?

The next paper was "Deception in Science Revealed by Stereotypical Behavior While Deceiving Others."

"Deception and falsification in science," the author began, "can result in damage to individuals and institutions. It is therefore useful to know when behaviors that may result in falsified data begin to manifest. This experiment examines the presence of stereotypical responses during acts of deception. Eight scientists were videotaped while they (a) explained the actual current state of their research, or (b) lied about how they had achieved positive results.

"The videos of the eight scientists were monitored by four observers. The observers followed the five criteria of the Reggio Emotional Control Scale, the ten criteria of the Public Self-Consciousness Subscale, the four criteria of the Cronbach Alphas Anxiety Index, the ten criteria of the Insincerity/Acting Scale, and the eighteen criteria of the Emory Reality Monitoring Scale. Observations were correlated, averaged across all five tests, and normalized.

"The results are conclusive with an error bar of $\sigma < 0.5$. They reveal that scientists who lie about achieving good results deploy a predictable range of stereotypies: They hesitate when they speak (= there is an increased incidence of the four principal hesitation indicators *mm, err, ah, um.*) They have higher-pitched voices. They keep their arms still (= typically akimbo or crossed.) They make relatively little eye contact, and their speech contains a higher than normal incidence of non sequiturs, repetitions, omissions, and digressions. Their deceptive behavior is also strongly correlated with tics, twitches, blushing, repetitive combing of the hair with the hands, repetitive stroking of the chin or cheeks, 'drumming' on the thumb with the first two fingers, 'hooking' of the fingernails

of thumb and index finger, shifting from one foot to another (if standing), and focus on objects that are not visible to the observer (= a supposed spot on the floor or fleck of lint on clothing).

"Scientists who lie and falsify data, whether they do so from internal compulsions such as neuroses or from a desire for fame or remuneration, are a detriment to the entire profession of science and its public image. It is therefore crucial that we act to minimize fraudulent science. The quantifiable study of stereotypical movements can contribute to limiting the number of cases of bad publicity that science receives on a regular basis."

Viperine had appended a note.

"Doctor Emmer, I draw this essay in particular to your attention in case you would like to consider that certain aspects of your behavior could be taken to indicate that you are unreliable. I find this to be especially concerning because the author of this essay is a certain Andrei Popp, who was instrumental in having Anneliese Glur removed from her position in Basel; and Anneliese, I'm sure you know, is a longtime friend of Catherine Sounder. You may reasonably assume that Anneliese Glur is aware of this research, and you may further assume that she has informed Catherine Sounder. I present this to you as a possible, if unproven, obstacle to your continued work in the department. Yours sincerely, Viperine."

I wasn't surprised that Viperine had been researching my colleagues, because I hadn't seen any limits to her intrusiveness or curiosity, but I was surprised that she cared enough to warn me. Maybe that was Vipesh's idea.

Last was a scan of an article in *Men's Life* from 1953, with the banner headline "Are All Geniuses Crazy?" The piece opened with a full-page reproduction of that photo of Einstein with his tongue sticking out. The author, Mrs. Harriet Pebletine, began with a conversation:

"Grandpa," I said, running out to meet him, "Please put away your toys!" As usual, he had his toasters set out on the porch. He had them on the garden table, on all the chairs, and lined up on the balusters. There were hundreds of toasters, all different sizes and shapes. Some were big and fit four pieces of bread, and others were small and held only one slice

at a time. He had toasters from Germany, Switzerland, France, Italy, Mexico, Japan, and many other countries besides. I especially liked his Chinese toaster with dragons around the top. But there were so many toasters! And my party was going to start in an hour!

"Why should I?" he said, ruffling up my hair like he always did.

"I think you know!" I replied, looking dejected, I'm sure.

"Oh my, it wouldn't be your birthday, would it?" he said with a twinkle in his eye.

"You knew! You knew!" I yelled, pummeling his tummy with my fists.

"Of course, darling. All the troops will be inside by dinner."

"That was my grandfather, a lovely man, as I knew him. Most of the world knew him as Professor Doctor Albert Einstein. He was never senile. In fact, he was sharp as a tack. But he loved to line up his toasters, all in perfect rows. He brought them out every weekend. We were under strict orders from grandma: we weren't to go out on the porch, and we had to be especially careful not to let the dogs out!

"When I grew up, I never told anyone about my grandfather's funny hobby. I thought people would think he was crazy. Imagine! The person who discovers how the stars go in the sky likes to surround himself with an army of toasters.

"But I know better now. I am a librarian in a big Middle Western city, and I have plenty of time to research. I've found that many famous and intelligent people liked to collect things and line them up in rows and other shapes.

"Some of our greatest figures have been nutters. President Thomas Jefferson kept a collection of silver spoons arranged in the shape of a star-burst, and another in the shape of a seahorse. The great Russian violinist David Oistrakh carries a set of Matryoshka dolls with him wherever he travels, and he has shown journalists how he takes them apart and arranges them in a row in his hotel room. The famous Japanese novelist Jun'ichirō Tanizaki keeps a drawer full of spare shoelaces all lined up. Tanizaki once told a reporter that he disliked the way that shoelaces have to be bent this way and that, and he preferred to give his own shoelaces a more relaxed

and happy life. The wonderful artist Ben Shahn, America's Chagall, collects cuckoo clocks. His wife says he loves to take them apart, but he can never put them back together right, so the cuckoos never come out, and she has to keep buying him new clocks.

"Some of the most intelligent people who have ever lived have had spooky habits. Another example is the poet, scientist, artist, and writer Johann Wolfgang von Goethe. It has been estimated that if there had been IQ tests in his generation, he would have scored 230 points. He kept diaries of his conversations in the form of geometric diagrams. Friendships were circles, and more complicated relationships were triangles or other geometric figures. He alone had the key to his secret codes! Today, no one can read those books, whose secrets are forever locked away. The inventor Thomas Alva Edison designed an 'imbricating key wallet' that kept his house keys in a neat row, each one overlapping the next, even though he admitted that the device did not help him to retrieve the key he wanted more quickly than just having all his keys on a ring in the normal way. The Polish magnate Zygmunt Solorz-Żak has a collection of five hundred identical model ceramic houses, which he keeps in a perfect grid. His daughter told a Polish magazine that her father relaxes by taking one house at a time out of the grid, holding it in his hand for a minute, and then replacing it.

"As far back as we go in history, we find examples of intelligent people doing crazy things. The Chevalier Pierre-Françoise Lemaire, gardener for the Château de Vaux-le-Vicomte in the nineteenth century, designed a hedge-trimming machine that could cut the tops of privet hedges so they were arranged by height, from one meter to three meters in one centimeter increments. Visitors delighted in viewing Lemaire's hedges from the terrace, where they seemed to look down a cascade of green staircases. Even prehistoric people could be eccentric. The famous cave at Lascaux in France has timeless paintings of animals, but it also has rooms full of scratchings and strange marks in rows and columns. The French archeologist André Leroi-Gourhan proposed that those marks are the compulsive doodles of the world's first artistic geniuses.

"Now when I think back on my very happy childhood, I remember grandpa and his toasters with great affection. He was a tremendous genius, whose ideas have changed the very world we live in. And yet part of his mind was dedicated to his silly habit. Perhaps those toasters meant more to him than we will ever know! Maybe they were a map of the cosmos. Perhaps they represented galaxies and stars. But on the other hand, maybe they were only toasters."

Just then the nine o'clock whistle on the Everal bridge sounded: a high pitched tone, sustained, then falling like a sigh.

At the end was another note.

"Dear Doctor Emmer,

"Although we value our relationship with you most highly and have certainly learned a tremendous amount from our laboratory and also from this special assignment to collect materials for your zoo tours, we are first and foremost two budding scientists, that is what we both fervently hope, and so we must be honest and truthful, because the unstoppable search for truth is after all the *sine qua non* of science. We are sure you will understand what Vipesh refers to as our clean intentions.

"In our estimation you exhibit several symptoms of the patients described in these articles, including, but not limited to, artistic and robotic punding, tics, and repetitive movements. This discovery did not please us, and we are sorry if you are unhappy to hear it, but we say this out of our dedication to truth and science and our generous concern for your health, so watch it. Thank you, V.P. and V.P."

Underneath was a note in Vipesh's scrawl.

"Doctor Emmer, please forgive my colleague Viperine. She is very clever and beautiful, but I confess to you I do not understand well what she says. Signed, Vipesh Pibulsonggram."

It didn't bother me that I had some of the same tics and traits as animals or meth addicts. Who doesn't? I thought. Who hasn't done some of the things described in these articles? Who hasn't lined up a row of pennies in an idle moment? Who doesn't appreciate that funny thing they do with toilet paper in hotels, where they fold the end so it looks like a

paper airplane? Who hasn't arranged stick pretzels into neat rows, with a separate pile for the ones that are broken or defective? Who hasn't forked the surface of a bowl of hummus into a nice pattern, and then erased it with a spoon, and then tried again, and again, and again, until the pattern is perfect? Who hasn't clicked and unclicked their pen while they read, especially if the text is boring or weird? Who hasn't bobbed their head from side to side in impatience and annoyance while they read things as unpleasant and repetitive as these essays?

Who hasn't unscrewed a ballpoint pen and taken out the plastic tube of ink and the little spring? Those old-fashioned pens are just asking for it, with their cheap metal pocket clips. Who hasn't bent one of those clips backward until it snaps off, leaving a sharp ridge and making the pen basically useless? Who hasn't broken a piece of chalk over and over until there's nothing left but little pieces? It almost seems like a long piece of chalk is asking to be snapped in two. Who hasn't been annoyed by the way people leave clothing lying around, and gone around after them, picking up the lab coats they threw over their chairs and folding them neatly, replicating the same folds that were used in the original packaging? Everyone does that kind of thing, it's what people do with clothes. Stamps are different, maybe, because when you have a whole collection of them they really have to be arranged nicely on a page, and it is actually not at all easy to do that. Even a slight misalignment of one stamp in a row of stamps produces a distinctly unpleasant feeling. And pencils. Who hasn't sharpened a pencil all the way down to the eraser, and then regretted it, and thrown away the useless pencil stub? Who hasn't sharpened more pencils than they'll ever use and stacked them in a mug, points up, and then tried to arrange them in rows and columns, which should be easy, because they are hexagonal, but they keep tilting over, because the sides of the mug aren't vertical, they keep slumping into unsatisfactory piles, and the whole thing becomes so frustrating that it's better just to throw out the mug and forget the whole problem, except that then I realized I could repurpose a black foam board by drilling holes in it and placing pencils, points up, in the holes, so they all stand at attention in rows and columns?

Those are perfectly normal things. Probably Viperine and Vipesh had also noticed that the polyethylene sample jars in the lab are all in rows and columns on their shelves, and the large glass culture jars are arranged so the spaces between them are equal to their diameters. They might have noticed that the disposable transparent pipettes are all stacked upright when most labs just keep them in bags, and the dropper bottles of organic dyes are in a wooden tray with recessed holders and labels for each bottle, even though the bottles themselves are clearly labeled and even though it is sometimes annoying to have to search for the right holder when it would be quicker just to keep the dropper bottles together on a shelf. Come to think of it, they had probably noticed that the translucent wafers separating the individual microscope slides, which are to keep them from scratching in transit, have their own miniature ceramic wastebasket on the lab bench. Catherine had undoubtedly noticed all those things, and many more besides, and come to think of it that might very well be why she volunteered me to study confined animals.

As the papers showed, it's all normal spectrum behavior. And really, who hasn't dreamed of disassembling certain objects around the house, taking down the wall clocks the way I did in the lab, taking each clock apart to learn how it works, dissecting the toaster into heating strips and stamped metal sheets, dismantling the coffee maker into its plastic parts, exposing its heating coil and setting its little green and yellow lights out in a neat row, putting the television face down on the living room rug, unscrewing its back plate and making a colorful abstract composition of its circuit boards, chips, plug boards, and wiring, there are a lot of those, who knew televisions are so complicated, disassembling the desktop computer, using jeweler's screwdrivers to unscrew the components. Actually, that is difficult because they use proprietary screws and wrenches, but at least unsnapping the plastic covers, setting everything that can be detached in rows, down to the tiniest screws and bits of wire, then pulling the refrigerator out into the center of the kitchen floor, throwing out the food, stacking the plastic shelf bins in a teetering tower, unbolting the back and lifting out the heavy metal compressor, taking it apart using a

set of car wrenches, with an old marmalade jar repurposed to hold the oil, then turning to structural things, removing the apartment's door knobs, leaving clean drilled holes in each door. The locks themselves can't be disassembled but the handles and trim can be, then putting the locking mechanisms in rows at the side of the hallway because they are all the same, removing some electric outlets from the walls, keeping the ones in the bedroom, kitchen, and bathroom, but removing the others, leaving live wires hanging out, switch plates and set screws arranged neatly on the floor, and then unscrewing the PVC plumbing under the kitchen sink, and setting out all the pieces even though they can't be lined up because they're all different shapes of elbows and Us, and even pulling the fire alarm out of the wall, and discovering it's connected to the fire department, and it starts wailing and screaming, so you have to reconnect it really quickly before the fire trucks arrive? Who hasn't sat down on the last remaining square yard of empty floor, and thought: there, now, that is what I call perfect? So satisfying to see what an apartment's made of, when you no longer need anything in it aside from the bed, the bathroom, and the microwave; when there's no one around to see it and say oh my god, oh my god, I totally forgot I have an appointment somewhere, I really have to leave.

If there is something wrong with me, I thought, it's that having the apartment that way doesn't bother me. I closed the folder of readings and went back to the lab to record the day's water samples. In a couple of hours the Everal river bridge would whistle again, and I'd still have time to get a microwave pizza at the grocery on Adams.

Fifth Dream

That night my dreams began as soon as I closed my eyes.

I watched as the images insolently appeared even before I had fallen asleep. As if they'd been waiting impatiently while I wasted my time being awake in the real world. They crowded into my mind and pushed aside the day with their strange insistent signals.

What choice do I have, I thought, these are not ordinary dreams that fly easily in and out of mind. They are like scenes from a parallel life that I have been living without knowing it, and now that life is coming forward, right to the edge of sleep, eager to cross over.

At the far end of a dry rocky pasture and a sparse scrim of pines I saw a mountain veiled in chalky light. It was smoldering, turning to ash.

I used to have all kinds of dreams. I dreamt about the usual things, girls and boys, monsters, fame, food, childhood, but now there was nothing in my dreams but this wandering in burning landscapes.

What does this place have to do with my life? I wondered, and I tried to recall something from my waking life, but my thoughts were indistinct. I could only recall people sitting at tables, tapping their toes and shaking their heads. I am asleep now, I decided, I know that because I can't remember what happened to me this week, even though many things did happen, including something important, but I can't think just now what it was.

What choice do I have, I thought, and so I stood there, alone, on a prairie, watching as the hill raised itself off the ground and became a cloud.

A long track led down toward the fire, but I was safe enough where I was.

How does time pass in this world? I wondered, drifting downward into my deepening sleep. This was a cold mountain, possibly in the arctic, with no roads in sight.

How long has it been since I watched that other hill burning? A few hours? A lifetime? And where is this mountain, and how did I end up here?

It would be hard to get to a place like this. Have I been walking for years, am I an old man? As I wrestled with my poorly formed questions the dream clamped down on my imagination.

I stood in the chill thin air, watching helplessly as a fire swept over a curved ridge like froth on a great ocean wave.

I need to know the rules of this life, I decided, using the last weak remnants of my waking thinking mind. This lonely world where I travel, apparently without any purpose, I need to understand it. It's signaling to me, it is a sign, it means something.

This is a place, I decided, where thoughts empty out. I still remembered myself slightly. But soon only cold air and the smell of charred timber would remain. For some reason I needed to hold onto an idea of myself, even though I no longer knew quite who I was.

I was asleep, and my thoughts tumbled over each other and fell out of my mind.

In the afternoon the fire spread down the mountainside, against the wind. I walked back and forth on the slopes across from the fire, getting different views as I went, watching from a distance. I wasn't in a hurry. I had no one to meet. I didn't think about where I might sleep or where I was going. Those things just weren't in the dream. The dream had only wandering and looking.

I was like a minor angel keeping an eye on the world, mildly curious about it, drifting from place to place, watching. Or I was a soldier after a long war, miraculously not wounded, but with no home or family. Or I was an animal that had been driven away by the fire, exploring its new unfamiliar forest, looking back in the direction of what had been home.

The mountains kept burning, first here, then there. It seemed to be late in the afternoon. I had the feeling it was time to leave. I wasn't in any danger, because the fires were far away, but I had walked for miles in the mountains, and in real life I would have needed to think about getting back. In the dream I wasn't so sure. I didn't have to return to the road, or my car, my hotel, or my home, because there was no road, no car, no home I could remember. It was as if I had once had a home, but it'd been ruined. Even so, I had that feeling you get when you are a long way from where you belong and it's getting late.

I walked away from the burning mountains, across a valley and up another range of mountains. Still the day did not end. Smoke sifted into the haze of the late afternoon. It is hard to get away from things in your dreams. I pushed my way through some dense thickets. It is hard to get clocks to move in your dreams, because time stays fixed on disasters.

At last I reached a height. Smoke dispersed across a deep landscape. The fires were far away now. Even if the whole world down there was on fire, I was safe up above.

I relaxed, and lapsed into that deeper sort of sleep where thoughts are muted and even images are extinguished.

6

A View to the Thruway

I woke with a start when the plane landed roughly, hard on the rear tires, in Knoxville. My fourth zoo visit. A dream stepped back away from my mind, as dreams do.

The teenager in the next seat gave me an evil sleepy look, as if I had been hugging him.

My guide at the Zoo Knoxville was named Stephanie Allmar. She'd emailed that she was sending two students, Liz and Jenny, to pick me up. They were easy to recognize at baggage claim among the bored limousine drivers and emotional parents. Liz had oddly large eyes. She probably tried not to think about the fact that people assumed she had a thyroid condition. Jenny seemed ill-composed. She fidgeted with fingerfuls of rings while Liz introduced me to her fiancé Sid, who was skinny and punky in a battered kind of way. We walked out to Sid's car, and soon we were on our way to the zoo.

Liz and Sid knew the area backward, not only the many strip malls with their unexpected number of sushi restaurants, but also the backwoods. In the Cherokee National Forest, Sid said, you can find fugitives from the law living in trailers.

— We used to go up to this lake, Liz said. It was pretty. But there were these trailers, and this notorious guy Adam who lived there.

— A fugitive, Sid said.

— People used to walk in looking for drugs.

For a moment we had a view between mangy hills into a hazy distance filled with crumpled mountains. A least it was warm, even though the air smelled odd, like creosote or oil.

— By Boxer's? Jenny asked.

— No, Frozen Head.

She didn't know what that was.

— Frozen Head State Park, past Wartburg.

She still didn't know.

— The lake is at the end of Flat Fork Road, Jenny, in Frozen Head State Park, in Wartburg.

Sid turned around.

— Liz, it's just off Flat Fork, it's not the end of Flat Fork, and it's not in Frozen Head, it's near Frozen Head.

— Jeez, Sid. It almost is.

— Here he is.

Sid handed me his phone. There was Adam the outlaw: shirtless, lots of little tattoos. Posing confidently by an old trailer, tilting his chin back to show off a pointy goatee.

He took the phone back and used it to gesture at the corrugated landscape.

— You see a lot of people like that out in the hills.

Mid-afternoon light shone through the sparse trees on top of the ridges, making the hills look like they had buzz cuts. There are always new places in the world, I thought, new things. The problem is there's nothing but new things, forever.

— Mainly we don't go up there anymore, Liz said. Jenny and I are students now.

— There are some freaky animals. Saw a sick porcupine once, with half its quills fallen out. Saw a white deer.

— The spiders, Liz said.

— Yeah, so one time Liz and me were camping in an orchard, and when we woke up our tent was covered with daddy longlegs. Did you know they come in different colors? They do. Blue, pink, white, orange. It was beautiful.

I wished I could say "beautiful" like that, Southern style, disdainfully, with a couple of extra vowels.

— Beautiful, Liz said. Her drawl was even slower.

— They were like stars, just fallen right onto our tent.

She contemplated the scuffed carpeted ceiling of their car.

If I had only refused this zoo project, I thought, I could be at home lying in bed, looking at the ceiling, which is perfectly white and has no spiders.

— Stars with legs, Sid said.

— Each one was like a little bulb, a baby Christmas light. They were beautiful.

She sighed, rolling her enormous eyes across the ceiling of the car. She was falling into a daddy longlegs trance.

I stared out at the prickly trees, the farms, the warm sour sky. Rosie would have liked it here. We'd gone to her brother's farm in rural Ontario, where the farms were bigger than these. She'd have said the houses here were sweet. "You make do with what you have," she'd have said, looking sideways at me like she did.

— Did you know you can keep daddy longlegs as pets? Jenny asked. I read about it once, in *Scientific American.* You feed them pats of butter and tiny, tiny pieces of hamburger, and you give them a saucer of water.

— A saucer like for a cat?

— Okay, Sid, not a saucer. The cap of a beer bottle.

— They have a really painful bite, that's what I heard, Liz said.

— They don't, I said. They have no venom. And they are not spiders.

— Ours never bit us. But they got stuck in the butter, and when they struggled they tore their legs off, one by one.

— Gross, Liz said, all their legs?

— Except for a few. Some ended up like little balls with a couple legs sticking out.

— Orange and pink balls, I said.

I wasn't interested, but this was my life now, catapulting from one zoo to the next, meeting miscellaneous people, talking about disconnected things, jumbling everything into balls of memory.

— The torn-off legs went on twitching a really long time, like, for an hour.

Jenny was somewhat alarmed at her own story.

— That must have been some seriously weird-looking butter.

Sid grinned at Liz in the rearview mirror. Her eyes bulged in horror.

— I mean, he said, the butter would have been like, hairy with spider legs, all twitching and everything.

— They aren't spiders, I said again.

— They got stuck on the hamburger too.

— You could've had sliders with spider legs in them. Hey Jenny, could they still eat when they had only like one leg?

— I don't know, Sid.

— Maybe if they were stuck in the butter, and their face was down in the butter, but not too far down in the butter, if they don't suffocate in the butter. Maybe then they don't need legs at all.

He laughed at his brilliant idea.

The farms along that stretch were cluttered with rusted cars and tractors. Some houses were nasty looking. A thin woman in a heavy yellow rain jacket sat on a porch, hands on her knees. I glimpsed her husband in the doorway.

— You'll see some homemade tattoos, Sid said. Lines and crosses people make on their hands. They do that kind of thing at home.

— You mean like with a needle? Jenny asked.

— Yup, and ink from a pen.

— Oh Jesus.

She winced as if someone had pricked her.

— Did you guys see the guy in the airport with a spider web tattoo on his wrist?

We hadn't.

— He had an umbrella tattooed on his calf.

— It's like they can't figure out what they want to put on their bodies, Liz said.

— Shit kickers, Jenny said.

— I have an uncle named Best, Sid said, checking Liz in his rearview mirror, who has JAILBIRD tattooed on his arm, from his bicep right down to his wrist, and he did that with a razor and ballpoint pen ink. When he was in prison. He was always totally weird. When he was a kid, he got this idea to buy other students' souls.

— That was Satan's idea, I said.

— Yeah, but Best had students sign. They signed little coupons in a three-ring binder, like "Jerry Spantelle signed away his soul on such-and-such a date, signed, Jerry Spantelle." My uncle Best bought a lot of souls. Then someone went and complained to the school nurse, and said "my soul is missing. I am feeling really bad." And the nurse said "what are you talking about?" and the kid said "I need an extra soul, please," and the nurse said, "what the fuck are you talking about, kid?" and the kid explained how he had sold his soul for five dollars to my uncle Gerry Best, and then the nurse ran and told the principal, and then the principal told my uncle he had to refund everyone and give their souls back right away. Uncle Best says some kids loved having no souls. He gave me his three-ring binder. It's empty, all the pages have been torn out, but on the cover it says, "BEST'S BOOK OF SOULS." It is super cool.

Sid was one of those people whose stories leave people silent. Liz was looking at her phone. Her eyes protruded, as if her brain were trying to expel them.

An image of a constellation of colored daddy longlegs hung in my mind. They might have been pretty from a distance, but if you looked too closely, your heaven would resolve into colored bellies with shivering legs and lots of tiny silver eyes. That tent must have been claustrophobic, with all those daddy longlegs so close above their heads. Same thing with the heavens, I thought. They're only sublime because we have weak eyes. Close up they are a mess: black holes, lethal radiation leaks, dust and rocks flying all over the place, those frightening voids between galaxies.

I felt a spider tickle my forehead. I jerked back, but it was just a thread hanging from the sunshade. I turned around and saw Jenny smiling at me.

The zoo trips had put me on edge. They pitched me from one thought to the next. My customary way of thinking was more placid, like slowly rising floodwaters that submerge one thing after another, until everything's floating in water that's hazy with mud. Quiet, and comforting in its own way.

Zoo Knoxville was in a hollow, hemmed in by the freeway and a cross road. A heavily made-up girl in the ticket booth sent us to the zoo office to meet Stephanie, the Assistant Director, an athletic-looking woman in a baggy tracksuit.

— Stephanie! Liz cried, hugging her. Hey, this is Dr. Samuel, from Canada.

She shook my hand over Liz's shoulder.

— And my fiancé, Sid.

Sid gave Stephanie one of those ultra-cool waves where you take your hand out of your pocket and raise it about six inches.

— Hi Sid. You're welcome. Well, Samuel, if I may, I'm happy to show you around, but we don't have many cases here. The main one is one of our African blue monkeys. She's been exhibiting her behavior about two months now. We're building a bigger habitat behind the one she has now. It's been slow, with the recession and everything, you know.

— Well, I said, that's not really an excuse.

— I guess not. But we have some success stories too.

She led us down a slope and into an artificial cave that ended in a viewing room fitted with a large Plexiglas window. We looked out onto a primeval landscape: the zoo's black bear enclosure. It had high cement walls meant to look like cliffs. Enormous tree trunks, cast in bluish cement, were laid on bare concrete.

There were no bears in sight. In the middle of the enclosure was a giant well, with colossal cement branches scattered around it as if they had been left by a tsunami. The whole had a kind of prehistoric gloom. It reminded me of movies from the 1950's like *The Thing from Another World* or *Mesa of Lost Women,* or maybe just that remake of *King Kong.* I wondered if the bears who lived there thought their cement trees were real. They wouldn't smell like trees, or scratch like them. Maybe only small children thought they were trees.

Stephanie walked over to the far left side of the viewing window and smushed her cheek against the greasy pane.

— There's one.

I spotted a patch of black fur between concrete branches. A thigh or part of a belly.

— Betty, the second female. Alphie's inside. Betty spends most of her day in a trance state. She's half asleep, on 200 cc's of Modatone. That calms her stereotypies. Otherwise, she runs around the enclosure, climbs the logs, falls sleep, drops off the logs, yawns, runs around, climbs up the logs,

falls asleep again. Over and over. Yawning, running, dropping, yawning, running, dropping. Like she can't decide if she's sleepy. Rested or restive. Restive, right? She's full of energy and she's exhausted, both. Modatone levels her symptoms off. Last spring, she twitched, like horseflies were attacking her. At first we thought there were horseflies, but they weren't. I mean they were nothing. There were no flies biting her. She was just like, "what's that on my ear?" and like, "what's that biting my nose?" We did a full work up. We got this guy Bill Al Abed from Pittsburgh who's an expert on ear, nose, and throat stuff in animals. He said there was nothing wrong with her in terms of physio. So now she's medicated back down into a mild trance state.

— Think she's happy? Jenny asked.

— You know, we hope so, we really do. I heard at last year's AZA conference that there's a sequence with some bears. When they wake up, they can't decide whether to sit there and yawn and blink or go and run around. They do both. It's like a short circuit. They run, but that makes them bored. Or tired. So they sit down and they yawn. Like they don't know: Should I run, or sleep? In the end the choice is too much. That's what paralyzes them. They hesitate. They look around, back and forth. Like, "I feel like running over there and yawning," or like, "If I yawn, that'll make me want to run," or like, "I can't really run and yawn at the same time, so I just won't do anything." I mean, that's not what the guy at the AZA said, he just said it's a sequence they get into.

— Poor old Betty, Jenny said, peering with great concern at the patch of fur visible between the concrete trees.

— The guy at the AZA said they need to be distracted or medicated. Otherwise that's it. They start rocking or twitching. That's what happened to Betty. The guy from AZA showed me where Betty's behavior is on the Roseman-Billinger temperament scale, the RBTS. It maps how one behavior leads to another. The scale starts with sleep, and goes through all the bear behaviors.

She unclasped a hard plastic folder and handed me a sheet of paper.

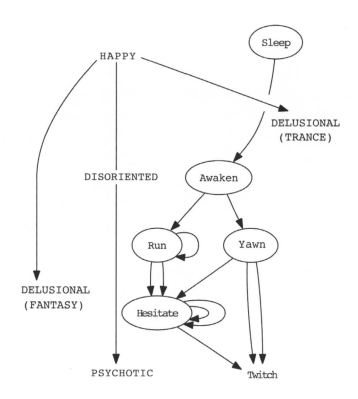

Jenny looked over Stephanie's shoulder. Sid and Liz had gone over to the other side of the viewing room where there was an educational display. Their heads were close together and they were laughing.

— After waking, either running or yawning. Exactly like Betty. Running can lead to more running. The looping arrow. Run–run–run. A feedback loop. Or the bear hesitates, things go wrong inside its head.

She moved her finger around and around on the diagram.

— In the end, there's twitching. Like last spring. Rocking and twitching.

— There are no normal behaviors on your chart.

— Correct. The guy said the chart only goes down. Psychotropics push it back up.

— Poor, poor Betty, Jenny said.

— "Medication suspends the fall," that's what he said.

Liz kissed Sid.

Stephanie pointed to the vertical line labeled HAPPY, DISORIENTED, PSYCHOTIC.

— The Roseman-Billinger scale is also done this way. It's to show how some animals go from normative to dissociative. Along the way, different things can happen. Some become delusional. DELUSIONAL (FANTASY) is like horseflies. Or they go into trance states, like they are looking somewhere far away. That's DELUSIONAL (TRANCE).

I thought of the bears in Helsinki. Maybe they needed more drugs.

— That's common, I said. It's all common.

Liz's back was against the bunker wall. Sid stood in front of her, hands at his sides.

— I don't really know what PSYCHOTIC means. The guy at AZA said Roger Billinger, he's the one who first drew this, he's still around. He said Roger could explain it better. What we care about are these feedback loops. Really, thank heavens for Modatone. If you'd been here last winter. Betty yawned and ran and yawned and ran. By spring, it was just twitch, twitch, twitch. Now when we go in to clean, she's pretty docile.

Liz reached around and spanked Sid, and he spanked her back hard. Then he slapped her.

— That is so sad, Jenny said.

Liz came over. Tears were pooling under her enormous eyeballs.

— Well, Stephanie said, taking Jenny's hand, Betty's okay now. The Modatone keeps her off the RBTS cycle. She plays, sometimes. She eats. Or watches people.

— She's a zombie!

— Betty's half asleep, Jenny. She's okay.

Stephanie put one arm around Jenny and the other around Liz.

— She's drugged. She's a zombie.

Jenny buried her head in Stephanie's shoulder.

— Sleep is the best, the sleep of dreams, Liz said, quoting someone.

— Sometimes anything other than sleep can be pathological, I said, even though I wasn't sure exactly what that meant.

Liz pulled away and stood off to one side, checking her phone. Sid glared at her.

A family came up, dressed in old jean jackets and boots. The men had mullets, and the women's hair was red, pink, and blue. The side of one man's neck was tattooed with a row of crosses marching up toward his ear.

— Jenny, come on now, let's show him the fennec.

Stephanie led us up out of the concrete cave and back onto the main zoo path.

In a dry dirt enclosure four rhinos were standing head-to-head. Three faced right, and one faced left against them. The three pushed against the fourth, and the fourth pushed back. The cluster moved in mincing steps. They were edging slowly toward a patch of mud, where a hose had wet the ground.

A placard read, "HELP US WELCOME CINDY, OUR NEWEST RHINO!"

— Is that Cindy? Jenny asked, pointing to the one that was being slowly pushed into the mud.

— Yes, she's found her new friends.

— They hate her.

— Not really, it's social behavior. Like a pile of kittens or puppies.

On the other side of their pen was a tree, rotten at the base, and some rangy bushes ringed by rocks. It seemed rhinos do not like to walk over uneven ground, otherwise they would have crushed the bushes. The rest of the pen was all packed-down dirt. It occurred to me some animals have no figure-eight paths because they go everywhere, until they trample their world into wasteland. Like people.

Behind me Sid was talking to Liz in a low voice. They were almost head-to-head like the rhinos.

— Oh Jesus, poor Cindy, Jenny said, clutching the rail.

— This kind of nudging is on the rhino behavioral palette, Stephanie said. There are like thirty recognized behaviors, nudging, licking, stomping, foot scraping, charging, rutting, grunting, snorting, snuffling, whistling, the others I forget. This is nudging. So don't worry.

— Cindy! Jenny called out as we left. Don't give up!

— Here, Stephanie said, pulling another sheet from her folder.

— The full version of the Roseman-Billinger temperament scale. On the right there's the time scale. When the animal is relatively happy, like at the top, its behaviors change quickly. No behavior goes on for very long. That's normal. The more it becomes disturbed, the longer its behaviors last. Betty ran and yawned, you know, for weeks. In the end, before we medicated her, she just twitched. That would have gone on a really long time if we hadn't found the right meds. The AZA guy said the most paralyzed

behaviors, the ones at the bottom of the scale, can last for years. Especially trembling. And staring. That can last for years. Until something shocks them out of it. Or the animal dies.

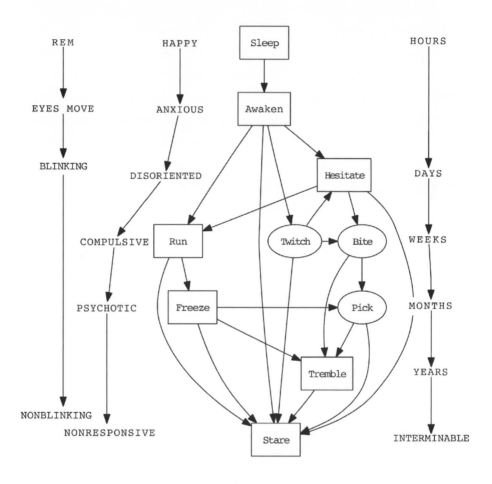

— Most animals stare, I said. Liz is staring at Sid.

— But for years.

— Everything on your chart runs downward. It all ends badly.

— It gets very involved. I can't say I follow it all.

She gave me the chart.

— Oh, that is so cool! Sid said, looking at a spill on the sidewalk.

Liz and Sid crouched down.

— Two spiders, licking spilled ice cream!

— I wonder if you can see their little tongues.

Sid got down very close, obscuring my view.

— Spiders don't have tongues, I said.

— Okay then, how do they lick?

Then he said something I couldn't hear. Liz shrieked.

Stephanie took us to an area with coyotes, foxes, ferrets, and other small dog– and cat-like creatures. In one cage, a fennec stood on top of a wooden crate that served as its den. It looked like a fox with humorously large ears. It stared at something behind my back, then nervously at the path to my right. Its nose went down, and it sniffed the ground in front of it. Then up at something it saw over my left shoulder. I turned. There was nothing. Its right ear rotated backward: it was listening.

— Melinda, what do you hear? Jenny asked.

The fennec had a cat's eyes and a woman's plucked eyebrows. It looked left, then right. I was in the way. It snapped at the air, a tender little bite. Twitching and punding. It looked at or past me, so briefly that I thought it didn't see me, but then I realized it had met my eyes for the smallest fraction of a second.

— Sweetie, what's wrong? Jenny asked. Are you looking for birds?

— Gnats, Sid said.

— Feeding isn't until seven o'clock, so she isn't interested in us, Stephanie said. This is pretty typical of what she does all day.

— Maybe she wants to play. Melinda, want to play? Want to play? Sometimes she plays.

Melinda briefly regarded an empty stretch of pavement behind our backs, and then her eyes traced part of the flight of a bird.

— Melinda! Remember me? She has a ball filled with suet, she plays with that. Melinda, what did you do with your ball? What are you thinking, sweetie?

Melinda took two more quick bites of air. Her little teeth clicked shut.

— I don't think she's in the mood, Jenny. So, this is hesitation, a low-grade stereotypy. I don't think we'll medicate because visitors don't perceive it as a problem.

— Melinda! You've forgotten me.

— She'll remember you when you're on feeding rotation next week.

Melinda sniffed something passing in the breeze. She snapped hard at the air. Her left ear folded back, then front.

— Poor, poor Melinda. Oh, poor Melinda. She only loves me when I have food, but I love her all the time. I understand you, Melinda, I know how you feel. I'll be back next week.

We went through an area where the signs were covered by black rectangles and labels reading UNDER CONSTRUCTION. Most cages were empty. They looked like they'd been abandoned suddenly, in an emergency. Or maybe years before.

Some enclosures had human-sized doors in back. What kinds of lives had been lived behind those bars? Were the animals drugged like Alphie and Betty? Did their days go by like a dream?

One cage looked like someone's back yard. There was a tire swing in a tree for the older kids, and another in a frame for the toddler. A wall in back was painted with a landscape of romantic mountains and plains, like the posters in travel agencies. The parents would sit in the shade and have a glass of wine. They'd say to themselves: We have a small house, just a door and one window. It's not the grandest, but it's sweet and comfortable and really just what we need. In front we have iron bars. Just like everyone.

Surely, I thought, the world is filled with families who are happy in that way. Surely there isn't much more to happiness than that.

The African blue monkeys were at the very end of the unused part of the zoo, in a forest ravine. Their cage was an old iron mesh corn crib, a cylinder about fifteen feet tall, made of rusting, heavy-gauge wire, topped with a funnel-shaped metal roof. It was set back behind two fences, one strung with chicken wire, and a larger one with rusted bars. Weeds grew between the fences. Behind the corn crib there were storage sheds, an area with some construction equipment, and then an embankment leading up to a line of trees. Beyond that, trucks roared by on the freeway. The whole was irradiated by harsh late afternoon winter light. The fences, the corn crib grille, and the bare trees cast confusing shadows on the inside of the cage.

A blue monkey sat motionless there, on a metal bar. Its head was turned in the direction of the freeway. A second monkey was engaged in a strange dance. It was pacing back and forth on a platform high up in the cage, under the tin roof. When it got to the end, it raised its right arm and curled it to the left over its head, like a ballerina. It cupped its right hand over its left ear. It pulled on its head with its right hand and arched its back, as if it were going to do a backwards dive, and then, with a twist and hop, it landed on its feet facing back the way it had come. It took four quick steps to the other end of the board and made the same curious twisting diving turn.

— Owole, Owole! Jenny called up to it.

— Its name means "not expected to live long" in the Ma'di language. We got both Owole and her sister Onzia from a zoo in Kampala.

— I don't think so, Liz said. I looked it up, and Owole means "rented."

— Who would name a girl Rented? Jenny asked.

— Who would name a girl Not Expected to Live Long?

— It doesn't matter, Stephanie said. Owole has been exhibiting this behavior for about two months. We were hoping to have her new enclosure finished by the spring, but now I think it will be next winter. We may transfer her to Nashville.

I walked around to the side to get a better look. Dive, four steps back, dive, four steps forward. Each time the monkey curled its arm over its head, it paused a fraction of a second, as if to say: I am improvising, I might do a dramatic backward dive, or I might collapse in a theatrical fashion. But the moment of suspension always ended in the same half-hearted turn and hop. The left arm followed slack at the monkey's side. The right arm did the guiding. Dive, four steps, dive, four steps. Owole was demonstrating, over and over, her complete lack of freedom.

I saw Owole's life stretching out ahead of her. The minute I'd been watching would become an hour, then a day. Then months, years. What is a minute, if every minute is the same as every other? I felt a weird elasticity of time. As if the monkey had decided she could no longer stand the whining freeway, the miserable patch of woods, the forlorn warehouses at the end of the zoo. She was protesting her intolerable existence by trying to stop time. If she did the same thing over and over, each time identically, then time would have to stop. She was refusing to let time pass. She was pretending she lived in a single spontaneous moment. But she was also torturing herself by extending time, making each second more painful than the last by making each second exactly equal to the last.

I imagined myself up there in the cage, looking out at the bleached parched forest and the speeding cars. I pictured what it might be like to sit there, hesitating, stuck in place by boredom like the other monkey. I would probably think about walking around the enclosure one more time or climbing the wire mesh, but after a thousand tours of the cage there'd be no point. One morning I would stand up, walk four steps, and try the half-dive. The pain of the first flip would be intense, because I would feel the pressure of the thousands of turns coming up, the ones I would then go on to make, day after day, forever. The second dive would be even more

painful, and the third, unbearable. I would know, then, that I could never stop except to eat and sleep. Every waking moment I would perform these exact same meaningless motions. If I did stop, I would never move again. If I stopped, I would be like the first monkey. I'd be paralyzed.

I felt an excruciating sympathy with that poor animal: I willed her to keep going, not to feel tired, not ever to stop, because if she stopped that would be the end. Whatever last thread of thought she still had would break.

Stephanie was a little way down the path, talking to Liz and Sid. They thought I was making observations for my report. Jenny stood beside me, looking up at Owole. The monkey was in a kind of pain I had never imagined. Much worse than Monika's hyena, with its patterns of figure eights. This was compressed desperation, impacted hopeless suffering.

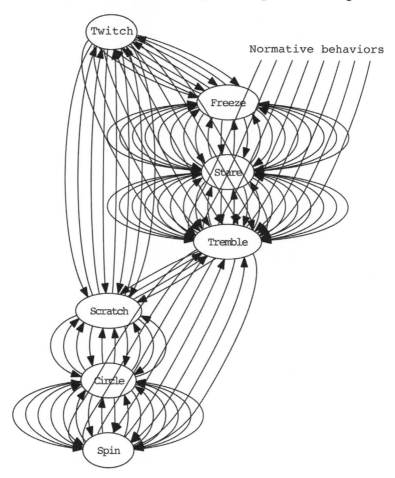

I pictured Stephanie's diagram branching into a forest of lines. Arrows like magnetic lines turning back on themselves. Movements repeated indefinitely, feedback loops with no escape. Spinning trembling spinning trembling. Twitching scratching twitching scratching. A hell of abnormal behaviors. In the center, staring. Blank staring. With glass eyes, frozen into their sockets.

— My darling Owole, Jenny said, walking backward, away from the corn crib, following Owole with her eyes.

We went back to the others.

— Ever had a twitch, Stephanie?

— A twitch?

— A tic? Like a tic, when your eye tics?

— Once or twice.

— That's what's happening with Owole. She has a permanent tic. In between each tic is an eternity.

— An eternity?

— Say your right eye tics every ten seconds or so. It can get obsessive. In between tics, you're just waiting for the next one, hoping it doesn't happen. You check to make sure no one is looking at you. Those are empty seconds. Nothing's happening, but you know the twitch is coming. You are a slave to it. Maybe you hold your breath, thinking a tic is like a hiccup. But that doesn't work. You can feel the tic coming. And then, pop! right in the middle of holding your breath there it is again. You can't breathe more than a couple of breaths before the next twitch.

— Owole doesn't have a tic.

— Not my point. A stereotypical movement isn't an illness. It's not temporary. For Owole every walk across the platform is an eternity, a torture. Same with all the animals. Every twitch, every bite of the air, each motion is humiliation, torture.

— Where are you getting this?

— Just observing.

— Well, personally, I think that's nonsense, but you're the expert.

— Your zoo is barely in compliance. But you know that. Owole's not even your main problem. You have a disproportionately large percentage of animals

on psychotropics. I've been over your fiscal reports. They show a suspicious number of euthanasias. You have too many old animals, animals dying in hospice. All this has to go in my report, you understand that, right?

— Okay. I hope you'll be fair. I didn't know you were reporting us.

— Let's go. I've seen enough.

I pointed up the path.

Stephanie set out, and I waited a moment to make sure she'd go on by herself. We went past an enclosure where a silverback gorilla was sitting with a proud expression, backs of hands on its hips, chin up, surveying a corner of its world.

Jenny came up beside me.

— Can you help Owole?

— You need to wake her up.

— She is asleep?

I wasn't sure how to answer that. She was, in the sense that she was not living. But she was also wide awake. She was in more pain than I could clearly imagine.

— She's caught. These stereotypies catch animals. They can't get out. Most of us, like you and me, we can go anywhere we want. Like you wouldn't get in trouble if you just walked off the job, if you just went out to the bus stop, just got on a bus and went to, I don't know, Nashville, and then on to San Francisco, and then down the coast to Mexico, to Central America, if you just kept going, without even saying goodbye to any of your family or your friends, and you just started a life of wandering, picking up odd jobs, never settling down, never giving your real name, moving from place to place for the rest of your life.

— I don't want to do that.

— Well, of course not, I mean most people don't.

— I want to stay here.

— But you can go, anytime, you could go. You know it. The monkey can't do that. Maybe her memories of Africa just got too jarring for her. Or maybe it was that thruway. She made a decision, I mean as far as we can picture what monkeys do, she decided not to live in the present anymore.

Not to live in the actual world. That movement she does, she's locked into it, it stops her from seeing the actual world. All she can think about is the motion. Four steps across the platform, flip, four steps back. It fills her mind, it locks her in. She can't think beyond what she is doing. Each flip is like she's erasing a blackboard. Whatever thoughts started to form there get erased. Over and over, before there's time to complete a thought. And the whole time she is awake, she knows what is happening, she feels it every single time. The pain is what makes it work. It's not numbing; it's not automatic. That's what people say. That's what Stephanie thinks. Owole needs the pain of the flip, and she needs it every four steps. Each time she feels the pain, it hurts just as badly as the first time, and that is how she knows she is alive. She needs a lot of pain, and she needs it over and over, it's the only way she can be distracted from her life. At the same time that is how she knows she is dead. Her sister is only a few feet away, but she may as well be in a different universe. Her sister is depressed, I assume. Her sister has no energy, no interest. That is a common condition. It is at the bottom of those charts. Owole's sister is living in the same cage, but she's as far away from Owole as two stars are away from each other. Two stars can see each other, but they can't communicate, because they are so far apart. Owole and her sister don't bother to look at each other, because neither one can comfort the other. Owole's sister cannot understand what has happened to Owole. She must know it is something terrible. It is like if there are two human sisters, and one has a stroke, and the other visits her in the hospital, but the one with the stroke doesn't acknowledge her sister. Her mind might be intact, but she can no longer speak. She can no longer turn her eyes to see people. She may be inside there somewhere, but there is no way to go in and find out. Like two stars, with millions of miles between them, and no way to signal from one to the other because the signals take so many generations to travel through space. Maybe the sister of the woman with the stroke is depressed, maybe she can't bring herself to leave their house and go to the hospital to visit her sister. That is like Owole's sister. But there is a difference. People can recover from strokes. They can learn to talk again, they can come back to normal. But

Owole can never stop. If she does, she will lose that electric pain she feels with each flip. The pain keeps her alive. If she ever stops, she will die of despair. Her world is just the corn crib cage, and the striped shadows of the bars and the trees, the storage sheds, and the thruway. She would crumple up into herself and never come out.

Tears were streaming down Jenny's cheeks.

We walked on together. I was very happy with my speech because it had upset Jenny, and also had clarified something for me, something to do with my life.

We came up some steps to a building with a clear plastic wall, which gave a view onto the interior of the chimpanzee house. Inside were three adults and a baby. Their room was furnished with wooden crates and hung with tire swings and pallets suspended by chains. The baby chimpanzee, in diapers, was prodding an adult, who seemed half asleep. A second adult was lying down on a crate, and another adult was standing beside it, bending over. Its legs were straight, and its hairless buttocks were facing the window. Its anus was gaping open, and the skin around the anus was pulled tight over its pelvis. The skin there was pale magenta and bluish gray, and it looked wet. Veins bulged around the anus. The sight of the straining, open anus was strong, and I turned away.

Stephanie came up with Liz, saw the anus, and moved down to the other end of the window. Sid stood next to me, gazing at the anus. A man and woman arrived with a baby in a stroller. The mother saw the anus, and stood a moment looking at it.

Then the baby chimpanzee ran across the straw floor and jumped up on a tire swing. That was a relief, and people walked over to ogle. The woman with the stroller was dressed in bright striped leggings and a rainbow tank top under a leather jacket. She went up close to the window wall and made a burbling sound. The man tried to show his baby the chimpanzee baby, but the baby's face wobbled, and it didn't see the chimpanzees.

I stood with Sid, facing the anus. How remarkable, I thought, that something so natural can be suddenly so obscene. I tried to regard it as a biologist should: the anus is merely the mammalian analogue of the

cloaca. Then I realized—the chimpanzee knows exactly what it is doing. It is showing itself to us because it hates us. It's not in estrus, it isn't trying to seduce us. That chimpanzee knows that it has an enormous, wide-open anus, and it is straining and pushing that anus into our faces because it despises us. And probably despises itself just as much.

Sid was testing himself to see how tough he was, and also how liberated, that he could spend time with a man staring at an animal's anus. We were both showing the chimpanzee we didn't care. We needed to show it that it was powerless. Could there be anything more cruel? More perverse? I was proud of myself, and I think Sid was too. Our faces were the equivalent of the chimpanzee's anus. We were showing the chimpanzee that it did not exist.

— Feel like a lick? I said.

— You wish.

— I bet you have a lovely pucker, I said, giving him my best sickly smile.

— Fuck, he said, and walked away.

The baby chimpanzee hopped off the swing and disappeared through a door. People began to disperse.

On the way back to the entrance Stephanie told Liz and Jenny about next week's work at the zoo. We passed the rhino enclosure. Cindy had been backed into the mud patch. Her body was tipped, or tilted, back against the wall, like a child's toy. The other three were pressing on her. They nudged her, inch by inch. Ratcheting her out of their lives.

When the zoo gates came into view, Stephanie took me aside.

— Please don't write us up, she said. If you've read our budget, you know how tight things are. We can't afford it.

I kept my eyes on her and shook my head.

— We love our animals. We really do.

— That's irrelevant. You need to be stopped.

I walked off. Sid, Liz, and Jenny were waiting by Sid's car.

As we drove through the uninviting landscape, the blue monkey's uncanny twisting turn kept repeating in my mind. It had become a stereotypy in my imagination, a loop in my thoughts. The monkey would still be

pacing, glimpsing the same stretch of thruway while we drove farther and farther away.

Melinda the fennec would still be glancing here and there, snapping at the air, or sniffing the ground. She was partly present, not gone like Owole. Someone needed to study her movements second by second, to see what she was looking at, deduce what she was looking for. Each glance, each turn of her head, was different. Each time she nipped at the air, someone could write that down. Each glance could be measured. The force of her air bites. The strength of her trembling. The dimensions of her twitches. Someone had to get into her brain, find a way to speak that language.

I imagined Stephanie's diagrams becoming even more elaborate. How many seconds, exactly, between one bite and the next? What is the amplitude of each twitch? When does a rapid series of twitches become a tremble? A monstrous diagram formed in my mind. A one-to-one scale map of Melinda's mind.

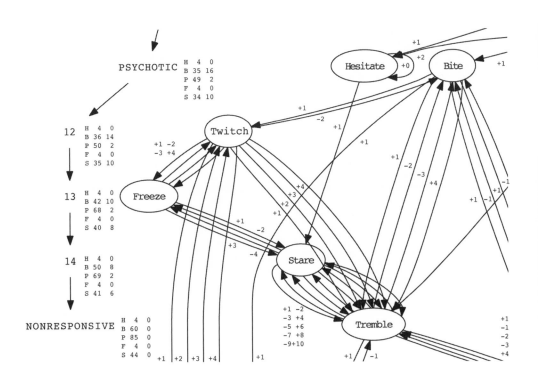

It wouldn't be an impossible project. Liz and Jenny could watch Melinda, spelling each other, eight hours a day. They'd type in every movement. Then we'd see what Melinda's life really is. Psychosis, stage twelve, would be revealed as distinct from psychosis, stage thirteen. We could ask exact questions. What does it mean that Melinda never stares after she twitches, never trembles before she freezes, often stares after she trembles, seldom freezes before she stares? How many kinds of twitches does she perform? What are her styles of air biting? The frequencies of her trembling? Are some stares glassier than others? We'd map everything. It would all be laid out in front of us, the diagram of Melinda's mind. We wouldn't be able to understand any of it, because it isn't a human language. But our graph would be beautiful like Monika's, and it would be our attempt at empathy.

Owole was different. There was no longer anything to measure. Her half-flip was the same each time. She no longer saw anything, heard anyone. She no longer had a language. Her one word was repeated forever, her single thought stretched to last her lifetime.

On the drive most of the talk was about Jenny's grandmother, who was in the hospital. Jenny got news on her phone, and the three of them talked about visiting.

At first, eastern Tennessee had seemed like a wild place, with outlaws and drugs. But there didn't seem to be any real evil in the air. The stories I'd heard were mostly small things: homemade tattoos, daddy longlegs. It seemed pretty harmless, except maybe for a few convicts.

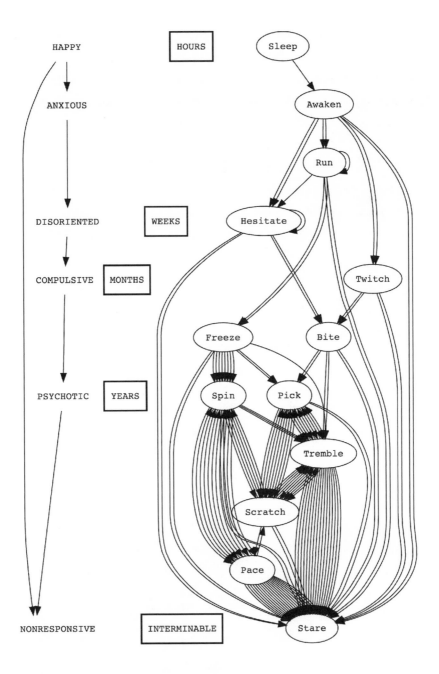

Versions of Stephanie's diagram kept coming into my mind. A tumble of mental states from normalcy to psychosis.

What hope did the animals have? Where were the arrows leading back up, instead of always down? There was no pleasure in the chart. Sleep was

at the top, so it was the best. Some philosopher said that: waking is sickness; sleep is palliative care.

If there was a version of the chart for me, the top would be sleep. Then waking up—and then what?

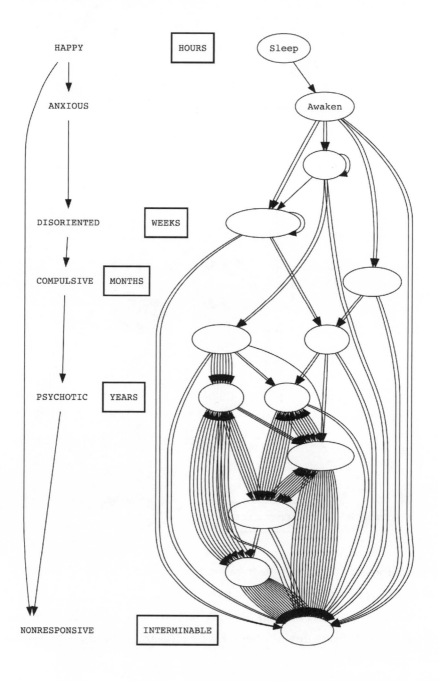

The anxieties of early morning, that's what. My habit of sitting and thinking. I definitely hesitated. My morning slumps at the breakfast table. Lost minutes spent dozing sitting up. My pacing around the apartment, doubling back and forth for things I'd forgotten.

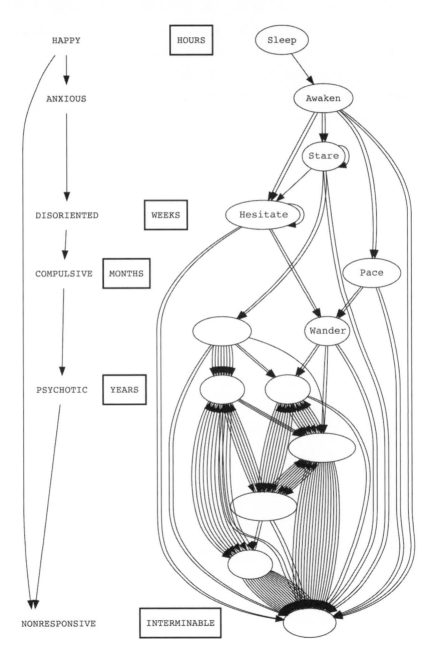

And below those? The Roseman-Billinger chart ended with trembling and staring, but those didn't sound right for me. Especially since Fina had left, when I got home, I led a molasses life. Occasionally I'd go around throwing out Adela's belongings. Or I'd disassemble a clock or a lamp, or spend some time at the small microscope I kept at home. When I used to sit on the couch watching TV, my eyes moved rapidly back and forth, following zombies or aliens or whatever was onscreen. Often I fell asleep, and woke up with one or another limb tingling.

I formed the chart in my mind. Not that different from the animals' charts, in the end.

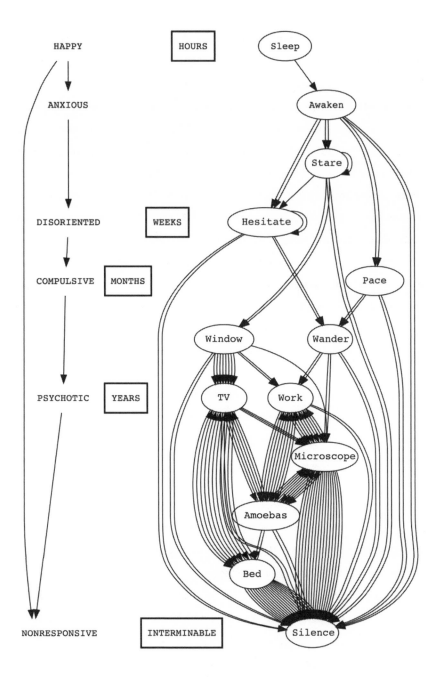

I watched the chart in my mind's eye. It appeared to me like the inside of a piano, with rows of parallel wires and some that had come loose.

The late afternoon Tennessee sky flowed past the smudged windows of Sid's car. We drove by yards scattered with farm equipment and neat

gardens with butterfly lawn ornaments. Sid and Liz were in the front seat. Sid had one arm over Liz's shoulder, and the other draped over the wheel. Jenny was on her phone, leaning as far away from me as possible.

Zoo Knoxville wasn't such a bad place, I decided. No more squalid than a Motel 6. Stephanie and Jenny were nice enough, and easy to frighten. Sid was especially easy. And they did love their animals. Imagine calling a rhinoceros Cindy. Or a spooked, bat-eared cat Melinda. But the blue monkey was something I shouldn't have seen. It was at the other end of the world from my life, and yet somehow it was a sign for me.

Jenny was weeping into her phone.

A vaguer version of the diagram came into my mind. This time nearly empty, with the wires gone slack. A picture of slow disastrous descent. It drifted a while in my mind's eye.

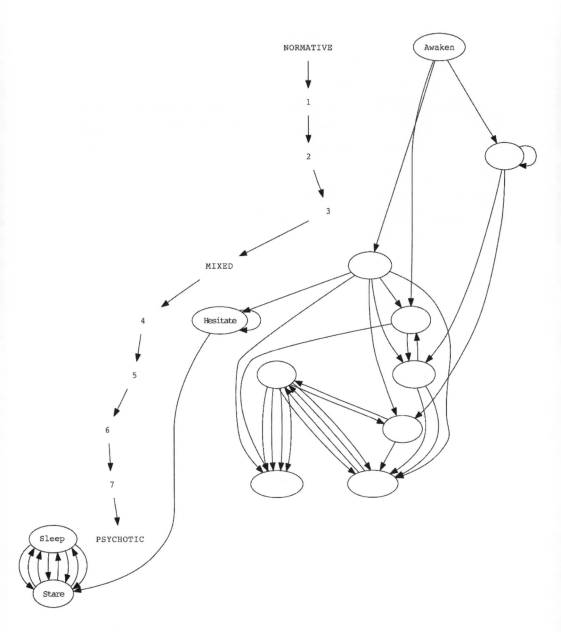

Maybe I'd quit my job in Guelph and come live in eastern Tennessee. I'd fit right in. Rosie could visit for a while, but she'd get anxious and go back to her brother's farm. I wouldn't tell anyone where I was from. I'd get to know my neighbors, maybe give myself a homemade tattoo. I'd go for long walks in the woods. I'd meet Adam the outlaw.

I looked at the passing houses to see where I might live. It could actually happen. I had a pension. I didn't need to keep measuring water samples or touring zoos. I didn't need to do anything for anyone.

It was the sort of fantasy that might suddenly come true if I didn't watch myself. I'd go to bed one night in my clean comfortable bed in Guelph, and dream about being a redneck in eastern Tennessee, and in the dream, Adam the fugitive drug dealer would come up to me and say, "want to buy some of this?" and I'd say "maybe," and he'd stroke his pointy goatee and say "I think you do," and I'd back off, but he'd stand in the doorway and smile and I'd get scared and wake up suddenly, and surprise! I'd be in my seedy bed in my scorching hot house in eastern Tennessee that I'd bought with most of my pension, and I'd rub my eyes and say to myself, I've done it now. I've really done it.

At the hotel, Liz said how much she'd enjoyed meeting me, and she hoped she could come visit our zoo someday. Sid made an inaudible sound meaning "goodbye." Jenny shook hands, looking at the sidewalk.

As I walked into the hotel's perfumed quiet, I pictured the chart again, this time with no labels at all. It made a jangling noise, like an infant's toy made of springs, the kind that is suspended over cribs. Parts of the toy move up and down like breathing. It turns slowly. The infant regards it through its unfocused eyes. It's entrancing, gleaming, and meaningless, just the sort of thing the infant needs.

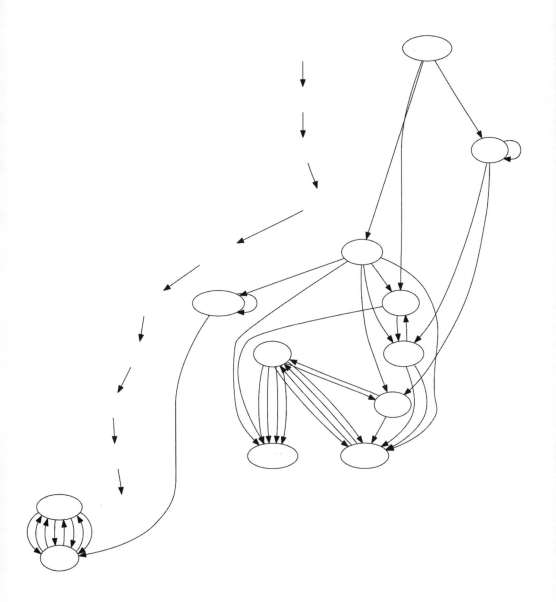

Sixth Dream

When I closed my eyes that night, the insistent images began again, returning me to the world on fire. I tried to fight the onslaught of images by thinking of zoos, of Rosie, of animals' lives, but it was hard to concentrate with so many fires.

It was as if I had taken my head in my hands and was forcibly turning myself toward something horrible. Images buffeted me, wrecking my chance to think of anything in my actual life, raining blows on my memories, washing my mind clean, pushing out the thoughts of the day, leaving me alone with my pointless dreams.

So I sat, in my dream, in a quiet mottled shade, with the smell of pine needles and dry earth in the air. Out past a range and a few farm buildings, a tremendous fire was burning.

They are all gone, I thought, imagining the farms on the other side of the ridge. If the fires keep burning, if I stay here, I will go up in flames just like them.

I came over a ridge and saw fires ahead. The road wound down past columns of smoke and into a valley, where there was a small town, also burning.

Perhaps this was a scene of war. It would be an adventure, the usual stuff of dreams and nightmares. I could drive bravely down the road and make a narrow escape through the town. But I knew that wasn't right. There was no war, no reason for the fires to be there. They were just fires, and I was the only one around. There was no one to put them out, no one even to watch them except me, even in my sleep I knew that much.

The images kept changing. Scenes of fire arrived one after another.

I sat on pebbles and scrub at the edge of a road, watching a dark fire. There were no flames in these fires. They were always at a distance: down in a valley, across a plain, over a steep ridge.

The gravel was warm to the touch and the plants were dry, scratchy. Cottonwood leaves shifted in the uncertain wind. The smoke cloud was nearly black. If the wind shifted it might choke me.

Later I was sitting in my car, looking at a valley dissolving in smoke.

Something had happened in the day that had just passed, I had seen something and lost part of myself, but the memory had been swept away. That is what dreams do, I reminded myself, they wash your memory, they clean it and give it back to you. Look, your dreams say, your clothes were never bloodied. They are fresh. They are burning, but they are fresh.

People used to think dreams were portents. But now we know better. Dreams come from your own mind, they are there to help you. You should listen to them. But what if your dreams don't mean anything? And what if they aren't your own? Well, then you aren't yourself.

These were images of a world that was ending. There were roads and a few houses, but no people. No firefighters, no helicopters bringing tanks of water. Fires burned wherever they wanted. For a long time, it seemed, maybe for years.

Somewhere in the American West, a road threaded a shadowed gully. The place looked peaceful. A low sun grazed the dry pastures. You could probably live a quiet life down there where the road ran in a pleasant shade. But why would you, when just beyond the mountain the earth was burning?

It is late afternoon, I thought, I have to go if I'm going to get home before dark, but then I realized I have no destination in these dreams, in this world. It will always be late afternoon. That fire will always be burning just over the hill.

I was thinking indistinctly, as people do in dreams.

I could still hear Jenny's voice, but I knew that in a few minutes I would forget her name. Later in the dream of the burning world, as I called it in my dream, as if it were a movie, hoping it was just a movie, later, after I'd forgotten the voice and the person, I would still feel a strange animal despair.

This is what it is like to get older: the details of the world get confused and feeble. The mood of the world becomes strong and insistent. The image of the world grows powerful, it ruins your mind.

7

A Day in the Life of a Fungus Gnat

In February and March, the days were crowded or clogged. I woke exhausted. There was no longer enough oxygen. My world was transforming into something not at all normal. A girl used a board game to calculate how to pull out her hair. A woman sat on top of a hyena cage in the middle of the winter. A boy collected other boys' souls. I used to be safe with my amoebas. Little gluey animals, tiny spots of sick. Now animals demented by despair shuffled across the stage of my imagination. They blinked and fidgeted and wouldn't scare.

I was up at 7:17 AM when the sun found a way between two misaligned slats of my venetian blinds. Owole was in the same time zone as Ontario, so the sun had probably woken her too. She might have done a hundred loops already. I imagined a satellite map of the Knoxville zoo, greens and grays, with a small bright red figure eight indicating Owole's path, four steps right, loop, four steps left. Other animals would have their own paths. A red circle for a zebra trotting around its pen. A scribble for a nervous fox. Other animals would be knots or rosettes. Owole's sister would a single red dot.

When I walked away from Owole, my route followed the zoo's paved paths, zigzagging through the parking lot to Sid's car, tracing sinuous curves on the thruway. In the Nashville airport, my red line accordioned at the ticket counter, hair-pinned down two flights of stairs, shifted a half

step left and right waiting to board. In the weeks since then my line had pretty much gone back and forth between the lab and my apartment.

Today the traveling continued. My red line had gone from Guelph along Route 401 to the Toronto airport. In a few minutes we'd take off and my red line would trace a graceful arc down to LaGuardia, and later a long smooth curve to Salt Lake. Owole's track would not change. All day long forever, a small figure eight.

<div style="text-align:center">

READINGS

FOR HOGLE ZOO IN SALT LAKE CITY UTAH, U.S.

AND BASEL ZOO IN BASEL, SWITZERLAND

COLLECTED BY VIPESH PIBULSONGGRAM

AND VIPERINE PISTOURIEC

</div>

Viperine and Vipesh. The first four letters of their names were the same, and the fifth letters only one letter apart. And the sixth letters also just one apart. Vipesh was apparently a real name, in Thailand at least. Heaven only knew where Viperine got her name.

There was a card stapled to one corner.

"Dear Dr. Emmer, here is your packet of READINGS for your trip to Hogle Zoo in Salt Lake City. Also the Basel zoo. Really it is not the Basel Zoo, it is actually the Zoo Basel. Also I am sad this is your last packet for this season. I must admit these are not my own research, but also Viperine Pistouriec has helped me very much. We are proud and happy to present parts ONE, TWO, and THREE. The last part is FOUR. It is very personal. Please open it at home if possible. Please I hope you will like these, each one is our new research! We look forward and greatly anticipate your report. Happy travels, interesting finds, signed, your intern, Vipesh Pibulsonggram, พิบูลสงคราม, and also Viperine Pistouriec."

Inside the envelope was a set of papers with statistics about the animals in the two zoos. I put them aside. Underneath were three blue folders and one red folder, each sealed fastidiously along three edges with miniature metal clips, as if the folders were recovering from surgery. I pulled the

clips off the first folder and scattered them on the floor under my seat. The cover page read:

PART ONE

SOME ANIMALS FOLLOW STEREOTYPICAL PATHS EVEN IN THE WILD;

OR,

THERE IS NO SUCH THING AS FREEDOM, DOCTOR EMMER

The first paper was about storm petrels. The author, Inke Sniodóttir, said it was difficult to study Wilson's storm petrels, *Oceanites oceanicus,* because they spend most of their lives flying over the open ocean. They nest on remote islands in the Antarctic. "Even if a researcher determines the site of a nest, typically high on an inaccessible cliff on a sub-Antarctic island," Sniodóttir wrote, "it can be close to impossible to sight the birds. They come in from the sea after dark and leave before dawn in order to avoid predation by gulls and other large sea birds. If there is a full moon, they may not come in to their nests at all.

"Wilson's storm petrel nests are vacant most of the year. The birds spend up to 98% of their lives flying over the ocean, without ever landing on the water. Young *Oceanites oceanicus* leave home for a 'year of wandering,' which may take them as far north as the Aleutian Islands, Iceland, Spitsbergen, and Greenland. During that year, they never touch land and they never rest on the water. They 'sleep' while flying, with a reduced heart rate and with their eyes closed."

Their dreams must be wonderful, I thought. Nothing but water below, through the darkness over the waves.

"The 'year of wandering' was named in the nineteenth century, because no one knew where the petrels went. It was thought the young storm petrels went wandering in the manner of Romantic male heroes in old poems and stories, who set out on great adventures before they settled, married, and raised children.

"The petrels' so-called 'year of wandering' remains a mystery to science. Tagged juvenile Wilson's storm petrels have been tracked in both the Atlantic and the Pacific, and they have no fixed paths. The individual

recapture radius may be greater than five thousand miles. 'Wandering' is presumed to be an adaptation to open-ocean life, because it permits individuals to seek out nutrient-rich waters."

Year of Dreaming, I thought, year without speaking or making a sound. Year without seeing anyone you know, except perhaps as a distant speck in a cloud. Or your own reflection, on very still days, in the silvery water beneath you.

But the year of freedom ends, Sniodóttir wrote, because as soon as they are mature, Wilson's storm petrels breed every year. They spend two months in their nests in the Antarctic, tending their young, and then they migrate north to feeding grounds in the Arctic. Using GPS tags, Sniodóttir's team discovered that adult storm petrels trace out enormous figure eights: one loop in the North Atlantic and another in the South Atlantic, or one loop in the South Pacific and a second north of Hawaii. Each year, the adult Wilson's storm petrels fly the same enormous figure eights over the ocean. "It is not clear," Sniodóttir wrote, "why the birds follow these routes, when they have capacity to find their own. The 'year of wandering' demonstrates that the storm petrel can fly anywhere over open oceans, which comprise seventy percent of the Earth's surface. After their 'year of wandering,' they have the navigational ability and instinctual memory that would enable them to find nourishment more efficiently. There are many reasons why it might be advantageous to diverge from the figure eight path: trade winds vary from year to year; there are often storms that should be avoided; and the small fish and plankton on which the birds feed may be more dense in some other part of the ocean. Yet tagged birds do not depart from their paths even when food densities become low.

"There is no senescence in Wilson's storm petrels. Tagged mature individuals followed the same figure eight paths for six to eight years, until signals were lost, in each case over open water. The birds presumably died while flying and dropped into the sea."

Maybe while they were dreaming, I thought. From a dream of flying into another kind of dream. I imagined myself as a petrel, flying over unending oceans. My year of wandering is over, and I need to keep to my

figure eight paths, so enormous that I can't even sense the slow turn I am executing, always to the left, slightly left, but seemingly straight for days. I dream, life turns into a dream, always water below, sometimes inviting me to dip down, always sky above, sometimes full of rain. I don't even need to open my eyes because I can hear the water beneath me. After a year, I do not even know if I am asleep or awake. And what is a dream, anyway, if you are flying? And are you moving if nothing around you changes? Or are you immobile, suspended between two shades of blue? Immobile, like a tiny bubble of air trapped forever inside a pane of glass, moving infinitely slowly toward the surface? Immobile, like one of those spacecraft that have left the solar system, flying motionless in the silence?

There was a loose page after Sniodóttir's paper.

"Note, by Viperine Pistouriec: storm petrels often host infestations of a parasitic philopterid louse named *Halipeurus*. The name means 'pervert of the oceans.' The lice attach to the storm petrel's scalp and gather around its eyes and bill. They ingest minute amounts of nutrients from the storm petrel's bill and eyes, but they do not reproduce until the storm petrels return to their nests to feed their own young. They then feed on the nutrient-rich gastric juices that the mature storm petrels regurgitate into the mouths of their young, an event that only happens during the brief breeding season. They mate and lay eggs that fall onto the storm petrel chicks. *Halipeurus* are probably among the most widely traveled parasites in the world."

Viperine knew me very well. The parasites were even more attractive than the birds. They did not have to fly. They just enjoyed the view and the predigested dinners. I imagined myself as a parasitic louse. I'd attach myself right next to the petrel's eye, so I could see the view it saw. I'd know when the petrel's eye rotated down, when it spotted some plankton-rich water, and I'd watch as we plummeted down and the ice-cold arctic water washed over us. I'd glimpse the little white shrimp as they funneled into the petrel's beak. Then we'd rise again, effortlessly, slipping up into the air. I'd get hungry, gradually, over the months, and then one day the petrel would fly back to its nest and stuff its head into the gullet of its chick. Hot

gastric juices and marinated seafood would wash over me, and I'd drink them in. I would have a very small brain, so I wouldn't really sense the beauty of the endless oceans or the poetry of wandering. I'd just cling and wait. A simple life. No responsibilities, no choices.

I imagined Vipesh and Viperine sitting in the airline seats behind me, whispering to each other.

— Veeps, look, he's reading everything.

— He doesn't need to know these things. They are upsetting him.

— He loves it, Veeps, trust me.

Next was a paper on deer in a forest preserve, illustrated with a photograph of snowy woods.

The author, someone named E. E. Ruud, had studied the paths of fallow deer in Sweden. He wrote a report in the *Helsinki Academy of Sciences Journal* in 1953, describing the tracks followed by deer in a one-hundred-hectare game preserve. Deer create paths for several reasons, he wrote. It is to be expected that they will follow habitual paths between their bedding areas and their foraging areas. It is also to be expected that when the

land is steep or rocky, certain paths are optimal, and the deer will follow them whenever possible. It is further to be expected that the deer will prefer thickets and brush land to open country, because they wish to conceal themselves from predators. However, it is unexpected that they rarely stray from this network of paths even though the game preserve has many thickly forested areas, and many areas with edible plants. In fact it is likely that certain individual fallow deer follow the same paths their entire lives, never straying more than ten meters from their habitual paths. Perhaps, Ruud speculated, deer are animals of simple instincts, and their brains cannot process more than a couple of possible paths at a time.

"In Figure 1," Ruud wrote, "the path to the left leads to a stream that remains open most of the winter. The path to the right leads to a field where the deer graze. There are many alternative routes through this portion of the game preserve, but the deer follow these paths in all seasons. They diverge only when they are threatened. In the background of Figure 1 the hindquarters of a single deer may be seen. It spotted the photographer and stepped to the side of its path to hide. After the photographer retreated, it returned to its path."

I could understand that. When I first came to Guelph, I tried different ways of walking to work. Cather to Lorck, Adams to Pearson to Cather to Lorck, even Paxton to Pearson to Cather to Lorck. A good way to waste time on the way to work was Edel to the university to Lorck. An even better way was down Marimba and all the way to Anthony Avenue, with a stop at the Yellow Hat, and then to Cather to Lorck. In the end almost every day for years it was Cather to Lorck, for no reason I could explain. I could never think especially clearly about paths.

The following paper was "Ecology and Social Behavior of the White-Nosed Coatimundi, *Nasua narica,* on the Barro Colorado Island in Panama." The author, George Winardy, did fieldwork in Panama in 1960, and published two years later in the *University of California Publications in Zoölogy.* He had spent what must have been a sweltering summer in the Panamanian rainforest, following coatimundis through the jungle.

He called the group he followed Troupe B, to distinguish it from three other groups on the island, which he named A, C, and D. Troupe B followed a series of "long leisurely loops" through the dense undergrowth. Sometimes they would repeat a loop several times a week, when certain fruit trees were in season. Other loops were not repeated until months later. But taken all together, it was clear that the individuals in Troupe B did not wander at random, but along a web of paths "invisible to people, but marked by scent and memory."

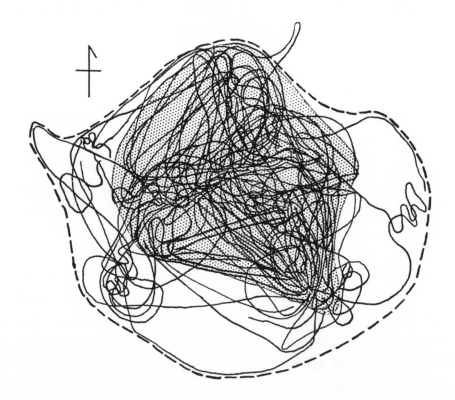

Most of Troupe B's "home range" was contained in a central area, which Winardy shaded with one of those stencils draftsmen used to use before computers. He indicated the sum total of Troupe B's territory with an interrupted line.

"Therefore, even apparently free-ranging, non-territorial animals such as the white-nosed coatimundi may choose to move along predetermined routes. Troupe B was not threatened even by its nearest neighbor, Troupe

A, and therefore they were free to expand to other areas of the island, but they chose not to do so."

To human eyes, Winardy wrote, the area looked like a trackless rainforest, but in effect it was signposted and paved, at least in the coatimundi's minds. He named Troupe B's main paths Lutz, Wheeler 1, Wheeler 2, Wheeler 7, Donato, Snyder-Molino, and Barbour-Lathrop.

"On one remarkable occasion," he wrote, "this pattern of ease and comfort was broken. On the morning of July 23, 1960, members of Troupe B turned off of Wheeler 1 and onto Snyder-Molino. They were feeding along Snyder-Molino, traveling spread out and at a normal pace, near the extreme northern boundary of their range. Several began moving north off the trail. The others followed, and soon the whole band was beyond the limit of their home range. This is indicated by the 'tail' at the top of the diagram, which projects about 50 meters beyond the troupe territory. After several minutes they stopped feeding in the leaf litter. They seemed confused and panicky. They bunched into a tight group and dashed back to the Snyder-Molino trail. They then ran back and forth along the trail, tails erect. Finally, they turned back the way they had come, joined Wheeler 1 and reëntered the heart of their territory."

Winardy said he then scouted the region to the north, but Troupe A was not present. The area was free of rivals and predators.

"After that incident, several individuals remained jumpy, running back and forth in an uneasy manner. The best way to understand what had happened is to say that at that moment, the animals were lost. They had left the area they knew, and they had lost their accustomed trails. To an observer there was no difference between the trails and the forest beyond. The rainforest floor was undisturbed in all cases. But to the members of Troupe B which were present that morning, a few meters too far beyond the accustomed territory produced marked anxiety. It appears that even wild animals can sometimes prefer daily paths and repetitive itineraries."

People's paths aren't so different from animals' paths, I thought. We're all attached to our habits. And every creature's path has two endpoints.

Mine began in the old wing of the Schuyler County Hospital. Over the next fifteen years, my red line snaked its way around the house, the pond, the surrounding woods, and the neighborhood, all friendly places for a little boy, happy loops from home to adventure and back, and then one day when I was seventeen my red line leapt away, down Route 79 to New York. Those were my years of wandering. In 1999 my line stopped in Guelph. Since then my routes have been stereotypical. Loops, just like in Monika and Wolfram's diagrams.

The end point of my path may be a hospital bed. Probably in the Guelph General Hospital. The way these things go, I'll tell myself I'm just checking in for a day or two, that I'll be up and around in no time. But then as the days in the hospital wear on, and the trips to the toilet get more difficult, and the drugs wash over me and make me weaker, and I'm only poorly aware of the nurses shifting me in the bed, only vaguely irritated when a fresh catheter goes in, at some point I'll realize that I will not be leaving the hospital, I will not see my apartment again, the book I brought with me will lie there on the side table until Adela or an orderly comes and clears it away. One morning I'll ring for the nurse, and when she helps me to my feet, I'll know this trip to the toilet will be my last, and the boost she is about to give me to get back into bed will be the last short segment of the red line.

I heard Vipesh's gentle voice whispering at my ear, and over Vipesh's shoulder, Viperine's even gentler voice, whispering into Vipesh's ear, encouraging him to provoke his dear teacher.

— Tell Doctor Emmer he is a coward.

— Vipes, please.

— Tell him.

— Dr. Emmer, please accept our helpful suggestions.

— Tell him he is a prisoner of his timid habits.

— Vipes, no. Doctor Emmer, you are safe. We are looking after you.

There were two more papers in the folder. First was a long essay in French, on the paths of lemurs through the cloud forest in Madagascar. The title was "Sur la structure non Euclidienne de l'espace phénoménal

(expériences sur le lémur *Mongoz* mongoz L. (*Mongozmaki*)),” published by the psychology laboratory of the University of Greifswald in 1934. In it the author, Tomasz von Ackwieno, speculated that some lemurs do not perceive the world the way humans and other mammals do, but rather they see bending lines where we see straight lines, and vice versa. Pages of geometric diagrams purported to show the anomalies in lemur vision.

"A typical mammalian matrix of vision can be represented as an 'eye hemisphere' that correlates both eyes' input," the author wrote.

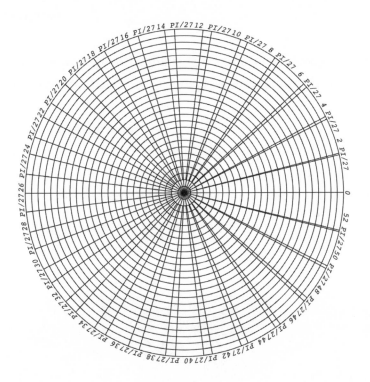

"Through a lemur's eyes, the same coordinate system could be subject to local non-Euclidean anomalies. Our experiment yielded the following spatial map for individual *Éibhear*:"

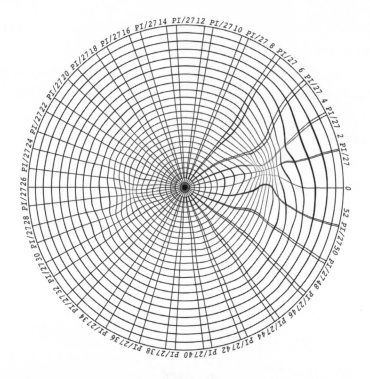

"And the following for individual Ciarán:"

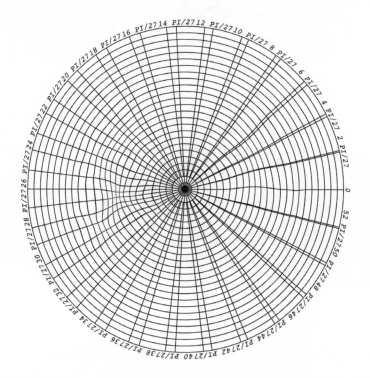

"The possibility of a fully non-Euclidean spatial phenomenology for certain subspecies is quite likely."

Seeing through those lemur's eyes, the author said, "means imagining an entirely new world, where distances work differently. Straight paths curve, curving paths run straight. It is difficult to understand how animals that perceive non-Euclidean space move through the world.

"Our research indicates slight anomalies may be the norm, producing even more complex effects, where local regions of perception are guided by the normative Euclidean grid, while others are influenced by the imposition of a decidedly non-classical non-Euclidean phenomenal percept, as suggested in the following examples from visual field tests performed on two individuals (Iarfhlaith, Éibhear). These grids are the standard visual field test pattern given to humans and primates. A Euclidean subject, such as a human, will perceive an undistorted grid. In this test Iarfhlaith has a distinct non-Euclidean anomaly in the lower center of its visual field, and *Éibhear* has an anomaly that runs from its upper-left quadrant down toward the center.

246

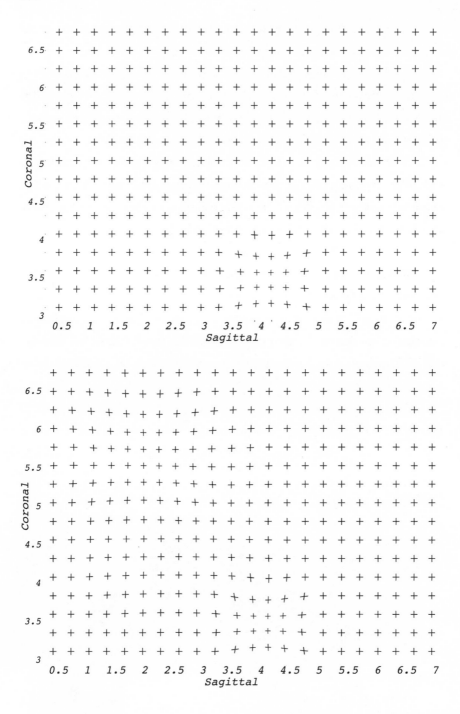

"These results show that not all higher animals perceive the world according to the supposedly universal laws of Euclidean geometry. At

least some species of lemurs perceive a world in which parallel lines do not remain parallel. These results have far-reaching implications for animal psychology and the philosophy of perception from von Helmholtz to Husserl. I leave those determinations to future researchers.

"This paper would not have been possible without the generous assistance of several people. I thank Dr. Arno Schmidt of the Bargfeld Leviathan Project, and Dr. J. A. Barend de Hühl for his generous assistance at the Berlin zoo. His support of innovative research has enabled me to prepare a German translation of my work, 'Zur nichteuklidischen Struktur des phänomenalen Raumes (Versuche an Lemur *Mongoz* mongoz L. (*Mongozmaki*)),' which will appear in the *Zeitschrift für Tierpsychologie*. I also thank laur. doct. cand. Wolfram Pichler for the diagrams."

Viperine had appended a note.

"Doctor Emmer, I hope you won't mind if I add a poetic note to this very serious and mathematically inclined paper. This may be the most romantic scientific essay I have ever read. The author demonstrates, unequivocally, that certain species of lemur—perhaps not all lemurs, and possibly only the critically endangered Mongoose Lemur and the rare mountain Indri lemurs, including the endangered sifakas—do not perceive the world as we do, as a place where the lines of a city street converge on the horizon like train tracks in the distance, coming together obediently according to the dull rules first set down by Euclid so many generations ago. Instead, they perceive parallel lines as snakes that intertwine. For them railroad tracks are braided paths. Or to put it poetically: the life paths of two people who care for each other, walking together through the years, side by side, would not merge at the end of life in the inevitable vanishing point. Instead, they would interlace, sometimes drawing nearer, sometimes farther, and even occasionally crossing. At least that is the author's conclusion, because he thinks lemurs see according to elliptical non-Euclidean geometry, where there are no parallel lines and all lines in a plane intersect. But his calculations actually point in another direction: these lemurs may perceive the world in *Gaussian hyperbolic non-Euclidean geometry*, in which parallel lines actually diverge. At infinity, which is to say at the end

of life, parallel lines will separate. There is no vanishing point: the point itself has vanished! All this may seem romantic enough, but there is something in this paper that is even more touching. The fact is that the lemurs have no chance to experience straight lines. They live in jungles, where the only straight lines are the paths of raindrops falling to the forest floor. They can never perceive non-Euclidean geometries, neither the Riemannian elliptical non-Euclidean geometries that the author describes nor the more accurate Gaussian hyperbolic non-Euclidean geometries. The author proves that the lemurs could perceive such geometries, but where they live, they have no chance to do so. They have built into their brains an exquisitely patterned geometry, a way of perceiving life, love, time, and distance, but they can never see it. It does not exist for them in this world. The paper is an unwitting poetics of Gaussian hyperbolic non-Euclidean perspective in species that do not know what they are not experiencing and may soon be extinct. I find that especially beautiful."

The other was a two-page essay by someone named Garreau de Loubresse, called "Seeking Behavior in *Paramaecium putrinum*." It was from an old issue of *Protistologica,* from 1956, recording the proceedings of a conference in Nantes. I didn't recognize the author's name or the place he had worked, the Laboratoire de Protozoologie et Parasitologie Comparée (LPPC), 61 rue Buffon, Nantes. It seemed unlikely that Vipesh or Viperine had found a source in my own field, written by someone I didn't know, and even less likely that I needed to read it for a zoo visit.

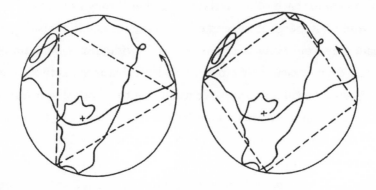

My eye was drawn to two diagrams on the second page. At first they looked like globes with the continents sketched in. Loubresse explained they were diagrams of a water-filled petri dish, showing how a paramecium had swum around looking for food. The two squiggly paths were almost, but not quite, identical. Apparently Loubresse had drawn them by hand.

"Does the paramaecium swim randomly in the absence of chemical gradients?" he asked. "Our findings indicate this is not true. The apparent random route of the *Paramaecium putrinum* can be correlated with two simple geometric patterns. With 70 percent confidence the Paramaecium follows coordinates of an imposed equiangular triangle. With 84 percent confidence the paramaecium follows the coordinates of an imposed square. We conclude that the paramaecium does not wander 'randomly' (Smith 1942; Emerson 1901) but in fact 'orients' (Ferber 1958) by reference to geometric forms. We propose that paramaecia may have the ability to orient by reference to skylight, the sun, stars, or magnetic fields, as proposed in the cases of birds, fish, and dung beetles (Corliss 1962; Bannister 1962; Augustin, Foissner, and Aufderheide 1960). This is possible given the organism's sensitivity to light (its eyespot) and its ability to align with static magnetic fields (Guebenkian, Qiáo, Sósia, and Camões, 2006)."

I slapped the folder shut. I didn't need to be persuaded that protozoa have complex lives, but I doubted they are governed by simple geometry, and besides, it was annoying to be instructed by Vipesh, or even Viperine.

— See? It was too much.

— Everything is going just fine, Veeps. Sit back, relax.

— But I think we should just follow Professor Sounder's instructions and give him readings on zoo animals only.

— Just wait, Veeps darling. Everything will make sense soon.

— You're very smart, Vipes, you know that?

— And you're very cute.

The next folder was titled:

PART TWO

SOME PATHS ARE DETERMINED BY NUMBERS;

OR

YOU DO NOT KNOW WHERE YOU ARE GOING DOCTOR EMMER

This folder opened with a paper by four Swiss scientists, Fina Wölfli, Ivka Rütti, Ueli Büchi, and Gioele Peyer, titled "Animals Do the Random Lévy Walk." That sounded like a dance, but according to the abstract, "random walk" is a mathematical theory developed to understand why microscopic particles in water don't sit still but ricochet from one place to another.

"This is the path of a typical classical composite Brownian walk," they wrote. "It may be a piece of alga, a bacterium, or a fragment of inorganic material, from ≈10 microns to the Planck scale. It moves randomly in response to collisions with invisible obstacles such as high-momentum molecules or ions. The Lévy walk is a variant of the Brownian walk, with different mathematical parameters. In a Lévy walk the particle speeds along in a straight line, and then becomes trapped in a tangle of short trajectories. After a while it extricates itself from the knot and flies off in another direction:

"Subatomic particles do not follow Lévy walks, but molecules do, and so do certain animals, including bears. One of us (Büchi) observed a brown bear on flat tundra outside Dikson on the Kara Sea in Siberia. It was in search of berries. It ambled in a straight line until it discovered a berry bush, and then it stopped to browse. While it was browsing it made many small steps. When the bear left the berry bushes it moved away in a straight line in an apparently random direction. This is because it did not know where the next berry bush might be. During the period of observation it deviated from straight lines only because of unevenness in the land.

"The bear's walk can be modeled by the random Lévy walk. Indeed, once a regional attractor comes within range, a Lévy walker produces a tortuous path. The duration of his area-concentrated squared-net displacement search mode is a function of the local patch richness. Where there is no unevenness in patch richness, the Lévy walk approaches classical Brownian motion, widely observed in microscopic particles, macroscopic particles, and even protozoa. The brown bear instinctively conformed to the Lévy walk. We interpret its behavior as a strategy for optimal searching in an unpredictable nutrient-poor environment. The bear did not need to 'worry,' 'think,' 'remember,' 'decide,' or 'calculate.' When it finished feeding it simply let itself be directed by an unknown mechanism that set it in an apparently random direction, generating a facsimile of a Lévy walk."

Several pages of calculations followed, showing how to model the knots and the length of the straight-line paths.

"An Elementary Introduction to Lévy Flights" was by Vuk Yaroslavtsev, Department of Theoretical Physics, KSPI, Akademicheskaya 1, 60661 Minsk, Belarus. "Lévy flights or walks," he wrote, "are Markovian stochastic

processes whose individual jumps have lengths that are distributed with the probability density function $\lambda(x)$ decaying at large x as $\lambda(x) = |x|^{-1-\alpha}$ with $0 < \alpha < 2$. Due to the divergence of their variance, $\langle x^2(t) \rangle \longrightarrow \infty$, extremely long jumps may occur. In addition Lévy flights are fractal, so typical trajectories are self-similar, on all scales showing clusters of shorter jumps interspersed by long excursions. In fact, the trajectory of a Lévy flight has fractal dimension $d_f = \alpha$.

"These flights have been used to model the motion of molecules, financial markets, contaminants in underground water, amorphous solids, polymeric systems, and turbulent media including liquids and plasmas.

"In this study, I apply Lévy flight models to the motions of ornate spider monkeys that were observed in treetops in Costa Rica (A. Cuarón, 2004). The dataset yielded a time series of 19 separate foraging trips, and a total of 363 excursions. The resulting log-log histogram of trip durations yields a straight line with slope 2, suggesting that the Ornate Spider Monkeys were performing Lévy flights, where the probability density function of trip durations t (in minutes) was $f(t) \sim t^{-2}$ for $t \geq 1$ minute. The data was consistent with the Lévy flight definition, viz., the tail of the probability density function is a power law of the form $t^{-\psi}$, where $1 \leq \psi \leq 3$. On further analysis, anomalous diffusion models where $\langle x^2(t) \rangle \propto t^u$, where $u \approx 1.93$, closely matched the foraging movements of the Ornate Spider Monkeys. This is a typical modeling exercise and could be applied to many datasets of animal movements, suggesting that Lévy flight models describe minimal energy expenditure behavior in living systems."

The next paper was by someone named Simon Benhamou, who worked with something called the Behavioral Ecology Group at the Centre d'Ecologie Fonctionnelle et Evolutive in Geneva. It was called "How Many Animals Really Do the Lévy Walk?"

"Following provocative suggestions by Wölfli, Rütti, Büchi, Peyer, Murko, Viswanathan, Buldyrev, Gomes da Luz, Havlin, Raposo, Stanley, Koehn, Pritsinas, and Yaroslavtsev, we investigate if animals follow random Lévy walks. The argument is as follows. The Lévy flight or walk is a random path similar to the Brownian motion observed in small particles

suspended in fluids. In Lévy flight the distribution of path lengths is heavy tailed, so that the particle tends to make jumps of greater length and then 'linger' in specific places. A heavy power law tail causes clusters of short steps to be connected by rare long steps.

"It has been claimed that a Lévy flight with constant velocity is optimal for an animal that needs to search for sparsely and randomly distributed target nutrients. The Lévy flight has been proposed as a model for the flight of wandering albatrosses as they search for food across the ocean surface, reindeer seeking tufts of grass in snowy landscapes, Siberian bears walking in tundra, bumblebees searching for flowers in mixed woodland, microzooplankton searching for bacteria in freshwater, gray seals searching volumes of ocean water for krill, and ornate spider monkeys jumping from tree to tree looking for fruit. In this paper I prove these results are incorrect.

"I present an optimal algorithm for the unbiased modeling of real-world data. As an example, I use an unpublished dataset of bat flights. Free-tailed bats in the Gunung Mulu National Park in Sarawak, Malaysia, were fitted with GPS transmitters. Echolocation sounds were recorded for an area of 0.5 km^2. The data was then idealized, and the bats were modeled as micro-bats (without spatial extension). The result was a bat-inspired algorithm, which yielded an optimized meta-heuristic search model. Because the bats navigate freely through three-dimensional space, their paths are modeled using phase space trajectories in six dimensions ($x, y, z,$ and χ, ψ, ω for the momentum vectors). For the purposes of this introduction my idealization of the echolocation of micro-bats can be summarized using a toy model as follows: Each virtual bat flies randomly with velocity v_i at position (solution) x_i, with varying frequency, strength, and pulse of echolocation signal A_i. As the bat searches for its prey, it changes frequency, loudness, and pulse rate. The bat continues to select the best parameters until certain stop criteria are met. The basic idea behind the toy model micro-bat algorithm is that a population of n (micro)bats of dimension d use echolocation to sense distance and fly randomly through a search space while updating their velocities v_i and positions x_i. Each solution

$$x_i = (x_i, \dots, x_d)^T \tag{1}$$

is evaluated by a fitness function $f(x_i)$, where $i = 1, \dots, n$. The loudness usually decreases once a bat has found its prey, and the frequency and rate of pulse emission increases in order to raise the attack accuracy. The new solutions for x_i^t and v_i^t at time step t are given by

$$f_i = f_{min} + (f_{max} - f_{min}) \cdot \beta \tag{2}$$

$$v_i^t = v_i^{t-1} + (x_i^t - x_0) \cdot f_i \tag{3}$$

and

$$x_i^t = v_i^{t-1} + v_i^t \tag{4}$$

where $\beta \in [0,1]$ (1) is a random vector drawn from a uniform distribution."

Pages of equations followed.

I skipped to the end.

"It is certainly true that Lévy flight patterns 'look like' the actual search patterns displayed by animals foraging in a patchy environment, but that is because the measurements of the animal paths are quantized using stochastic models that are homologous to the equations of the Lévy flight itself. This is shown here by blind modeling both the meta-heuristic search model based on the micro-bat data, and also the Lévy flight equations themselves, which reveals that the two conform to different meta-models. It turns out that free-tail bat flights are gamma distributed, with an exponential decay for the longest flights. A re-analysis of the data on bumblebees, reindeer, ornate spider monkeys, brown bears, gray seals, and albatrosses (the microzooplankton data was unavailable) finds that none are optimally modeled as Lévy flights. Bumblebees conform to the principle of least action, and their flights yield Hamiltonian equations of motion. Given this result, we should consider Lévy flights as contributions to pure mathematics, and we should consign theories that animals in the wild conform to stochastic processes with heavy-tailed distributions to the realm of unsupported fantasy."

— Oh, Vipes, this is too much for him to take in.

— He will understand enough.

— It makes my head go for a swim. He's going to get annoyed at us. He's going to fire me. I'm not going to get a letter of recommendation. I'm not going to get a job. We have to stop.

— Veeps, you are especially cute when you get worked up. This is science. We are simply being accurate.

— It's true, we are scientists. I mean, we want to be scientists, right?

Viperine had appended a note.

"Doctor Emmer, you may recall from our conversations last year that the bats in the Gunung Mulu National Park in Malaysia include the species *Cheiromeles torquatus,* the Sulawesi hairless bat, often called the 'naked bat' because it has almost no hair. Also, that naked bats are parasitized by a kind of giant earwig, *Arixenia esau,* which is in turn parasitized by a species of *Entamoeba* named *nyctumia,* which is in turn parasitized by giant viruses, *Mimivirus,* which can be half the size of the amoebas they are inside. Together they form a symphony of parasitism, a chorus of species inside one another. This is extremely beautiful, and I hope you think so too. The English team from Sussex have invited me to join them, and my mother will go with me this summer. I want to make this the subject of my doctoral research at the University of Guelph. It is hard for me to imagine anything more romantic, traveling to enormous caves to study parasites."

At the bottom of the page Vipesh had added "Doctor Emmer, I want to inform you that Viperine is very enthusiastic about this cave. Today Viperine sang a song all day. This is the song.

> There's a fleck on the speck on the tail on the frog on the bump on
> the branch on the log in the hole in the bottom of the cave.

Viperine sang also this song for one day:

> There's a germ on the flea on the hair on the wart on the frog on
> the bump on the log in the hole in the bottom of the cave.

Once I also heard Viperine sing this song all day:

> There's a bit on the bleb on the bubble on the bug on the cyst in
> the pimple on the scab on the sore on the tail on the whale in the
> hole in the bottom of the cave.

Science is serious but also you can sometimes sing with it. We hope you do not mind these unusual readings, perhaps they are music in your ears. PS, in fact these songs are annoying but I do not mind when my colleague Viperine sings because the breath of Viperine is very quiet."

The next paper was a joint effort by a Romanian mathematician named Sorine Puiu and a Swiss biologist named Eberhard Zweihoff. It was a lengthy overview, "Random Walk Models in Biology," published in *The Ceaușescu International Journal of the Mathematical Biology (Bucharest)*. The first illustration was a grainy photo of a lawn, with a snaking path.

"Fig. 1 depicts the path of a Phorid fly, probably *Megaselia*. This fly is commonly known as 'humpback fly' or 'coffin fly' because it burrows up to six feet underground in search of decaying meat. The fly is also known as 'scuttle fly' because it alights and runs quickly before flying again. Here, a specimen is searching for mushrooms. Phorid flies are common pests of commercial mushrooms. They lay their eggs in mushroom caps, and the larvae tunnel through the mushrooms. In this photograph, there is a loose scattering of mushrooms of the species *Hypholoma incertum*, the Uncertain Hypholoma. The Phorid fly moved quickly through the group, stopping momentarily to lay its eggs on several mushrooms.

"Using a Beaulieu R16 film camera fitted with a 25mm macro tube, running at 4 fps, we capture the movement of small fast-moving animals. We

printed an enlargement of the field of view 40cm wide, and mounted it on a wall. Using a Lafayette analytical 16mm film projector, we manually ran our film one frame at a time and marked the position of the fly using small dots of China white ink. We then connected the dots to approximate the movements of the fly. The result is a Cumulated Film Photograph (CFP), showing the position of the animal in increments of 1/4 s.

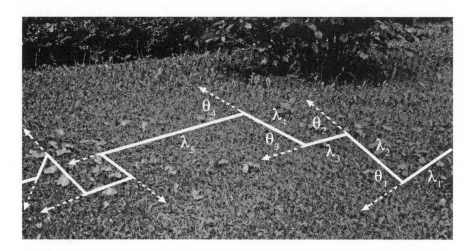

"In Fig. 2, the track of the Phorid fly is analyzed by reducing the traces to a vector map. In this way it becomes apparent that the fly follows a series of line segments approximately orthogonal to one another. The fly proceeds in one direction for an average distance of λ. It turns at angles Θ_n, which average 90 degrees ± 10 degrees.

"It has been claimed that animal search patterns approximate to mathematical models known as 'random walks.' In this paper, we demonstrate the paths of some 'randomly' searching animals are actually determined by simple rules and mechanically constrained by the environment."

There was a loose page paperclipped to the printout. "Note, by Viperine Pistouriec. Doctor Emmer, I am sure you know that adult fruit flies do not eat fruit, just as the adult *Megaselia rufipes,* the coffin fly, does not eat meat or mushrooms. Phorid flies are attracted to decay, and they feed on the fungus and bacteria that have already begun the decomposition process. The coffin fly in this article was depositing its eggs on the *Hy-*

pholoma mushroom, so that its larvae could begin eating the *Hypholoma*. You may not know that the adult also seeks out *Hypholoma* and other mushrooms that are already infected by coffin fly larvae, because when the larvae feed, they open wounds in the caps of the mushrooms, and those wounds collect water, and attract other species of fungus and bacteria that feed on the mushrooms. When the adult phorid fly discovers a pocket in the cap of a mushroom that is filled with coffin fly larvae, swimming in a slime of their own excrement, mixed with bacteria and other fungi that are also digesting the *Hypholoma* mushroom, then the adult can feed. It ingests the contents of the wounds, 'cleaning' the wounds for the larvae to continue feeding. The Phorid larvae are technically parasitoids, that is, they kill their hosts, but it is not widely appreciated that the adults 'care for' their young by cleaning out the byproducts of their digestion, and that the young 'care for' their parents by producing bacterial slime. This is another example of coprophilia, the natural production and consumption of excrement, and it is also a curious example of 'caring' between larvae and adults."

The article continued: "In Fig. 3, a small black ant, possibly *Monomorium minimum,* is running quickly in ground cover. The image capture at 8 fps produces a track of white dots. The ant may be searching for aphid frass (feces), which is high in sugar and nutritious to ants. During the observation period the ant did not appear to find any aphids or aphid frass. It performed a partial survey of several plants, visiting less than 50% of the leaves on its route. This path is not random because it exhibits a high degree of correlation with elements in the environment. In addition, the path is not random because the ant performs identifiable search strategies: walking around the edges of leaves, taking right turns whenever possible, spiraling up and down stems, and moving along the veins of leaves.

"Fig. 3a is a close-up detail. It shows the ant's path on a single flower. The ant crawls up the stem until it encounters the ring of sepals. It then proceeds systematically around the edge of each sepal in a clockwise direction, avoiding the blade and the rib. When it has surveyed every sepal (some not captured by our camera) it proceeds to the corolla (its path there could not be analyzed by our camera), and then down the stem (not

shown here). Its behavior is apparently wholly non-random, because it is determined by simple rules, including (a) turn right whenever possible, (b) remain on edges of sepals and petals, and (c) do not repeat any paths.

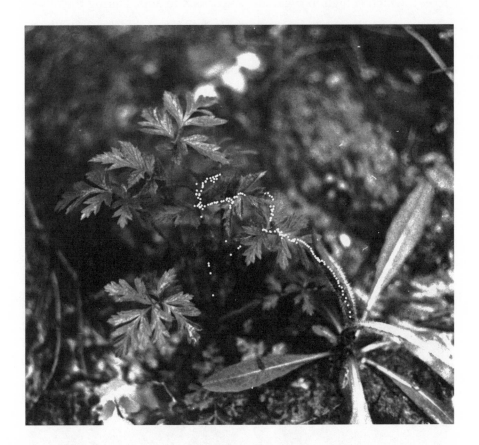

"Fig. 4 shows the path of a thrip, also known as 'corn louse' or 'storm fly,' possibly *Thripinae*. It was discovered isolated from other thrips, crawling on its own on the ground. It may have been dislodged from its leaf by wind or by an animal. Here it is searching for its proper food plant. This search is apparently random, but it is presumably constrained by chemotactic signals. The thrip began by climbing the rib of a small plant, possibly a caper spurge. The chemicals of the caper spurge signaled to the thrip that it was inedible. The next plant was an Apiaceid, possibly a parsley. The chemicals of the Apiaceid signaled the thrip that it might be edible,

because the thrip altered its search pattern. It may be assumed that in the absence of the correct chemical signal, the 'corn louse' or 'storm fly' has no chemotactic response except continual motion. According to Ananthakrishnan and Gopichandran's *Chemical Ecology of Thrips*, it is likely that this thrip could not feed on either plant. According to Kibby and Mound's *Thysanoptera (Thrips): An Identification Guide*, this thrip probably had a lifetime of approximately two days, and so it probably starved before it found its natural food plant.

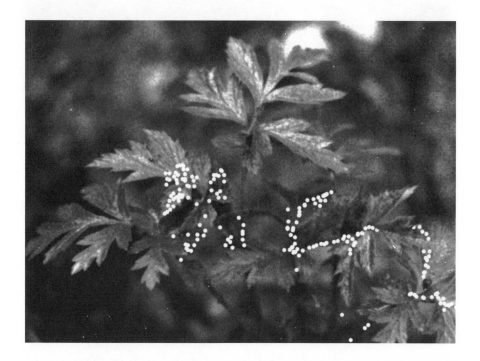

"Fig. 4a shows the continuation of the 'storm fly's' journey. It slowed on the upper leaves of the Apiaceid, possibly from exhaustion. We conclude that the 'storm fly's' path across the Apiaceid was not random, but was a strategy for accumulating chemotactic signals, but that they caused it to expend so much energy that it slowed and finally stopped (not visible in here). It may have died soon after we stopped observing.

"Fig. 5 records the flight of a small gall midge or 'gall gnat,' *Cecidomyiidae*, over the forest floor. Here the 'gall gnat' is searching for an appropriate plant into which it can inject its egg, which will then produce a plant gall. The 'gall gnat' entered the frame from the right. Its flight pattern was approximately linear, possibly following the shadow of the railroad tie that occupies the top right portion of the frame.

"In the middle of the frame, the 'gall gnat' encountered a small spider web, several strands of which are just visible below the arrow. It successfully navigated around the edge of the web, apparently by lightly touching it with its wings. It then initiated a more erratic flight pattern, flying rapidly and in a 'panicked' fashion, possibly to escape from the perceived threat. Its pattern in this region may conform to a Lévy walk, although the data points are too confused to analyze.

"Fig. 5a is a detail of the initial flight of the 'gall gnat.' This is known as a 'barrier condition' walk, because a barrier, in this case the edge of the shadow of the railroad tie, served to keep the path linear. It is possible a vector analysis of this track could determine its parameters, as in the case of the Phorid fly, but we did not record sufficient detail for such an analysis. Some frames recorded the 'gall gnat' as a smear or streak, indicating increased speed. The analysis of the 'gall gnat's' behavior cannot be completed given the technical constraints of our experiment."

Viperine had inserted a page after that one: "Note, from Viperine Pistouriec. Gall midges are practitioners of paedogenesis: the larva reproduces without waiting to mature. As you know, Professor Emmer, parthenogenesis is when reproduction takes place without insemination, as in some spiders, water fleas, electric ants, velvet worms, salamanders, aphids, and parasitic wasps. Gall gnats also reproduce by parthenogenesis, but in addition they exhibit paedogenesis, because the pregnancy takes place in the body of an immature organism. It would be roughly comparable to an infant becoming pregnant. The combination of paedogenesis

and parthenogenesis is rare in the animal world. In addition, I have dis-
covered that gall midges are the only known organism that combines pae-
dogenesis, parthenogenesis, and cannibalism. This is according to Gustav
Spackel, who did research in gall midges in Minneapolis in the 1980's. The
daughter larva, which grows inside the mother larva, may attempt to eat
the mother, which is still a larva. Spackel thinks this behavior is caused
by the fact that the larval form of the gnat is not equipped to give birth,
so the larva inside it has no other way to escape. This would be roughly
analogous to a baby pregnant with a full-term fetus, which attacks it from
the inside in order to escape. In the gall gnat, once the 'baby' larva eats its
way out of its 'mother,' it continues to grow as a normal larva, inside the
plant gall. It is possible the 'baby' larva derives nutrients from its 'mother's'
body, which would make this an example of parthenogenesis, paedogenesis,
and cannibalism. In effect the gall gnat has skipped a generation. The
mature gnat which emerges from the gall in the spring is the partheno-
genetic 'granddaughter' of the gnat which laid the egg, rather than of the
daughter, which it may have eaten. And Spackel made an even more un-
usual observation. He reports one case in which the larva that had been
'born' from another larva, which ate its 'mother larva' from the inside out,
was itself pregnant. Once it emerged into the plant gall, it immediately
produced an offspring. The tiny larva, Spackel says, did not survive, but it
damaged its 'mother' by prying apart her tergites and sternites in the region
of her subgenital plate. If Spackel is correct, that was a case of a larva in
a larva in a larva. I thought you might be intrigued by this. Spackel felt it
was an anomaly, but given how few people study paedogenesis in gnats, I
believe it could be normative. It might even be possible to find a case of
four larvae, each inside the other, each one attempting to eat its way out."

I imagined Vipesh whispering in my ear:

— Please excuse my colleague Viperine, she means well. But this note,
I am sorry, I tried to talk her out of it, but she is very insistent.

And Viperine, whispering in Vipesh's ear:

— Don't worry, Vipesh. He will love this. It is just the kind of thing he
likes.

— Vipes, please. Dr. Emmer, we sincerely hope and wish that you enjoy and profit from these readings. They are fascinating, aren't they? Even if they are not always easy to understand, at least for me, but I am only a beginning student in biology, I am sure that for you they are common like bread and butter.

— Now you're brown-nosing.

— Oh, okay, Vipes, do what you want. But please don't start singing again.

The paper concluded with a photograph of a cold-looking waterfall.

"Fig. 6 is an image of the downward motion of two 'fungus gnats,' *Bolitpholidae*. They are probably *Cliopisa occlusa*, the commonest species in Mosjøen, Norway, where this data was collected. These 'fungus gnats' were observed March 26, 1982, several weeks after an unusually early first thaw. These two survived the winter by an unknown mechanism. They had possibly been preserved in frigid matrices in decaying wood the previous autumn, then liberated by the unusually warm weather. In the ordinary life cycle of *Cliopisa occlusa*, adults hatch in mid-June from larvae that feed on fungi and mycelia in decaying wood. The two gnats observed here

were executing normal mating behavior even though no females were in evidence. In general, males fly upward quickly (not shown) and then descend slowly in a helical pattern, making use of upward warm air currents to slow their descent. This behavior attracts females (not observed). The number of cycles in the downward path is dependent on the air currents.

"Fig. 6a is a detail of the end of the path of one 'fungus gnat.' It may be assumed that in the absence of asymmetrical air currents the 'fungus gnat' will descend in a perfect helix, but on the day of this observation the air was quite still. It is therefore conceivable that there are deviations built into the path, which may be attractive to the female 'fungus gnats.' That would be typical of mating 'dances' in many animals. The deviations may appear random here only because of the limitations of our recording technology. The path might have a pattern that has not yet been discerned. These 'fungus gnats' have an average lifetime of around one week, and these were probably at the end of that period. They had woken too early in the season. They would not be successful in mating."

— Vipes, what are you doing?

— Shh, I am adding some papers to the folder, look, Warren Sallman's "Not Today You Don't!: Sperm Rejection in Female Fungus Gnats." Isn't that fabulous? Jeremy Biles's "The Strange Asymmetrical Mouthparts of Thrips," Max Wastl, Lisa Wainwright, and Shirley Richards's "Bored and Nauseated: 16mm Pornographic Films Shown in Ultra Slow Motion with the Lafayette Analytical Projector," and Gregory Pillsleben's manga *Sad Larva, Bad Larva.*

There were a dozen more papers at the bottom of the folder. I ignored them.

— Vipes, you really like larvae, don't you?

— Well, you're one.

— Am I?

— You're young, you don't know much about the world yet. And you're soft and round.

— I am not. And I'm not a gnat or a fly either.

— Those are creatures Samuel loves. Small and frail. No one even notices when they kill one. When they die, they disappear. You don't see corpses of fungus gnats lying around in fields, do you?

— Well no.

— This is how Samuel thinks of himself.

— And how do you think of yourself?

— When I look at myself, I see only the outlines of my fascinations.

— What does that even mean?

— Shh, wait, he's going to read the next set.

I pulled the clips off the next folder, which had the title:

PART THREE

SOME PATHS ARE NOT PATHS;

OR,

YOU DO NOT KNOW WHERE YOU ARE, DOCTOR EMMER

On top was a printout of a slide talk by a person named Elisabeth Neely, given at the Third International Conference for Marine Bio-Logging at

the University of Tasmania. The first slide had her title in purple bubble lettering against a green ground: "Where is That Animal? Problems in Mathematical Location Estimates." Underneath was her name and title, Pan-Hellenic Aquamarine Research Institute 2011 Bellerton Fellow. The first slides were pictures with bullet-point captions.

- Classical model: animal follows path between GPS3 points

- Problem: GPS3 points have variable error

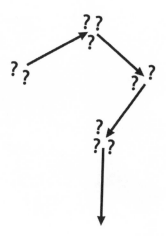

• Result: true probabilities are difficult to obtain

• Challenge: how to represent intermediate positions?

The next slide had a map of a coastline. It had the title "Attempting to track a fur seal around South Georgia Island."

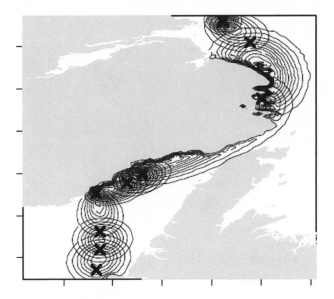

- Black xxx = GPS "track" appears accurate.
- Concentric circles = GPS data cumulative error bars.
- Clearly inaccurate!
- Solution = <u>pay attention to the mathematics.</u>

Then came a slide that looked like a stream running through a cave. It was titled BEST PRACTICE.

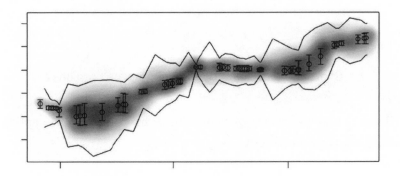

- Obtain fur seal's locations as given by GPS3.
 (Note <u>error bars!</u>)

- Apply Bayesian analysis to the locations.
 - Obtain <u>probable path</u> (dark gray)
- Add upper and lower boundary lines at 5-sigma
- Result: Best guess for the fur seal's path

The next slide was titled SUMMARY.

- GPS only <u>appears to be accurate</u>
- Satellite collation + firmware limitations
 - + bandwidth limitations = <u>error bars</u>
- Bayesian model to predict
- Correlate with GPS
- The animal is anywhere within the 5-sigma.
- Fur seal becomes a set of probability isolines!
- <u>There is no "path"</u>!!!

Neely's last slide was black, with the words THANK YOU in small purple bubble letters.

Next came a paper by someone named Jonathan Wotherspoon, called "Estimation of Probable Locations of Mammals Using Bayesian Mathematics." He noted that mammals are relatively large, so you have to know which part of them you are measuring. Deer make narrow trails in the woods, Wotherspoon wrote, but they aren't so narrow themselves. "A deer, walking gingerly along its trail, each foot in front of the other, is actually a mass of moving parts, overhanging the trail. Its haunches sway left and right. Its neck swivels. Its eyes rotate. Parts of it are ahead, parts behind. If it is 'single tracking,' i.e., all its hoofprints fall in a single line, then its pelvis and shoulder girdle tilt left and right to keep it balanced. If it is 'diagonal walking,' 'pacing,' 'cantering' (or 'loping'), 'trotting,' 'transverse galloping' or 'rotatory galloping' then its center of mass will vary less from side-to-side, but its legs and hooves will deviate from the single line path. For example a 'canter' is an asymmetrical gait, alternating single steps by the right front and left rear leg, with a simultaneous step by the left front and right rear leg (or vice versa), resulting in an asymmetrical

distribution of the center of mass relative to the averaged path (although animals such as horses instinctively 'stutter step,' i.e., they alternate the side that takes the simultaneous step, from LF + RR to RF + LR).

"Determining the probable location of an animal at any given moment in time, or as a time series, therefore depends on where the tracking device is attached to the animal. A typical collar device can be used to follow the cervical vertebrae and thorax but not the skull. A nano backpack on an ear tag will be consistently skewed. In this paper, I discuss how to replace the conventional single GPS point with a fluid 4-D Bayesian model. Bayesian animal models represent context-responsive and species-specific alternatives to the single idealized one-dimensional animal point. No animal has a single path, except by gross approximation."

In Appendix 1 Wotherspoon announced a "Model Code for Markov Chain Monte Carlo Approximations for Large Mammals," and then he added a ferocious equation, and another, and another. At the end was another note from Viperine.

"Doctor Emmer, I would like to extend this research. I propose a connection between the determination of an animal's location around the GPS signal, and the determination of the location of the self within the mind. In Bayesian theory, as you move, your location becomes a question of probabilities. The key is Bayes's formula

$$\mathbb{P}(S|s) \propto \mathbb{P}(S)\,\mathbb{P}(s|S),$$

which is used in the following way: S represents your present location and s your most recent previous location according to the GPS data. The *location posterior* $\mathbb{P}(S|s)$ represents the probability that you are located at position S given that the GPS previously identified you with coordinates s. The probability $\mathbb{P}(s|S)$ is the so-called *location prior*, the probability that you were at s given that you are located at S. The probability $\mathbb{P}(S)$ is defined as

$$\mathbb{P}(S) := \frac{\sum\limits_{s \in \mathcal{A}} \sigma(S,s)}{\sum\limits_{s \in \mathcal{A}} \sum\limits_{S' \in \mathcal{G}} \sigma(S', s)}$$

where $\sigma(S,s)$ is called signal dominance, and \mathcal{A} denotes the set of all of your known positions. This is part of a general notion of location which can serve as input for the model of location likelihood. A specific instance of it, the *Voronoi location dominance*

$$\sigma \equiv \mathrm{Vor}(S,s)$$

is the optimal model here. Together with the model for the location likelihood, this simplifies the initial equation to

$$\mathbb{P}(S|s) \propto \sigma(S,s).$$

Then it's easy, because the interpretation of $\mathbb{P}(S)$ depends on the instance of whatever $\sigma(S,s)$ has been chosen. Let

$$F : \mathcal{A} \to \mathcal{A}'$$

be an arbitrary function that maps prior locations onto predicted ones. Then, by setting

$$\sigma F (S,s) := 1 \text{ if } s = F(S), 0 \text{ otherwise,}$$

the prior in the equation for $\mathbb{P}(S)$ becomes uniform. Since $\sigma \mathrm{Vor}$ is a specific instance of the function σF, the location prior with $\sigma = \sigma \mathrm{Vor}$ also simplifies to the identity prior. In this way of calculating, Samuel, your present location becomes a combination of probabilities and location matrices, at once very precise and limited by the probabilistic (Bayesian) framework.

"I believe there is a parallel between this kind of location technology and the psychological techniques of locating the self within the thinking mind. The usual picture of the psyche locates the thinking and volitional self, the 'I' or *ego,* that is the part of you that thinks, in the center. From there, the 'I' observes and directs conscious operations such as intentions, fears, and interests, as well as the preconscious memories and impulses that come to it from time to time as they are brought up into the light of conscious awareness.

"Before Freud, the 'I' was imagined as the pilot of the ship of the mind, always locatable at the center of the mind, surveying it and ensuring that all its operations are in order, the decks are clean, the course is set, the sails properly deployed. Freud cast doubt on that by revealing the presence of unconscious ideas, which undermine and partly control the supposedly magisterial I, so that it can no longer be located behind at the helm of the ship of the mind. A psychic GPS would no longer find the I standing at the

wheel. The I has wandered off. Perhaps it is standing by the rail, looking toward the horizon. Maybe it is below decks sleeping. Possibly the I is sick, and it's lying in a bunk in the infirmary, or even sitting on the toilet. In recent psychoanalytic theory it has been claimed this I doesn't even exist. It is a deliberate and elaborate lie assembled and supported by the unconscious elements of the psyche to reassure the self that something is in control. If that is true, then if you look, you'll see the I once again standing behind the wheel of the ship, but it is no longer rational. It no longer knows what it is or where the ship is going. Most recently, it's been claimed that Descartes had no clear idea what he meant by 'reason' or 'thinking.' When he said 'I think, therefore I am,' he could just as well have said 'I'm emotional, therefore I am,' or 'I hate Beeckman. He stole all my ideas. It's all I can think about.' In this model, there is no I because no one knows what it means to think or reason. It's not only the pilot who is un-locatable. It's the ship itself. Perhaps it's not even a ship. In this situation I believe that new tools are needed to help locate what remains of the I.

"*J'ai de la peine pour toi, Samuel, je pense que tu te sens perdu, et je veux t'offrir le soutien très fragile d'une personne qui se sent elle-même perdue. De même qu'il n'existe aucun moyen de localiser votre position dans le temps et l'espace, quelle que soit la précision des systèmes GPS3, et quelle que soit l'élaboration des méthodes d'analyse Bayésiennes, de même il n'existe aucun moyen de localiser le moi intérieur que vous appelez encore nécessairement «je». Les deux problèmes sont strictement, bien que poétiquement, simi-laires. De ma position incertaine, à la fois dans mon propre corps et dans mon esprit, et par rapport au chemin de ma vie dans le monde, je fais appel à vous, où que vous soyez sur vos chemins et vos pensées incertains et mal définis.*"

I closed the folder.

— If that doesn't show him.

— What did you write?

— It's personal, Veeps.

— Vipes, darling, you are disturbing him. Look at him. He is tired, he needs his rest.

I imagined Vipesh putting his lips right to my ears.

— Doctor Emmer, in conclusion, we hope these papers will provide you with some amazing information. None of your colleagues have this information, and we are confident that you can introduce it into your discussions and effortlessly become the leader in your discussions, by talking about this information that no one else has.

— Psst, Veeps.

— Just one moment. We feel you can have impressive conversations with Doctor Sounder. We are confident about this, because she does not have this information.

— Psst, Veeps.

— What?

— Tell him we hope he is thinking about his own life. Tell him if he is paying attention, these essays should be deeply disturbing. Tell him, deeply disturbing.

— No, Viperine. Be nice.

I looked again at the title of the packet, YOU DO NOT KNOW WHERE YOU ARE. But maybe I did. In fact, I was closing in on LaGuardia. I could see it on the inflight screen. We were somewhere near the Hudson River.

That map was my path. Ten minutes earlier, I'd flown over the Finger Lakes, not so far from Watkins Glen. Then the plane had made a loop. Probably the pilot had been told to delay his arrival a little. I hadn't known I was moving in a loop, but that's how paths are. You don't always pay attention. After that we were in a holding pattern somewhere north of Peekskill. It was gratifying, for some reason, that the holding pattern was a nearly perfect ellipse, tilted just east of north. In three hours, my path would head west to Salt Lake. I had a good enough idea of *Where I Am*. I had less of an idea of *Where I Am in Life*.

The last folder was red. It had the title:

PART FOUR

SOME PATHS ARE ONE-WAY ONLY;

OR,

WHERE ARE YOU GOING, DOCTOR EMMER?

Underneath, Vipesh had written: "Very special, please open at home if possible." The folder was sealed around the sides with tape. I put it back in my computer bag.

My mind was in a holding pattern, banking and turning.

— See what you've done, Vipes. You have confused him.

— He is stalled out. No harm done.

— Oh, Vipes.

— You'll be fine. C'mere, little Vipesh.

— I am not little, please leave me alone.

— C'mere, l'il Vipesh.

— Why are you being mean to Doctor Emmer?

— He is losing control of his life. He needs to know that we know, even if we can't help him.

—Ooh, that is so mean, but also sexy.

The plane to Salt Lake was only a quarter full. I fell asleep a few minutes after takeoff, and five hours later, I was jolted awake when the plane's tires hit the runway in Salt Lake. My legs ached as I walked up the jet bridge. I

was enervated. Instead of looking for the baggage claim, I sat down on a bench, the kind they put in the middle of long corridors for people who can't walk the eighth of a mile without resting.

A perpetual stream of passengers passed by me, their eyes scanning the landscape of parked jets and service trucks, shoulders stooped as if they were being whipped along by Roman soldiers. After several minutes wondering whether I would feel better if I just lay down, and how long I might be able to sleep until a security person woke me up, and whether, if I stayed awake and read a book, I'd be allowed to remain on the bench past midnight or maybe even into the next day, leaving my seat only for short trips to the bathroom or the CHINESE WOK I saw in the distance, and whether, if I kept a reasonably clean appearance, I might spend three or four days in the airport, missing my appointment, moving from one terminal to another, eating croissants in the morning and orange chicken in the evening, suddenly I jumped up, surprising myself. I accelerated from a shuffle to a hurried walk, rejoined the stream of invisibly enslaved travelers, felt the surprisingly gentle touch of the legionnaires' whips, and, just as I was enjoying my fantasy of being a contented slave, reconciled to my lot provided the Roman army kept feeding us on orange chicken from CHINESE WOK, I found my luggage carousel, and soon I was in a taxi.

In the hotel I sat in a purple wide wing chair, staring at a painting of swirling red lines. It was meant to look scientific, like oscilloscope tracings or the orbits of electrons, but I thought of it as a map of my entangled thoughts.

— See how sad he is.

— He is relaxing. It was a long trip.

— We have confused him, he has no idea what to do.

— Veeps, c'mere. You are very cute.

— Shh. He will hear you.

— I very much doubt that, Veeps, considering he is only imagining us.

— He is disappointed in me. He is angry at me.

— He has no clue. C'mere.

Seventh Dream

Again my struggling mind lost its battle, and again I fell, as we all do, into the world of dreams. A hopeless agitated feeling came over me. Something was ruined. In my sleep I still knew my anxiety came from events

in my life, but I couldn't think what. My unsettled mood merged with the endless landscapes. Something is ruined, I thought, looking at smoke steaming from a cleft in a rocky mountain. Already ruined, I thought, but I didn't know what. Fires from underground, I thought, but I wasn't sure what that meant.

In the logic of the dream I decided I would be safe if I watched the world burning from a distance. From this dirt road high up on a mountain. In one of the few places where the sun was still shining, where some daylight remained. But the shadows were deepening and the fire was creeping forward.

I was like a very young child who watches terrible images on television. The child sees murders on the nightly news, pictures of unfolding disasters, people yelling and fighting. He doesn't understand, but he knows something is wrong. He raises his hands. He looks around. After a while he begins to cry. He waves his hands as if to say stop, wait. But the images keep coming.

No one arrives to help. The child's parents are in the next room, talking with their friends, but the child is helpless, held captive by the images. He is fearful and bewildered. He isn't sure if the images are on television or in his world. Perhaps they are happening all around.

Those are just clouds, he thinks. Everything is fine. It is just the sky. He is comforted, a little, and he stops crying. But then he sees that the land is burning, everywhere.

No, no! he says, but the images keep coming.

The child runs out of the room. He tries to save himself, but the monstrous clouds come after him.

Deep in my dream, I thought: I need to leave. I felt obscurely that if I drove away from the fires I could wake up, or at least I could find a place to sit and recover. Obscurely, I hoped that if I could see a sky without smoke, I might remember who I was and understand why I had been thrown into this imaginary world.

So I got in a car and drove away from the mountains. I drove several days, until I was in rolling grassland. Still the fires burned: in patches of woods one road over, in the next town, in gullies and stream beds, down the side roads. I threaded my way between them. The fires kept their distance, but they were everywhere.

You cannot escape a dream by running. Even dreamers know that, even while they are running. But they run anyway, because the thought is incomplete in their minds. It hangs there like a command: Run. Get out. Don't stop even when you see it is hopeless. I knew I couldn't escape, but I was like that child, with no language to help me think.

I drove on through a flat country. Maybe Saskatchewan, or the Dakotas.

In some places there was very little that could burn, but the fires started up anyway, picking over dry earth and wheat stubble.

It was painful to see so many fires. My eyes burned. Each fire was a wound, a cut in the earth. Each was a laceration in my thoughts, a small painful operation. Each one sliced something from my memories and burned it.

It became difficult to think. It was hard to keep seeing the world on fire, to keep trying to make sense of the onslaught of images. The fires meant something, they needed to be understood. They were like people waving frantically at me, trying to get me to understand something.

I could always drive away. But there they were, right in the next field, over the rise, in a patch of woods.

Each day the smoke got darker. Perhaps cars were burning, or houses.

I tried to understand what was happening, but I was exhausted from driving, tired out by the harsh images, tired from fighting against the dream, from driving on in the dream to escape from the dream. Always inside it, always driving away from it.

The fires burned darker. Their smoke was dead black.

It was thick smoke, heavy with soot.

Under those clouds day was unnatural night. Soon the world will be like this, I thought.

The sky will be dense and black. Bare trees will be lit by some waning light. The wind will turn, and I will be in darkness.

Do people fall asleep in their dreams? I did. I slept on the ground, under a starry sky. In my dreams, in my dreams, the world was darkening. The fires kept on, without sound, without light, while I slept, in my dreams, in my dreams.

8

The Gray Loris

Salt Lake turned out to be cold. The air was dry and curiously empty. The door to the zoo office was unlabeled, between the side of the antelope enclosure and the toilets. A young woman was sitting behind a counter, looking at a multiplex feed showing a dozen cages. Her nameplate said BEATRICE GUBLER. I was about to ask if she was my guide, when an obese, half-bald man in his thirties stood up from behind a desk I hadn't noticed and identified himself as John Preteen, Mammals Curator. He sucked on the retractable nipple of an energy drink.

Preteen held the door for me, and we joined the flow of visitors.

— First, I'd like to show you, oh, wait.

He turned and went back into the office.

The cacti and desert grasses were bleached in dry morning light. Two young women passed by, each pushing a stroller.

— I wish to god I'd brought a flask with me, one said to the other. I always bring one.

The sun was unpleasantly aggressive, needling my eyes. Things were gearing up for a full-on desert day. Preteen returned with a clipboard.

— Okay, he said.

He peered at the clipboard as if it were dark.

— Okay. I have to show you the tiger enclosure. You'll be interested and it's right here. And the alligators, well, the alligator, and if you have time, there are primates to see, and ungulates, and our elephants, or elephant,

there's only one, our hyraxes, our tamarins, our Colobus monkeys, our howler monkeys, our spider monkeys, our proboscis monkeys, our squirrel monkeys, and of course our devils. I'm so glad you're here.

He beamed at me.

We set out at a fair pace. Preteen wheezed and swayed from side to side as he walked.

— We had two elephants, Ellie and Galilee. They were both elderly, I mean Ellie still is elderly. One time Galilee got sick, and out of her vagina came gallons of blood. I mean four or five gallons, a flood.

He made a gesture with both hands as if his inguinal ligaments had ruptured and his large intestine was spilling out.

— We sedated her, but what could we do? I was, like, twenty-four. I was terrified. The vet came over and said it was a uterine polyp, not any kind of danger, really no problem, he said. Galilee stopped bleeding all on her own, and she was up and about that same day. We washed her off. But we couldn't mop up that much blood. We covered it in dirt. Ellie watched us do that. But then Galilee became anorexic. She didn't eat for a couple of weeks, and the skin was hanging off her. She yawned a lot, and one day we noticed bumps on her groin. The next day she had trouble breathing. She was gasping and making sounds like a backhoe digging up a swamp, and then she went into convulsions. Ellie watched all that too. The next day Galilee was dead. Haemorrhagic septicaemia or else EHD, the vet said.

— EHD, I said. Very common.

— Actually septicaemia. The vet said he was sorry he didn't catch it before. He showed us how you know. For next time, he said. He pried open her mouth with a shovel and we could see that inside it was mucousy and covered with mulberry-shaped sores. Septicaemia, bacterial infection, he said, it kills very quickly. So, we chained her up and hauled her out. Ellie watched that too. She paced a lot and pawed the dirt. That's what elephants do when they are sad. I love the flat pads of her feet and her big round toes. She used to paw the dirt, right where Galilee's blood was. Okay, so one day Ellie she got a toothache. We could tell by the way

she kept dropping branches out of her mouth and drooling and flapping her tongue around. We shot her onto a slumping hill, they're for geriatric elephants who can't get up, so she was out of it, leaning against this mound of dirt, with her tongue hanging out. We looked inside her mouth but there were no mulberry sores. The vet brought out this unbelievable cannon, big as a sewer pipe, and pushed it down her throat. Then they got a compressor, oh wait, here's the tiger.

An elderly man with a cell phone was standing at a metal fence, looking across a pit at a grassy slope that ended in high concrete wall, sculpted to look like a natural cliff. The tiger was standing at the top of the slope just under the wall, flank pressed against the fake rock, looking up.

Preteen pointed out there was no fence at the top of the fake cliff.

— The trick is to make the enclosure as natural looking as possible. She's been looking at that part of the wall for a couple of days. I think she's probably going to try for it, so we'll have to take her back inside and build up that part.

He peered at the man's phone.

— We're keeping tabs on how much time she spends looking up there.

At the man's feet was a large red and white bullhorn, a taser in a holster, and a can of pepper spray.

— Those are for if she makes a move. Looks like we're going to have to take her away for a while and build up an overhang.

I told him it would be depressing for the tiger when she came back in and saw the new cliff.

— Hmm, I don't think so. We've done it before. The cliff keeps getting higher.

I pretended to write something on my notebook.

— But Preteen, I said, from the tiger's point of view, this is some kind of surreal torture.

— Keeps her occupied. She was sick last spring, she had chronic feline leukemia. She scratched herself trying to scale the cliff, and her wounds didn't heal. She had abscesses. I had never seen so much blood on a cat. We had to wash the blood off the cliff. She got infected, she had a fever

and diarrhea. But she's fine now. She likes to plan her escapes. You can call me J.P.

The tiger hadn't taken her eyes off the top of the wall. She probably knew the wall could get higher overnight, that she had to get out now.

Preteen led me away.

— So I was saying about Ellie, they just shoved this big pipe down her throat.

He opened his mouth, cupped his hands in a big circle, and made vigorous pumping movements.

— They hooked the pipe up to a compressor, and that kept her out. The anesthetic pumped into her, and you could see her whole belly puffing up and down with the gas. Then they propped her mouth wide open with a thing that looks like the Jaws of Life. It's like there was scaffolding inside her mouth. We saw the bad tooth. It was all caved in and blackened and her mouth smelled horrible. Plus, the anesthetic gas, we tried not to breathe it. The pipe scratched her mouth. She was bleeding. The blood was pooling in her mouth. I told them to hurry up. The vet went at that tooth with monster pliers.

Preteen made his arms into big curves and swung them like pincers. I imagined him as a baby elephant, swinging his trunk back and forth, sputtering blood.

— The vet just hauled on those giant pliers, back and forth, he just rocked back and forth until the tooth cracked, and then he pulled it out and blood went gushing out all over him and he had to spit elephant blood out of his mouth. A couple hours later she came out of it and stood up. She saw her blood on the ground and stood there patting it with her trunk. For a long time afterward she stood over that spot, and the spot where Galilee's blood went, and she patted the dirt, like, rest in peace. That was like eight years ago. She's been okay since then, but she's really, really old. All she does these days is stand and raise one foot, and then put it down. See for yourself.

And there was Ellie, at the far end of her dusty pen. Her tiny black eyes might have been closed. She lifted one of her rear feet a few inches off the ground, and then let it drop. A minute later she did it again.

— We hardly ever bring her out. There's nothing left in her, all she does is lift that foot up and down. We thought of amphetamines, but she's old, they're not good for her heart. She's doing her best. After feeding, they'll push her back inside. Gently. She's a good girl. She can't do anything anymore. So now I have something really special to show you. Stay here, please, while I go around.

He posted me by a shoulder-height wall in front of an empty pen, and went through a door half hidden by bushes. In a moment he came through the pen and stood opposite me, on the other side of the wall. He was holding a bulging fat animal, which was squealing, whining, and barking. It had a surprisingly large mouth, full of nasty looking teeth. Its fox-like snout snuffled in all directions. He had his right hand under its belly, holding it out like a baby. With his left hand, he gripped the base of its tail. His index finger was either on the animal's anus or inside it.

— That's to keep control, so she knows who is in control.

The animal wrestled and squeaked.

— We have four Tasmanian devils here. They are an amazing species. They have twenty-seven vocalizations, everything from little sneezes to ear splitting roars.

He put it down, and it barreled around the pen, tipping from front to back like a rocking horse, and also side-to-side, as if it were lame. In a moment it was back at his feet.

— They love being scratched, he said, roughing it up with the hand that had been in its anus.

It grunted, then wailed like a siren, then sneezed.

— But you have to be careful. Those teeth can go right down to the bone. Still, they're not as bad as Tasmanian quolls.

I asked him if he meant koalas.

— Quolls. They're smaller. We'd like to keep them here, but they are too hard to manage. They have chainsaw teeth. They move their lower jaw rapidly back and forth. They can pulp animal tissue. Quolls wait in trees, and then they leap onto their prey, bite it in the neck, and eat just a little— some heart, some brain, or the eyes—slurp up some blood, and then leave

the corpse for the devils. In the past devils and thylacines. Ideally, we'd have them all together, devils, quolls, wambengers, numbats.

The devil huffed and showed its enormous mouthful of teeth.

— Our devils just don't know what to do with themselves. They run round and round. We tried Valium, but it didn't have much effect. Last year a guy from Melbourne Zoo recommended Haldol, that's an antipsychotic, and it works fairly well. In people, it can produce facial tics and jerking movements, they call it tardive dyskinesia. And guess what, that's what happened. Our devils are always twitching and lurching, but people think it's normal.

I was about to bring out my Roseman-Billinger charts when the devil yelped and thwacked itself against Preteen's shin. He picked it up by its tail, finger on its anus, and hung it upside down, scratching it all over with his other hand. The devil shuddered.

— Our devils are akathistic. They have an intense desire to make noise and move. The Haldol just puts that in overdrive. But devils are always loud and twitchy, aren't you, honey?

He threw it down, and it galloped around in a circle, nearly tipping over.

Preteen went back into the enclosure. In a minute he emerged on my side of the wall. He probably hadn't washed his hands.

— Next is the reptile and insect house.

He held the plastic-flap door for me.

— Hope you're enjoying this. It's so nice to talk to a fellow professional.

Inside was the usual reptile smell: non-mammalian waste, not disgusting like mammal shit, just unpleasant and weird, as if plastic could sweat.

— Here's something unusual. Our South American tarantulas.

He steered me to a small terrarium set into the wall. I peered in, but didn't see anything except a row of empty tin bowls, yellow leaves, and dirt.

— They're up there, he said, curling his finger to indicate the roof of the terrarium.

I leaned down, turned my head up, and was rewarded by the sight of three large hairy tarantulas on the other side of the glass a few inches from my face.

— Natal Brown Bird Eaters. There are only three left. There were nine. Something's killing them. They climb up there, maybe to escape. We don't know why. One by one, they're dying. We thought it was their food, so we switched to premium South American pinhead crickets. Still, they kept dying. We thought maybe a fungus or a parasite. We took one and scrubbed it. Did you know there are little wire brushes for tarantulas? Because you can't touch their hairs, and also you need wire to really get in there. But it was clean, we didn't find anything except mites. We took a blood sample too. Know what color tarantula blood is? Blueberry blue. But there was nothing. So we put it back in the terrarium, and it died. If only they could speak.

— Please save us, I squeaked. We're in terrible pain. It's joint pain, can't you see? It's just the worst thing for us spiders, we have eight legs, like fifty joints. For god's sake Preteen, just give us an ibuprofen.

— Well ha ha, but okay, we might as well try that. They drop off the ceiling one by one. I wish I could help them. Still, they're only spiders. We can always get more. And you can call me J.P.

He gave me a tap on the shoulder to turn me around.

— This is a great success story.

On the other side of the corridor was a large terrarium with succulent plants arranged around a central rock. On top of the rock, under a garish orange light, was a large iguana, flopped out, legs hanging down. Its eyes were closed. It appeared dead. Its skin was dry past repair, cracked and stained like an old concrete building.

— This is Lucy. She had a hysterectomy two years ago, and ever since then, she loves the heat lamps.

At once I saw the bank of orange heat lamps suspended from the terrarium's ceiling.

— She's happy as anything.

The plastic door to the reptile and insect house opened and the woman from the zoo office came in.

— Hi, I'm Bee, she said, taking her earbuds out.

— I was just being introduced to Lucy.

— She's a success story.

I couldn't read an expression in Lucy's face, or even a sign of life.

— She used to lie on her back, Bee said. That's what lizards do when they're sick. So we did some blood tests, and we found her estrogen was out of whack. Now she's on hormone therapy.

Lucy was an exceptionally unpleasant-looking creature. Her skin was as dry as my mother's had been. Even when I was young, I'd found my mother's skin disconcerting. The closest I'd seen to the corrugated wrinkles on her arms was a bog man in a museum in New York. My own skin was headed in that direction. I stole a quick look at the back of my hand.

— She loves to sun herself. That's her thing, Preteen said.

— She's one happy iguana, aren't you, baby? Bee said.

— She looks dead.

— She is basking.

— I think she's in pain, Preteen.

— Really?

— She looks miserable.

He looked at her carefully.

— She's happy.

— She was mean, Bee said. She fought Babe and Tootsie, the other iguanas. She hid behind her mountain, and then she jumped on them.

— Know what color iguana blood is? Green. Bright green. We'd come in and there'd be Babe and Tootsie, their bellies all green.

— She bit the plastic plants, too, Bee said. Now she's medicated.

— I hate you all, I squeaked. I hate being naked on this cheap plastic rock. I hate you telling everyone I had a hysterectomy. I hate this stupid terrarium. It's filthy. I'm crabby, Tootsie says it's the change of life, but I had a hysterectomy for god's sake. And keep those bitches away from me, I can't stand Babe and Tootsie, they are always showing off their cloacas. And I want more of those nice meds. I want to forget everything.

— She's fine, really she is.

— Want to know what I really love? Want to know what I'd really like?

— Tell us, Bee said.

— Blood. Green blood is good for my complexion. I like red blood too, if you know what I mean. I'd like to be caked in red and green blood. It would do wonders for my wrinkles. It's all I dream about all day long. I would look so glamorous.

— Okay, okay, Preteen said. We could try to up her meds.

Preteen and Bee headed out. The filthy plastic flaps of the door slapped me in the face.

— Are you studying to be a vet? I asked Bee.

— Oh no, I'm married to my job.

She took Preteen's hand.

— We're going to be engaged soon! he said.

— We are?

They both giggled.

Just outside the reptile and insect house we came to a shallow pool with a large American alligator in it.

— Now that's a sad story, Preteen said. That's the male. They were a couple since before I got here. Then last winter the female attacked him. It was savage. He needed stitches. We used fishing line for that. He fought back and snapped off two of her claws. She bit him in the jaw and cracked his mandible. That's not easy to do. No one knows why she attacked, but they had to move her, so she went to Fort Lauderdale. He's staying here. They will never see each other again.

I looked into the animal's oyster shell eyes, which seemed at once canny and infinitely stupid.

— Maybe she was just fed up with him. Maybe she said "I'm telling you, if you keep looking at those young crocodiles, I'm going to bite your head off."

— Probably he just took her food. With alligators that's all it takes, and bam! a lifetime of companionship is over.

— I think she put up with him for years, I said. She kept saying "you know, Marvin, you're a sick bastard. You do nothing but look at those lady crocodiles. Some of them aren't even five feet long. You're a total perv, Marvin."

— His name is Gerald, Bee said.

— If I were his wife, I'd call him Marvin. He's got Marvin written all over him. "You're a total perv, Marvin," that's what she said. "What am I, a mudfish?" But Marvin just grunted and went on ogling those crocodiles across the way.

— They're all males, and they're a different species.

— Marvin had interesting taste, didn't he? He was a perv. And after years of that nonsense, she went postal. "Damn you!" she screamed. "I'm going to splinter your mandible. I'm a fucking alligator. It's what we do!"

— Gerald, you're a crap husband, Bee scolded. What did Priscilla ever do to you? Men are just crap.

She slapped Preteen gently, and then smiled at him.

I made a series of checkmarks in my notebook, as if I were running down a list.

— I have to tell you, Preteen, Marvin is not well. And neither is Ellie, and neither is Lucy. They are sick animals, Preteen, sick, sick, sick.

He regarded me with quizzical concern. Bee took his hand.

— This zoo of yours is a mess. The reason Lucy the iguana looks happy is that she's blissed out, she's pre-orgasmic. Hormone replacement meds can have that effect, I'm sure you know that.

— Ew, Bee said.

She let go of Preteen's hand.

— Ellie is one of the saddest creatures I have ever witnessed. She was forced to watch while the only companion she ever had died a horrible death. Now she has no one. It's no wonder she doesn't even have the strength to walk. You traumatized her. You've ruined her life, you need to euthanize her. Shove her onto one of your slumping mounds, shoot her, and cart her off.

— Well, Doctor Emmer, I'm sorry you feel that way. We really do care for our animals.

I tried to look severe, with a touch of disappointment.

— Every animal you showed me is traumatized. Your Tasmanian devil is high on Haldol. It has Tourettes-like symptoms. Marvin was assaulted and then punished by being isolated for life. Your tarantulas are clinging

for life, watching each other die. Your whole zoo is like that, the animals are just trying to stay alive one more day.

I glanced at my notebook, which had nothing in it but scribbles.

— Your tiger still has hope, but god knows why, after what you've been doing. Next time it comes out and sees the cliff raised up even higher, it will probably collapse in despair. You'll have to give it Haldol, too, and then it'll jump around. That will be great for the visitors. It'll seem frightening and vibrant like a tiger should. In fact, now that I think of it, why not give all your animals Haldol? Ellie will dance the jig. Visitors will think she's having a great life. Your tarantulas will scurry all over the place. Children will squeal with delight. Lucy will spend all day trying to kill Babe and Tootsie. Kids will love it. Antipsychotics all around! Your zoo can be a dance club. Horror show psychotic animal dance club. Every animal jumping and running like your demented devil. The zoo will be full of howling and shrieking and barking and roaring and chirping and grunting.

I made a selection of the appropriate noises.

Preteen took two steps back. Bee held his hand.

— But seriously, your zoo is a disaster. When I write up my report, it'll probably end up in the paper. Your visitor numbers are going to drop.

— What report? Aren't you with a zoo in Canada?

I shook my head to indicate how naïve he was.

— I only write the reports. I have no control over where they go.

— Okay, look, I'm really sorry you feel that way. I guess I'll have our legal guy contact you. And oh, sorry, I think I have another appointment. But thanks so much for visiting, and please, if you spot anything else just tell Bee.

He turned to go and waved goodbye at the same time, but he rotated too far, on account of his large mass, and ended up facing sideways to me, so that when he set off he was wobbling in the wrong direction and had to correct his course, like an overloaded barge.

— Bee will take you around, he called out, turning his fat neck slightly to indicate he was trying to call out over his shoulder.

He ambled off as carelessly as he could.

— Your zoo is horrible! I yelled.

Even at top speed he was only waddling, so I could have kept shouting, but I wasn't sure what else to say. It was a question of caring. At one moment I felt too much, and then the next moment nothing.

— I'll finish the tour if you want, Bee said quietly.

On the other side of the zoo a large orangutan habitat was under construction. Bee told me how orangutans watched when people built their platforms, so they knew how they were constructed, and then later they tried to disassemble the bolts even though they had no tools.

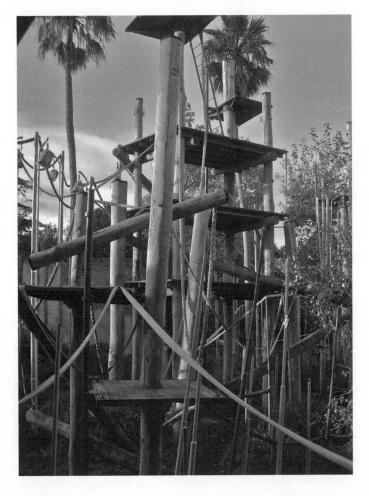

— They are very smart, she said. They try to turn the bolts with their hands, and eventually, after months of work, the bolts come loose, and then they take everything apart.

— See, if a world is built for you, and you don't belong in it, you need to tear it down. If your world doesn't make sense, you need to take it apart. One hex nut at a time.

— I guess. So we keep them away when we're working. That way they don't know how their recreational area is built.

— Well, I said, for one thing those straps won't work. Your females will rub themselves against the straps or mount the poles. Males will fuck the holes you put in for drainage. Or use banana skins to masturbate.

— Oh, no. Don't tell me those things, please.

— They love to do that stuff when people are watching.

— Our orangs are very well behaved.

— That won't last long. Orangs fuck and masturbate in public, and it's not because they are sex maniacs. They do it out of anger. It's because they live in world they didn't ask for, a world that doesn't make sense to them. They live in a place where their keeper sodomizes animals with his finger. I saw Preteen do that with a devil. The poor thing was frantic.

— Oh, she said, wincing, he doesn't do that. What's wrong with you?

— Ask him.

— John does not sodomize our animals!

— You can keep saying that, right up until Marvin starts inseminating his pond whenever he looks at the male crocodiles.

— It's Gerald. And sorry, I just really have to go.

— Or until Lucy has squirting orgasms under her heat lamps.

— You're gross. The zoo exit is that way.

— Fine, you'll understand when you read the report.

I turned around and walked off in the direction away from the exit.

In the back of the zoo, things were shabbier. There was an aviary with a row of crudely built birdhouses, a kind of bird tenement. The holes had been roughly drilled, splintering the wood. Some had been gouged out with a hammer. I supposed that didn't matter because the birds wouldn't know. Or would they? Can you tell when your world is badly made?

My apartment in Guelph was just a concrete and steel box like any other high-rise. Plaster and paint make us think we're cultured, but we all sleep in dusty boxes with bars all around and perforated holes for ventilation.

We think we keep our houses clean. But there's always dirt if you look for it. In one cage, an animal had scattered lettuce and peanuts, and then peed on the floor. Its bedroom was a crate with one panel torn out. In the end, my apartment wasn't that different.

I went into the monkey house, which was warm and smelled of damp fur. In the tamarin cage there was an absolute frenzy. The keepers had given them a cardboard box filled with thin plastic ribbons, and the tamarins were wild with happiness. Their frantic little lion faces were distorted by grimaces and spasms of delight. One took a ribbon and ran up a ladder, unfurling the ribbon all the way to the top of the enclosure. It pushed the ribbon against the ceiling and held it there, like a hysterical decorator demonstrating a swag of fabric. Then it grinned and ripped the ribbon. Tattered pieces drifted gracefully to the floor. Another tamarin crumpled a pile of ribbons together and then tore them apart, as if it were looking for something inside. Other tamarins, infected by the general hysteria, ran here and there, or sat motionless, showing their teeth and blinking.

I heard Preteen come in, talking to someone. I walked on, farther into the monkey house. At the end of the hall there was an unlit room. He wouldn't find me in there. A sawhorse, set across the doorway, indicated the room was off limits. I went in.

The display windows were all dark. Some had signs underneath: PARDON OUR CONSTRUCTION. A NEW EXHIBIT IS COMING IN. I walked carefully, peering into each one.

At the end of the room there was a display with an animal in it. In a space the size of a refrigerator, in the middle of a tangle of branches and leaves, a fairly large, white animal was moving very slowly. I looked for a label, but there was none. The animal seemed ghostly in the bluish light. It moved like a sloth, but it wasn't a sloth. It had a white dog's body fitted with strong curving fingers. I couldn't see its face. Carefully, it lifted one hand-like foot, found a new branch, and moved onto it, insinuating itself into its tangled web, flowing slowly through its maze of branches. A long curling tail unfurled along the branches behind it, as if it was caressing each one and saying a reluctant farewell.

Suddenly a door opened and two women came in with a boy. I hadn't noticed the room had an outside door.

— Jeez, the boy said, this smells like poop.

The door closed, and the family stood a moment in the darkness.

The animal turned slightly, and I saw a small, flattened face and large rubbery snout.

— This smells like a toilet, where you poop, and then you don't flush, the boy said.

They walked behind me into the lighted rooms.

From close up, I saw the animal's hairs were spines with black tips. Could it be a porcupine? I looked again for labels and found one a few feet away that said CREATURES OF THE FOREST. Another label was covered by a sheet of butcher paper, taped down. I tore the paper off. The label was about parrots.

The animal worked its way down to the middle of the cage, and then started back up. It seemed calm and at home in the dark.

Preteen came into the room with three other people. I tried to move away, but it was too late.

— This room is going to be South American jungle habitats, he said to the people with him.

Then he saw me.

— Oh hello. I'm sorry. This area is closed.

He walked over to the ghost animal. I realized I didn't want to know what it was. I walked past him, out into the blinding sunshine.

For ten minutes I circled the plaza space in back of the monkey house, looking at the refreshment stands, watching families hurrying down the paths in search of more entertainment for their impatient children. Finally I decided Preteen must have gone out the front door, and I went back in. It was quiet. I stood a minute in the dank air while my eyes forgot the sun outside and settled into the darkness. The animal was balled up in a high corner behind some branches. It was asleep. Its tail was wrapped around its head. Its breathing rocked it back and forth.

— Sleep well, I said.

On the other side of the room there was an exhibit labeled GRAY LORIS. At first there wasn't anything to see except jungle foliage. Then a tiny white hand, perfectly formed, reached out from behind a leaf. As the little hand extended, I saw it was attached to an arm that was as thin as a wooden match. The little hand gripped a twig delicately, fifth finger first, the others curling after. The hand pulled the body after it, and the body was a shock. It was like a fat mouse's body, just the belly part. In front was a blackened, punched-in face with two enormous eyes, right on the belly. The hind legs were just as thin as the front legs, and they also ended in little grabbing hands.

The loris moved slowly, as if it didn't want to wake the branches that it touched. It seemed so wrong: a fat blob of a body like one of Liz and Sid's daddy longlegs, with tiny hands. Or like a decapitated teddy bear with its glass eyes sewn onto the stump of its neck. Or like a tiny man, impossibly old, shrunken with age, belly distended, head sunken into his chest, pale, frightened, moving weakly on skeletal limbs.

Behind it came another, with a baby clinging to it. The baby looked just like its mother, but smaller, and that, too, seemed wrong. There was nothing babyish or cute about it. The family crept silently along their twig. Their little round rumps bobbed slowly up and down.

The shrunken facsimile of a family slipped slowly by. The one in front disappeared behind some leaves. The mother hesitated. She, it, turned and looked out in my direction. There was a deep orange light in her eyes. They glowed, like a cat's eyes, but stronger. Two orange headlamps in the darkness. Her retinas were reflecting the light from an exit sign behind my back. It was uncanny, as if she was irradiating me in orange light. The creature had no corneas, no expression, no gaze. Just streaming orange eyeballs. I guessed that my own feeble eyes were reflecting back a glint of that orange, and the loris was seeing that. Seeing its own eyes in the back of my eyes, knowing I was looking at it. Maybe it was wondering if I was an enormous predator.

I opened my mouth. I could put the mother and child in my mouth at once.

The baby loris clung to the back of its mother, hands and feet clenched in miniature knots. It was looking up somewhere, into the dark roof of the enclosure. Its eyes were like those glass beads on the ends of some pins. Then the mother's frail hind legs pushed up, and its baby slumped forward, and the two of them moved forward and disappeared behind the leaves.

I glanced over to the other cage, where the pale animal was still sleeping.

I imagined myself as a loris. My bones would break easily. I'd be like someone's shrunken grandfather with osteoporosis. I'd be a cross between an emaciated child and a daddy longlegs. My body would be withered to a little pouch stomach, with twig limbs stuck into it and two expressionless eyes in place of nipples. I'd do nothing but look around: I'd no longer speak, or leave my apartment, or even put on clothes unless I had to see people, and even then, I'd just pull on a cotton hospital gown. I'd regard my wife and child with a devoted but bewildered stare, intending to say, I love you, but I don't understand who you are. I'd offer my hand, aerated

with osteoporosis, delicate as a dried crane fly on a windowsill, but my wife wouldn't dare take it. Still, I'd offer it slowly, elegantly. My needlelike fingers would uncurl delicately, little finger last. My pin-like child would give me the lightest touch, for fear of breaking me. I wouldn't let anyone know that I'd seen it cringe. I'd be ancient, the last to know the things I knew, the last to remember, but I wouldn't have the lungs to speak. After some time, my wife and child would leave, as mine actually had, and then I'd creep slowly back into my bed, which would be made of tissue paper.

I'd have a mouth of pointed teeth so tiny they were almost invisible, but perfect for crushing a rainforest stick insect or a small plated beetle. I'd have a nose for subtle smells. I'd sniff out the faint stink of a green bug hiding under a nearby leaf. Or a column of edible ants, smelling of formic acid. Or the chilling scent of my enemy the hawk eagle, which always brought an odor of lice. I'd have tremendous hearing. I'd listen to aphids lapping leaf sap. I'd hear worms shifting around inside fruit. My white fur would be astonishingly fine, softened with patches of mold.

I frowned at myself in the dark. It was hard to know what was wrong with me. I walked quietly across the room, feeling the animals' eyes on me, and opened the door onto the glare.

I decided to have a look at the platypus house. Two sets of doors led into a darkened room. The entire back wall was Plexiglas, and the other side was filled to my eye height with water. Below the water line there was a good four feet of water, and above it, another couple feet of simulated Australian riverbank coated with algal scum. A little girl shrieked and bumped into me.

— There it is!

Another girl pushed by as if she needed to make room in a closet. They were twins. Their parents came in after them, chatting. The platypus was swimming around on the bottom, its beaver tail flapping to keep its head down in the muck. It shoveled back and forth, like a child pushing food around on its plate. Then it lifted off and swam rapidly around underwater, undulating like a flying carpet, creepy little webbed feet clawing at the water.

It twisted upward and hurled itself onto a log in the middle of the tank. I looked at it, eye to eye. The thick Plexiglas split its body in two, pushing its refracted submerged part a couple of inches to the right. The platypus reached behind its ear and began scratching madly. The twins stood side by side, watching the refracted platypus.

— There are two of them.

— Of course not, stupid!

— Two. One there, one there.

— One. There is one.

— Look. One there. One there. Okay?

— No.

One twin pulled the other one's hair.

The platypus scratched with insane speed and force. Its body twisted abruptly, then froze in an impossible pose, back arched, head twisted upside down, throat facing up. A front leg appeared and reached back, scratching the platypus's flank. A little webbed foot with its claws vibrated back and forth. Its wet fur sprinkled water on the Plexiglas. It twisted its head farther back in an ecstasy of self-stimulation. Then it pulled its rear end in, hunched its back, and brought a hind leg forward to scratch behind an ear. The scratching went on and on. The log vibrated, and hundreds of tiny ripples spread out across the murky surface of the pool. Its eyes closed halfway, then rolled backward in their sockets. It flipped again and dove into the water, headed for the bottom, turned, and swam in circles. The two little girls ran back and forth, giggling, following it wherever it went. It went to the bottom, opened its beak, and troweled a mouthful of mud. Then it expelled the mud and shot up like a missile onto its log. The scratching started up again.

The girls were still arguing.

I guessed its scratch rate was approximately ten scratches per second, almost invisibly fast. It must have been practically dying of itchiness. It never paused more than a second between bouts of scratching.

At last, the girls grew tired of arguing, and the family left. Immediately another family came in.

— Look, Ed, a platypus!

The little boy clapped his hand onto the Plexiglas, but the platypus didn't notice. Four more boys and a girl came in, followed by three adults. The room was crowded.

— There are two of them! the boy cried.

No, there aren't, his father said in a tone so exhausted that I wondered if he thought his son ever said anything intelligent.

— Look, he's got a mosquito bite.

The father was exasperated.

— That is *crazy*, Ed.

Four children banged on the Plexiglas.

The platypus stopped for a long second, then hurtled into the water. Down to the bottom, five scoops of mud, up to the log. Scratching. Stomach up, left hind paw scratching belly. On side, left front paw scratching violently inside left ear. Twist. Right hind paw scratching lower spine. Hanging onto the log with front paws, rear paw scratching flank. Slightly slower scratching under water. The children fought and ran around, hammered on the Plexiglass, tugged at their parents. It occurred to me that if I slapped one of the children, its parent might hit me, and then we'd all be fighting. We'd look as crazy, then, as the platypus.

SCRATCHING AND TWITCHING ROOM, I'd call it, if I ran the zoo. I'd move the Tasmanian devils in here, let them run around with the kids. The tamarins, too, with their ribbons. Then I'd fill the room with mosquitoes. Put up a big poster of the Roseman-Billinger chart. With flashing lights for TWITCHING, SCRATCHING, RUNNING, BITING, PUNCHING.

After that I walked down a path that led into a grove of bamboos. In the middle there was a clearing. A bench overlooked a shaded pit. The sounds of the zoo were quieter there, split and dispersed by the bamboo. The pit was about thirty feet wide. The bottom was mud and concrete, sculpted so a rivulet meandered through it. Toward the back it was planted with a copse of small trees.

I didn't want to see more animals, but I wouldn't have minded seeing Preteen and Bee again. I wanted to ask Preteen if Bee knew he sodomized

devils, if she knew how much he enjoyed repeatedly sodomizing devils, if she thought maybe he enjoyed sodomy. When I'd started the zoo project, I sympathized with the people I met. Abigail, with her budget problems. Dr. Tank, who wished she had a better life. Even Pekka, who had no real sympathy himself. Now I only cared about the animals, and I cared too much.

In a far corner, half obscured by a rock glazed green with algae, two otters were sitting side by side on a mat of dry leaves. Their long bodies were bent in twin sideways S-curves: heads up and poised, shoulders down in the slinky otter crouch, rumps up, tails down. One flinched. Its head moved incrementally to the left. The other did the same, so they were mirrored again. They were touching along the lengths of their bodies.

The one on the right bent into a tighter S, compressing like a spring, and then its head went high up in the air, its front feet left the ground, and its head turned to the right. It bent fully backward, a move that would have broken a human's neck. I saw a flash of white from its neck and belly as its head whipped around, and it landed awkwardly on its partner's back. A half-hearted somersault, like Owole. It was a twitch, a neurotic jerk, and the otter didn't seem to have any control of it, or so it seemed because it landed on its partner's back. The pair adjusted themselves, reassembled side by side, and took a few steps together in my direction.

The first one twisted again. The motion was quick and unpleasant, like a horse trying to throw off a persistent fly, or like a man shrugging to loosen a tight collar. They reformed as a pair and ran rapidly around a couple of rocks, shadowing one another, first one leading, then the other. They leapt across their little stream, one just ahead of the other, and onto a clay bank in front of me. Only one had the convulsive tic, but the second reacted to each move its partner made: once it turned its head a couple of degrees, as if it were listening; another time it jumped forward, stopping and waiting for the convulsion to end and its partner to catch up.

They rested, touching each other along the lengths of their bodies, looking in the same direction. Motionless. One adjusted its right paw a fraction of an inch, and the other did the same. The second turned to look

at something on the far side of the enclosure, at the top of the wall. The first mimicked the second's turn. Then they were still, like taxidermy.

The first flipped again, twice. The second waited out the flips. The two convulsions landed the first one a few steps ahead of the second. Then it jerked its head up, but didn't flip. Maybe it had stopped itself. A break of five seconds. Then three more flips. Like hiccups, like spasms. The second one caught up and they started out again, scurrying, partly running, across their landscape, around a tree and back to where they had started. They settled, side by side.

A young couple came by and watched for a few seconds. They left together hand in hand. The boy was anxious or impatient. He dragged the girl, and she kept her arm in his. He pulled; she adjusted. They fit with each other. Whatever his problem was, she knew about it. Maybe he couldn't concentrate or couldn't sleep. She'd comfort him, saying small things that didn't mean much. When she felt his fingers with the bitten-down nails, she'd squeeze them a little. It was her job to show that she noticed. It was his job to appreciate what she did.

They walked off through the bamboo grove. That's how it is with couples, I thought. There wasn't any reason to worry about that otter, provided it had the other one. Or any reason to worry about the frail gray loris, as long as its even more delicate wife and child followed behind. But Marvin must have felt he was alone. That white animal in its leafy cage had nothing but the branches it held for company. The platypus was disintegrating into a mass of tics.

I tried to stand up, but I was rooted in place. My leg was asleep. I toed a candy wrapper with my tingly foot.

I needed to get away. Really far away, farther than these zoos, farther than the backwoods of eastern Tennessee or the blue forests in Estonia.

I needed to go to some stupendous paradise, away from my job, away from everyone I knew, a paradise, where the world shines so brightly the sun scars your retinas blue. Where the leaves are bleached white and the grass shines like tinsel. Where faces are too radiant to see. A coruscating impossible paradise.

I needed to walk in a grove of sharp palm trees. Their fronds shimmering in yellow-blue light. Where I would be washed by warm evaporating rains, dried clean by the serrated sun. A paradise, almost too strong for my eyes and heart.

I needed to go to a windy island, whipped by trade winds that came from the Southern Ocean, far out at sea where even sea birds don't fly.

A place where the beaches would always be deserted, it'd always be off-season. I could live in a seaside hotel. My balcony would look down on a playground, where swings creaked and whistled in the perennial winds. I'd live there, witnessing prodigious things: waterspouts, entire years without rain. Whales would surface close to shore and turn slowly in the chill waters, rolling in the milling surf, their fins emerging and sinking back as if they were dying. I would stand like those figures on Easter Island and just stare out at the desert ocean, the air speckled with particles of salt and whale's breath, knowing there was no point in sailing that way, no landfall before Antarctica.

The two otters swarmed over their sunken landscape. They swirled around the rocks, spilled themselves into the little stream, then out onto the clay bank.

They froze. The first one twitched. It looked at me for the briefest instant. In that moment I saw it saw nothing.

Eighth Dream

That night the world filled, once again, with fires. I slept suddenly and deeply, gripping the pillow in both hands.

The same dream, I said to myself, still in the dream. Still in the same dream again. I saw whole settlements of fire, villages of fire, celebrating all night long. The night sky was ruined by their glare and the air was poisoned with their charred smell.

The unburnt forest stood by, waiting.

It was pitch dark. I was crouching under some low trees. Their silhouettes trembled against the light. Winds threw their branches back and forth as if they were dancing.

The fires burned very close. I listened, uneasy, as they raged and flashed just out of sight. There was a roar of flames. They wailed like caged animals. In one place the fires screamed continuously for several minutes, spewing dark smoke. Perhaps the fires were suffering, like animals burning in place.

The horizon was sharp, a torn sheet of paper. I watched a cleft on the ridge where the light was brightest. That was where flames would first appear.

The next day I woke, still in the dream. I was standing in a clearing high on a mountain.

That is when I saw flames for the first time.

They were flickering behind a screen of trees. I stood and watched them. It was as if they were looking out at me. I couldn't see them clearly, but they could see me, because I was standing in a field.

A flame peeked out between two pines and glared at me. For the moment, at least, the fires were shy.

The field was cold, but I waited there for some time, wondering if the flames would come out.

After that morning I saw flames everywhere. They taunted me, but they kept their distance.

One afternoon, they whooped and danced along the ridge of a high hill, celebrating victory over land I couldn't see. The flames had funny shapes, like hands waving, like arms flailing.

The place felt ruined, the world felt ruined. People say, "Oh, my life is such a wreck. How did things get this way?" and they don't see it's been a long time coming.

It was as if the flames wanted to run down the hill at me. They jumped up and down like children eager to get a look at something. But they stayed in place. Their rage burned black and yellow.

— Aah, they cried, Aah, here we come.

Later, walking across dry pastureland, I was stopped by a screen of smoke. Flames guarded the way. I could see them at work on the grass, busy at their task.

I walked closer, and the fires jumped up. They see me now, I thought. I need to go.

The flames turned back to their work.

It is only a dream, I said to myself, calling on that refrain dreamers have chanted since the beginning of thought, that refrain that never works, fails to still the imagination, fails to quiet the thoughts or quench the flames or even delay the inevitable disaster.

9

A Map of France

How does time pass? One day the wind is harsh, and the streets are choked with dust. The next day there is sun, and the world seems clear again.

We were still at cruising altitude, between the earth and the sky. For years, I'd enjoyed discovering new places. The Yukon Territory when I was young, Bratislava with Adela. Now the world felt the same from one end to the other. An idealistic young girl in Nunavut, dreaming of a happy family, has the same naïve thoughts as a young girl in Malta. The two girls wouldn't see the similarity, because their imaginary husbands and families are so different, but their dreams are the same. The girl in Malta wonders what the world is at the other end of it. She leans on her sun-bleached windowsill, looking out over a field of orange and blue flowers behind the school. She thinks about the arctic, and how she would live there, encased in ice and snow. The girl in Nunavut, half asleep, peers through the breath-smeared window of her bedroom, watching her sister's children playing naked in the nearly freezing stream. She thinks about Malta, and how she would look out a window there, and stare in sorrow and silence at a barren wall of stone. The two girls' thoughts happen in different languages. The views distract them differently, but soon they are again dreaming about their future families, and those dreams are the same, absolutely and forever the same.

The men they marry will fail them in the usual ways. One will be unfaithful, and the marriage will be torn apart. The other will decide he needs

his space. He'll spend his time traveling, puzzling over what he's doing, wondering, while he walks, why he wanders, always thinking and forever forgetting to go back home. He's a dromomaniac, a compulsive traveler. The signs are all there. If he's not traveling, he's antsy. He needs to get those tickets, that new visa, a better suitcase, a more efficient battery-operated travel razor. He has to pack, get to the airport, see something new, his days need to be filled with wonders and marvels, otherwise they're crap. That's dromomania, it's not a very interesting condition. Millions of people have it out of simple nerves and because they can't think of anything else to do with their lives. Most dromomaniacs get tired of going here and there for years on end to see Grand Canyons and Taj Mahals and Machu Picchus. So finally, the husband reconsiders. He goes back to his wife. They sit down and talk. They end up buying a house by a frozen river in the arctic or a blistering cliff in Malta.

I looked at the soiled back of the seat in front of me. Smudged by the foreheads and hands of many people before me, thinking the same muddled traveler's thoughts. The plane came out of its steady cruise and headed down toward the Basel airport. The passenger at my right was fidgeting. He put his earbuds back in their little plastic case and put the case in the inner lid pocket of his leather briefcase. Then he took it back out and put it in the main compartment next to his computer. Then he picked it up and put it in his left breast pocket. He craned his neck forward to see if the flight attendant could see him, and then he unbuckled his seat belt and looked back down the aisle.

One windy inhospitable airport, coming into view through a bleary airplane window, looks the same as any other. There is the ash-gray terminal with the city's name in giant red or yellow or white letters. In this case EUROAIRPORT BASEL MULHOUSE FREIBURG. It was airport weather, too: stubbornly overcast, pierced by an unpleasant ray of sunlight. People always say the light in their part of the world has something special. Ah, the raking silvery light that skips along the tops of those trees in December, they'll say. So typical of our country. Or, oh, the baking orange haze in summer when the air is thick with pollen blown in from

the upland farms. No other place is like this. Or, ooh, that indescribable feeling of the early spring breeze as it curls around our clock tower and rushes through our market stalls, that's what it's like to live here. But it's all the same. It's the same sky. A cloud, fluffy and summer friendly, caught for a moment on a white steeple in New England, is the identical twin of a cloud, blistered and frozen, tethered to a pinnacle of ice off South Georgia Island in the roaring Antarctic ocean. The stench of car exhaust and uncollected garbage is the same in the grimy streets of São Paulo as it is in the choked developments in Shenzhen. That awful last ray of sunlight glancing off the glass terminal building at the EUROAIRPORT BASEL MULHOUSE FREIBURG is the same ray anywhere and everywhere in the world, glancing off all the terminals right into all the tired travelers' eyes.

As soon as the seat belt sign turned off, the man jumped up as if his life depended on it and rushed back several rows to get his roller bag. There are hysterical people in all parts of the world.

Viperine was hysterical, in her own peculiar way. Her mind was full of bizarre fantasies about parasites, which she loved to talk about in a sultry bedroom voice. She wanted to tell me I am no different from the animals in the zoos, as if that would shock me. She kept sending me messages: Samuel, watch out, you don't know where you're going, as if that's a surprise. Watch out, Samuel, you have no idea what is happening to your life, but don't worry, I can help you because I'm a creepy French woman who loves parasites. Watch out, you're autistic; you're a mass of tics and compulsions; you're lost; you're a fly or a gnat; and by the way, don't you wish you were a tiny parasite clipped to a seabird's eye? I know I do. You and I could travel the seas together, clinging to a petrel's eyebrow feather, just watching the ocean unfurl beneath us, wouldn't that be romantic? We could eat regurgitated seabird spittle. Or how about if we were a pair of lemurs, sitting cross eyed in the jungle in Madagascar, trying to imagine straight lines, and failing, because our minds are lemur minds, and for us parallel lines diverge. Just like two people in life who begin together, belong with each other, but still they diverge, slowly and inexorably, does that sound familiar, Samuel?

When I got back, I'd have to fire her. When she arrived in Guelph, she tried to confuse everyone about her gender, dressing and sounding like a boy, then a girl, then a boy. Rosie used to say Viperine was a boy, and she might be right. Maybe Viperine was just working out her sense of herself. But she couldn't keep writing me those notes. It wouldn't be easy to fire her, I knew, because she didn't actually work for Water Management. She was Vipesh's companion. I could just fire him instead.

The line started moving. The man pushed by me and ran up the jetway. Early spring air gusted through gaps in the plastic apron. I was on my way to the last zoo of the year.

The Hotel Krafft Basel looked like it had been remodeled in the 1990s to resemble the 1930s. Monika Woodapple would have felt at home. In my room a white leather-upholstered rocking chair had been placed next to a battered wooden worktable. Large windows looked out on the Rhine, which was dark and seemed somewhat oily. I pulled up the rocking chair and sat watching people walking along the bank. Their shoes clattered on the wet paving stones. I stretched out my legs, and then my arms, forming myself into an emphatic X shape, locatable by GPS.

An hour later I woke, still in the chair, my passport and room card in my hand.

I showered and tried to gather my thoughts, but they wouldn't. It was one of those days where you pull on your clothes without thinking, because you've done it tens of thousands of times before, except that you take off your socks as soon as you put them on, and then you have to put them on again, and then you take them off, because you can't decide. It might be a long day at the zoo, and eventually all of a sudden there you are, dressed, but the thing that sticks up out of the collar and looks back at you can't possibly be you, because it's a mess. It's older than it should be. It's even got wrinkles. Its eyes are glassy and indistinct and seem to belong to some animal that has no expression, like an iguana or an octopus, where the eyes just sit there like buttons, or like a whale, where the great barnacled mass of the body would be just another rocky outcropping except that there, right in the middle of the scars and fissures, there's an eye, which looks out

of that mass, unmistakably looks right back at you, proving something intelligent's in there, a mind is trapped inside that mountainside of scar and blubber. The eye looks at you and wonders about something.

Karin Günther, the Basel zoo's interim director, met me in the hotel lobby. She was probably unwashed. Her hair was greasy. There was mud on her steel-tipped hiking boots. We walked out into the fresh damp air.

— Excellent that you are here today. It is only seldom that we have visits from our colleagues in North America.

— I'm not a colleague, I said.

She handed me a zoo map.

— Yes, I read your emails. I received an email also from your research secretaries, Mr. P. Vipesh and Ms. V. Pistouriec. They inform me you are a world-renowned expert in animal locomotion, and you have consulted at many zoos. You will look at our elephant. You can tell us what to do.

— It's true, I was originally trained as a large-animal veterinarian, I said, and a small shock of adrenaline ran through me as I registered the fact that my lie would require more lies later.

— This elephant has stomping and circling behaviors.

— I can cure those, I said.

She splashed along the wet sidewalk.

— We suspect it was badly treated by its previous owners, Circus Knie, that's the Swiss National Circus.

— Yes, I have dealt with them before.

I was warming to my role. Yet if I lied continuously, I would never make it through the day. At some point I'd have to run off.

An American family passed by.

— No, the mother said to her daughter. We will not eat at the McDonald's. We did not come here for that.

— Overall, the Zoo Basel is very clean, almost no stereotypies. I have only thirteen things to show you.

— Crap, said the little girl.

— Well, I understand that your bear enclosure has some issues.

That was less a lie than a guess.

— We have no bear enclosure now. It is under renovation, and the bears are in Zürich and Bern.

— I see. Bern? Really?

— I know, but their finances are in order now. The Canton is supporting them.

— I'll buy you something at McDonald's, I called out to the little girl.

Her mother rushed her away.

— I want to go with that man, the little girl said, and burst into tears.

— What I heard is that they are very far from stable.

— Hmm, she said.

At the zoo, she took me down a narrow path to the hippopotamus enclosure.

— Our first exhibit. You will be amazed at this.

As she said it, I was, because less than six feet from me a hippopotamus was gliding by in the water, its eyes level with my shoes. It was in a deep trough of water, which I hadn't noticed, and the water was nearly at lawn level. Between me and the trough there was only a single rope, strung a foot off the ground. That couldn't possibly stop a hippopotamus, I thought, and then I realized the rope was to prevent people from falling into the water. The hippo couldn't climb out of its trough. It glided by, one enormous gluey eye fixed on Karin, rotating and bulging to keep her in sight as it passed. A small hippo came just behind. Their canal went around a bend, like a race-track, and into a fenced-off area.

I was trying to think of something to say that wasn't truthful when a boy came up beside me and aimed a big, old-fashioned umbrella at the receding flank of the big hippo.

— Bang! Bang! Bang!

— Oh, stop, David, his father said, in an English accent. That is a nice hippo.

He tried to take the umbrella, but the boy ran along the rope, aiming and shooting, shouting even louder as the hippo drifted away.

— Die! Die! Bang! he screamed, and then he stopped, and lowered his umbrella gun.

— Why are you stopping? I yelled.

He stared at me, and then at his father.

— Shoot! Kill them!

The boy looked at me suspiciously and walked back toward his father.

— Give it to me, I said. I'll shoot them both.

The father took his son's hand and led him away.

Behind the fence, the hippos' canal got shallower, and there was a place where they could climb out. The big hippo had a hard time getting up the bank.

— The current carries them around this loop to the visitors, and then back into their habitat.

— This display is inappropriate, I said. Hippos are easily disoriented and prone to vertigo.

— Vertigo?

— You should read the literature about hippo water parks. The hippos do very poorly. Yours are probably dizzy from going around your canal.

— I don't think so. What is a hippo water park?

— It's an enrichment idea. They come down slides and make enormous splashes, kids love it but the hippos get nauseous. Also, hippos dislike steep embankments because they live in swamps. Their bone mass isn't sufficient to enable them to climb up your concrete embankments. Sooner or later one of your hippos will hurt itself, and then it will be swept around and around in your hellish canal. You're going to need a net and a tow truck haul it out.

I looked at my folding zoo map, which was unnecessarily complicated.

— Actually, this is a close approximation to their wild habitat. They use the river loop every day.

— For heaven's sake, Karin, you need to read the literature. These hippos are at stage two or three disorientation. After that comes eye-rolling, nausea, and vomiting.

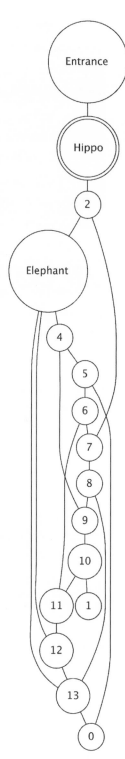

— I'll look into it.

— Hippo vomiting, you don't want to see it.

She took me down another path toward the elephant area. It turned out the elephant with the stereotypical behavior was asleep in its inner enclosure.

— Okay, wake it up, I said, looking at my watch.

— I do not think so, she replied, but she didn't sound certain.

— I would prefer to examine the elephant now.

Lying isn't easy, I thought. You have to pay attention, and you have to be ready for the consequences. What if she asked me to wake it up?

— Let's get a coffee instead, she said.

We walked on past the elephant enclosure to the zoo's open-air café.

— We hope the elephant might stop pacing and stomping if we enrich its environment. We will soon begin a trial. We will introduce smells. It has been discovered that spoor of other elephants can have an energizing effect. Zürich will send us some of their elephant spoor.

— I've never heard of that, and it sounds insulting. Elephants are supposed to care about each other's crap?

The coffee was absurdly bitter. Karin drank hers without noticing. I pushed mine to one side. Another American family was sitting at the next table. The father was watching his son play a video game.

— That's it, he said, you've got it. Push them. Use the crowbar. One, two, three.

The child hesitated.

— Push. Do it now.

— If that does not work, we will try other smells. The mammals curator in Bern said we should try lion's scat.

— You have been communicating with the Jacksonville Zoological Park.

— I do not know them.

I was silent a moment to express stupefaction at her ignorance.

— Well, they tried it, and the elephants became agitated. One is now on medication for a heart condition.

It was stupid to name the zoo because she might contact them. Hopefully she'd forget by the end of the tour.

— In general, I continued, olfactory enrichments are unsatisfactory. They have tried all kinds of smells: tobacco, perfume, spices, tiger urine, lion urine, antelope urine…

— Wow.

— Horse urine. Turtle urine. Fish urine.

— How do they collect fish urine?

— Human urine. People have tried pissing into tiger enclosures to subdue rogue females. The zoo in Karachi tried that. There are literally dozens of studies. I can send them to you. Smells distract the animals for a while, but they get used to it. It's an old strategy, and it hasn't been used by the North American Zoo Association for several years now.

— Yes! Yes! Now lock them up! Now, do it now!

The boy's face was inches from the screen.

— The Turin zoo broadcasts sounds to its elephants.

I gave her a skeptical look.

— Birds from Kenya. Captive-born animals do not respond. But wild caught animals become calmer. Our elephant was collected in Zambia, and then it spent thirty-one years in a circus. We could play birdsongs from Zambia. It might remember.

— That's an old strategy. It's not likely to work.

The boy turned away from his father, hiding the screen. His thumbs were moving furiously.

— Okay, okay, great, the father said. Now there's going be monkeys jumping on your head.

He moved his chair back to talk to his wife.

Karin led me down the zoo's main avenue.

— There is another possibility, she said. I have heard about a study of stereotype modification in dogs, which may work.

I raised my eyebrows, perhaps a bit too theatrically.

— I understand that when a dog has an unwanted behavior like barking, a trainer can select for that behavior and begin a positive training regime.

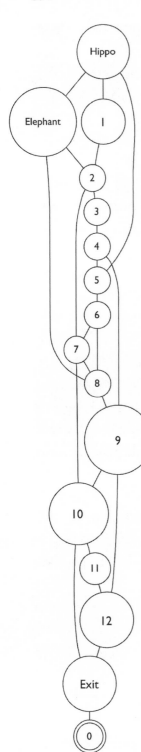

The trainer actually rewards the dog for performing the bad behavior. Then the trainer stops asking the dog for the bad behavior. The bad behavior disappears.

— There is no way that can be right, I said. Is it in the literature?

— Maybe not, it is something I heard from a trainer.

— A dog trainer.

I felt like a cat that's discovered a baby bird fallen from its nest. It's like a gift. The cat can paw at the bird, mashing it, pricking it with its claws, taking care not to kill it. If I was careful, I could keep Karin alive for at least an hour.

— Let me explain how wrong this idea is. Say it's a person, not a dog, and you're a therapist. Say your patient has a neurosis, like a repetition compulsion. He puts his socks on, and then he takes them off, and puts them on, and takes them off, a dozen times each morning. That's actually common. Then you say to him "what you're doing is not a symptom. It is an achievement, congratulations."

— I suppose.

We passed an enclosure full of flamingos standing knuckle deep in an outdoor pool. One swept its head back and forth across the surface of the water, eyes down, using its bill to scoop algae. Its legs moved in rhythm, knees double jointed forward, backward, forward. Numbered metal bracelets jangled above each knee.

— Cold.

— The pool is heated, actually.

— Well, but you know artificially heating outdoor pools produces efflorescences of spirochaetes and free-living amoebas, which can cause respiratory infections and diarrhea.

— Our flamingos are healthy so far.

— There are at least ten kinds of respiratory infections that have been documented in tropical birds kept in cold climates. I don't know about flamingos specifically, but I really don't see why they should be any different. Amoebas of several different taxa cause intestinal issues in birds, which can result in sulfur-yellow diarrhea, liver abscesses, oh, and feather loss, and crumbling bills, that's when the bills become chalky or powdery. The bills fray or break, to the point where the bird is unable to feed itself.

Lying is like dreaming, I thought. There needs to be just enough truth to keep the dreamer asleep, to make it all seem plausible. While you're dreaming, the part of you that's making up the dream is back there somewhere, inventing things, improvising, trying not to mess up.

— Our avian expert has not mentioned that.

— Okay, that is repetitive behavior.

— What?

— The bird that is feeding. It's stepping back and forth for no reason.

— They do that a lot. You may be overly sensitive.

— I am not, I am a specialist on this subject.

— Bang! Bang!

The English child shot his umbrella gun at the flamingos.

— Our avian expert is Reinhold Fasching. I will ask him. He is one of the world's most respected experts on tropical birds.

I shrugged.

— I'm just trying to help you.

The boy's father was nowhere in sight.

— Kill, David, kill! Kill them all! I yelled. Aim for their throats. When you shoot them the necks snap off.

— Die, fuckers! the child yelled. Then he ran off to the next enclosure.

— That's horrible, Karin said. Why do you encourage him?

— In Guelph we're going to have toy guns mounted outside some exhibits, so children can practice shooting.

— That's horrible.

— Well, you may think so, but studies show that children's aggression is natural. Also hunting can be utilized as a productive learning environment. When people hunt, they look closely. Children learn to observe closely, see the vulnerable parts. That way they remember the animals, and maybe in the future they care more for them, or at least maybe they want to go shoot a few.

So back to the example. You might convince your patient that it's an achievement to take off his socks forty-nine times each morning, and then to put them on fifty times each morning. But repetition disorder in humans is connected to serious mental issues. Maybe your patient's only release is his ritual with his socks. Your patient knows something is wrong with him. He is depressed and anxious. And all of a sudden you tell him he's healthy? That could have serious consequences.

Like a dream, I thought. I am lying to keep myself asleep, so I don't have to be in this world. If I stumble, I may have to get serious. Karin will realize I am lying. She'll want to know why, she'll report me. There'll be all sorts of trouble. And I'm also lying to keep her quiet, so she doesn't tell me things about the real world, because those are worse than what I am making up.

Each new zoo had been putting me deeper to sleep. I was sleepwalking through my life, flying from Tallinn to Knoxville to Basel without waking up. Even on that day in Basel, trying to orchestrate my lies, I wasn't entirely sure if I was awake, I mean really awake. I cushioned myself by daydreaming that I was dreaming, or even dreaming I was daydreaming, it didn't really make a difference, even though of course I was awake and having all sorts of random encounters, but I was folding them gently down into my dreams.

Plenty of people sleepwalk through life. It's nothing remarkable. People like us don't get up in our pajamas and walk around in the middle of the night. We are always in pajamas. We are asleep all day. We are in pajamas at work. We're in pajamas when we're getting married. We're in pajamas when we're walking around a freezing island in Helsinki. We are the incurable, un-wakeable somnambulists, sleepwalkers for life. People like to say life is a dream, and it can be if you make it that way by lying.

Karin stopped to look into the wombat pen. It was a field of mud. In the back, a big round wombat had fallen asleep on top of a teddy bear.

— And so, you praise the patient for taking off his socks forty-nine times each morning and putting them on fifty times. Well done! you say. Very dedicated. Great work. And then just when your poor confused patient is becoming a little confident, a tiny bit proud of himself for the first time in years, you take away your support. He goes back to putting on his socks just once a day. Well, you have destroyed the symptom. Congratulations. But here's my question, Karin: What have you done to the underlying condition? When your patient performed his repetition disorder, when he put on his socks, and then took them off, forty-nine or fifty times a day, he did that to control his life. He is suffering from a trauma that is not conscious. That is the purpose of a repetition compulsion, according to Freud. It protects a person from thinking directly about traumatic memories. Anything that repeats over and over in your life is like that. Pulling on the sock is like remembering, and pulling it off is like forgetting, and pulling it off, I mean putting it on, is like remembering, and so on, it's soothing, he doesn't know what he's doing. He is helpless, he's a child. He doesn't understand. He knows he's sick and the socks keep him calm, and that's all he knows. And then you take away the one solace he has.

Probably the same with the cat, I thought. It doesn't think because it is too busy torturing the bird, and that keeps it healthy, keeps it a cat.

— I suppose. I have not studied psychoanalysis. I wonder why does Matilda love her teddy bear so much?

— Sleep is the ideal state. Everything else is illness.

It's really the same with me, I thought. I comfort myself with this dream business. A person like me likes to tell himself he's a secret to himself. It's a point of pride, as if it's an accomplishment not to understand yourself, it makes you deep and fascinating and helps you ignore the fact that you're anankastic, that you have a disorder which requires professional attention. People who are anankastic can continue that way their entire lives. They may even get worse. They may never settle down, never go back to their

snug little house in Nunavut or their dilapidated farm in Malta or their nearly empty condo in Guelph.

Karin got a phone call. I walked a few feet away, next to two women and two children. Their kids were entranced by the wombat and its toy.

— Fatso loves fatso, one of the children said.

— I just want to say how lucky I am, one of the women said. How privileged I feel to have been able to work with you, to count you as a friend, to be able to come into your office and hear your ideas. I hope we can stay in touch.

— Oh, thank you, her friend replied. It has been a pleasure. But I think—

— I do have a question, the first woman said. If you don't mind. I want to have the benefit of your wisdom. My question is: where should I go now? I want to stay true to the strategic stuff. Should I go entrepreneurial? Or corporate? Right now, I think I want to do more work with emotional intelligence. I won't necessarily dive into higher management at this point.

— I'm sorry, her friend said, I can't help you with that.

— Fatso on fatso action, the other child said. He's doing it.

— Don't be rude, I said to the children.

They looked at me like I was about to hit them.

— Wombats are not fat, actually. You are both skinny. The way you look is your fault.

They looked at their mothers, but they hadn't heard.

— Definitely, the woman continued, I am spending a lot of time and energy developing my deeper in-depth knowledge around emotions, being able to digest that information and take it out into corporations, but it is not always therapeutic, if you see what I mean. That's one area I'm interested in. Another is taking a stance in relation to women and corporate development. Those things are all percolating for me.

— Oh, for god's sake, I said.

They turned and stared at me.

Just then Karin came back. We walked over to the next pen, which was for peccaries. It was simulated grassland, and the peccaries' paths were

clearly visible, all figure eights with multiple loops. Just what I was supposed to be studying.

— Notice the log there, she said. These peccaries have stereotypical abnormal pacing. We put barriers to help them discover new paths.

— That's awful, I said. Some wild animals follow stereotypical paths even though they don't have to. They prefer stereotypical paths. There is loads of literature on that. Everyone knows it.

— Their paths disturb the zoo guests. One visitor said it looks like our pigs are in prison. This way they have to go around the barriers. They make new paths. Our guests can see they are exploring.

— I just told you there is literature on wild animals, like deer, like coatimundis. They prefer paths even in the wild.

It hurt a little to say something true. If I kept going, I would be the one who'd wake up, and I wouldn't have upset her at all.

— Peccaries are intelligent, I said. They are aware that you're torturing them. They just haven't figured out why. When they do, they will charge your fence.

— We'll see. For now they are fine.

She twirled her greasy hair.

The next enclosure was for nutrias. Several large, repellent, rat-like specimens were lolling in black mud. One arched its rodent back. The rangy hairs on its spine bristled, popping out of the dried mud that caked them.

— Nutrias are easy to keep, she said. They tolerate—

— Never mind, I said. I'm not finished discussing the dog training idea. This is basic stuff in psychoanalysis. Originally, the patient has a repetition compulsion, which of course he knows about, because how can you not notice something's wrong when you need to put on your socks, and take them off, and put them on, and take them off, and put them on, and take them off, and put them on, and take them off, and put them on, ninety-nine times every morning? The patient knows he is in trouble, but he doesn't know what's wrong with him. So you go up to him, he's in despair, but you pull up your chair right in front of him, so your knees

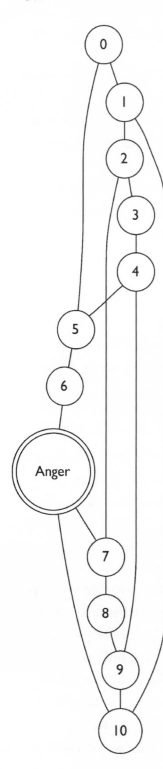

are almost touching, and you say "your feet are lovely. I love the way you put your socks on. Do it for me," you say. "Put them on. Beautiful," you say. "Now take them off. Oh, great. Slower. Go slow. Let me watch. Beautiful. Do it again. Put them on again. Flex your toes. You have magnificent feet. Can you do me a favor? Take them off again. I love to watch. Yes, yes. Now faster. Faster. Again, again. I love it. I love it." And then, according to your dog trainer, when your patient comes back the next week and starts acting all seductive with his socks, you say "that's okay, I don't need that anymore. Keep your shoes on, you're fine. Oh, and by the way, you're cured. You can go home."

She was wiggling her finger at one of the nutrias.

— I think you should see the hyena enclosure. It's over by the Schwanensee gate.

As we walked away, I looked back. The nutrias were staring at me. They had horrible faces, like fish eyes glued onto muddy fur.

— So, this is how I see your idea of the dog cure for your elephant.

— Not my idea. It was a dog trainer.

— You are taking it seriously and so am I. Using a psychoanalytic model, for example Freud's first topography.

I shot her a look to make sure she didn't know what I was talking about.

— You have a repressed idea that is potentially so traumatic that the psyche needs to keep it bolted down in the basement of the

unconscious. God only knows what that horrible idea is. Freud's patients were shell-shocked veterans of World War I. The world had assaulted them. They had seen and done things. They had compulsive thoughts and screaming nightmares. So your patient goes home. He is depressed and confused. He does not feel cured. When he goes to bed he has the same dream he always has, every night as soon as he falls asleep. The dream is horrible. He has stepped on a landmine and he is being exploded, in slow motion. He feels his legs being pulled free of his pelvic girdle by the force of the explosion. His legs distend, in ultra-slow motion. The skin stretches. The muscles pull and rip. The bone snaps and shatters. He looks at his mangled body. Why does he have this dream every night? Because he was traumatized by what he saw in the war. He wasn't ready for it, and so his mind helplessly, hopelessly, uselessly replays the same dream every night, in an attempt to get him ready for something that is, in his mind, about to happen at any moment, but which has, in fact, already happened.

I affected a scowl that I'd seen in a photograph of Freud.

— The soldier, the dog, the elephant, they are all just trying to keep themselves going. Your circus elephant is shocked by years of slavery. Carry that clown on your trunk. Put the clown down and pick up that ballerina. Bounce the beach ball. Spray the clown with soapy water from that basin. Put your front legs up in the air. Climb up on that box. Lift the acrobat on your tusks. Take the oversized cookie in your trunk. Balance on your front legs and put your rump up in the air. Put your front legs up on that elephant's rump, as if you wanted to fuck it, but don't. Stand still while we insert this douche. Bend down so we can put on your maid's frill and miniskirt. Stand still while we wash your infected eye. Lie down so we can operate on your tooth. Step back while we hose down your excrement.

Every day the circus elephant has to come out for a show. Then it has to go back into its pen. Every week there's the state-mandated medical exam. Then it's herded into its metal trailer and driven to a new city. Finally, the elephant is about to crack. It hears nothing but static. It no longer recognizes its handlers. It is going insane. It develops a stereotypy, like rocking back and forth or pacing in circles, or—

Suddenly I ran out of ideas.

— Okay, she said.

— Repetition compulsion works like this, I continued. Some idea, some terrifying experience, has to be kept away from the soldier's conscious awareness. It has to be hidden from him, buried, kept secret from his waking self, his waking mind. Over and over, he dreams the same thing. The dream becomes stronger. If he does not resolve his trauma, eventually the dream will invade his life, it'll overrun his life. Same with the socks. If ninety-nine times each morning isn't enough, then that patient will develop more repetitions. Maybe he will put on his underwear and take it off ninety-nine times. Or all his clothes, one at a time, ninety-nine times. Or he'll wash his face ninety-nine times each morning. Or boil his eggs for ninety-nine minutes. Or call his mother and then hang up and call her again and hang up and call her again and then hang up and call her again and hang up and call her again and then hang up and call her again and hang up and call her again and then hang up and call her again and hang up and call her again, ninety-nine times each morning. Eventually he will break. He will—

Again I ran out of ideas.

— That is awful.

— Yes. So, the psyche develops a routine of repeated actions in order to distract the conscious mind. Some people tap every light pole on their way to work, or try not to step on cracks in the pavement, and if they miss and step on one crack, they have to go back, all the way home, or else worse things, like they pull out a small pinch of their hair every night, or make a tiny cut on their forearm with a straight razor every day.

I made a pinching gesture and dragged my fingers across my arm.

— Until they use up both arms and start notching their legs as well, or they find a cigarette butt on the street and just pop it in their mouth, playing that horrible game of torturing themselves by putting the butt in their mouth every time they see one, or I guess each time they have been careless and stepped on a crack, or each day they have skipped

cutting themselves, or each time they lost count while they were putting on and taking off and putting on and taking off and putting on and taking off and putting on and taking off and putting on and taking off and putting on their socks they punish themselves by putting cigarette butts in their mouths.

— Is that real?

— Those are case studies, I said, adopting a grave tone and shaking my head.

— Hyenas are down this way.

— We all have touches of obsession compulsion, like tics and punding. The serious cases are people who can't stop doing what they're doing even if it is self-destructive, even if they frighten their friends and drive away the people who love them. The ordinary cases, like you and me, we've probably tried that game of avoiding cracks in the sidewalk, or we've put old cigarette butts into our mouths once or twice.

— That's gross. I have never done that.

— Well, okay, I have anyway. Also, have you ever lit a cigarette and tried smoking it backwards? With the lit end inside your mouth?

— God, no.

— You should, it's an Indian thing. Reverse smoking. It looks very cool. The hot ash burns behind your teeth, but it's worth it. My point is that all repetitive behavior is done to keep some unacceptable idea away from us.

I turned and cornered her against a high wood fence.

— So now with this canine therapy, Karin, you are taking the symptom, which is the last hope in the tortured mind of the poor animal, its last attempt to keep itself upright in the world, and you're taking it away. Say it's you. Say you're the one in trouble. Say the little boat of your mind is leaking.

I tapped her forehead, which I thought was a nice touch.

— You're madly trying to bail it out, a cupful at a time, as quickly as possible. Cup after cup. The boat is pitching and the waves are getting higher and water is sloshing over the sides. You only have a coffee cup. It's not going to be enough, but it's all you have, so you keep bailing. Two cups

a second, three cups, as fast as possible. There's more and more water in your little boat, Karin.

She was nodding to placate me. Her eyes were wide open.

A group of teenagers was standing near us, looking over the fence at some monkeys in a stand of trees.

— Personally, one said, I think there are more important things in the world than that. I try to focus on the really big issues, you know.

— You need to know, the teenager's friend said. It is totally important, these things. You need to get it right.

— So there you are, just barely hanging on. Just like your elephant. And just before your little boat is swamped, just before your entire psyche becomes one enormous open wound, just when the pressure is building up on the internal organs of your mind, when they're ballooning out with the pressure of your impending insanity, just when psychosis is pressing on the thin stretched film of your mind, pushing so hard that you can see its warty shape through the rubbery membrane that keeps you sane, just then the well-meaning but misguided keeper, I guess that's you, she tricks you, I mean you, the elephant, into giving up the one thing you have left, that's your sad little stomping and pacing.

— I have a very authentic relation with myself, another teenager said. I have my motto on my bathmat. Sometimes I read it over and over in the morning.

The American family came up and stood on the other side of us.

— Look, Seth, the boy's father said. Put down your phone.

— What's your motto? I don't have a motto.

— You should totally have a motto. My bathmat says FEET FIRST, HEART LAST.

— If you try this therapy, your elephant will be in real danger. Its poor damaged psyche will suppurate. That is Freud's own word, suppurate. It will burst. It'll herniate. You will have a psychotic elephant, a rogue elephant. Your elephant will become unreachably insane. If you are that elephant, you will grab your keeper, I mean you, and smear her back and forth on the ground until she is a soft red pool.

— I have a crazy house life, the first teenager said. We all think about crazy stuff. I invent new mottos, and I sing them. I'm like Bob Dylan slash Bruce Springsteen slash Snoop slash Crash slash something.

— So am I, her friend said. You have totally got me in the habit of winking. Now I wink all the time, I wink too much.

— No, Seth said, looking at his phone. No.

— Hey, I said, can't you see your son hates you?

— Hey Seth, his father said, looking at me. Here's a good one. What did the guy say to the monkey just before he cut its tail off?

— Dunno, Seth said, still looking at his phone.

— Well, it won't be long now!

— Oh my god, that's so funny, I said. You're such a good parent. Karin pushed by me in slow motion. I turned to the teenagers.

— I have a motto too. I have a tattoo of it. Want to hear what it is?

— What is it?

— "Eat shit."

— Asshole, one said under her breath.

— Wow, I said, how did you know where I tattooed it?

I ran to catch up with Karin.

A small child carrying one of its shoes in its hand half-ran, half-hopped in front of me. I stumbled to avoid it, started to fall forward, and staggered a couple of steps. The child went up to its mother and held up its shoe. I gave her a ferocious look. She glared back.

— Your child is unbelievably clumsy, I said. Maybe you should keep her at home.

I walked ahead a few steps and caught up with Karin.

— All that business about picking up cigarette butts and putting them my mouth, I said loudly, in the direction of the mother, I really enjoyed it. Yum, yum, I love old cigarette butts. But now you never ask me to do that. I think you don't love me anymore.

She turned her child around and they walked back down the path.

— If you're that girl, Karin, your mind is a mess.

I put my finger on her forehead.

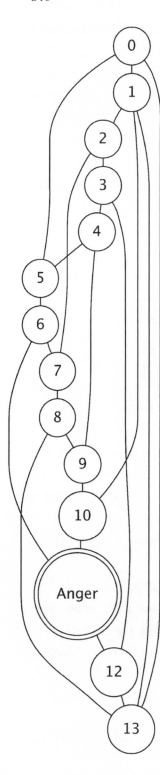

— I suppose the advice from the dog trainer will not work, she said.

She glanced sideways at a path that led to the aviary. Be like the cat with its little bird, I reminded myself. Don't mangle it up too much, that way you can do much more damage before it dies or escapes.

— So Karin, here's what I think you should do. Say I have been making little slices in my arms or legs. One short slice each morning. Say I have been doing that for a long time, scarring and healing, until one day I am discovered at the office with blood soaking through my shirt in a hatch-mark pattern, and I end up in therapy, and the therapist says "I want more of that, more cutting. It's wonderful. I love it. Please show me a fresh cut each session. Make sure it's not an old cut. I'm going to ask you to remove the bandages. I need to see the red inflamed skin on each side of the incision. I think it's a great thing you're doing, Samuel, a really wonderful thing. It's your best attribute, your finest accomplishment. It means health, strength, empowerment. Your life is your own, Samuel! You're in control!"

— Mm.

Her eyes were on the pavement.

— Okay, so then imagine I do that for a while, a new cut each week, nice and neat. Rows up my thigh. Almost healed at the bottom, inflamed farther up, bleeding at the top. Fresh for my analyst. She praises it. She notes how well I have lined up all the cuts, heading up to the crotch. My arms, too, down into the armpits and over to the chest. That goes on for a couple of months, and then one day I roll up my pant cuff to show her the latest mark,

and she isn't interested. "Let's not talk about that today," she says, and we spend the hour talking about how I lost my virginity to that spotty girl in junior high School. The next week, I'm anxious for the therapist to see the newest cut, to praise it. I show it to her right away, but it's as if she doesn't like it. "That's fine," she says, like a mother who is tired of her child who keeps going out and picking her wildflowers. At first she loved getting flowers, but now they're just boring. She thinks her child is insincere. My therapist doesn't reject my cuts, or tell me to stop, but she seems to lose interest, just like your expert dog therapist said. Slowly, over a period of weeks, I decide not to cut myself anymore, because my analyst doesn't care.

— Okay, okay.

— Or trichotillomania! Say I am a teenage girl. I take a pinch of hair from the top of my head, every day, and yank it out.

I pretended to pluck some hair.

— There's a whole ritual, probably. I turn my hair around my fingers before I pull it out.

I pointed down at the top of my head and made a twisty gesture with my index finger.

— The hair gets oily. Squeaky. It annoys me. I feel itchy.

I grabbed a handful of my hair. Karin's face was impassive. Maybe this wasn't shocking for her. Perhaps she did the same thing. Maybe I should get her to confess.

— I hold the hair tight. Then I just pull a pinch out, a dozen hairs at a time. It hurts so hard my eyes tear up. But for a while, I don't itch.

— I get it.

— So that goes on for a long time in secret. I watch that spot on top of my head to make sure no one can detect where I've been pulling out the hair, but of course eventually it gets obvious, so I comb some hair forward over it, it's easy when you're a teenager and you have lots of nice thick healthy hair. But after a while I have to wear hoods and scarves.

— Right. You don't have to—

— I know I'm headed down a wrong road. I see my life closing down in front of me. I count the hairs I have just pulled out. I measure the bald

patch with a millimeter ruler. I allow myself one hair an hour, or up to exactly twenty-four hairs a day. Sometimes I let myself heal for a few days, sometimes I don't. I pull one patch until it's clear. It's complicated. I can't explain it, but I have a system.

I brought out a diagram.

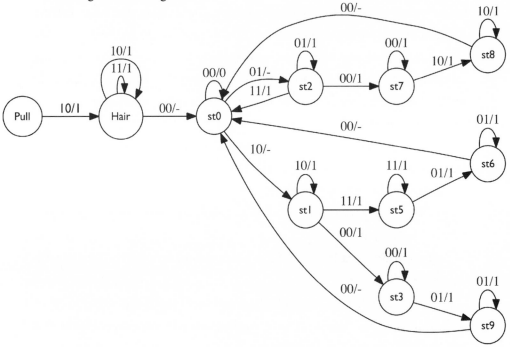

— This is a progressive scale of hair pulling. The patient flipped a coin to decide how much hair to pull. Zeros and ones for tails and heads. She drew this chart for herself and followed it fanatically. She had bald patches all over her head.

— Sorry, I don't understand that at all. What are you saying, exactly?

— It's complicated. Say I am doing this. If I keep going at my full permitted rate, I will have male pattern baldness in eight months. That's what this patient called stage eight, where people whisper to one another "oh my god, look at that girl. Let's cross the street." But there's also stage six, patchy bald. That's where they say "oh Jesus, what's happening to her? It must be cancer. Let's cross the street anyway." She devised this system to get her to stage nine, which is sustainable pulling.

— Samuel, Doctor Emmer—

I put the diagram back in my notebook.

— Of course it is terribly hard to keep to my system because my hair just tempts me, it teases me. It waves when I move my head. It whistles "yoo-hoo! Pull me out!" Eventually my mother confronts me. I end up back at the therapist. I expect him to be all superior and silent. But I am in for a surprise, because he's been listening to your friend the dog therapist. He says "ooh, Karin, I love what you've done with your hair. That bald patch is so cool, so different." I'm blushing, including I suppose my bald patch. "I'm just sick of all these patients who look the same. Be yourself, that's what I think." He leans forward, which frightens me, and I go all tense. He lowers his voice. "Please make me a present," he says in a husky voice. "Don't stop pulling out your hair. You have a lovely little bald patch, and I want to see more."

— That's enough.

— Wait, I'm almost done. I shrink down in my chair. "Keep pulling," he says, "until it forms a map of France. The hexagon, they call it, because the country has six sides." He sits back, not looking at my face or my body, but at my very top, my bald patch. I am entranced. I go home, I get a map of France. I stand in front of the sink in the bathroom, turn my head down, hold my mother's big green plastic-handled makeup mirror in one hand, and peer into her small compact mirror with the other. I arrange the mirrors so I can see the top of my head as my analyst saw it. I notice the bald area doesn't really have a shape. But I see potential. I consult the map of France. There's a big protrusion on the west side, labeled Brittany. It ends like a pointy nipple, labeled Brest. A naughty name. I pull out two clumps of hair that will be Brittany. It hurts to do two at once. I pull a third clump, and a fourth. Soon I have the little nipple shape. My eyes are streaming tears. I am flooded with happiness. One of my branching futures isn't a dead end after all: it's a rainbow, glowing with love. If I can be bald France, my therapist will love me. The next day I study the result. I put gel in my hair to control it so I can see my map. It is perfect. The next session I show him, and he is delighted. We discuss how to do the irreg-

ular coastline. Should we try to show Monaco? Should we leave a tuft of hair in for Paris? Paris surrounded by a desert of scalp: great idea.

Karin stared determinedly ahead.

— Over the next couple of months, I begin to feel spectacular about myself. I am an astonishing work of art, a living map, a unique person in the entire world. My therapist loves what I'm doing with myself. I am so happy I could shriek. My mother suspects something, so I play morose and mopey. I am totally cured, but I am also inside my own illness. It's like being in a wonderful dream where you're married to a prince and you're eating only honey and peanut butter or whatever a little girl might say along those lines, even though you don't like honey or peanut butter and you basically have to choke them down but it's worth it because the prince is a pretty great guy except that he has this obsession with honey and peanut butter. This is all in the patient's second diagram.

I unfolded it for her.

— See, love at the end. That shows the hope she had.

— Ugh.

— Of course that is when the horrible thing happens, the thing you're planning on doing to your poor elephant. Back to me. My therapist starts losing interest. "Never mind finishing the map," he says, "it's nice but I'd rather talk about your friends in school, and that boy you've been dating. His name is Samuel, right?"

I paused for effect. That was a good touch.

— The next sessions are confusing and painful. I make the map a total masterpiece. One evening I get out a brown felt-tip pen and outline all the provinces and I get a blue felt-tip pen and draw in the major rivers. I even letter *Paris* in curving capital letters around the proud tuft of healthy hair that remains at the top center of my map. I get a tiny dentist's rubber band, the kind they use for retainers, and I tie the tuft into a little pig-tail. I show him, pushing my head forward, looking at his shoes, glowing with pride, and he says, "Yes, very nice. But let's put that off for a while. I am more interested in this fellow Samuel, the boy you said puts cigarette butts in his mouth."

No discernible reaction from Karin.

— Over the course of a long hot summer, my therapist loses interest. He stops asking and I stop showing. He only wants to talk about Samuel. He tells me Samuel says I have spots, but he likes me anyway. He seems to know Samuel. He says Samuel has prospects. He wants to become a veter-inarian. I retreat into a state of confusion. Am I being good? Am I cured? Or am I worse off than ever? My life is a disaster: I can't figure out how to get my therapist to like me. I have a big fight with Samuel. He's always eating cigarettes. I tell him he's disgusting.

A large animal snorted and snuffled behind a high wall.

— Now I just sit around the house. My hair has pretty much grown in. I remember how it used to itch. I was very sad then, but I don't know why. What was bothering me? I used to have a secret shameful collection of pulled-out hair, a pretty insane thing to have, and then I made myself into a picture of France for a man who loved me just for the top of my head. I

was a cartographic exhibitionist. This is how the girl would be thinking, right? Paralyzed, confused, hurt. Full of love and self-hatred.

We came to the hyena cage. A group of five or six were asleep in their artificial cave, draped over one another like a lumpy blanket, breathing heavily and quickly. I turned around to face Karin, making what I hoped was a nice composition with the hyenas behind me.

— I no longer know who I am.

I smiled, trying to look like a little girl.

Two women in track suits stood near us.

— I have the mood swings, one said, but when I'm down, it's like it's the end of the world.

— Fight it, her friend said.

— That's the end of my story, I said.

— Good.

The two women leaned against the railing, looking at the hyenas.

— The only reason I moved back home was because my mom was having surgery. But having nine people in the house is ridiculous. The girls have the upstairs bedroom. Fred and the others are in the basement. My mom stays in the living room because she has a neck brace, and she can't get up and down stairs.

— Well, the first woman replied, it's like I said. I'm not joking. I put three men in the hospital. Broke their bones.

— I bet they all deserved it.

— Absolutely. Especially my ex-husband. I hit him on the jaw. Broke it. Not just bruised. Broken.

— So Karin, here is the psychoanalytic theory behind that story. I will sum it up in four images.

— Oh, please don't bother.

— No bother at all. There are four things in the girl's mind. They drift around like chunks of boiled meat in a soup. Number one. The half-dissolved remains of her earlier self when she was healthy. Number two. Her horror movie twin, the one who spent her time itching and pulling. Three. An abnormal twin of that twin, an extra twin of the girl with the repetition

disorder. She is dressed like an angel. She glows and beams, she's full of secret pride. She is the symptom, created by the therapist, that's you, because you're the one who insisted that hair-pulling is a lovely thing—are you following me?

— Of course I'm following you.

— Number four. An extra double twin, a third twin! Another girl who pulls her hair, but this one is desperately sick. She's poisoned by neglect. She's been discarded. Forgotten. She's still dressed like an angel, but her dress is dirty, and her hair needs a wash. Like yours.

— What?

— And her boots are muddy. And there's a dribble of blood on her front.

— Oh, please, Doctor Emmer.

— Do you know who this fourth girl is? She is the one you made. The little girl is ruined, and it is your fault. These four little versions of her drift around inside the poor child's mind, rubbing up against one another, holding onto one another, like the limbs of naked people crowded in a hot tub, feeling each other, pushing up against each other, touching.

I smiled at her with my little girl's smile.

— You could win the most dangerous waitress prize, the second woman said.

— I'm harmless, her friend replied. Only don't touch me. Just don't touch me.

— Wait a moment, Karin said, I have to talk to that man.

She went around the back of the hyena cage where an attendant was standing with a utility dolly.

I held the cold metal rail in front of the hyena cage. My heart was pounding. I had pummeled the bird, pricked and prodded it. It was damaged, it was going to have little bird nightmares. It'd been such fun.

The hyenas' bodies heaved in a quick rhythm. The grass in front of their cave was scored with stereotypical paths, like in Monika's diagrams. A wet wind brought an unpleasant smell out of the cave, a mixture of mud, hay, and the odor of animals that never clean themselves.

Karin appeared at the back of the cage and yelled to me that she was sorry to go, but she would meet me at the zoo entrance in twenty minutes to say goodbye. She and the man with the dolly went into a service building. Her shouting had woken two of the hyenas. They ran around their knotted paths like race cars, narrowly missing one another.

— Show me again, the second woman said.

She twirled around, arm out, fist clenched.

— Like that.

— So great, her friend said.

— Come here, I said to the two women.

They turned around but didn't move.

— I am an animal welfare specialist from Canada, and I am inspecting the zoo to see why its animals are continuously sick. And it's because of people like you.

— What?

— You're loud and aggressive, both of you. But especially you.

I walked up to the woman who had been punching the air.

— You need to back off, she said.

— You need to watch your tone. I am an animal welfare specialist.

— Big deal.

— You're aggressive. You're full of hatred. The animals see you, and they get enraged. Look at them.

The two hyenas were pacing wildly. Just then the boy with the umbrella gun came up.

— Hey David, I called out, want to shoot a person? Shoot her, she deserves it.

He stuck his umbrella gun into her stomach.

— Bang! Die! he yelled, poking her. Bang! Bang! Die!

— Fucker, right?

— Bank, fucker! Die!

— See what it feels like? I said.

The boy's father came running up.

— David! Stop that!

He pulled his son away.

— Thanks, David, I called after him. She needed that.

— I could break your jaw. You know that, right? I broke my ex's jaw.

— The entrance gate is that way, I said. I suggest you both leave. These animals need calm, not psychos like you swinging their fists around.

They walked off, looking back at me, looking me up and down. I figured I had a few minutes before security arrived.

The two hyenas ran rapidly on their tracks, around and around in opposite directions, tongues out. They looked quickly at me each time they passed. They might have been thanking me for entertaining them.

I imagined Monika standing there beside me, as she was in 1937 or 1938. It was snowing. She was bundled in a second-hand felt overcoat. She had a blue scarf on, which she'd pulled up over her nose and mouth. We were in Berlin, watching her hyena. In her hands was a thin wooden board with a sheet of paper clipped to it, and on the paper a carefully drawn plot of the hyena's enclosure. The walls and fences were in their proper places, drawn to scale. Trees and shrubs were indicated by small circles. She was sketching the figure eights with a sharp drafting pencil. Later she would give the sketch to her boyfriend Wolfram Pichler, and he would redraw it in permanent ink so it could be published.

Monika was lonely, I could see that. Only a few people came to the zoo in winter. Her overcoat and clipboard gave her the appearance of an underpaid worker, while in fact she wasn't paid at all. Hyenas were the end of the world for her. Nothing had worked out in her life. Her brother had joined the army. Her father was so patriotic she couldn't talk to him. Her classmates had all married. So she went to the zoo, a place where no one she knew would ever come. She spent her time looking at the only creatures who were more miserable than she was. She was devoted to her work. She had discovered that captive hyenas pace in two different ways, and she'd named them *blind pacing* and *telescopic pacing.* She was proud of that. She was writing a definitive study. The animals we were looking at went round and round like the mechanical figurines in medieval clocks, clearly an example of *blind pacing. Blind,* she wrote at the top of her drawing.

She tapped her pencil in satisfaction. She had discovered something, and she knew it was also something in herself. Her immobility in the freezing weather, posting herself above the hyena pen: that was *flight in place,* caused by her aversion to people. Her daily rush to get out of her tiny bedsit in a poor part of the city and into the zoo: that was *fear-induced fixation,* caused by her anxiety about the red banners on display throughout the city. Her routes to and from the zoo: those were *telescopic pacing,* because she thought only about the hyena, and not about Wolfram, or her brother who was in training near Bremen, or even her poor mother. And her paths through her life, from the university to her bedsit, from her comfortable childhood to her current poverty: that was *blind pacing,* caused by a need to go as far through life as possible without thinking about marriage and family.

I had her figured out. She wasn't a heartless scientist after all. She felt an absolute identification with the creatures she studied. They were as far from help as she was.

— Monika, you're like me, I said, out loud.

— That's what you think, she replied. You should go. The security guard will be here any minute. People like you make animals nervous.

— By the way, Monika, as long as I have you here, tell me, did you know my mother?

She pulled her scarf up to her eyes and turned away.

The hyenas were crude-looking creatures, with muscular front halves and shriveled rears that made them gallop in an awkward way. Their hair was rangy, their teeth were broken and brown. Each time they swung by the front of the enclosure, they looked straight at me. Their tongues flapped. "Thank you, Samuel," they slobbered. "What a great day it's turned out to be!"

I said some gracious things to Karin when she saw me off at the zoo entrance. Apparently, I hadn't been reported.

— And by the way, I said, I'm not a veterinarian.

— Yes, she replied, that is very clear. Good luck with your project.

As I walked past the turnstiles, I felt like a prisoner who's been unexpectedly released. I glanced back to see if anyone was coming after me. The

day could have ended in the zoo's security cabin, sitting at a table across from that angry woman and that English man, or those teenagers, or those two women with their nasty kids. I could even have ended up at the police station. But instead, it was like the deepest dream, the kind where you know you're not going to wake up. You run right up to the ogre and stab it with your dinner knife. You jump into the fire. You throw yourself off a cliff. You swim down to the bottom of a lake and try to breathe water. But none of it works, you're still asleep.

I stopped at a trash bin in the parking lot, rummaged in my pockets, and threw away the zoo map and the diagrams I'd been collecting, and my notebook full of fake notes. And my pen and my watch, which I'd never really liked.

On the walk back from the zoo I was in a strange mood. I swept down the steep curving streets of the old city and across the wide uninteresting Rhine. Basel was the last zoo of the year. I wouldn't see any more anguished animals until next season.

I ran across a broad shopping street and narrowly missed being hit by a tram. I caught a glimpse of disapproving looks and darted down a side street to the hotel.

Something had gone wrong with the world. It was crowding in on me. It wasn't like sleeping, I decided. It was more like a narrowing corridor or that trapezoidal room. The days were too strong. They were thronged with loud unpleasant things, battered by a hail of unhappy animals' lives, bombarded by Viperine's neurotic ideas. There was a pelting randomness to it. The world was pummeling me, preventing me from thinking clearly. My attempts to understand what was happening didn't amount to anything because I no longer had the presence of mind to think anything through.

I imagined myself in a collapsing mine, a mile underground, the passage behind me filling with rubble so I had to run deeper into the mine to escape the collapse, the mine squeezing me out of my own life, pushing me farther from the entrance and any hope of rescue, the mine narrowing to a crevice, constricting me into a cleft, the air becoming unbreathable, crowding ash into my throat, filling my lungs with black grit, suffocating

my thoughts, filming my eyes with dust, gripping my chest, crumpling me until there was no space for even an ordinary simple idea about what my days should be, what I should do with my days, no way to think before it was too late to think at all.

I caught sight of myself in a mirror and saw again the whale's face: an inert corrugated surface with two eyes in it, rotating, peering, with no expression I could discern.

Ninth Dream

When I closed my eyes I immediately remembered the forests. At first it was almost a relief to know they were there. I'd loved forests as a child. They were comforting and peaceful. Then I felt the stagnant cold and the smell of burning, and I realized these were my nightmares, that I fell into them every time I slept, that there was something wrong with that, wrong with me. I had to find new dreams, think of something else, anything, something, it wasn't healthy.

It was like the time when Sam was young and his friend John was seriously ill. John couldn't breathe properly, his throat had torn and he was swallowing blood. The doctors put him in an induced coma. They said he would heal in a few days, but then he wouldn't come out of the coma. He was unconscious for eleven days, and when he finally woke up, he said it had been horrible. He'd heard us in the room, not perfectly but he knew from the sounds who we were. He could picture us there, he knew he needed to wake up, and all the time he had dreams of drowning, but he couldn't get himself to wake up, he was underwater or under blood and he couldn't get to the surface. He felt that if he didn't wake up soon, he might not ever wake up. He heard the nurses talk about his bed sores, he knew it had been days, but he just couldn't wake up, and when he finally opened his eyes he held our hands very hard. He was still inside his coma, but he held our hands very hard. He told us later he was afraid that if he let go, he'd sleep forever. When he woke up, he was terrified, he was sobbing.

These forests in my dreams weren't healthy, and where did they come from? I needed to stay awake in my dreams, I needed to change the images, think of something else, I had to remember to struggle, but just as I resolved that I smelled the damp leaf smell of the deep woods, and I stepped over moss and patches of mud and was asleep and lost to myself.

In the dream it was autumn. The woods were hazy. There was a pervasive odor of charring.

Soon I came upon a fire. It was less than a hundred feet away, across a clearing. As if it were waiting for me. The ground was on fire. The woods beyond were smoky.

I stood by a twisted branch and watched the fire turn and snap at itself. Wet wood was burning. The smoke was ugly black.

Deeper in the dream, on a rocky hill, I was startled by a sudden flame. The flames rose like a tattered curtain. Twigs splintered in the intense heat.

Sparks and gleams of fire burst out in the thickets. Bushes shivered and then flashed into fire. Smoke went like spies through the undergrowth, looking for dry wood to ignite.

Brush was burning everywhere. The flames made loud crackling sounds as they boiled the sap in the green branches, bursting them. Each burned bush was cause for celebration, and the fires jumped up and flailed their arms for joy. They knew I was there.

Flames shined like gold in the afternoon light. Fire decorated the cracked remnants of trees like fur collars whipping in a breeze. The world sparkled, but it was torn.

There had once been a house in this clearing, but now there was only a gap where the door used to stand. The fires were stronger now, they worked quickly. The house had been made of thick beams, like the one where I grew up in Watkins Glen.

Most people dream about other people. I knew that much, even in the depths of my nightmare. Normal people dream about people they love, or their pets, or their favorite places, or even monsters, but not about fire. Normal people don't stand around in their dreams watching fires. And what's more, I thought, kicking at an ember, normal people are not happy when they are lost, or when they are alone every night, or when they have the same dreams again and again, or when their world stops making sense. Yet there was something gorgeous about this place. A carbon black trunk looked glamorous dressed in silvery white fire. On the other side of the doorway the fire was soft like down, like white fungus on a peach.

Beyond the burned house, a steep slope reminded me of a hill in Watkins Glen with a tall pine at the top. Perhaps it was farther up this slope.

But then I wasn't so sure. I leaned against a tree to keep my balance and turned the words over in my mind: Watkins Glen. The name sounded odd. I couldn't picture it. And then, as it happens in dreams, I couldn't say what Watkins Glen was at all, except it felt like the name of a thing I had once known.

The going was difficult. Fingers of fire walked up the slope; arms of fire lay across the path. The fire walked back and forth, balancing on fallen logs.

Then my way was blocked by a fierce torrent of fire. It poured like a mountain stream, but uphill, against gravity. I stood for a while by a chalky white rock. In the pale light of a smoky sky, I watched the insane continuous stream of fire rushing incessantly up the slope.

Somewhere out in this direction, at the top of the hill, I knew there was a stand of tall pines. I could climb one, I thought, and look out over the burning forest.

Fires flowed up the hillside, like movies in reverse motion. Some stopped to rest behind two trees. Flames ate away at their trunks, weakening them, killing the trees. They would fall uphill, into the fire.

A memory flickered in my sleeping mind like a spark in the brush. I almost remembered my waking life, but I couldn't recall some details, like my name. At the same time, I knew that in that other life I also spent my time wandering. Perhaps I was lost in both lives. That thought gave me a strange sadness, but in a moment the spark of the memory of that other life flickered out.

The flames were in a hurry. They looked back at me, but they went on uphill, backward like crabs.

Fires jumped down onto a slope just above a house and burned madly behind a stand of trees. They waited in the backyard. From inside the house, I realized, everything would appear normal. A strong wind brushed all the smoke to the back of the hill. The view from the little window in the house would be sunny, peaceful.

Some houses are like that. They look idyllic but just out of sight, something has gone wrong. That seemed like an idea full of significance, but only, if only if there was a waking mind to consider it.

Vaguely, I knew that everything I saw meant something, and faintly, I realized that in the other life I would understand all this, but I was losing touch with that life. It was in fact unlikely there was another life, because otherwise I'd be able to remember it.

At the top of the ridge the tall pines were engulfed in a tornado of flame. Fire coiled around their trunks, killing them quickly, shearing off the pine needles, disintegrating them into billows of black smoke.

I winced at the fierceness of the fire. It jumped from one tree to the next, leaving shocked skeletons shivering in the sunlight. When the fire left, the bare branches were singed and barely warm.

Fires seemed to be everywhere now. The world was becoming a dangerous place.

I saw a farm torn by crazy flames. The fire twitched like bats' ears, it ran and jumped like rats. Flames spewed gleefully from a chimney pipe. The fire seemed insanely happy, as if it had finally found what it was looking for. It wanted to burn houses, and especially it wanted to burn people, but there were none around.

I was tired, but there was no place to sleep. I spent the night walking. Fires made their way back and forth along the forest floor. They crossed in front of me without looking up, as if they were preoccupied.

A person should belong in the world, feel at home in it. The world is the place where people feel at home. We are only in the world for a few years, and then we all have to leave, so we should feel as if we belong.

I didn't, and yet I had made this world. Even dreaming I knew that. These things were in my mind. I was watching my own mind ruin itself.

10

Into the Whisper Gallery

After the trip to Basel, I didn't have the energy to do much. I left my bags unpacked in the hallway. Each day I passed by and took out what I needed. In the end I'd just throw out the suitcases and whatever was left in them. In the back of the computer bag I found the red folder from the last set of readings, taped shut, with Vipesh's warning on the front: "Very special, please open at home if possible."

PART FOUR

SOME PATHS ARE ONE-WAY ONLY;

OR,

WHERE ARE YOU GOING, DOCTOR EMMER?

Where was I going, indeed. The folder was mostly photos, no essays. The first photo had a note paperclipped to it.

"Path followed by the convicted felon Abraham Nessway, sentenced to be killed by lethal injection on February 13, 1941.

"1. Detention cell, second window from right. 2. Courtyard of Block 2, where Nessway was permitted a half hour to walk. 3. Execution chamber entrance is in this building."

I heard Vipesh whispering.

— Viperine, now what are you doing?

— Shh, Veeps.

— This is not right, is it?

— Trust me, Veeps. When have I ever done anything thoughtlessly?

I squinted at Nessway's window. He would have looked out at the side of the building across the way. He would have seen the winter light bleaching the paved ground in front of the prison. If he pressed his face against the window or pushed up against the bars, he could see the building where he would be executed. Death is just out of sight, I thought, and then I thought, Viperine is just out of sight too, whispering, hiding behind her preposterous name.

The narrowing spaces that lead to nothing good. His last half-hour walk in the corner of that shaded courtyard. The corridors and walls he

saw during his few minutes. Like those siphoning fences that lead cows to slaughter, past prods and shocks until there is no longer space to move and the halter comes down and the cow is shot in the head with a captive-bolt gun.

Then came a photograph I'd seen somewhere before.

This also had a note clipped to it in Vipesh's crabbed handwriting.

"Doctor Emmer, this is Charles Franklin Craig, famous in your specialty. He made breakthrough experiments on kittens. He proved dysentery is caused by an amoeba. He injected the recta of kittens with human diarrhea and that was to prove dysentery is caused by an amoeba. As you know many kittens died. I hope that when Viperine and I are both scientists we do not inject recta of kittens with diarrhea. Doctor Emmer, Viperine has disclosed to me a fact that is so surprising. This man married a woman called Edna Felton, and then they had a child and they named it John Melanchthon Craig, I do not know why, and John Melanchthon Craig also had a child

and named it John Charles Craig. You may say to yourself well this is not very interesting but you will be incorrect. This John Charles Craig must be familiar to you! He is exactly your age, and he lived only one street from you in the house where you grew up, at 32 Parkway Road in Watkins Glen, New York, U.S. A photograph of John Craig appears in your own Elementary School yearbook in the graduation year 1981. Later he attended the Watkins Glen Central High School together with you.

"We do not know how closely you are friendly with the son of Charles Franklin Craig. We hope you are not very closely friendly to him. Because we are sorry to inform you that your dear childhood friend John Craig passed away ten years ago in an unfortunate accident inside of Europe. Viperine and I are sorry to discover this to you. We are very rueful now to inform you in this letter. We hope this information does not cause you undue distress or distract you from the important work of the zoo research project."

The note continued in Viperine's practiced cursive.

"John Craig was killed when he threw himself in front of a cement truck in Absdorf, Austria. His spine was pulverized. He had no identification, and he was going to be buried in an unmarked grave in the Friedhof Absdorf cemetery when the authorities located his few belongings in a backpack in the local train station. The backpack contained only basic necessities. I hope your sadness when you read this will be tempered by the thought that he had a productive life as Administrative Head of the Northern Light Inland Hospital in Waterville, Maine. He was divorced and left no dependents or relatives."

— Viperine, he's going to be so sad!

— Shh, Veeps. Keep your voice down. He will hear us. We're showing him we care. We know where he comes from.

— I feel it is wrong. I am worried. Why do we need to tell him his dear child friend is dead?

— Aw, Veeps. There is nothing wrong with telling people the truth. He will be glad that you and I are so dedicated. He will be delighted that we have researched so well. Imagine! We found a connection between his childhood and his job.

— Now he will never write a recommendation for me. I wish I'd never met you, Vipes.

I looked at the photo, trying to recall John's face. But the man who tortured kittens had a tense, insincere smile, and it didn't help recover my indistinct memory of the clumsy, enthusiastic boy I had sometimes played with as a child, who had once been sick and nearly died.

The rest of the folder was photos of old prints.

The first showed a man sitting at a table, with books behind and a view onto a city or a castle. A devil dressed in one of those silly men's skirts was pointing a fire bellows at him. The devil looked like a pesky old man, and he had a mischievous smile. The man looked prissy.

A ladder rested awkwardly against the man's head. Its upper end looked like it was going to slip off some clouds. Up above the clouds there was an elliptical sunburst.

The man seemed to be stopping up his ear, or maybe gesturing at the ladder. He was also pointing to a passage in his book, as if to say "this will save me." Before the devil came scooting in the man had probably been planning to write something. He had his quill pen, his ink bottle, his scroll of blank paper, and a knife for paring his pen. Was he a supposed to be a scientist? He seemed more like an aristocrat, with his fur stole, ruff collar, and heavy necklace.

The message was clear enough: this man is going to heaven, despite the devil's distractions.

Next was a cute picture of two people walking in a landscape. One was an angel, although she looked more like a country girl with a wing stuck on her back. They both had walking sticks. Her companion was probably a woman, unless of course these were both men wearing skirts. The country-girl angel had a big head, which made her look like a child. Her companion was an adult, or maybe a younger child. It was hard to tell. They seemed to like each other. It looked like they were talking.

They might have just missed their road. Or they were leaving their village. Either way, it wasn't any big loss, because that village didn't look like much. The road was rocky and probably muddy too.

In the sky, two strange clouds glowed from behind. It was hard to imagine where the sun was. Maybe it was nighttime. The clouds looked like amoebas, or like people watching from above. At the bottom were four tussocks of rangy grass, like beach grass. Maybe they were near the sea.

The two girls seemed happy enough, but the village was more depressing than quaint, and the clouds were a little unnerving. I also came from a little village, as Vipesh and Viperine knew. Maybe they thought I needed a country angel to guide me.

— I'll be your angel, Viperine whispered in my ear. Vipesh doesn't understand. He thinks we're just getting extra credit for the assignment. You need an angel. Oh wait, here he comes. Hi, Veeps.

— Oh no, Vipes. What is this?

— This is a picture to show Doctor Emmer that he is not lost.

— Is that girl with the long dress supposed to be Doctor Emmer?

— Yes.

— He doesn't wear a skirt.

— But she looks a bit like him, doesn't she?

— Am I the little angel?

— If you want, Veeps.

— My hair is too long. And I need shoes. He will not recognize me.

— Often people do not recognize their guardian angels.

— I think you are a kind person even though you are also very creepy.

— Thanks Veeps.

In the next image, the little angel was breathing fire on her companion. The picture had a caption: MY SOULE MELTED, WHEN MY BELOVED SPAKE.

The Soule held her palms out. She was dripping like a wax candle.

— Is that Doctor Emmer again, in a skirt?

— Very good, Veeps!

— And I am burning him up with my research.

— You are melting him; his soul needs to be melted.

— Oh, Vipes, you are a very profoundy thinker. I cannot understand you.

Fourth was a picture of a man resting against a stone wall. He had a kind of crude backpack bound with rope, and he was resting it on a stone wall. He'd tossed his hat down on the ground. He was taking a break, but he wasn't completely relaxed. His left hand was still hooked under a strap of the backpack.

He was looking off into the distance, where a castle perched on a hill. Maybe that was home.

Between the hiker and his home was a high treeless mountain that looked like Pike's Peak from *Close Encounters of the Third Kind*. A ridiculously badly drawn road snaked up the mountain. At the summit was another ladder leaning against some clouds. A man was climbing that ladder. One foot was on the bottom rung, and the other on the second rung. It looked dangerous, not to mention stupid.

Again it was obvious what the moral was. It'd be fairly easy for the hiker to get to the little village. He'd have to climb down into some bushes and get across that Pike's Peak wasteland, but he'd be home in an hour. He'd have a much harder time if he decided to climb that mountain. The artist was trying to urge his viewers to take the difficult road. Maybe Viperine and Vipesh were trying to encourage me: Follow the angel with one wing. Climb that mountain. Go on your great journey.

The hiker wasn't an especially great avatar for me. He had his hair brushed back, and he had a bushy beard. At least he was an improvement on that aristocrat in the first picture, or the childlike person in the second picture.

This one was somewhat disturbing, because the scene was enclosed in a ring, and outside it, the landscape continued in a hazy dreamy way, but there was no sign of life in it. The whole picture looked like a view through a microscope, as if the world is a vast empty landscape, and the hiker only lived in a microscopic droplet of it. The real world, outside the hiker's circle, looked dead.

— Doctor Emmer, may I please take this opportunity to tell you how very sorry I am for these readings and pictures? They are one hundred percent Viperine's idea. Most particularly I apologize most especially for this image in particular. It makes you look old, but you are not old, and if you do become old I am very confident you will not sport a pointy white beard. Please please ignore all these images and consider I am a most excellent lab intern and researcher, and I am normal in almost every way.

— What are you saying, Veeps?

— Ooh, I didn't see you there. Nothing.

— Veeps, darling, these pictures are good for Samuel. They are things he needs.

— You are a very deep person, Vipes, and I cannot argue with you.

— That's right, you can't.

Then came a picture of a naked man hanging from a palm tree. He was gripping two fronds. The situation didn't look that serious. It seemed like he should just drop down and walk away.

— The man will fall on the city.

— No, Veeps. The city is far behind him.

— But Vipes, his feet are going to touch down on the wall there.

— You are the silliest boy.

It was a stupid picture. Does any palm tree look like that? The artist had barely fit it in the picture: the whole thing was crushed up against the top frame. And how in the world had the man gotten there to begin with? Had he fallen out of the clouds? Still, I got the idea: I was hanging on for my life. The palm stands for salvation. Viperine was sending me a message: I am in danger. I am going to fall.

384

— Just a little jump, Doctor Emmer, down onto that wall. Just hop down and walk away. And put some clothes on.

— Veeps, he won't land on that wall. He's going to fall behind the tree. See how far the landscape is? He will fall a long, long way. He needs to hold on.

The next picture was a bat showing off its wings.

It was hovering or floating in the night air. It looked like the same landscape as in the last picture. It had one of the same buildings.

The bat didn't look like it was flying. It was fixed in place, resting in its part of the sky.

Another bat. This time it was looking at the sun. There was a crowded village in the hills beneath, some badly drawn trees, and some tree-sized weeds. The sky was hung with rows of clouds like theater drapes. The sun was reverberating, sending out rings and arrows of light. But still the sky was dark. Perhaps it was the moon, not the sun. On the right, behind the bat, the landscape looked brighter. I supposed that was meant to be daylight, and the rest was night.

— Okay Vipes, what is this?

— These are pictures of bats. Samuel knows what they mean.

— I am sure he does. He has a prodigious memory. But can you just remind me?

— You're adorable, Veeps. But that little trick won't work. He knows, if he only thinks about it a moment.

Yet another bat, a stranger one. Those first two were just fat mice. This one had a small naked head like a bird's skull. It looked wet or rubbery.

The sky was a wreck. Clouds hung like formations in a cave wall. It was another reverberating moon, and this one had a sort of face, like a glove puppet. The lines of its light were sharp like scattered pins. A sloping roof gleamed in the unhealthy light. Again, the badly drawn plants, as if the artist had been in a hurry and didn't want to look at the picture longer than necessary.

These were images of disaster, doom. Odd villages with no people in them. Haunted skies. Bats flying at sunset or in the night.

Then I remembered.

— I hope someday you will join me in the bat caves, Viperine said in an especially soft breathy voice. Me and my mother. Will you?

Icarus falling into the sea. His wax feathers were melting, and he was falling upside down. The sun looked concerned, but what could it do? Icarus had opened his arms to accept his death. He was falling so fast his penis was swept upward by the wind.

I felt Vipesh's breath in my ear. He always used Clorets breath mints. Viperine was just behind him, holding his shoulders.

— You are falling, Viperine whispered.

— You'll be all right, Vipesh breathed, his lips touching my ear.

— You will not be all right.

— Falling, they both whispered, their words overlapping.

And another Icarus. This time he had wings on his ankles, too, but they didn't help. The sun was a little brat, looking complacently off to one side as if nothing was happening. Icarus was so terrified his body had twisted until it was practically broken. His chin had hit the ocean, and his hands were pushing on the water.

In the distance a man sat in a boat. Maybe he was fishing. Maybe he'd noticed Icarus, but he didn't care.

— Falling, Samuel, you are falling. You have been since I first met you. I have been watching you fall. Even your eyes, when you talk, they wander here and there, and then they fall. I have been trying. Who is talking to you but me?

— What, Vipes?

— Nothing, I was talking to Samuel.

And another. Three bats and three Icaruses. This time the sun had a kind of stupid shock on its face. It looked a bit like Vipesh. Its rays were quills, about to stab Icarus. His penis was sideways and so was his hair. He must have been spinning around as he fell.

— Oh no! the sun said, with Vipesh's voice. I melted your feathers. Oh no, your wax feathers are coming off right away. I am so sorry, I can't help myself. Can you forgive me? If you do not drown, will you write me a recommendation?

Icarus turned and saw his wax feathers falling off. The remnants of his wings were too small to help him. There were boats on the sea, but they

were too far away. In a minute the skies would be clear and a faceless sun would shine brightly on the curling waves.

I turned to the last image.

An animal was lying on a bare patch of ground up in the mountains. It looked like it had been pressed down into the clay. The moon was just barely past new, but its thin crescent shone a bright light on the animal.

It was a lamb with a long tail. It looked dead. A black shadow pooled under its belly. Shadow grew like black fur on its back. Maybe the artist meant it to be sleeping, but it looked dead, crushed into place.

The sky was calm and clear like threads of silk, and it ran under the frame and continued everywhere.

— Put it in the red folder, Veeps. Seal it up.

— Why are we putting these clips on the folders?

— You never know. He's absentminded, he might show them to Dr. Sounder.

— Do you think Dr. Sounder told us to do this?

— I don't understand you, Veeps. Dr. Sounder is too literal minded, she'd never think of something like this. And even if she did, she wouldn't send it to Samuel, because fundamentally she doesn't like him even though she's always pretending to be his friend.

— Actually, he knows that. They both do.

— How did you know that, Veeps?

— I don't, he does.

— You know he's become especially poor at distinguishing real life from things he's imagining. Now he's forgotten he's imagining what we think, and he's just going and putting his own thoughts in our mouths. Erasing us.

— Why does he do that?

— Same as everything he does. To not think too clearly. To keep thinking unclearly. To continue not to think well. Ultimately, I suppose to stop thinking, to not think, to say no to thinking. It hasn't done him any good, it hasn't helped. He needs to let go. It is time to fall.

— Vipes, can I ask you a question?

— Ask.

— Are you a boy or a girl?

— Come in here, and I'll show you.

Tenth Dream

In those days dreams were as far from the real world as they always are, which is to say lifetimes away and yet right next to me, as close as my glasses. My waking world had become a dangerous place, like a radioactive building in some movie, where the hero has to go in to defuse a bomb or rescue someone, so he rushes in, does whatever he has to, and tries to get out as quickly as he can, almost holding his breath while he's inside, even though he knows that radiation is seeping into him. That winter the radiation of waking life seeped into me. I fell asleep quickly, gratefully. The nights got longer, and my dreams crowded up against my days.

I came upon a grove of oak trees. Thin ones, maybe twenty years old. It was a clearing in the woods, and there were also pines, even younger, just a few years old. The fires seemed to have subsided. That comforted me,

and for a minute I thought I might be on my way home, that the woods of Watkins Glen were on the other side of the clearing.

But as I watched, the ground itself began to smoke.

Flames spurted from the dry dirt, hissing, crackling. If it weren't for the fire this would have been a lovely spot. Up above, spindly oaks and willows were tossed affectionately by summer winds. Little Sam would have come to a place like this with John. They would have searched the woodpiles for snakes, or tried to catch butterflies. Sam would have come here on his own, lain on his back and watched clouds pass silently behind trees.

Now it was ruined. My mind gave me these presents, and then burned them before my eyes.

Soon I'd be staring again at the horrible fires that gouged out my happiness, burnt into my mind's eye, ripped away my thoughts, and gave me nothing in return. If only they would stop. I would be happy just to stay here, in this lovely clearing washed by hot breezes, shrill with the buzz of insects.

But instead of cicadas and crickets I heard only the idiotic snapping of twigs in the flames.

A ferocious brush fire burst out right in front of me. The flames were hot. I felt them on my neck. Charred flakes of wood and leaves were tossed into the air.

I hated to see it, and it raged in return.

These fires were not an infestation that had to be stopped, an illness in my dreams. They were the image of my own life. I myself was burning my life away. I was burning bridges, memories, relationships. I was wrecking my life, and each night my dreams showed me the results. This was my own diseased world.

That was an important thought, I knew, and I tried to hold it in mind, but that never works in dreams. My painful idea crumpled and dried like the tinder on the forest floor. The harsh thought compressed into thorny twigs. I saw them there on the forest floor without understanding what I was seeing. Then they snapped and burst into orange flames.

That is the usual way, I decided, keeping an eye on the fire advancing down the slope toward me. A person doesn't live his life in the full glare

of some deep insight, but in the smoke of everyday confusion. A person may come across a real truth about himself, but it hurts and so he forgets it. In that way a person can mistake a thought that could save his life for a bent twig on the forest floor. We live by stepping around obstacles, I concluded, as I stepped gingerly down the slope to avoid the spreading fire.

I looked over a pile of burning timber. Trees had fallen on top of the fire, like logs laid in a fireplace. Smoke patrolled the forest behind.

I knew, at last, again, that the fires were my own mind. It wasn't necessary to escape because it wasn't possible to escape. The world was burning everywhere, fires were the same throughout this world.

There are probably other forests, I thought, each with a single person wandering in it. All of them hoping, at first, to find other people, to find their way home. All of them realizing, by stages, that they are the fire, that the images are faithful self-portraits.

Each burning branch was an idea I had forgotten. If this landscape is my life, I thought, then every tree that catches fire is like a year of my life that I've forgotten, each twig a place I've visited, each leaf a person I've met. The fires are burning an entire lifetime of experiences. One memory after another turning to ash.

So many things were burning: streets I had lived on, phone numbers I'd had, books I'd read, shirts I'd bought, people I'd met in Guelph, on trips, in the Department, the names of my friends, the faces of my family, the idea of having a family, my home, the idea of having a home.

Fire boiled in a pit. The wind tore it and mixed the flames with smoke, and then it looked like the smooth fur of an animal's pelt. At the bottom of the pit, the flames washed and foamed like ocean waves. It really was beautiful. Smoke curled and eddied like long hair tossed over a shoulder.

What could be more lovely than branches lit by the X-ray of the fire, going soft and pliable on their way to ash?

What could be more entrancing than fire decorating the trees like liquid Christmas lights, dripping candles of light from twig to twig?

Or more lovely than the fire drawing its territory on the ground, scoring a compass around its territory, the bright circle enlarging like a pool of water?

Fire dripped down from wet branches as if it was rainwater.

The ground was also burning, and down there in the flames, ants of fire crawled up and down on twigs. The ants burned inside the fire, with small flames of their own. Some crawled out of the fire and onto a dark bush.

This was my world after all. I breathed a lungful of smoke that smelled sour like an electrical fire.

It was entrancing. It was all I needed.

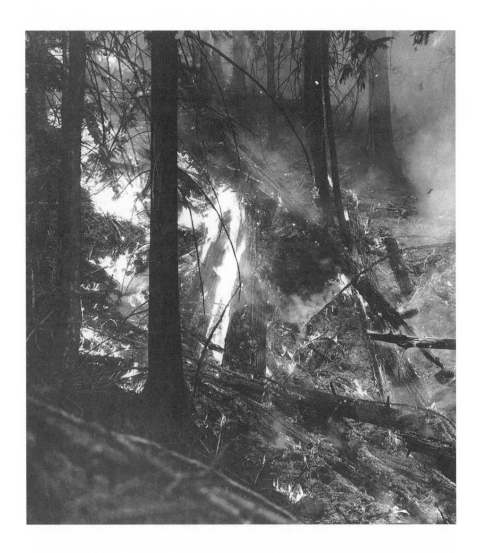

In the end, what matters in the end? It's enough for most people if the person they love understands them. But what if no one ever has, and what if you try to understand yourself, and even have some good insights, but you know they don't amount to much, that you have never known yourself, and no one else has either?

If the person who still cares for you is too young or weird or downright insane, does that matter? It does. But love isn't constant like one of those eternal flames in a cemetery. It looks up, sees an opportunity, and in a moment it's gone.

I observed a soft white fire. Wispy flames hung on twigs like spider's silk. Like spiders, the fire was all around. It was almost underfoot.

Does it matter if the people you think cared about you really didn't? If the person you loved goes off to a city far away and won't come back, that matters, right? Well it should. For most people it probably would. But it doesn't, really, because people drift apart, that's just what they do.

A person's affections swerve, like fire that jumps from a thicket up into a tree.

People think if you make yourself famous, you can save yourself from being forgotten. You make a fortune, build a great business, buy an enormous house. You set up a foundation with your name on it. You're a pillar of society. You're mentioned in the papers. A street is named after you, then you're safe. You'll be remembered, or will you?

People think if you raise a big family, and your many healthy children have many healthy children, and you live to a hundred and see with your own rheumy eyes your twenty-three great-grandchildren, each one healthy and vigorous, each destined for extravagant happiness, your family is a dynasty, your legacy. You're safe. You'll be remembered, or so you think.

It doesn't take long for people to forget each other. A few years at most.

Ferns warmed their fronds on the blaze that would kill them.

Does it matter if the people you loved don't think of you? Does it matter if you're forgotten? Does it matter that when you die, the people you know won't remember where you're buried? Won't call you to mind even on holidays? Does it matter if you're forgotten if you've forgotten yourself?

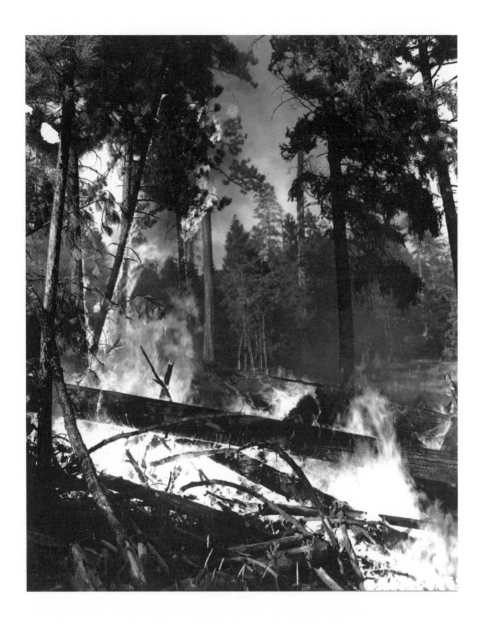

Does it matter if your mind becomes disarranged? If you dream about a lonely world where fires burn for no reason? If you get to actually like that world? Even prefer it to the other one?

It doesn't matter. No one's healthy, really. Burning down is what we do.

I stood at the top of a steep slope. A dozen feet below me a fire was seething. Flames licked at a tree trunk. Smoke lingered everywhere. It was the worst possible world, so it was the best possible world. Nothing was hidden, so nothing was left to fear.

I knew without searching that there was no one else in the forest. No one anywhere. As it should be. We think the world is full of people jostling and poking and squealing and yakking and kissing and fretting and preening and primping and boasting and blushing and hoping and moping and dancing and drooling and giggling and choking and cursing and vomiting and collapsing and dying. We think the world is overstuffed with people, but that's not the case. We are, each one of us, alone in our own mind. That's why this world, the burning one, had no people in it, because that's the way things actually are.

It is right for the world to be burning, I thought, because that's what happens in life. Our minds burn before our eyes. From the moment we become aware of ourselves, when we look around and see how we've turned out and decide what we might do with ourselves, from that moment things begin to smolder. By middle age, the library of memories has caught fire. In old age even the people we love start to burn. The minds of older people are populated with scorched remnants of the people they used to love. The remnants stand in their minds, seared, unrecognizable. That, too, is normal.

Our world is scorched by our own minds, and living is burning down.

In the other world, I remembered, dreams always need to be interpreted. They have significance. They are portents, they have hidden symbols. People talk and talk about what their dreams are trying to tell them. This is a sign, they say, that means this, or this means that. You'll see what your dream is once you interpret it.

Those people would look at my dreams and say, Samuel, your dreams are unhealthy. You need to figure out what they mean.

I don't need to. Some things in the world have no meaning. They just are what they are, and not any other thing.

For example those fires sprawled out on the forest floor like injured people, writhing and thrashing.

I decided not to walk around the fires anymore, not to run away. I resolved to stand and let them come to me.

All it took was that thought. Immediately the earth was on fire, everywhere. Flames surged forward like waves on a beach.

This world was finally ruined. Just like the other one.

The fires became furious, delirious. They ran in zigzags, like lightning, up and down the slopes, in a kind of mindless anger or joy.

And then it was time. Fire burst out in the middle of a stand of trees, like an abscess opening and disgorging poison.

Flames surged around me.

I held my arms down, and felt the flames hanging on like children. I swept my arms around in the fire as if it was foaming water. As if I was standing in a surf.

I took deep breaths of fire. It smelled like orange-scented air.

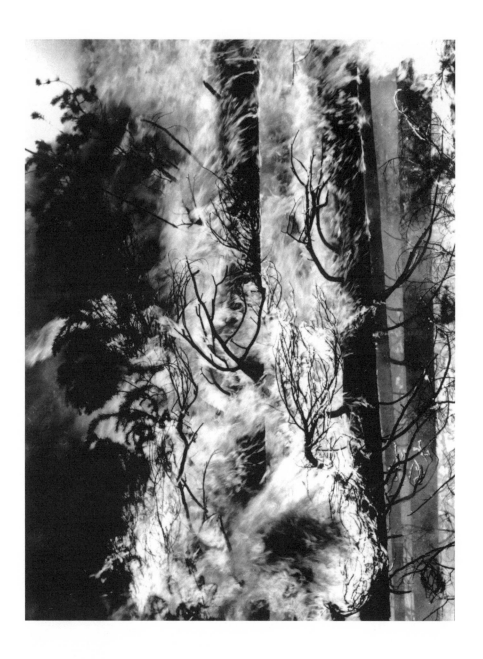

The trees were my body, burning.

 In the trunks and branches I saw my own bones, charred.

 I saw my arms, with the bones of my fingers gesturing.

I felt a sudden fierce unhappiness. The fire was frantic to consume me. The force of heat pulled me upward. I had never felt so sad, so at home.

Fire tore me from myself. At last, I said, at last.

11

The Planet Mercury in October, 1937

When I woke, I couldn't move my eyes, couldn't turn them. I was clamped in some ferocious dream. I tried to remember it, but as dreams do, it washed from my mind, like a body in the surf being pulled back into the ocean.

I walked to work like I always had, down Cather, right on Lorck to the Water Department. It's strange how things you've seen a hundred times become invisible, and then when you look at them, it's as if they are not there, like you're only thinking of them and not actually seeing them, like you're remembering one of the many times you'd passed them before and glanced up and seen them, rather than actually pausing, today, and seeing them there, now, as they are. Kopp's Meat, the empty strip mall. RNR Custom Bikes. All where they always were. I hadn't noticed them for ages. This morning I looked at them and they seemed like photographs of places I'd visited sometime in the past. As if there were no present, only inadequate images of the past.

Rosie had left a package on the lab table. It turned out to be the book Sirje had promised me back in Tallinn. It was bound in sky blue, and the spine was embossed with gold letters: HIMMELS-ERSCHEINUNGEN DER PLANETEN Appearances of Planets in the Heavens. Below the title was an asterism of three dark suns:

✳ ✳

✳

followed by the author's name, again in gold: WOLFRAM PICHLER.

The spine was bleached a lighter shade of blue than the front and back covers, a sign the book had lived for decades in someone's bookshelf. I pictured a dark-paneled science library in a small German town. The little suns may have looked out on that room for an entire generation, maybe even longer, staring blindly out at empty chairs and tables and milling particles of dust. The real sun would have come in a high window and struck the blue paper spine, whitening it. As the blue went from azure to light cerulean, the suns would have stood out, shining darkly, sending their rays a few millimeters into the field of pale blue paper. Those little suns were like sea urchins, or flowers with their petals plucked off, or eyes with pins stuck in them.

In the middle of the front cover was a golden frame, also embossed, surrounding a dark picture with swirling white lines. One was a figure eight.

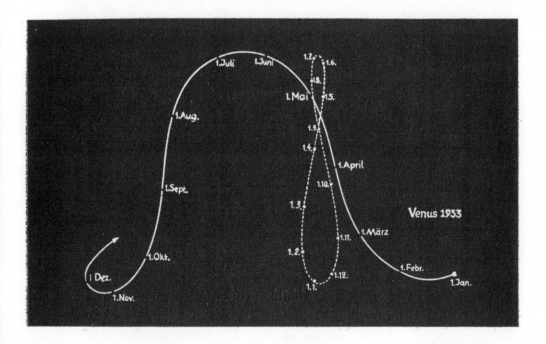

"For Doctor Emmer," Sirje had written on the title page. "Here is the book I told you about. Ideal paths of ideal animals in the heavens. I hope it makes you jealous, Regards from rainy Tallinn, Sirje Kukk."

The introduction explained that the figure eight was an analemma, showing the sun's position in the sky at noon on each day of the year. At the bottom of the figure eight was the place of the sun at noon on the first of January 1933, marked 1.1. As that year went on, the sun moved upward in the sky until the summer solstice, then down.

If the stars were visible in daytime, Wolfram wrote, people everywhere would know this figure eight shape, because they would look up at noon and see the sun moving against the stars, a little each day. The figure-eight path of the sun would be part of the human imagination. There would be myths and legends telling how the sun has to follow its track, how it dreams of freedom, how it feels the tedium of its unending life.

Unfortunate, I thought, that the unthinkably enormous sun, the most powerful object it is possible to see, can't just go anywhere it wants in the sky.

A bookmark fell onto the table. It had a picture of the bronze wolf at the entrance to the Tallinn zoo.

Tides pull on the sun and the Earth, Wolfram wrote, and the analemma is shrinking. In the coming millions of years, the figure-eight analemma of 1933 will tighten into a knot. Finally, the sun will hover in the same place. It will no longer move in this graceful curve. It will still circle the heavens, Wolfram wrote, if anyone is there to see, but actually it will be fixed motionless against the stars.

Like that final scene in H.G. Wells's *The Time Machine,* I thought, when the hero goes as far into the future as he can, long past the day when the last lonely anemic demented exhausted human, soaked in toxins and numb with grief, gives up their last aimless stumble between nowhere and nowhere and crumples in the sand. In the story, the time traveler keeps going, far past that pathetic inevitable moment, and lands at last on a desolate beach, where there are almost no waves, because there is no tide, because the heavens have stalled. The traveler climbs down from his

machine onto the icy beach and regards the pale sun. It looms on the static horizon. It is nearly dead. A sparse snow is falling. Everything on earth has died, except some last creature, a marine worm or a horseshoe crab, that drags itself along in the shallow water.

Summers will be chill then, like they were in Watkins Glen. Little Sam was another sort of planet. He used to run around in knots and loops, orbiting his little world. Above his head the sun was far off in the sky, like it had forgotten its job. Now I am more sedentary. My orbits are simpler. In the end, all orbits decay. An hysterical animal, pacing its figure eights, loses increments of energy with each lap. Eventually, it rests. In the distant future, the sun will be like that. Enervated, not wanting to move, barely remembering what it felt like to swing across the heavens in its magnificent figure eight. For now, the sun goes up and down, performing this unexpected path.

The continuous white line in the same picture traced the path of the planet Venus in 1933. At noon on January the first of that year, Venus was off to the right of the Sun. It would have been invisible in the glare. As the year went on, it migrated off to the left of the Sun. Venus's path reminded me of the arc of a life: begin with nothing, build yourself up, try to achieve something, keep the brakes on as you sink. But Venus is immortal, so it keeps going. The path in the picture ended with an arrow, showing that Venus was going to circle back.

As I read on, I saw that Venus follows complicated paths, different each year. In 1932, the year before, Venus had risen up to the left in the spring, then gracefully danced over to the right, then down, like a stage curtain for the Sun.

Venus 1932

In 1934, Venus played coy, hurrying past the Sun, then doubling back and dipping underneath it.

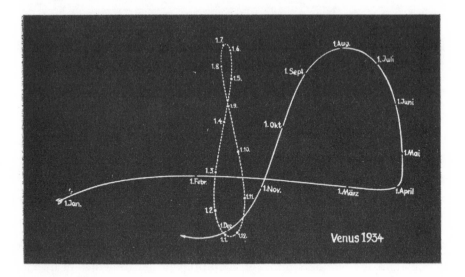

Venus 1934

I turned the pages slowly, following the undulating paths. Wolfram hadn't drawn any constellations. The sky was flat and black with flecks of dust.

I could see why Sirje wanted me to have the book. These were perfect orbits, like the ones in that zoo in Tallinn, where the strange mountain sheep spiraled placidly up and down their dirt hills. When nothing is in the way, and you have nowhere to go, your paths can be beautiful.

The diagrams went from 1930 to 1937. That was the year Monika Woodapple was in the Berlin zoo, watching the hyena, drawing her diagrams with freezing fingers. Down on Earth, the hyena paced out its figure eight in the wet snow. Up above, in the cold heavens, Venus traced its elegant curves.

Wolfram drew a different diagram for 1937, holding the sun still in the center.

I imagined Wolfram in his under-heated office in the Potsdam observatory, drawing these star charts with drafting tools and China ink. One day there is a knock on the door. A young woman dressed in a shabby coat explains that she admired some diagrams he had drawn for an article on lemurs, and she wonders if he can help prepare her drawings of hyenas and dingos. He's surprised when he sees her sketches. They have both been drawing figure eights!

Wolfram admires Monika's diagrams, or rather, he admires the animals who made them, doing their best to avoid trees and people, navigating their cramped enclosures and still performing nearly perfect curves. Monika

admires Wolfram's diagrams because they reveal paths no one can perceive. He had to calculate them.

— No one can see an analemma, he says. These are the handwriting of the planets. Maps of their travels.

— And these are the signatures of the poor animals, she says. Maps of their travels.

— Pointless travels.

Venus 1930

Venus 1931

Adela's orbit was like Venus in Wolfram's diagrams. She came near me in 2000. We married the next year, and then she veered away. We still felt each other's gravitational attractions, but only in certain seasons. She was like Venus, or like a comet, speeding in from obscure reaches of space, burning brightly for a while, heading out again. I hadn't called her for months, since the zoo project began.

I sat in the lab holding Sirje's book open with both hands. A finely entangled state of mind bound me like a spider web. Clearly that comet idea came from my mother's interest in comets, which she'd gotten in Potsdam, studying with Wolfram. It was as if Wolfram were speaking to me, as he had spoken to my mother. My mother might have had this same book, so I may have seen Wolfram's diagrams when I was very young. The book was probably in the house when I helped clear it out after she died. I might even have picked it up, without noticing what it was, and thrown it away.

It could only be luck that Sirje had sent me the book. Yet something I said in Tallinn must have reminded her of it, and that wasn't entirely luck, because the book had probably been somewhere in the back of my mind since I was a child. I may have seen it open on my mother's desk, or closed, with its three black suns on the spine, in her bookshelves. Maybe little Sam had stopped and wondered at the three dark suns, as I had just done. The book may have meant a lot to her. After all, she had letters from Wolfram.

Or maybe this was all Viperine's fault. For all I knew, she could have written to Sirje. After all, she knew my itinerary, and she'd even researched a childhood friend I'd almost forgotten. She could have discovered the connection between my mother and Wolfram. She could have told Sirje, asked her to send me the book.

— He's close.

— Nonsense, Veeps, there's nothing to be close to.

— Aren't we plotting?

— It's not a plot, we're only trying to reach him. Samuel, can you hear me? I don't know Sirje, but I think she cares about you.

There was a rap on the door and immediately afterward Catherine came in.

— Agathe's here, she announced, tipping herself gingerly into a chair.

She crossed her legs, apparently not without discomfort. She made a kind of squinty flinch, which looked more like a tic than an expression of pain.

— Why? I asked. Agathe never comes to the personnel building.

Catherine's face flowered into a disgusting display of mirth.

— Well, let's just say it's been crystal clear since the beginning that you aren't on board with this zoo project at all, not even one tiny bit. We've been

hearing about you. When we got the first email, from Dr. Stserispaa in Helsinki, I thought there might be a translation problem, because I didn't understand why he thanked us for the idea of using contraceptives on endangered leopards, and asked if our zoo was going to sterilize its animals. Then we got a letter from Dr. Preteen in Salt Lake, suggesting in very polite terms that you might not be appropriate for the job because you seemed to be obsessed with animals mating with other species and eating their own excrement. And then someone in Basel contacted Josh for information about you, and afterward Josh got a letter warning him you might not be capable of carrying out your assignment. And last week there was an email from Dr. Günther in Basel, co-signed by the Director and the entire Board of Zoo Basel, alleging that you are aggressive, imbalanced, and delusional, that you have fantasies about cutting yourself, smoking cigarettes with the lit end inside your mouth, and pulling out the hair of underage girls. It seems you assaulted two women with an umbrella.

Only four letters, I thought, it could have been worse.

— I wrote the people in Basel a very nice response. I assured them you are an excellent scientist.

— Thank you, Catherine, I said. And I can explain all that.

— Just kidding, Samuel. I wrote all of them, telling them we'll take their allegations seriously. Agathe, François, Mike, Josh, and I, we're on the same page about this. Agathe's coming in to tell you what we have decided. We can't fire you, not right away. You're a civil servant. But with these letters, we can get you off the zoos project and out of this lab. When François read that part about underage girls, he said you shouldn't teach labs anymore. You won't see your interns again. François said we can invoke Chapter 75 of the reform act, that's probation for inappropriate behavior. You can go away for a while, and then you can come back and do your idiotic water sampling by yourself, until it drives you crazy, if you're not crazy already.

She went on, explaining Canadian civil servant law, telling me how diminished responsibility contracts are considered terminations of full employment, provided the employer has no intention of recalling the employee to their

original contract, and how in those cases, employers have responsibilities and obligations to employees, and employees like me can benefit from defined rights such as protection and appeal, how in my case it was only a Chapter 75 action, and as such it did not immediately affect my retirement age or pension, how I was lucky that civil servants are so protected, because if it was a business, like for example a zoo, I'd be fired immediately. She said she wanted to be fair, and she wasn't explaining all this just because Legal had told her to, but because it was best for me to know right away because I would have to present myself in a month's time to a review board, and my case was technically an instance of constructive dismissal, involving failure to comply with the contract of employment in some major respect. There was a lot more, which I figured I'd get in printouts and emails, so after a minute I stopped listening.

— Samuel, just out of curiosity, when you listen to people, do you actually listen? I mean, can you tell me anything about what I've just said?

I told her I could, and I closed Wolfram's book to demonstrate my attentiveness.

— You know you're a shit for pretending to read while I am telling you the most important news of your career.

— Well, I said, we're friends.

— That's interesting, she said. Let's consider that. You can see I have a disability, but have you ever asked about it? You've opened doors for me, that's about it. And what do you know about my family? Do you know, for example, if I have a brother? Do you think I have a sister? Maybe two sisters, what do you think? I know all about your wife, how Adela has gone back to her mother's house, how she is following her family's destiny, and so on, and so on. Do you know if I've ever been married? What do you think, maybe I'm married now?

— Are you?

— In your imagination I'm not, anyway. Here's how you think of me. I'm a sympathetic character. I have this disease or condition, you can see it causes me pain, but it's nice that I deal with it in a socially acceptable way, so you don't have to ask about it. I don't complain about it, and that

makes me an endearing figure in your eyes. I'm sharp and critical about everyone, and that's fun. As far as you know I might be gay, but then again you've never asked. For all you know I might have someone enslaved in my cellar. Or maybe I just enjoy some sort of appropriately perverse niche-market pornography. I wonder what you think I do on weekends. What do you suppose my house looks like? Where do you think my house is? Where do I go on vacations? Where did I go to school? Where was I born? How old am I, anyway?

— Fifty-five?

— When we first hired you, I thought, okay, here's someone who can be a friend on into my late middle age, but guess what, you turned out to be utterly uninterested.

— Fifty?

— First of all, my kidneys hurt. All the time now. The only man I have ever loved is in a vegetative state up in St. Mark's, and they have just taken him off his latest course of antibiotics, and I do not know where I will go or what I will do when he dies, because then I will be lost.

That was my cue to say something, but in the face of a confession so startling and aggressive I couldn't find the words.

— I'm gone after next month, Samuel. I've even told you that before, but I'm sure you've forgotten.

She waited for me to say something.

— So that's it. It was nice knowing you.

She wrenched herself out of the chair. In a moment she was gone, leaving the door open.

I could see why she was angry. The job and the Department meant a lot to her. But she was retiring. She'd be okay. Eventually she'd get over her raving. I'd call her later in the summer. We wouldn't speak about her so-called husband. Her story, which was probably an exaggeration or a lie, would just fade away. It would be as if she'd never mentioned it. Her ailment was another matter. That was real. I made a mental note to ask about her kidneys, and I put a Post-It on the mental note that I shouldn't be surprised if she said it was never her kidneys.

At first I thought of writing letters to Preteen and the others, apologizing for the way I'd acted, but it'd be better to wait to see what Agathe had to say. If my contract was going to change there'd be no reason to make the effort, which would be insincere anyway.

So I went back to Wolfram's book. He started his first chapter with simple pictures. If you are in the Northern Hemisphere, he wrote, and you look East after sunset, then the stars will seem to rise, forming trails up and to your right.

If you look to the West, then as the night deepens, the stars sail down and to your right.

You can sit outside, he wrote, and see this for yourself. Take note of where a star is. For example, find a star near a tree. Check it again in a minute. You will soon be able to visualize these invisible streaks. They will appear in your mind's eye.

Looking North is different, because the stars rotate around the pole.

To sense these curves, he wrote, find a comfortable seat under a tree or next to a building if you live in a city. Note the position of several stars. Observe them again in a few minutes, and then again after a half hour, and then after a full hour. You will then be able to imagine these curves.

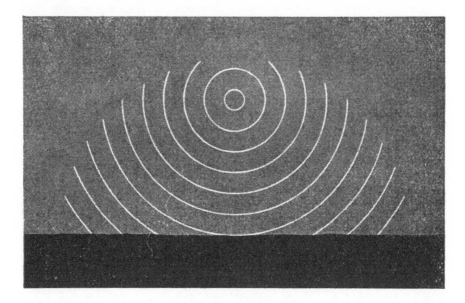

I wondered why Wolfram had drawn these diagrams instead of reproducing the usual time-lapse photographs. He must have loved the simple lines. His heavens were tidier than the real ones. Neatly scored like lines on a globe, but with no continents, just the dark sky beyond.

To the South, he added, the stars orbit an unseen pole. This must have been mysterious to early observers in the Northern Hemisphere. They must have thought something was hiding down there.

Stars follow simple paths, he concluded, but planets are different. They wander in the heavens. The Greek word means "wanderer." This, he wrote, is the subject of my book.

The second chapter was about Mars. Wolfram compared its paths to cursive script. It writes its way across the heavens, he said.

It is like a hand writing in chalk on the firmament.

It signs its name on the sky like a busy man, in a single swooping line, the letters stretch into loops or zigzags. It is elegant and impatient.

Mars does what it has always done, I thought. It writes nothing, just the loops of a signature, without the letters themselves. Ornaments without sense.

The pictures reminded me of needle scratches on sooty glass. My eye slipped along the tracks like a needle, etching the paths, practicing the Martian signature.

Mars's paths also reminded me of birds looping in the sky, or better, the gnats and flies from the readings. Writing endlessly in the air, without meaning. Neither suffering nor happy.

The phone rang. It was Agathe.

— I'll be right there, she said.

A minute later she was in the room. She was dressed, as always, in a business suit, as if our little Water Department was a great and powerful company.

— You know, Samuel, she said, some people just aren't suited for certain kinds of tasks. We each of us has our own strengths, and I suppose necessarily we have our own weaknesses. I know I do. You have a great strength in your branch of water management. Your reports have always been perfunctory. But that doesn't matter now. As I think Catherine told you, we decided on a leave of absence. The principal issue is that one of the letters, the one from Switzerland, could get the City Council in trouble. I had to show it to Legal. François, Josh, and Mike were there, and they decided you shouldn't have contact with the public, and that includes interns. We'll find someone else to do the next round of your lab classes, or I'll do them. You'll have to sit for a review board, and they'll make the final recommendation. I don't judge, you know, and I'm really not angry, but I am disappointed. People are genuinely upset. François told me I shouldn't meet with you at all unless I'm accompanied by someone from Legal, and Mike said probably a counselor too. But we all want the best outcome, so here I am. It's just that we can't understand—

— When is the review board? I asked.

— This is April, the board will sit on July 15. If the inquiry goes well, and we don't receive any formal complaints, you should be back in September.

— So five months.

— I hope then we can make use of your capabilities, of course in a more carefully restricted setting, because after all—

— I'd rather have a year's leave.

She smoothed out her skirt with her hands.

— Your option. By all means. Take all the time you need.

— You could hire someone to replace me.

— That's not a problem. We can even hire one of your interns. We'll keep your things here in the back of the lab.

— You know, I said, leaning my chair back and pretending to think, what I would really like is a five-year hiatus contract.

— I don't know anything about those. But if that's what you want, we can make it happen.

— Wait, I said. I know what I want. I want to leave.

Her hands paused on her thighs.

— In that case, we can get Legal to draw up the papers. We could present them at the next department meeting, or in the fall, whenever you have prospects. You'd want to review the city's terms. Osler's Pensions and Benefits are good people. We had someone who used them a couple years ago.

— I mean I want to leave now. Permanently.

She looked at me with an expression intended to convey sadness and gravity.

— Well, if you do that, you'll lose a lot, and the balance will be moved into a locked-in retirement account. No one is asking you—

— Now. I want to leave now.

— Okay. In that case, I can only say I am sorry. We wish you well.

— No, you don't.

She stared at me with a flat expression. She seemed to be looking at a point somewhere inside my skull, where the centers of rational thinking are supposed to be.

Then she stood up and walked out, closing the door quietly but quickly.

It'll be easy for them, I thought. They'll find someone to teach the summer lab. I'll recommend Vipesh. It will take them a while to advertise my position, but by September they'll have a permanent replacement for me. By Christmas, no one will think of me anymore.

I went back to the book.

"Mercury," Wolfram wrote, "has the most interesting path of any planet. If you go out immediately after sunset, you may see it somewhere near where the sun has gone down, or if you go out before sunrise you may see it a couple of minutes before the sky becomes too bright. Mercury will appear as a faint dot in the sky, just above the horizon. If you watch day by day, you will see that Mercury flies around the setting sun like a dazed moth.

"Whenever the weather permits me, I go out at dusk or dawn to observe Mercury. It is satisfying to see the pinprick of light exactly where I have calculated it should be. That is the joy of astronomy: knowing that objects in the heavens move according to laws. Such objects are predictable even though they are quite complex."

I imagined Wolfram, twenty-five or so, in his robe, standing in his back garden with his notebook in hand. He has stepped out just before sunrise to try to spot Mercury. It is the first of January. His slippers crunch in the frost. According to his calculations, Mercury should be above the sun, just where he has drawn the fletching of the arrow. He has a good chance of seeing it. And sure enough, just above the Grünewald, there is the little point of white light, pinned motionless to the brightening sky. He opens his notebook and writes the time with a hard, sharp pencil.

On the other side of Berlin, on that same morning, Monika is getting up, putting on her old coat and blue scarf, stuffing a felt blanket in a bag, preparing to go out and watch the hyena perform its mathematically predictable figure eights.

At that same moment, a half-minute before sunrise on the first of January, 1937, out at the zoo, the hyena is lying in its box. It doesn't feel like pacing yet. It gazes, without thought, out past its bars. There, in the thin winter woods, it sees a spot of light, hanging like a bright spider in a mesh of bare branches.

Merkur 1937

Wolfram's drawings showed the sun's figure eight with the mad spinning paths of Mercury flying around it. "These patterns have never been graphed before," he wrote. "See how beautiful they are, the hidden geometry of the heavens."

"For several years I have been able to spend considerable time on these calculations. Unfortunately, leisure is a luxury that the poor cannot afford. Next year, I begin full-time work at the Potsdam Observatory, and I doubt I will be able to continue these calculations in future."

I closed the book.

I had negotiated my own firing, so there was no need to finish the day's work, or even clean up. I had a last look at the three suns,

☀ ☀

☀

and then I put on my coat and left the building. I intended to get a hamburger and go home, but instead I turned in the parking lot and walked over to the physical plant. Normally I only went there to get water samples. There were many parts of the building I'd never seen. For some reason I wanted to have a look before I went away for good.

Inside, the walls were cinder block, painted enamel white and lit by banks of low-energy fluorescent lights under milk plastic covers. The place was deserted except for the guard's station and the maintenance people in front. A worker had left a stepladder in a hallway. Some panels of the drop ceiling had been removed and were stacked against one wall. I took a look around, then climbed the ladder and stuck my head up through the opening. It was dark up there. Light filtered upward through seams in the drop ceiling. Aluminum suspension rods hung all around like stalactites. The space was draped with that tired kind of cobweb that hangs down and just ends. Darkness stretched away in front of me. I turned carefully on the ladder and looked in the other direction. Above me the suspension rods were bolted into the concrete ceiling with L-shaped brackets. The kind of thing no one ever notices. Even the people who installed them probably barely paid attention to what they were doing.

For a few minutes I stood there, wobbling on the ladder, thinking of those movies where people try to hide up above a drop ceiling and how it never works because it's already infested with aliens, or it works at first, and then the panels break and they fall down right in front of the monster, or right onto a conference table. I climbed down and walked through to the engineering area. In a basement corridor I found a Coke machine and bought a drink I didn't really want. I tried the doors as I went. Several opened; they were storage rooms stacked with wooden crates. One door opened to the outside, and I found myself on Lorck.

It had gotten dark. I walked on a gravel drainage strip next to the high brick wall of the physical plant. On that side the building reminded me of a high wall around a prison. Then came Waterworks Place, the one-track road that led to the parking lot. I'd walked or driven down there every workday for decades. I looked right as I passed it, watching the road go by

like in a movie. At the end was the bank of trees that obscured the Everal river. A sight I'd seen hundreds of times and enjoyed just a little each time. I realized it reminded me of a row of trees in the back yard of the house where I grew up. Seeing that screen of trees, and not the river, had made me feel a little at home each day I came to work, but the thought had never quite surfaced. I wondered why I'd finally made the connection just as I was leaving for good, when I would probably never see the department, or those trees, again. But I was no longer that interested in understanding myself. I was content to let things be, as they wanted to be. Reasoning is something you do when you think you can fix yourself, or the world.

Walking down Lorck, I felt a sort of breathless relief, like sky divers must experience after they take that first step off the plane. I had finally lost sight of my path. As I walked I kept repeating to myself: now all I have to do is fall well.

Eleventh Dream

It was morning. The long night of burning had passed. Fires were scattered like salt across the charred land. A mournful parade of flames snaked up a hillside. Other fires rested, exhausted, by a road.

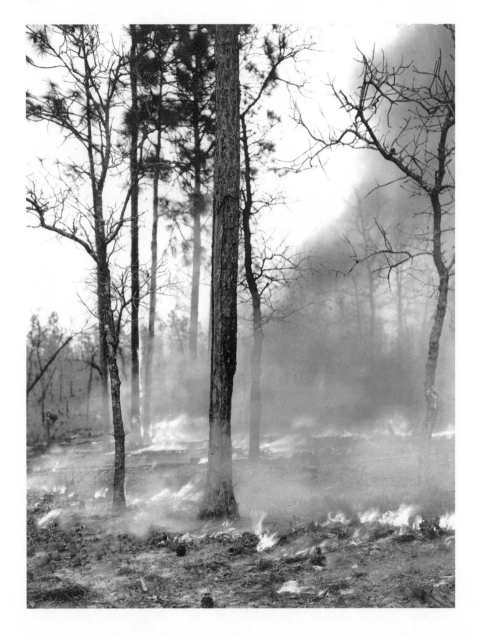

Fitful fires gathered like birds and foraged in the stubble, flapping and pecking at the dirt. Soon there would be nothing left for them to eat.

I stepped over flames the way you might step over a nest of ants.

In some places trees had survived. Their trunks were charred, but they kept their needles. Low fires rolled along the ground, consuming the last leaves and twigs.

Some trees had burned almost to the ground. Stumps continued to spout flames, like volcanic vents.

Twigs crackled and small leaves shattered. The forest floor was alive. The ground was hot.

The stumps were like furnaces, roaring. As if the fire had gone underground, leaving the world to cool.

Later there were fewer fires. They got weaker. They hid. The ones that remained seemed shy, embarrassed at what they'd done.

By the afternoon the fires were out. Resinous pines hissed and smoked black like chimneys. Gray smoke drifted tentatively through the wrecked forests.

With the flames gone, the land grew cold.

The remains of the forest settled. Charred branches collapsed into charcoal and powder. Burst and split bark collapsed.

Then it was quiet at last.

12

Dromomania

For two months I sat around the apartment, doing I suppose what many millions of unattached people do, watching TV that I forgot minutes after I'd watched it, browsing the internet, browsing in my refrigerator, watching people meander down the street, wondering if some were as purposeless as I was, drowsing in bed, drowsing on the couch, sleeping by the window, slumbering sitting up.

My new life started abruptly. That day I had spent the morning throwing out some remaining pots and silverware, toiletries, and bedding. The bedroom was a mess, because I had been disassembling the Venetian blinds, which turned out to be made of prefabricated rails and slats that had to be individually prized apart.

I emptied my computer bag so I could discard things I no longer needed. My Water Department ID, a wallet full of loyalty cards, department paperwork, a dozen pens, an address book of municipal contacts, my phone. Five large black garbage bags went down to the skip along with two suitcases full of clothes.

I paced the almost empty apartment. In the living room I walked past the bookcase to the sofa, then to the north-facing window. That was my habitual path through the living room, year in year out. I went back to the sofa. Why always take the same routes around the furniture? For that matter why always walk *around* furniture? Suddenly I turned and jumped over a corner of the coffee table.

That felt good. Why not jump completely over the coffee table?

I came around again, picked up some speed, and leapt awkwardly over the table. I had to pivot to avoid crashing into the Cather Street window, marked number 9 at the top of the floor plan of the apartment, and that adjustment sent me careening past the television and television stand, numbered 6 (6a).

I stood still, between the couch and the bookshelf, at point 23.

Then I made a sudden run and jumped over the middle of the coffee table.

Around and around and around I ran, like a monkey in a zoo, like a hyena, a fox, an otter, a monkey, a panther, like any demented animal anywhere.

I had a feeling stopping wouldn't be a good idea, because then I'd feel stupid. Why do caged animals pace? Because, like Owole, if they stopped, they'd see their cages clearly, they'd see their lives.

Furniture wheeled around me. Tables, bookshelves, and televisions became obstacles, useless and annoying like those fake rocks and plastic plants they put in the animals' cages. Each time I came to the coffee table I jumped over it, turned, and jumped again, because why not? Once I turned and wheeled the other way and nearly tipped over the standing lamp, labeled number *11*. At the last second I scooted behind it and jumped over the entire seat of the couch, marked number *4*.

I counted my steps, because that's what Monika did. From the coffee table to the lamp, three. From there to the couch, two plus a stutter step. I put my hand on the wall at the point X to avoid hitting the standing lamp. I figured out how to duck behind it, push against the wall with my left hand, and emerge with enough spring in my step to come at the television, labeled number 6 *(6a)*, with sufficient speed to make it less than an entirely foregone conclusion that I would be able to turn three-quarters of the way around without falling onto the coffee table, labeled *1*.

I fell several times, but I got up quickly.

Then I devised a fail-safe: if I came over the couch too quickly, I let myself bash into the bookshelves, labeled 5 *(5a)*, and then I set off for the coffee table, labeled *1*, and jumped it. But if I emerged from behind the lamp, labeled *11*, more slowly, I turned and headed back, over the empty space in the center of the room, by the number *19*, and ducked behind the lamp. The two alternatives kept me occupied for several minutes: either come out from behind the lamp quickly, bash into the stacked bookshelves and careen over to the coffee table, or come out at a moderate speed, in which case pivot and return.

Even when I was behind the lamp, my left hand pressed against the wall, the pressure on the wall increasing as I ran the last half-step toward it, my head and shoulders turning to catch sight of the sofa, still I didn't know which of the two trajectories I'd take. Sometimes I ricocheted off the bookshelf like a pinball bouncing off one of those spring-loaded bumpers. Other times I turned as if someone had caught my eye, and returned to the lamp as if it was an old friend.

I don't know exactly how long I did this. That is just why animals pace, so they fail to feel time passing.

The room smeared out of focus. It felt safe that way. I was moving too fast to read the plastic wall clock. One time I thought I saw both hands pointing down, 6:30, but on the next round I was sure it said ten minutes to midnight. The third time I looked the hands seemed to be spinning madly.

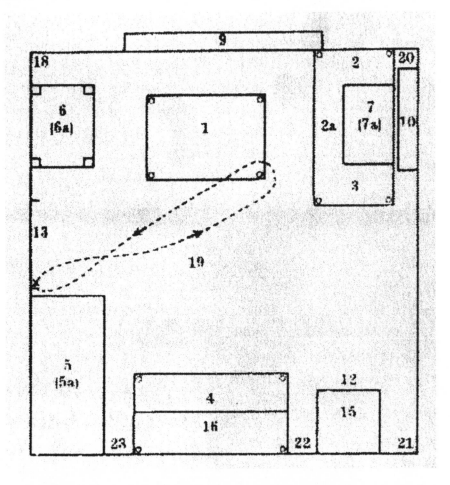

I chose a different route, from the coffee table, where I had been ignoring a bowl of cashews, just as frantic zoo animals ignore the food that is supposed to distract them from whatever psychosis has possessed them, to the room's small west-facing window, labeled number *13*. I performed a classic figure eight. It was awkward to race such a tight course. I had to incline my body toward the middle of the figure eight.

The room became soft. The walls liquefied. The room's four corners seemed far away. Each time I got to the lower end of the figure eight loop, I glimpsed the moon outside the small window, labeled *13*. It was in the middle of an empty sky, like it usually is.

Then suddenly, again without thinking, I took two long steps over to the Cather Street window and began another figure eight, a slower one that included an optional lean over the coffee table to get a couple of cashews, then a step directly into the corner, labeled *18*, and a half-second pause at the window. When I looked out the window I pressed my left shoulder and half my chest against the pane. The new route felt like a sham. It was what any distracted person might do, eating nuts and staring out the window. Any slower and I'd be back in my normal life, and I no longer knew what normal life was.

I stumbled again and discovered that it was possible to make a very tight loop right in the corner, labeled *18*. It was dusty there, and I couldn't turn comfortably, because I was crowded into a foot of space between the corner and the television and television stand, numbered *6 (6a)*. A couple of times my foot got jammed in, right at the spot labeled *X*. That was a pleasant feeling. I pushed hard on the walls and the bottom of the television stand. Big cats turn in tiny spaces. Maybe it gives them pleasure to force themselves into areas even smaller than their cages. Squeezing into the corner made me feel petulant, like a child that wants to show its parents it's not happy, so it pushes itself into a box.

If I were a child having a tantrum, I would eventually tire out, and that would be good because my parents would comfort me and soon we'd be eating lunch and watching TV. If I were an animal pacing, I would try to keep going until I could fall into an instant deep sleep, in order not to see my life. If I were an automaton, I would go until my battery ran down, and then I would simply turn off. I couldn't stop because I wasn't any of those things.

I ran frantically from one place to another. I tried leaping into the three available corners of the room, even the tiny one behind the sofa, labeled number *20* in the upper right of the floor plan. I hit my shin against the coffee table and knocked over the standing lamp, which I then kicked against the wall.

lamp had been. I turned and ran out into the middle of the room, and back to the wall. After one particularly hard collision, I stayed leaning against the wall, breathing hard. I was exhausted and dizzy.

The wall clock was frozen at five minutes and fourteen seconds to twelve. According to my phone it was 2:44 in the morning. The standing lamp was broken. Its arm was snapped at the swivel. There was a depression in the wall, and in the middle of it, two cracks.

The furniture looked fake, and the room was too small.

I put on shoes, grabbed my credit cards and car keys, and headed down to the garage.

It'd always been in the back of my mind that having a car meant I could just go, anywhere, any time. My car, a late-model Toyota, still had that familiar plastic smell. I'd hardly driven it that year. It'd always been in the back of my mind that the car was for driving the wrong way, suddenly, for no reason.

Outside the night air was warm and humid. Cather street was nearly deserted. A lone car, several blocks away, turned off onto a side street. I drove a hundred feet to the intersection with Adams and waited at the red light.

I wanted to drive, but I didn't want to decide where I was going. I needed someone to give me directions. There was change in the drinks well. I could flip those coins to determine where I'd go. I had the beaver nickel, a couple of reindeer quarters, and a dozen maple leaf pennies. But I didn't want to make up the rules, I needed them to come from someplace else.

The light turned green. No one was behind me.

I typed "random directions" into my phone and found a site that randomizes any list you give it. I wrote "L R S" for left, right, and straight, repeated it seven times, and pressed "randomize." The website returned my driving directions: R, S, R, S, S, S, L, R, L, S, R, L, R, L, R, L, L, R, S, L, S, S, S, S, R, L, S, L, L, S, R, S, S, L, S, L, R, R, S, L, R, L, L, S, L, R, L, L, S, R, R, L, S, R, L, S, S, S, R, L, S, S, R, S, L, R, L, L, S, L, R, R, S, L, S, S, R, L, S, L, S, L, L, L, R, L, S, S, L, L, R, R, S, R, L, S, R, L, L, S, R, L, S, R, R, R, L, S, , S, S, L, S, L, R, R, R, R, S, L, R, L, L, S, R, L, L, R, L, S,

S, R, L, S, S, S, R, L, S, S, R, S, , L, S, S, R, L, S, L, R, S, R, S, S, L, L, S, L, R, L, S, S, R, L, L, S, L, S, L, L, R, L, S, S, L, L, R, R, S, R, L, S, R, L, L, S, L, R, L, S, R, R, L, L, R, L, S, , S, S, L, S, L, R, L, S, R, S, L, R, L, L, S, L, R, L, L, S, R, R, end.

A car came up behind me, and before I could pull over it went around. A light mist was settling on my windshield. If I followed this set of orders my drive would be like the random walks in the readings.

I pulled back onto Cather and took the next right. That was Paisley. Agathe's assistant Cora lived in the building on the corner. I went Straight through the next intersection, then Right, which brought me onto York-shire. Maybe I'd end up driving into Rosie's neighborhood. But then I had to go Straight through the next two intersections, which brought me up to Norwich, and first thing I knew, I was on the dull north side of town.

Next up the list required a left turn. But Norwich continued on, and King Street went right. I stopped. The next direction was Right, so I went down King.

As it turned out, I went several blocks farther into the north end of town, where lower-middle class bungalows followed one another with narrow alleys in between. It felt good not to make decisions, and it was a relief that I could always get more directions, pretty much forever.

In the next half hour I drove by Rosie's apartment twice, but I hadn't wanted to, so it didn't reflect on me one way or the other. I'd never been down Lane Street, or behind the Antioch Community Church. There was a cul-de-sac off Peoria that ended in an overgrown roundabout with a motorboat in the middle, filled with rainwater. I felt like I hadn't really lived in Guelph, even though I had lived there for twenty-one years. The town was actually an expanse of suburban houses. A house on McCartney Street had a sculpture of a Komodo dragon on its front lawn. I would have remembered that if I'd ever seen it. Farther down McCartney someone had made an old Ford truck into a lawn ornament by planting flowers inside it. Someone else had put two piles of red flagstones in their front yard and put a fountain in the middle, just like one of those fake environments in a zoo. Most people were asleep, but a couple of times I saw people in their living rooms.

An hour later, it became clear that my random turns were edging me slowly toward the far end of town. Soon I'd end up on one of those country roads where intersections are kilometers apart.

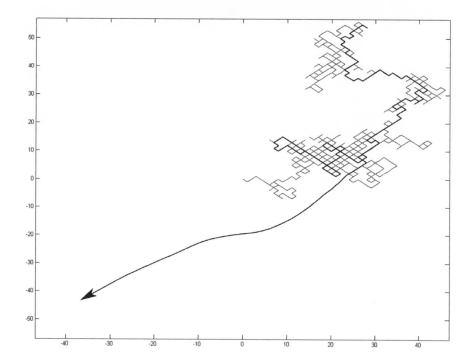

I passed a sign for Route 124 North. My set of randomized choices was running out, and if I stopped at the end of that set, I'd end up parked somewhere like Mullin Drive, looking at faceless suburban ranch homes. Why not just go north and see what happens? I turned toward Route 124, put my phone in the drinks well, and drove on out of town.

That is how I ended up driving in the general direction of the Arctic Circle. I should probably have thought more soberly about exactly what I was doing. People who drive to the Canadian arctic generally plan their trips. They pack for the north, and they probably don't leave in the middle of the night.

Soon I passed the crossroads at Brisbane and Erin, and then I was out beyond the conservation area. Route 124 became Rural Route 24, a narrow road with farms set far back into the fields. The moon was behind a veil

of clouds and ringed with a bruised brown aureole. The fields had an unpleasant pallor. A few lights sparkled on the horizon: those were porches or floodlights on barns, which farmers leave on just to signal there's life inside. My skin was bled to a sickly ash color in the moonlight.

In another hour, Rural Route 24 dead-ended at a T junction. I knew more or less where I was. This was Severn Bay, one of the big lakes off the Great Lakes. To go north, I had to go around it. I turned right in order to meet the road that would lead farther north. The moon came glancingly over my right shoulder, glinting off the phone.

At four-thirty in the morning I found myself driving through scrappy farmlands near Sudbury, where arable land gives way to the trackless rocky woods and lakes of the Canadian Shield. Eventually, I thought, I'll need to find a hotel, and if I keep on tomorrow, I'll need to buy some clothes, a toothbrush, toothpaste, a comb, stuff like that. Toothbrush, toothpaste,

razor, comb. A suitcase or duffel bag. Changes of clothes. Different shoes. A cable to charge the phone. Boots. Snacks for the car.

The sky brightened and the sun rose over a ragged landscape. The flat land, fuzzed with pines, reminded me of Estonia. The forest wasn't all tamarack yet, but it was getting there. A few stray northern pines and paper birches stood like officers in an endless army of enervated soldiers. In Estonia I hadn't known what it really means to go astray. Really going astray means there's nothing to avoid. No reason to hurry or hide.

The faceless Canadian forests swept by on both sides of the road, and so it went for several hours. In one place a hawk circled far overhead. Dark clouds came up behind me. Then it rained, hard. A couple times I had to slow and drive around pools of water.

I watched the signs, but nothing caught my eye. Driftwood, Hunta, Genier. Brouwer, Clute, Ressor. Somewhere up ahead was northern Manitoba, and after it, Nunavut and the arctic. Then the towns would have unpronounceable Inuit names, which would be more inviting.

Around five in the afternoon, in a daze of driving, with the wipers going full speed, I abruptly turned off the road and checked into a Super 8 just short of Apperson Park. In the morning, I'd have to do some shopping. The list played back in my head: underpants, socks, shirts, undershirts, pants, toothpaste, toothbrush, comb, disposable razor, small suitcase, or bag. As I rehearsed it, the list became a rhythmic chant.

> Underpants, toothbrush, toothpaste for the teeth
> Straight razor, comb or brush, pants shirt socks
> And a bag, and a bag, and a bag, bag, bag.

There was a cyst in my mind: go to the end of the road. No more tangled paths and figure eights. No more returns of any kind.

Quiet woke me in the middle of the night. The storm was over. The large Canadian darkness pressed on the window.

Twelfth Dream

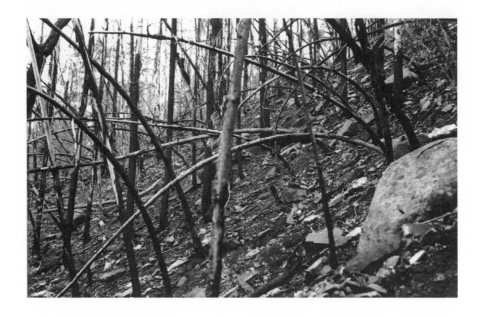

After the burning, the landscapes in my dreams were bare. No fires or smoke.

I must have burned my life down, I said to myself, in the forest, in my mind, in the dream. That felt like an accomplishment, and it frightened me. I tried to remember what I had done, but in dreams we're helpless, and my mind veered away from making sense and steered me back to the place I had given myself.

I crouched on a steep slope scattered with flinty stones. Leaves and green shoots had been stripped by the fires. The air was clear, and the forest was silent. Nothing was left alive.

Up ahead some trees were bleached by a low-lying sun. I set off toward them.

I walked down an ash-white hillside, threading twisted remnants of bushes or scrub. Blackened trees were planted in scoured ground. They looked like worms poking out of the mud at the bottom of the ocean.

The ground had that exhausted, powdered look of the surface of the moon. Long shadows striped the land.

The heatless winter sun cast the upright shadow of a tree on a pyramid of rocks.

Behind it another tree gestured frantically.

I wouldn't find any more houses or roads. I knew that the way you know things in dreams, without reason. I'd only find rocks that seemed to be left by people, or trees that seemed to signal to me. Random things, ghosts. Clumps and arrangements without meaning.

A high hill was furred with a fine stubble of white trunks. Here and there a single pine tree, spared for some reason.

Some trees had fallen in the fires. Their roots must have been burned through.

Others had been scoured by fire, stripped back to their trunks.

Needles had survived on many trees, but not enough. They would die over the winter.

The cold was nearly unbearable. There wasn't even the mesh of pine needles to slow the wind.

The scalded white branches were brushed back like old men's hair.

On a hill, a group of trees stood sentinel for nothing.

This world is something like death, I thought. It isn't normal sleep, I'd always known that.

I considered these things as I walked, but I also accepted the landscapes the way a child accepts the world it's born into. If it's a cold place, the child learns to bundle up. If there's not much to see, the child doesn't mind, because it doesn't know about anything else.

There was no longer anything to figure out, no path to find or place to go. It used to be that when the sun was low, I had to hurry home. Here it would always be shadows raking across infertile ground.

The stripped charred trees stood like barbed spines of some enormous animal. Like a microscopic close-up of a fly's skin.

There were no pine scents, no smell of wet earth or rain. No calls from distant birds. Ash covered the scents of life.

It was quiet, so I thought about it quietly. This is what I have left, I decided, settling into the dream. As I made my way down into the next valley my feet made sounds like breaths in the soft ash.

Envoi

Notes

One

Once, a little boy who answered to the name of Sam lived at home with his mother and his two brothers, Tee and Alec. Their house was on a hill above a long deep lake. The beach had no sand. Instead, it was covered with smooth black stones the size of coins.

If you stood on the beach looking past the small wooden lighthouse at the end of the pier, you could see far up the lake, into blue distance. You could never see the other end of the lake, where there was a second lighthouse, because the lake curved between the hills on its way up north.

When he was little, Sam spent time wandering around by himself, looking at the sky and at trees. He listened to places more than people. The landscapes used to talk to him. They asked him who he was, what he was doing there. Trees wanted to know how he felt when he stood near them. Fields wondered where he'd been. The lake kept calling out, asking him when he could visit. He was not a normal child.

Two

Once, a man who answered to the name Samuel Emmer stood on the shore of his uncertain life. Behind him was the mess he'd made of it up to that point. Ahead was open water and banks of fog. It wasn't easy to see into the indistinct distance.

He had bad dreams. He stayed in a trapezoidal room. He couldn't keep his mind on things. He watched a monkey and a platypus, an otter, and an elephant. He read some unusual books.

When Samuel Emmer wrote this book, he was trying to understand what happened that year. I think mainly he wanted to know what he was supposed to do with the fact that each week his life was becoming stranger, more strangulated.

Three

Now, there is a perilously old man who calls himself Emmer. I'm 90+. I live in a cheaply built house a hundred miles north of Guelph. A couple months ago, I was cleaning out the basement, because Fina Hodges told me it was leaking, and I came across the manuscript that I'd nearly forgotten.

Every day I sit in my study, looking over the pages. I read about the things I said and saw forty years ago. I mainly fail to care about them, or even remember them.

This morning I am looking out the window, where an untrimmed hedge blocks my view of the uncertain distance. Can you say your life is your own when your childhood has gone so far away into the past that the boy with your name seems like someone else's child? When you read about your own life and there's no glow of recognition, no pleasure in revisiting scenes that had been long forgotten? I have added these Notes to explain, possibly to someone, how that feels.

This book

This book spent over twenty years in a storage space in the musty back room of the basement. As I went about whatever I was going about, it looked up from its cardboard box at an unchanging view of other boxes. For some years, it saw a mattress wrapped in plastic and an old window screen. The storage compartment was made of heavy-gauge steel wire mesh. On either side, there were other compartments full of objects I'd taken from Guelph, mashed up against the screens: my old bicycle, a stereo, appliance boxes filled with forgotten junk. In front, this book looked out at a cement block wall. A light bulb in a metal cage, just out of sight, cast a dim unchanging light. It was quiet. The principal sound was the buzz of the heating and air conditioning units. Frail-looking spiders, silverfish, and mice were the main inhabitants of the storage area, except when the main fluorescents turned on and I came down, looking for a saw or a ball of twine or the snow shovel.

As this book lay there, staring up through the fine dust that was slowly covering it, Samuel went about his life. At first, he must have thought about the book a lot. After all, it had been hard to write, and it hadn't been of any use. Gradually, imperceptibly, he left the concerns of the book behind. Storage compartments are where people put things that they hope one day to rediscover, but they're also places where people hide things that aren't quite parts of their life. When something's put in storage, it's still precious, but the longer it stays there, the less it's thought of, until eventually it painlessly drops out of the person's life like a scab that's finished its work. I think Samuel put this book in storage to help him forget it, and because despite everything, he knew he would forget it once enough time had passed. Sometime during those twenty years, the book vanished entirely out of his mind and was replaced by an indistinct idea that the middle storage compartment had something special in it, which might be worth retrieving some rainy weekend.

Twelve years ago, the house needed a new central air system, and I had some people move the contents of the storage compartments to a room on the other side of the basement. That room has small windows high up under the ceiling, so the book saw daylight for the first time in a generation. In summer, it saw grass on the lawn, rangy stalks that the mower couldn't reach. In winter, snowdrifts sometimes covered the windows. I never went down to see what that looked like from inside the basement. It must have been a ghostly light. Throughout the year the outsides of the windows were filmed in white dust, and the insides draped with a mesh of spider's webs woven over each other. I don't keep a light on in that room, so nights were very dark. Occasionally moonbeams would have shone on the floor like theater lights. Every couple of months the book heard creaking on the stairs when I came down to fetch something, but I never went into that room. It heard the plumbing, and every afternoon it heard me playing the piano.

In that way the book spent almost two generations. During the time it was in the first room, a person could raise a family, see their kids all the way through school and off to college. In the time it spent in the second room, a person could become a grandparent, and watch their grandchildren grow into teenagers. I spent those years upstairs, mainly reading, walking, and playing the piano. My earlier life slipped from my mind, like the oldest cobwebs that drop silently to the windowsill.

It is Fina Hodges's fault that I found this book, because she nagged me to have the basement cleaned, and to be fair, it was leaking, and things were rotting.

Emmer

For thirty-nine years now, I have lived here, off Route 6 near Mar, north of Shallow Lake. The developer widened a farmer's track between two cornfields and put six houses at the end. They are all Northstar modular homes. Mine has oatmeal-colored vinyl siding and mushroom-colored stains. The house was brought here in three parts. It has several opt-in features, including shutters, dormers, and ten feet of aluminum decking.

I don't have much interest in the world outside the Bruce Peninsula, that's the name of this part of Ontario. I don't follow the news. At my age, that's common. To me everyone on the news looks young, including the heads of state, and it is hard to be interested in things young people say.

I have the usual sparse commitments of the elderly: I see my doctor, I drive to the mall in Owen Sound for groceries and pills. Sometimes I eat at Errol's Diner in Mar. I say a few words to Monserrat, the woman from Costa Rica who comes in to clean once a month, and I talk amiably to the people who live in the other houses on our dead-end street. Our homes are virtually identical, so we talk about insulation, vinyl siding, and weeds, or else we talk about their kids and they avoid asking about mine.

The rooms of the house have various uninteresting views: a patch of woods, the access road, a field, parts of the neighbors' houses. My study looks out onto a hedge. It's common to have uninteresting views, most people have them.

I live alone. At my age, that's common as well.

I am very tentatively healthy. Fina isn't so sure about that, and she's arranged for me to move to her place in Cattaraugus so she can keep an eye on me. She says I shouldn't go on walks by myself, and I shouldn't be here for a month at a time without visitors. It's all too risky, she says. She's four hours' drive from me, and I'm a half hour from Grey Bruce Health in Owen Sound.

I have syncopes. The first was in the kitchen and lasted for most of a day; I assume that anyway because when I woke up there was toast in the

toaster, but it was dark outside. The second time was on the porch. The doctor in Grey Bruce said it must have been at least an hour because I had sunburn on one side of my face. These absences don't bother me. I'm never in a hurry anyway. I hardly ever have appointments or places to go. I believe I collapse gently.

Fina, however, is bothered, and so starting in October I will go live with her.

I told her I am busy. I need to write these notes, but she said thirty-nine years is enough.

This summer, she has been visiting every other weekend. She cooks dinners and we watch movies together. There is nothing in any of this to complain about. I'm discovering that old age can be a long quiet interlude. The clocks tick so slowly they are almost silent.

When I went down into the basement, I discovered my suitcases had been damaged by the leak. You can measure your life in suitcases. When you're very young you don't have them, because your parents carry everything for you. Then you have a toy suitcase or a child's backpack, but your parents are still carrying everything for you. An adult is a person with one or more suitcases. A middle-aged person has a collection of suitcases: overpriced new ones, old ones with rips and repairs, even older ones smudged and torn from use. Then comes the period when the suitcases are put away, first in closets and finally in attics or basements. That is old age.

The piano I bought when I moved here is in a corner of the living room. Stacks of scores are piled around it like people listening. Composers are mainly my company. They have occupied my mind as much as a family, as much as friends you see every day. When I read about that year when everything went wrong, I don't remember the days and details, and I find myself thinking about music instead. It occurs to me that music has snuck into those parts of my mind that were once occupied by the people I loved and the places I visited. I have substituted music for people. I am surprised by this, but not too much. It's been a long time since I've thought about that year, and now I see that certain pieces, particular composers, have let me keep the feeling of that year long after

it ended, after the events in it fell from my mind, after the people who lived in it dispersed and died.

I no longer wander, like Samuel did. My forest is music. I have thousands of scores. They're out by the piano, and here in the study they're scattered on the table and stacked on shelves. In front of me I have Bohuslav Martinů's *Puppets,* which he wrote when he still lived with his family in an apartment in the bell tower of a church. An amazing piece of luck for a composer, to live in a place like that. There is my old copy of Francis Poulenc's exquisite *Pastorale,* and Einojuhani Rautavaara's *Fiddlers,* that's crazy music with incomprehensible Finnish titles like *Hypyt.* In another pile, there's Vincent Persichetti's three volumes of *Poems for Piano,* with romantic titles like *Sleep, Weary Mind* and *Dream, Heart's Desire.* And under it, Irving Fine's modest *Homage to Mozart* and Guus Janssen's immodest *Brake,* which opens with whole and half notes and then fractures until nothing is left but a torrent of hundred-and-twenty-eighth notes.

Some of these composers are almost gone out of history, with no one left to play them. There is Josef Hauer's *Nomos,* written in 1919, when atonal music was still rare. He refused to be romantic like Schönberg. He wrote page after page of dissonant notes, with no mood, no purpose, no expression, no letup. Under that, I have Pedro Humberto Allende's *Doce Tonadas de Carácter Popular Chileno,* written in the same year but on the other side of the world. Allende's pieces are sad in the complex way that only isolated people can be. In the next pile is Rodion Shchyotkin's *Polyphonic Notebook,* written in Brezhnev's Russia, prickly and unconvincing from the first page to the last; also Einar Valen's *Ice Sonata,* wonderfully glacial and frigid, like the view he had out of his sister's house onto a fjord and the mountains beyond; Franco Donatoni's *Third Extract,* which scatters staccato notes over the whole keyboard, randomly like sleet; Gavriil Popov's difficult *Images* from 1928, composed before the Soviet authorities censored his work, before he became too frightened even to visit his friend Shostakovich, before he lost heart, before he became the alcoholic composer of *Honor of the Motherland* and *Everything That is Beautiful in Life.*

Farther down the desk, there is a pile where I put compositions I've stopped playing. At my age, each time I put a score in that pile, I know I may have played it for the last time. I have a couple dozen of John White's two hundred piano sonatas there. He wrote them over the course of sixty years. The first ones are lovely, but as the decades went on, they lost their point. They went from inspiration to compulsion to empty habit. For some reason he couldn't stop. He had to keep writing them, and when I played them, I felt his own lack of engagement. I couldn't pay attention. Under White, there is Alexander Goehr's *Symmetries Disorder Reach*, which takes pieces by Bach, Handel, and Mozart and brings a very intellectual disorder to each one, distorting them until they can't be recognized, draining them of pleasure, splintering and discoloring them. Under that, I see Alexei Stanchinski's *Three Sketches for Piano*, feathery or crystalline, written when he was still hanging on to a normal life, before his father died, before he got hallucinations, before he was found dead by a river, not yet twenty-seven years old. Then Ivan Wyschnegradsky's *Nocturnes from the Vologda River*, one of his last compositions using ordinary notes, before he decided to adopt the quarter-tones in between the keys on the piano. The *Nocturnes* sound strained, as if the music was unhappy with itself and needed different sounds. Wyschnegradsky was increasingly unhealthy at the time, and the next year he checked himself into a tuberculosis sanatorium in St. Martin-du-Tertre. It was a short stay, only three years, but soon he was back again for the rest of his life. That was when he composed the unpleasant music that I still love. And in a corner of the study, rolled in a big cardboard tube, is Karlheinz Stockhausen's *Piano Piece 11*, a constellation of notes printed on a single enormous sheet of paper, like a map of some fabulous kingdom.

There are many more. These are the characters that fill my days and remind me what to feel. There is Boris Arapov's *Stavetsian Dance*, supposedly transcribed from a melody he heard in the Ukraine when he was young, supposedly happy and patriotic, but deformed by an irregular meter, ruined by his inexplicable attraction to sour sounds; Viktor Ullmann's last three piano sonatas, composed in the Theresienstadt concentration camp

where he was killed; Helmut Lachenmann's *Guero*, a piece full of clicking and rattling sounds, which he wrote in his second-floor office in the music school in Hannover, listening to the sounds of the animals in the zoo at the other end of the park; and Beat Furrer's *Aphesis*, written in his anechoic study, which he had constructed in emulation of Proust's cork-lined room, but with high-tech pyramids of blue-green radiation-absorbent material attached to the walls like pineapples; and Sergei Protopopov's hypnotic and boring *First Piano Sonata*, composed in a tiny badly heated apartment in Kiev, in a state of constant hunger.

These are my forest. It is every bit as easy to get lost in it as in a real forest. Only a few steps in, a couple minutes of playing, and I am lost for the day, as I have been for years.

Almost all the music I have was composed in the last century, about the span of my parents' lives and their parents' lives. That makes sense to me. Older music can be beautiful, but who is it for? Chopin, Liszt, Mozart, and the others wrote for salons of young men and women in Paris, Budapest, and Vienna, ten generations ago. I play them sometimes, but it doesn't take long before I see the ruffled cuffs and the buckled shoes, and I want something that was written for me.

I think of Stanchinsky, walking along a stream in the Russian countryside, hallucinating, ready to die. Lachenmann, sitting at his office piano, looking out over the park, wondering how to play the piano without making human music. Furrer, concentrating on his work in a room so quiet he could hear the blood circulating in his neck. Valen, sitting at the upright piano in his sister's house, looking down at the tiny ships in the fjord, pondering how to write modern music a thousand miles from Vienna.

The scores are my world now. Stockhausen in Darmstadt in 1957, in a white shirt and short tie, giving a chalkboard lecture about his latest theories. White, sitting in his damp study in Worsley, staring absentmindedly at the Manchester ring road, writing yet another piano sonata, not knowing whether it would ever be performed, not knowing even why he was writing it. Wyschnegradsky, in his enamel-painted room in the sanatorium in St. Martin-du-Tertre, playing one of his specially built microtonal

pianos with 160 keys, coughing, waiting for the inevitable appearance of the attendant to register yet another complaint from the other patients.

When I read this book, I hear these composers. They retell the book's stories as music. For me, the music is just as detailed as the events I described so long ago. Music is strange portraiture: it preserves every nuance of mood and light, but the faces are hard to see. The feelings are exact, but the people are gone.

I see the things in this book from a great distance. Like I'm in a plane, flying above thirty thousand feet. The ocean is far below. Its lattice of waves is blurred to a watery haze. I fly over that year, looking down on it from an unimagined future. It is too far away to see now, my life. I peer through the blue and white atmosphere and imagine there must be ships or whales. I read about the zoos, the disturbing things I saw, and the wracking dreams, but I no longer feel them. For me, this isn't a book I wrote, it's a book by someone who had my name.

At first, when I read this book, I worried that I wasn't remembering more. People who reach my age often have Alzheimer's or some other condition. They struggle to recall what happened in their lives, who loved them. I think my case is different. I have no problem remembering the myriad of little things that happened since I moved here. The winter when the access road wasn't plowed, and our little community was cut off for a week. The year I got a kidney stone and spent two days in Grey Bruce Health. When Fina married Steven Hodges she drove me down to Cattaraugus for the wedding and we had a big friendly reception at Baby Devil's Snack Bar. And of course, their children, my grandchildren, now grown. Fina used to bring them up a couple of times a year until they got married. Teresa still comes along with her mother sometimes. Hundreds of things, thousands maybe, from every year since I bought this house.

All that is normal memory. But it has been a very long time since the year in this book, that other life. Most of the people Samuel knew that year are long dead. Long dead is different from dead, long dead means the person has walked away into the landscape, into the distance, until I can no longer see them. Like I have sped away from them on a train. I

can point to the place where they disappeared. Down that road. Over that mountain. They have taken their words, the things they cared about, even the smell of their clothing, into those silences. I think this may be a common experience for people who live long enough.

An inconceivable distance has opened within a single lifetime. I am as far from the life described in these pages as a boy who is brought to a cemetery and told to look at the headstone of his grandparents, whom he never knew. He reads their names and dates. He listens to his mother talking about them, sees the tears in her eyes. But there is nothing to feel except the grass.

I only recall glimpses of that life. A summer day in Watkins Glen, it must have been autumn because leaves were floating in the water. Adela held Fina's arms up while we waded. The water in the gorge was only a few inches deep, but the smooth rock underneath was slippery with green algae. Fina was four or five, in her little blue bathing suit. Adela was young too. It was midway through the ten years of our happiness. Fina was gathering oak leaves. She was talking, but I can no longer hear her. They walk past me in my memory, out of nothing and into nothing. I once felt happy about this scene. I was probably proud, it was a precious moment to call to mind. Now it's bleached, like white driftwood high up on a beach, abraded by sand, less like a tree than a bone from an enormous creature. That day still comes back into my mind, but it no longer means anything to me.

Or that day when my mother told me about her first marriage, and how much she loved her first family, who died. That used to be painful to think about. Now the scene is short. All I see is her cigarette on the paint can lid she used for an ashtray. The bad feeling of the day lingers like smoke that makes you blink, but you wave your hand and it's gone.

That year comes back to me in random scenes. Toronto airport in the early morning. The lab the last day I was there. Two large wooden crates with Anneliese's notebooks in them. My microscope in back, with bottles and pieces of equipment all around it. And out the window, the trees that screened the Everal river, tousled by the wind.

I must be good at leaving my life behind. When Samuel wrote this book, he had already forgotten most of his childhood. Back then, when he thought about childhood, he pictured himself as someone else, a boy he called little Sam. All that has happened again. As if my life in Guelph was a second childhood, now also vanished.

Again, I don't think this is uncommon. Each life has lives that came just before it. We all know of people who died around the time we were born. Stravinsky died the year I was born. It doesn't mean anything, and yet it does. It's as if his world were linked to mine, like two pieces in a jigsaw puzzle. That's how I feel about the person described in this book.

My mother's parents visited from Germany when I was very young, but I don't remember them. They were both dead before I was five. My father died the next year. I don't know when his parents died, or even where they lived.

My mother died ten years before the year that's described in this book, inconceivably long ago. Before I was born, she knew Wolfram Pichler, the astronomer in Potsdam. He wrote her letters, which I should have kept. Should have read. Of all the things in this book, that's the one I remember best. Anyone who knew your mother before she met your father can never leave your mind.

Night

Out here in the country, it gets very dark. At night the hedge is an area of blackness bordered with serrated leaf silhouettes. Beyond is a grayish-black screen of trees, intermittently lit by my neighbor's television.

Darkness suits me. I like to walk along Route 6 just after sunset. First, I see the brightest stars, and then, as I keep walking, because there's no reason not to, the thousands of fainter stars that populate the sky, magnitudes two, three, and four. There are the constellations: Ursa Major, Cygnus, Cepheus, Cassiopeia, Hercules. The small ones too: beautiful Corona Borealis, crown of the northern heavens. Sagitta, Lacerta, and Serpens Caput.

After a half hour walking in darkness, I can see stars down to magnitude six. The test is the last star of Ursa Minor, η UMi. It completes the cup part of the Little Dipper, and if you can see it, the sky is dark and clear. That's something my mother taught me, one of the things that has stayed with me. She would never have imagined I'd be thinking of it, walking down a rural road in Canada, fifty years after she died. I am much older now than she ever was. In my mind, she's a middle-aged woman. If we were out walking together, she'd want to walk faster than me.

The sky fills with faint lights. It is full night. The stars are candent.

The road around me is close to invisible. Stretches of pavement are drowned in pools of darkness. If I have a syncope here, I'll just crumple comfortably into the ditch, I'll be part of the darkness.

On the walk back clouds grow like dark spills, forming black irregular shapes where there are no stars. Beyond all that, out in the universe, there are more dark areas. Those are the Voids, places in the universe where there are almost no galaxies, no stray stars, nothing.

The road sinks into oily darkness, the sky is marred by black clouds, the universe hollows itself into Voids. All this seems appropriate. When you're very old, you're content with very little. Absences are companionable.

Animals

The animals Samuel encountered that year are all mixed together in my mind. I don't remember them one by one. I hear them whimpering and snuffling, howling and yelping. There's something wonderful about those cries. None are in words, none make human sense, so they make an amazing music. This is how I think of Helmut Lachenmann, the composer who refused to let musical instruments make musical sounds. He was the composer of animal sounds, of clicks, shrieks, and whines.

To play his piece *Guero,* I sit at the piano in the ordinary way, but I am forbidden to press the keys with my fingers. Instead, I am instructed to run my fingernail along the front edges of the keys, under their little ornamental flanges. My fingernail makes a ratcheting sound as it moves left and right. I am not depressing any keys, so I don't make any musical notes. Pitch doesn't change because nothing inside the piano moves. The keys clatter against each other.

Then I am told to run my middle fingernail along the top surfaces of the keys, but to take care not to actually strike any key. That makes a soft slipping or whistling sound, like a ghost glissando. If I haven't cut my fingernails recently, I hear a ladder of fingernail snaps against imitation ivory.

Guero is a quiet piece, full of taps and flutters. Nothing normal is permitted. It is as if actual music is dangerous and striking a note might be like firing a pistol.

The score of *Guero* shows how I am supposed to slide my fingernails up and down the keyboard. The curving lines are to give me an idea of how to move. The clefs are general guides. It doesn't really matter which keys I tap. I keep time using tick marks along the top: the piece has a very slow quarter note, like an adagio.

top of the keyboard one division = ♩ = ca. 50

f with force

p

< *f* >

middle C

bottom of the keyboard

The boxes indicate I should run my middle fingernail along the front faces of the keys. Left hand first, starting low down and moving up toward middle C. The < *f* > means my middle fingernail is supposed to strike louder and louder, then softer. While I'm doing that, my right hand starts above middle C and goes up a few notes. The dots are to give an approximate idea of how many keys my fingernail touches.

My hands go back and forth, producing rasping sounds, like two rattlesnakes in a box.

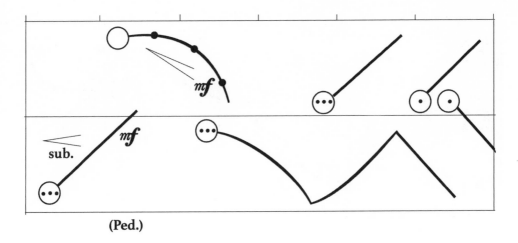

(Ped.)

Guero continues this way, not making music. Circles mean I run my fingers along the tops of the keys, without depressing them. There are no melodies. The tapping and flicking sounds are reminders of music. It feels like I'm thinking of playing, recalling how my hands move playing different pieces. Or it's as if I have dementia and I have forgotten how to use the piano. If Fina saw me playing this she would think I have finally lost my mind.

Guero is a quiet piece, because even if I really bear down on the front surfaces of the keys, I can't make very much noise. If I draw my fingernails over the top surfaces of the keys, I have to be careful not to accidentally strike any notes. Sometimes Lachenmann marks the score *ff*, but it's really like a stage whisper.

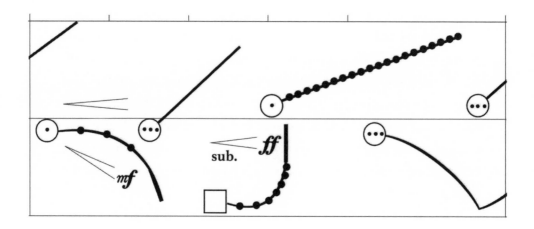

In other places *Guero* becomes very quiet, *tutti pp.* Then the sounds are tiny. On stage they would barely be audible, like beetles crawling inside a glass jar.

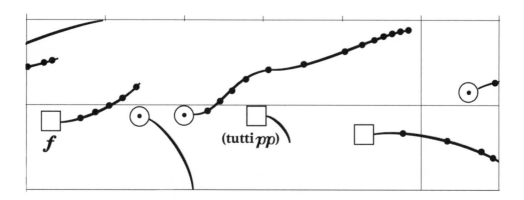

Guero is a Spanish word that is used to describe someone who has light skin and blond or light brown hair. I think Lachenmann meant that his piece is like music, but paler.

Guero has its own language. It speaks, and I listen. I don't understand it, but I don't miss anything.

In the last couple of minutes, I'm instructed to reach inside the piano and pluck the piano wires themselves, but not in the usual way that produces a sound like a guitar or a violin pizzicato. Lachenmann tells me to pluck the wires between the tuning pins and the saddle. That is up where the wires are tied, beyond the area where they are free to sound musical tones. Picking wires in that place produces slightly musical tones, but they have no special pitch. It's as if *Guero* is straining to become music. Like a swimmer coming up from a deep dive, seeing the surface approach.

A few seconds before the end, I'm instructed to stop. There is a double fermata at the end of the line.

(Ped.)

pizz.
(with the fingernail)

As high up as possible on the wire
very close to the saddle

Hit the pedal hard

Then I stomp on the pedal, which produces a thump, like throwing something into a dustbin.

I reach into the piano and choose two high notes. I am told to pluck the wires close to the saddle. This produces two musical pitches, the first actual notes in the composition. Plink. Plink. They sound like high notes on a harp, but with a strained quality. Still not quite normal music.

These are the only two notes in the piece: a dotted eighth note, and then, after a rest, an eighth. Precise, strictly limited. The exact pitches aren't given. I use my ring finger.

The two notes die away. I lift the pedal and wait one more beat without moving.

I love this passage. As soon as music appears, the piece dies. Music kills it.

When Lachenmann sat in his office composing *Guero,* he heard the chirps and whoops of the animals in the Hannover zoo across the park. Their bellows and roars were attenuated and refracted through the city air. He wanted music to be like that, nothing but feeling, no singing, no sentiment, no human sense.

My fingernails make sounds like animals pacing in their cages, scraping their claws against the wall, gnawing on sticks. I hear them scratching, whimpering, tapping. When I snap my fingers against the tuning pins the clicking sounds are like animals' claws on concrete floors. When I stomp on the pedal I make a booming sound, like a large animal crashing itself into the wall of its cage. At one point there is an uncanny grumble, like a lion. Then high flutters and tinkling sounds. The animals are straining to speak.

This is how I feel about the chapters with zoos. The decades have crushed the dissonant experiences of that winter into a kind of harsh static, a white noise, like fingernails clicking along piano keys.

Lachenmann also composed a set of short pieces supposedly for children, *Kinderspiel.* The first is one of the most famous of all German children's rhymes, "Hänschen klein," the song of little Hans, a sweet little tune that's taught to every small child as soon as it gets to school. It has the simplest possible rhythm: it's 4/4, with a word on 1, 2, and 3: one, two, three, and, one, two, three, and. A real infant's melody.

Little children must love this song because it tells them about their independence and reassures them that mother is waiting back at home. It speaks to adults too, because who doesn't leave their home, and who doesn't get lost in the wide world?

Lachenmann's version starts at the very top of the keyboard and gradually falls. The well-known melody is gone, but I can hear it in my head, because the rhythm is the same.

I play this as hard as my fingers can strike the keys. It's earsplitting. As if a teenager is screaming the melody, making fun of it, turning a sweet nursery song into a hysterical anthem.

Lachenmann has me press some keys at the bottom of the keyboard without making any sound, and hold them down. That way, when I hit the high notes the piano makes faint wailing and moaning sounds, resonating with the low notes.

The original has a nice ending when Hans runs home to his mother, but in this version he does nothing but fall. The notes march down, louder and louder, toward the very bottom of the keyboard.

Little Hans's fall is horrible, and it's doubly awful that the melody never appears. His life is nothing but a march down to nothing. Always in the same baby rhythm, one two three and, one two three and.

In the last three measures there are two lovely notes, played in octaves. As soon as they appear, the piece is over. It's like *Guero:* Lachenmann only permits himself two notes of ordinary music.

Before I play those two last notes, I silently depress three keys with my left hand, making an unsounding chord. It holds some of the sound that is still rumbling in the bass. I hold those keys down while I play the two high notes. Lachenmann has designed it so that as the piece dies away, I hear faint sounds of the original melody lingering in the air. Not the melody of the children's song, but echoes of its notes, sounding together.

Once again ordinary human music is poison. For Lachenmann, normal notes are like illnesses. Songs must have sounded horrible to him. Musical notes had to be kept away from his compositions. When they appear, like in *Kinderspiel* or *Guero*, the composition is over.

I see, reading this book, how little I talked that winter. I didn't speak to Adela or even Fina. Love would have poisoned my poisonous solitude. I was in a curious state, learning to live by myself, and people were dangerous. Like a patient who needs silence because he is concentrating on his illness. Like the famous line in T.S. Eliot: "Till human voices wake us, and we drown."

When he was young, the American composer Ben Johnston had one of his pieces performed in an outdoor concert, at Tanglewood I think. One of Bartók's pieces was also on the program, and Bartók himself was in the audience. It was summer 1942, just three years before Bartók died. After the concert, Johnston couldn't find Bartók. Finally, he spotted him walking behind the theater. He ran up to Bartók and asked him what he'd thought of his piece. "Oh, I am sorry," Bartók said, "I never listen to music by other composers. I was walking in the forest."

I thought of this recently when I was playing Lachenmann's *Guero*, because it reminded me of a similar story. In 1992, the Dutch composer Jopie de Leeuw had one of her string quartets performed at the same concert as a piece by Lachenmann. She was delighted to see Lachenmann in the audience. He had been famous since the 1960s, and he was rarely seen in public. After the concert, she went backstage to find him, but he wasn't there. A violinist told her Lachenmann was in the basement, and he showed her a door marked NO PUBLIC ACCESS. The staircase did not look safe. It was dirty and lit by bare light bulbs protected by metal cages. But the violinist said Lachenmann was there, so de Leeuw went down. She found him sitting in a small room three floors below the theater. The room was full of machinery, presumably for heating the auditorium. de Leeuw said it was very loud, and there were groaning and snapping noises. Lachenmann saw her, but he did not look friendly, and she went back up the stairs.

Lachenmann wrote another horrifying composition supposedly for children, called "Clouds in Icy Moonlight." It comes right after "Little Hans." This piece is all piercing loud notes at the very top of the keyboard. After every other note, I depress the pedal, so the next one strikes inside an icy cloud of overtones. The pitches ratchet their way up to the second-highest note on the keyboard.

Every second note is struck without the pedal. Those are sharp like stars or like the moon in a clear night sky. I think Lachenmann pictured the pedaled notes as clouds. The width of the clouds is the width of the pedals. The notes march along, clanging like iron pots.

"Clouds in Icy Moonlight" is a vicious parody of all the simpleminded pieces composers used to write for children, with titles like "The Song of the Rainbow," "The Brave Mouse," "Little Rabbits in the Meadow." I have a dozen pieces in my collection that conjure peaceful winter landscapes. "Skating on the Wannsee," "My Sled Ride," "Winter Sunset." This piece is a pure nightmare.

As "Clouds in Icy Moonlight" goes on, Lachenmann adds more loud notes. He is careless about it. Some are seconds, so they are dissonant; others are single notes or consonant intervals. It seems he just threw the piece together. All that mattered was the incessant excruciating march.

In one passage, I am asked to hold down a cluster of keys at the bottom of the keyboard. The shrieking hammering at the top of the keyboard brings out a dull rumbling echo from the bass, like grandparents muttering under their breath when a grandchild is screaming.

Lachenmann seems to think "Clouds in Icy Moonlight" is beautiful. Midway through there are the letters *Vi—* in large print, and later on there's the rest of the word, *–de*, that is *Vide*, meaning "Look!" He imagined a delighted child staring in wonder at moonlit clouds and stars.

Lachenmann had long, oily gray hair, and he tended to look unwashed. I can picture him dragging a frightened grandchild outside on a bitter cold night and forcing it to look at the stars.

On the page, "Little Hans" and "Clouds in Icy Moonlight" can be mistaken for children's melodies because they are simple to play. Actually, they are unbearably unpleasant. After I've finished playing, they shake for a while inside my head.

The zoo trips were the end of my working career. That was the spring I left Guelph. It took decades for their reverberations to die down. Like church bells, the zoos kept shaking in my mind, producing faint sour mixtures of tones.

In an interview, Lachenmann said he planned to write a companion piece to *Guero,* also for piano. He wanted to call it *Prieto,* a Spanish word that is used to describe people who have a dark complexion and black hair. *Prieto* was going to be made of loud sounds in the lowest bass. It was to be played along with *Guero*: one piece with light tapping, the other deep and loud, the two somehow synchronized.

The problem, he said, was how to do it without producing pitches, without making musical notes. He tried laying a heavy chain inside a piano. When he moved it around, it created deep confused sounds, which he liked, but it damaged the wires. How do you do it? he asked an interviewer. How do you make music without making music? Music without pitches, without notes? You have to try. Otherwise, he said, the music will sing. It may even speak, and we've had about enough of those.

Thirty-five years after he wrote *Guero,* Lachenmann finally finished *Prieto.* The score is the same as *Guero,* except that now it is a picture of the sides of the piano. The score is performed by shoving, rapping, and punching the side of the piano. The score is read as if it is drawn on the

outside of the piano. It begins to the right of the keyboard and continues where the case curves and then around the back.

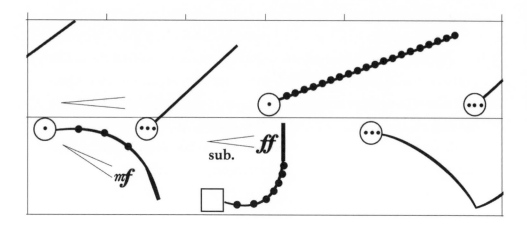

This time, circles indicate punches. Performers should hold their hands close to the piano case and strike very forcefully, in order to shake the piano. When lines in the score slope upward, performers should follow the same path up toward the lid, rapping with their knuckles.

The two pieces *Guero* and *Prieto* use the same score and have the same duration. Lachenmann says they are to be performed together, on a single piano. The performer of *Guero* remains seated. The performer of *Prieto* stalks around the piano, pummeling and knocking on the case.

The clicks of the first performer's fingernails against the keys almost match the raps and punches of the second performer's knuckles against the case. "The performer of *Guero* should be nervous," Lachenmann writes. "The performer of *Prieto* should be angry and forceful as if he wants to hurt the piano. The performers should be filled with a hatred and fear of the piano."

When he was eighty-six, Lachenmann wrote a composition called *Pression* for cello. As in *Guero,* the performer is not allowed to play in the ordinary way. The cello is assumed to be concert grade, and the musician is assumed to be a virtuoso. She dresses appropriately and comes out on stage looking confident and professional. You expect a captivating melody,

hopefully something soulful. She holds the cello lightly in one hand, the way cellists do. She raises the bow. Then come the taps and scratches. Her fingernails on the wooden neck, the pads of her thumbs on the belly. She scrapes the wires near the tailpiece.

Pression sounds like a person breathing quietly in a metal box, like peeling off a wetsuit, like an electric saw skipping along a metal sheet, like a robot belching, like a tugboat droning its foghorn in a strong wind, like a cork forced back into a bottle, like a frightened bird squealing, like people chewing on knives and forks, like a fox panting, like an owl shivering in a hollow tree, like a person who has practiced cello her entire life but has suffered some catastrophic illness and forgotten everything.

The dreams

My dreams that year were very strong.

Some dreams are wonderful, but they push you out, as if you don't belong. They shove you back into your life. You wake up, and you want to go right back into the dream. Those are the dreams you love, but they don't love you.

Other dreams come up all around you when you think you are still awake. Those are like a faint smell in the air that reminds you of something, a pine forest maybe. At first, you don't pay attention to it, then you glance around to see if there are trees nearby. The scent becomes stronger. Pervasive. And you realize: this is the air of a dream. You understand you are inside the dream. It wants you, even if you don't love it, even if you want to get away. A dream can love you very strongly. Ordinary waking life is weak in comparison.

Samuel was chased by dreams that loved him. They hid his imagination so he couldn't find it. They kidnapped the people he loved so he wouldn't be distracted by them. They told him the world was empty. Then they hypnotized him with fires, more dangerous, more seductive than any person or place could ever be. In the end, the fires surrounded him, he threw himself into them. The dreams won, they burned him down.

Music loves me in that same way. It empties my world and tells me there's nothing else to do, nowhere worth going, no one worth talking to. I have never resisted. It's good to be loved.

My dreams no longer concern me. If you live long enough, your dreams get tired along with you. The beautiful ones no longer seem so attractive. If you see one, you smile, but you turn away and sleep for a while without dreams. The bad dreams no longer frighten you. You no longer wake up, like a child from a nightmare. The unruly dreams settle, they come up and shake hands. Hello, I'm the ogre who chased you through your nightmares when you were young. I live across the way.

Last week I dreamed that I asked Fina to buy Dijon mustard next time she goes to Food Land. That was a useful dream, because it reminded me that I wanted to ask her to buy Dijon mustard for my hot dogs. I also had a dream about my neighbor to the left. Both our houses have hedges in back, and the vinyl siding next to them gets mildewed. He was telling me vinegar and water don't work, and I suggested he could add some detergent. He said there must be commercial products, and I agreed, but neither of us knew the names of any. That dream was mostly true. There is mildew on the back side of the house next to the hedge. I have tried scrubbing it with a mixture of vinegar and water, but that didn't kill the mildew. It must have been on my mind to ask my neighbor on the left side.

It's not that you ever stop dreaming, it's that dreams are no longer the undertow that tugs your ankles when you're chest-deep in the surf, sucking the sand out from under your feet and pulling you down and away into the sea. In old age dreams are the weak current that rearranges the sand around your toes when you're standing on the beach, helping you settle in so you can enjoy the sun and the wind.

Viperine

The Austrian composer Beat Furrer wrote a piece for piano called *Phasma*. He meant phantom or apparition, but phasma is also the name of the order of stick insects. A Pink-winged Phasma is an enormous stick insect, leaf green with lurid pink wings like flowers. Other stick insects are delicate, with skinny bodies like twigs. Phasmas are large plant-like animals. Animals that pretend to be plants. A different kind of apparition.

In Furrer's piece, I use my forearms on the keyboard to make sudden quiet sounds. To make the first chord, at the beginning of the piece, my right elbow is at high C and my left is at the C two octaves below. My hands overlap around middle C. I press my forearms on the keyboard quickly and very quietly and I release immediately.

It's an unusual gesture: I have to lean forward and press down on the keyboard. It reminds me of tamping down an overfull cardboard box.

Phasma continues with these quiet, muffled sounds. They are quick and irregularly spaced, with silences between. I have to count carefully, five beats per measure, differently divided each time. The first measure is *one*-two-three-four-*five*. The second is *one*-two-*three*-four-*five*. The third is one-*two-three*-four-*five*. There is no break. It is not easy.

After a minute, the piece becomes more complex. Ordinary chords begin to strike here and there on the keyboard. Furrer has to put them on an extra staff because they are in between the forearm clusters.

The chords are divided four to the measure, against the clusters' five. That is very hard to play. A listener can't perceive the four beats, so the chords sound like random interruptions. They strike all around the clusters, inside them, quite close to them: like that knife game where people splay their fingers and stab the gaps as quickly as they can.

Phasma never lets me relax. I don't have time to straighten up between the forearm clusters. I have to concentrate on counting the irregular beats and moving very quickly to fit the chords in between them.

The Pink-winged Phasma is one of those creatures that would be lovely if it was smaller. But it's enormous. Its body is covered with prickles. Its wings are thin and shiny like iridescent mylar. And yet the Pink-winged Phasma is shy: it wants to camouflage itself, to look like a thorny forest plant. Large birds eat them, and people kill them, dry them, and put them in shadow boxes. Frightening, but decorative. Instantly repellent and oddly attractive.

Phasma and *Phasma*. These two images flutter together in my mind, like one of those trick lenticular postcards that show a woman with her eyes closed, and then when you turn the card, her eyes open. First there's Furrer, the fastidious composer, working in his soundproof room in Vienna, and then there's the Phasma, creeping along eucalyptus branches in Australia. Together, this is what remains for me of the intern Viperine. She was an apparition. Exacting, exquisite, repellent.

Furrer's *Phasma* takes a long time to play, almost a half hour. It has no melody and no overall structure. It possesses an uncanny cold precision. As it goes on it becomes frantic. The chords multiply until they are all over, like a cloud of flying insects.

It's exhausting. I have to keep rigorous time, counting five against four, but the effect is always irregular, as if I'm not counting. *Phasma* is surprising but monotonous, exciting but numbing. Like Viperine, it is precise and complex, but its emotion can't easily be located.

The Phasma is not one insect, but an entire order. The Lesser Phasma looks like a shriveled yellow flower. It is monomorphic, both sexes look the same. In other Phasma species the males and females are completely different. The female Peruvian Phasma mimics a gnarled black twig, with vestigial polka-dot red and black wings like the little fins on a sea dragon. It is especially aggressive looking. You'd scream if you saw one in your room. But like all stick insects, it is harmless. It's large and heavy, and has sharp claws, and when it crawls over you it can puncture your skin. Its unexpectedly small polka-dot wings are outlandish. They have no known function. They look like two miniskirts. The male Peruvian Phasma is a small brown bug.

When I play *Phasma*, I do not enjoy myself. It is not easy to stay hunched over like that for a half hour, and I can't stop concentrating and counting even for a moment. Sometimes Furrer demands that I stand up quickly, find a single wire inside the piano, pluck it, sit immediately, and keep playing. He does not give me any time to settle on the seat or get my bearings in the score. The moment the note is sounded, I have to find the next notes on the keyboard, the next cluster. It's like a sadistic army drill, standing and sitting as quickly as possible, then leaning forward, quickly, arms crossed on the keyboard.

Phasma ends suddenly with an outlandish crashing broken chord, which I play as loudly as I can, ending with both arms flat on the keyboard.

Afterward, I like to play something relaxed and simple, like Dvořák or Sibelius. Music where the sentiment is clear and there are melodies that can be sung. Where happiness is stupid and obvious, and sadness familiar and consoling. Compositions I can play while I'm comfortably seated, maybe even glancing out the window.

But later I find myself fidgeting. I tap the kitchen counter, four beats in one hand, five in the other. I practice dividing myself into two incompatible rhythms. The music comes back to me, fluttering, whispering. I lean over the counter with my elbows out, in the same slightly uncomfortable position required by *Phasma*. The discomfort and the nervousness are addictive. I go back to the piano and try again.

I only knew Viperine for that one year, and I never saw her again after I left Guelph. *Phasma* expresses her better than words. There was no way to relax, nothing normal happened from beginning to end. *Phasma* is an uncompromising weird piece, and it always brings with it an apparition of a Phasma insect. Alarming, delicate, and compelling.

The days

Sergei Protopopov. What a great name, so much better than mine. I suppose literally it means one who came before the Popovs, the prototypical Popov. Wonderful name.

He wrote three stupendous piano sonatas and invented his own theory of harmony. At the beginning of the first movement of his first sonata, Opus 1, there is a bar of music in small type. It sets out the sonata's underlying system: four tritones, intervals of three whole notes, each with its resolution, in a rising sequence. It's all very mathematical and experimental.

When the sonata begins, my right hand rehearses his system, at first rising up, and then falling.

It's like a drumroll. The waves in the right hand are marked *rumore sordo,* meaning "with a thudding sound." My hand splays and contracts as I play, like an inchworm making its way up and down a branch.

In the left hand a melody rises and falls, out of sync with the right hand. It is marked *sotto voce, lugubre,* "dismal, quiet."

A normal composer would give that up after a while. A normal composer would take a break, change the texture. Cut back on the thudding, perk up

the dismal melody. A normal composer would let the performer rest after those mechanical chords. But Protopopov needed his music to follow his theory without deviating, no matter how tedious it might become or how hard to listen to. So the tritones continue page after page. They lose whatever interest they had and become an undulating wall of sound.

Clamando, he says in this passage, "crying out, without stopping, with a loud voice." The pedal is down through the entire passage. The sounds build up.

Protopopov thinks in great surges of emotion. His music is like waves, but not like salt water. Something more viscous, like the waves of protoplasm in an amoeba, spilling forward and pulling back. He can't stop. His music is a single mass, stuck to itself. This is how I think of my experiences that year. I was already drowned by the first zoo and the papers I had to read on animal behavior, and the flood just kept coming, turbid, repellent, undulating. Following a logic I could not understand.

The sonata is not easy to play. It is clogged. The chords don't feel right. They're for large, perhaps even slightly deformed hands, with abnormally long ring and little fingers, and minimal webbing between the digits. Or hands like amoebas, that can flow and ooze over the keyboard.

From a distance, Protopopov writes, because in this passage the waves are coming back again. The music here is quick, threatening. *Scolding,* he writes, *harsher and harsher.* Then it fades. A roar into a rumble down to a mutter. But you know the waves will be back. They need to keep repeating the theory, they have no choice. They are the sound of the blood roaming in your ears.

Listening to Protopopov is like watching a slow river of magma pour out of a mountain, spitting and burping and tumbling over itself. It's compelling, and then, after a while, it's boring. It is fascinating because it's so alien—rock that glows, that looks alive—but it's inert. It has no connection to life.

This is the music of all the strange things Samuel saw and heard on those tours. Viperine's letters, the scientific essays, the poor animals. The twitches and sudden shakes, the pacing and staring. The platypus, madly scratching. That white animal in the dark room, in the cage with no label. Mushka, the morose Pallas's cat. Pekka's strawberry face. Dr. Tank's fortified life. Sirje, with her double haircut and fangs sharpened like steel. Preteen, swaying as he walked, telling the story of blood gushing out of Ellie's mouth. Even the little Chinese quail, without a thought in its head. And for some reason Jaagup, who stared at trees, and Melinda the fennec, who stared at flies or flecks in the air, and that tiger, gazing up at the wall that was always too high to scale, and Monika's hyena, looking blankly at Mercury in the predawn sky, and Betty the black bear, blinking into its haze of drugs, and Owole the blue monkey, no longer looking, no longer seeing, its eyes no longer turning, no longer needed.

Memories like Phorid flies swarmed over Samuel's ruined life and overwhelmed his thoughts. Instead of air he breathed a viscous churning protoplasm. The first sonata is crowded but monotonous, like that winter. Everything new was unpleasant, and everything unpleasant was the same forever.

Protopopov's second sonata begins almost silently, in the bass. It is marked "vague, always undulating, threatening."

Senza tempo *Vago, sempre ondeggiando, minaccioso*

Like the first sonata, this one is made of great blocks of unpleasant stone-gray sound. It all feels wrong, as if someone is pressing their palm onto the side of my head, pushing me to the side, not letting me look straight ahead.

Protopopov got his theory from his teacher Boleslav Yavorsky. The two of them believed that a true Russian avant garde music could be made by building compositions on tritones instead of fifths. That way music could avoid the easy conventions of tonality that still pleased crowds in the Grand Hall of the Saint Petersburg Philharmonia. Music could resist becoming Western

like Stravinsky. Yavorsky's theory was an anchor, chaining music to its deep Russian past, to the modes of the Byzantine and Slavonic church. Protopopov's music was traditional and nationalistic, and also radical and modernist. He never strayed a single note away from his teacher's theory. In his mind the only thing that prevented music from collapsing into trite tonal symphonies like Tchaikovsky's or decadent Western entertainments like Stravinsky's was the theory of tritones. As long as he could stand the groaning and bellowing, the music would be strong.

In Yavorsky's theory there is no way to end a piece of music because it has to remain uniform and dissonant. Protopopov's sonatas stop suddenly, harshly, as if the music is a writhing snake and it has become necessary to chop it in half. Just as Samuel's year ended, because it was all suddenly too much.

Protopopov wrote a treatise on music theory called *The Structure of All Possible Musical Speech*. In it, he proposed dividing the octave into eighteen parts, and then thirty-six, and finally seventy-two. Many more divisions than Wyschnegradsky. He gave a talk on his theory at a musician's and composer's union meeting in Leningrad in 1931. He spoke like a fanatic. His ideas were judged to be insufficiently Marxist, and he was expelled from the union. He knew the next step would be imprisonment. He renounced music and got a job in a bank.

He watched as his fellow avant-garde composers were given negative reviews by the state media, blacklisted, even sent to the gulag.

He wrote a second treatise called *Ideological Bases of Advanced Music Theory*, explaining how his compositions fit Stalin's aims. At the time mathematics was considered a threat because so much of it was being done in European and American universities. There was pressure from Stalin's government to establish full ideological control over mathematics. Protopopov's second treatise is full of mathematics. He hoped it would inspire the musician's union to re-admit him. "It is mathematically advanced," he wrote, "to divide the octave into eighteen parts, because the ratios between pitches are infinite nonrepeating fractions, not like the traditional simple harmonies of the twelve-step scale." The diatonic scale used in classical music, he said, is indebted to Pythagoras, and is therefore Western and compatible only with capitalism.

He presented material from his new book at the mathematician's union annual meeting in 1939, but he was refuted by Ivan Orlov, Stalin's advisor on mathematics. Orlov said Protopopov's theory was just an example of Western mathematical idealism, that Protopopov was unreflectively following Georg Cantor and the other European mathematicians. According to Orlov, European mathematicians thought that transfinite numbers were the way forward for mathematics. "Protopopov doesn't realize that concrete experience is what the Russian people need," Orlov said, "not more abstract and supposedly pure Germanic reason." Orlov had a pianist play excerpts from Protopopov's first sonata to demonstrate the horrible results of giving in to Western transfinite mathematics.

It was the first time Protopopov had heard his work performed in public. He was jeered.

For the rest of his life, he kept quiet. There is a page in his third and last sonata marked "hysterically, insistently, endlessly," where he writes notes that are higher than the keyboard. That didn't matter, because by then he knew his music would never be performed. The sounds existed in his mind, in those waves of densely packed black notes.

In the third sonata, there is also a long passage marked "unreal, as if from afar, growing into a majestic torrent." I hold down the pedal for pages on end. The sounds rumble and swell, and the swell becomes a roar. My coffee cup rattles on its tile coaster.

The relentless days and nights of that year are crushed together into Protopopov's lugubrious waves, rolling over me like the caterpillar treads on a tractor. That year finally broke the broken life I had led and pushed me on into my long decades of quiet.

Protopopov had two sons. One died in the Second World War, and the other, named Beresh, moved to Charlottesville. In 1980, a young musicologist visited Beresh to see if he had any of his father's music. Beresh said his father had continued to compose in secret. He told the musicologist that when he was young there were two cabinets full of compositions in the apartment. His father told him they could never be played. In 1954, Beresh said, two months before his father died, he heard a rumor that the police were coming to search the apartment. He took all his musical compositions out to a lot behind the apartment and burned them.

Beresh said the compositions were "awful," and he disliked it when his father played them. "I hate to say it," he told the musicologist, "but really it all sounded the same. Like when he took me to the Southern Pier in Kaliningrad, and I had to sit watching titanic waves of ocean water smashing against enormous concrete cones. My father held me tight. He told me I had to listen; those waves were the soul of music. I had to watch hour after hour in the cold. I had to be silent and look at the ocean. It is a bitter memory."

Preludes and fugues

The days and nights in this book remind me of preludes and fugues. In music, the prelude comes first, and goes on as long as it likes. When it finishes, the fugue can begin. Usually, they have different melodies and moods. It's as if they aren't aware of each other.

Preludes are like days, with all their noise and distractions. You never know what will happen during a day. A prelude can be anything—a military march, a dance, a dirge, an ornamented lament, or just some crashing chords or a rush of notes.

Fugues are like dreams. They live in their own world. Time runs differently in fugues. A fugue opens with a lone voice, in single notes with no harmony. The voice sings for a while by itself. Then it is joined, and the new voice sings the same melody. That is the genius of a fugue: a voice is by itself, and then it is joined by another voice, but the second voice is itself, a memory of itself. What time is it when that happens? The time of the first singing voice, or the time of the memory?

As the fugue goes on, the melody keeps coming back, overlapping itself. The fugue replays what I have just heard. As the dream deepens, the voices weave into one another. Sometimes the opening melody plays at double speed, other times it's stretched out or it runs backwards. Clocks move against each other. Time doesn't move forward.

No rule says when a fugue should end. There does not need to be a great crescendo like in a symphony. A fugue might not end with a definitive chord. It might just unravel. Its voices are like threads in a carpet: at the center they're knotted in an intricate pattern, but at the borders they hang free. A fugue can just evaporate like a dream.

When the fugue is over, so is the night. It's time for the next prelude. Bach is the model for composers who want to write sets of preludes and fugues. The *Well-Tempered Clavier* has preludes in as many styles as he could manage. Some are marches, others serenades, chorales, or country dances. There are virtuoso pieces, with notes speeding up and down the keyboard. It hardly matters what is in them. As you listen, you know night is coming.

While I am playing a prelude, it is hard to remember the fugue that came before it. In the daytime, all I know is that between each day there are depths. Things that happen there are not easy to recall.

Every once in a while, Bach's fugues begin with melodies taken from the preludes just before them. The opening theme of the fugue may repeat a motif in the prelude before it, but soon it moves away. As if it forgets. And then it forgets that it has forgotten. That way it can sing its own melody, without wondering where it came from. That is like when you fall asleep, and your mind selects a scene from the day to lead you into your dreams. Soon enough the link is forgotten, and you are lost in the dream.

I no longer feel the pressure of that year. Samuel was crushed between his asphyxiated days and his airless nights. He was trapped. His days were filled with random sights and sounds, like preludes. His nights were a single landscape, unfurling ahead of him like the unspooling themes of a fugue, overlapping, intertwining, braiding into a forest. The iron stares of the animals clamped down from above, and the teeth of his dreams pierced him from below. I feel sorry for him, if that makes sense, but it was long ago, and he was not me.

Now the days are still and the nights are flat and featureless like the land around here. My dreams are weaker than I am. Nothing much happens in my days or nights. The emptiness is lovely.

Preludes and fugues are well named, because the prelude always seems to be looking forward to something. It is incomplete, it anticipates some resolution that it cannot imagine. The fugue is the response that the prelude never survives to experience. Dreams, as everyone knows, are attempts to heal damage suffered during the day.

Preludes and fugues normally come in sets of twelve pairs of pieces, so that there is one for each key from C major to B major. If the set includes minor keys, that makes twenty-four pairs of preludes and fugues, or forty-eight individual pieces in all—a prodigious effort for any composer. Bach did it, and he even wrote a second *Well-Tempered Clavier* that goes through all the keys again.

In the twentieth century, the greatest set is Shostakovich's *Twenty-four Preludes and Fugues,* but there is also Zaderatsky's anguished and strident

Twenty-four Preludes and Fugues and Rodion Shchyotkin's unsettled *Twelve Preludes and Fugues.* I also have sets by Aleksandr Flyarkovsky, Matvey Gozenpud, the Armenian composers Eduard Abramian and Gayane Chebotaryan, Valentin Bibik, Paul von Klenau, Hans Gál, Pavel Novák, Sergei Mikhaylovich Slonimsky, Miroslav Bázlik, Trygve Madsen, Arkady Filippenko, Nikolai Kapustin, Gary Bachlund, Krzysztof Meyer, David Diamond, and Henry Martin. There are many more: Hiroshi Hara's *24 Preludes and Fugues*, Alexander Yakovchuk's, Astri Kvassnes's, John White's set, Mark Alburger's, Joseph Podlesnik's, Igor Rekhin's, Franciszek Zachara's well-meaning *New Well-Tempered Clavichord*, Viktor Poltoratsky's angular and crude *Twelve Preludes and Fugues,* David Cope's trivial *Well-Tempered Disklavier,* Ron Weidberg's apocalyptic *Voyage to the End of the Millennium,* James Dillon's impossibly difficult *Ceithir uairean fichead,* Christopher Cope's *Perfectly Distempered,* Jeffrey Nosanov's inventive *Shostakovich / Jarrett,* the feeble German composer Julius Weismann's *Tree of Fugues*, and the compulsive Danish composer Asger Gaarn's monumental, indigestible 626 preludes and fugues.

Those are all accomplishments, records of struggles. Few are ever performed. When I play most of them, I think: this may be the only time this music has been heard since the composer died. At this moment, I am the only one who hears them.

Each prelude is like a new day. It shakes itself off, tries to recover from the poison of the night. Then when the prelude is over, the music falls asleep again and the next fugue comes, ruining the memory of the prelude before it. Night smears day until day is unrecognizable. Each night is a balm for a wound that has been forgotten. All nights resemble each other, in the same way that different sizes of bandages resemble look alike.

In a lifetime, each of us has tens of thousands of those gaps in consciousness. I have a thousand left, more or less, if I'm lucky. And now I have syncopes too. As far as I know, they are pure and dreamless.

Some composers wrote sets of preludes without fugues between them. Those are hard to listen to, because there are no gaps for the days to recover, days follow days like jolts of electricity. Chopin's set of *Twenty-four Preludes* is exhausting to listen to when it is played straight through, because it wasn't

intended to be a single concert piece. Preludes are like wounds; fugues are like salves. Bach and the composers who followed him knew this, and they linked preludes and fugues together, for safety.

Preludes and fugues do not need to be in any order, but composers have usually wanted to arrange them in some kind of order, usually by keys. Bach begins with a prelude and Fugue in C major, then a pair in C minor, then C♯ major, a tricky one to play, because it has seven sharps, then C♯ minor, D major, D minor, E♭ major, and so on, through all the keys, twelve notes up the scale and back to the beginning. In Bach's mind that was a circle. He must have had an excellent sense of relative pitch, so he heard the keys ascending and felt the octave circling back onto itself. But if you cannot name the key of a piece of music, and most people can't, then you can't hear the *Well-Tempered Clavier* as a cycle. It's just a set of twenty-four pairs of pieces that can be played one at a time or in any order, as pianists often do.

The first Prelude in the *Well-Tempered Clavier* is simple. It sounds like a player absentmindedly warming up. The twenty-fourth fugue is its opposite, long and experimental so Bach could show off the limits of his art. Other than those bookends, Bach could have changed the order of his Preludes and Fugues, made the third one the eighteenth; switched the second for the tenth. He would only have needed to change their keys. People find patterns in the *Well-Tempered Clavier,* but they would find patterns no matter how Bach had arranged it. The *Well-Tempered Clavier* does not move forward in time: only the individual Preludes do that, because they are little marches, canons, chorales, or dances, each with its own beginning, middle, and end. When each one finishes, it is erased by the following fugue. The clock is reset.

In the year that's described in this book, time didn't move forward the way it is supposed to. In the daytime, clocks were broken. Time moved forward in the dreams, which it should never do. Each day was another hysterical prelude to the night it would never know. And each night was the only possible response to the day it had forgotten.

I think the whole idea of preludes and fugues is unhealthy. Fugues are rehearsals for the oblivion we fall into each night and sometimes for years, and, I suppose, in the end, forever.

Fugue states

Fugue is also the name for a severe mental disorder. In psychiatry, fugues are dissociative: you forget your family, your home, even your name. A fugue state can last for a day or for years. It typically involves unplanned travel or wandering. Patients wake up and find their house unfamiliar, as if they are in a hotel. It does not strike patients as odd that they don't know where they are, or who is in the house with them. People in fugue states are typically calm but intent on leaving. They may grab a credit card and a toothbrush and set out for the nearest bus stop or airport.

When patients return, they are aware that a certain period of time has gone missing, but that recognition is generally not troubling. They may only remember the end of their journey, in the same way as a person who wakes up in the morning may have a rapidly fading memory of the last few moments of their dream. Others may remember only the beginning of their journey. "I recall I took my coat, even though it was summer," they'll say, or "I saw the plastic clock on the wall, and I remembered it was time to go." Some patients give odd reasons for their absences. "I had to walk back to Paris to get my hand towel," they'll say, or "I went to Russia to see a fir tree."

Occasionally, they are aware that their decisions were not logical. "I decided to turn the wrong way out of the airport," they'll say, or "I just drove at random, and I ended up going north." Those moments, when patients are aware they are not acting rationally but are not yet in the full fugue state, are known as twilight. They are the analogue of hypnagogic states, where people have disconnected or unrealistic thoughts that cause them to realize they are falling asleep. There may also be moments when fugue patients realize they are emerging from their fugue state. Those are the analogues of hypnopompic dreams, in which the dreamer becomes aware of the waking world. In a hypnopompic dream, there might be a bright light, from an eye doctor's headlamp, for example, which turns out to be the sun shining on the bed. Patients in fugue states may visualize a scene from their previous life, or suddenly think of their address, or hear a voice that tells them where to go. That guide, the *pompos,* vanishes when the patient wakens.

Patients regard their lost days or years in the same way we think of a night of sleep. Those who have spent long periods in dissociative fugues tend not to be concerned about the months or years they were absent, just as we aren't alarmed to discover we have slept for many hours. When patients are asked to recall their fugue periods, they may say commonplace things like "well, I liked that hand towel, so I just had to spend a year trying to find it," or "some of the pine trees in Russia are pretty magnificent. It is worth leaving your family to see them."

Therapy and hypnosis have not been effective in uncovering fugue states, and questions can create unproductive anxiety. The best clinical practice is to keep questions to a minimum. As a result, little is known about fugue states themselves. In standard psychiatric practice there is not normally any treatment for people who have been in fugue states.

In rare cases, fugue states may last for decades. In one case, a man presented at a police station, insisting his house was at a specific location but that it had disappeared, and upon investigation it was determined the house he described had existed at the place he specified, but it had been destroyed twenty-five years earlier. A woman reported encountering a man she knew in a shopping center in Durban, South Africa. She had not seen him for several years. She had not expected to see him in a shopping center in New Germany, a suburb of Durban, because as far as she knew, he had no connections to South Africa. She asked if he was in Durban for business. He said he was just there to get a coffee. She asked him where he was going, and he said "yesterday I drove to Ladysmith, and tomorrow I am going to Ixopo." She asked him how his family was, and he said, "I think they are fine." The conversation bothered her, and later she called the man's wife in Connecticut. The man's wife broke down and cried. She had not seen her husband in two years. This story is known because three years later, the man came home to Connecticut with no awareness that he had been away. Eight years after that, he left again, taking only a raincoat.

The root of the word "fugue" means flight. Patients flee from their own lives, from themselves. In rare cases, people who appear normal can be identified as fugue patients. A doctor may suspect a dissociative fugue when a patient

seems confused about who they are, or is unable to recall their past. The patient may say, for example "I am not sure where I was born," or "I can't remember where I went to school." The doctor may then draw out the patient by asking easier questions, such as "are your parents still living?" "Where do you live now?" "What is your partner's name?" The patient may become defensive when they realize they do not know even the most basic things about their own life. But they are seldom anxious. They are convinced that what they know about the world is all there is to be known, all that anyone should be expected to know. Patients can become anxious if they see they are failing to answer questions that are being put to them by a person who is anxious. "Should I know that?" the patient may ask. "Why should I know my partner's name?"

Patients who recover from fugue states are likely to relapse. Many experience brief fugues, a few minutes in duration. Those brief fugue states can recur as often as once a day. Patients may find themselves in an unusual place, like inside a closet, outside under a tree, or in a ditch by the side of the road.

Bad dreams

In Shostakovich's set of *Twenty-four Preludes and Fugues* the eighth pair, in F# minor, begins with a short prelude, just two pages long. Every note is staccato. There is no variation in tempo: it is as metronomically perfect and cold as the pianist can manage. It is bright music, and the clock is ticking loudly.

The fugue that follows is a long deep dream, almost a coma. The music falls into a poisoned lethargy. It moves so slowly it hardly breathes. The voice at the beginning is made of short sighs. It is on the point of collapse. It repeats itself, three times, until it is exhausted. It does not move forward. These measures have so little energy that it seems the fugue will have to end, and yet the lifeless melody keeps going for ten measures before it is joined by its identical echo. I find the fugue is overwhelmingly tiring to play. Each measure sounds like it must be the last. Yet the half-dead music continues, quietly and deliberately. It is nearly impossible to keep listening.

Shostakovich's first critics did not approve. Some said he had made a mistake writing such a long and uninviting fugue. But he composed exactly what he intended: the fugue congeals time. You have no choice but to listen to the enervated sighing melody, knowing that it will remain exactly the same, that there won't be any relief, only the feeling of being so tired that it is impossible to do more than breathe.

When I am finished playing that fugue, I think back to the prelude. It was short and sharp sounding because it sensed the endlessness that would come afterward. It was supernaturally bright, as if to say: I am immune from the dream that will follow.

A prelude and fugue pair isn't like a conversation between two people. It isn't a natural give-and-take. The fugue doesn't mean to contrast with the prelude, as critics say, because the fugue does not know the prelude at all. The pairing is unbalanced. It's as if I stand in front of a bird cage and sing to the bird. That would be the prelude. Then the bird sings back. That would be the fugue. The bird might or might not be responding to me. Maybe it just wants

to sing. Even if it is responding, its song is not human. I can't understand what it wants to tell me. It is living in a mood I cannot experience. The eighth fugue is a kind of living death, a coma, or a paralysis.

Shostakovich's *Twenty-four Preludes and Fugues* is more diverse than the famous work that inspired it, Bach's *Well-Tempered Clavier*. There are dirges, marches, dances, lentos, and prestissimos, hymns and toccatas. Some are so tonal there are hardly any sharps or flats. Russian composers who had escaped to Europe wrote vicious things about Shostakovich for composing music like that: too old-fashioned, they said, not modernist. But other pieces modulate with every beat. In the middle of the collection there's a fanfare, Prelude 15. At first it seems boisterous and happy like a good Soviet march, and it is infectious to play. It sounds a bit like *We Wish You a Merry Christmas*. It barrels along in 4/4 like any march. But something is off about it. Each time the theme is repeated, it's louder and higher pitched. The thing seems never to end, and after a couple of pages, I realize: Shostakovich isn't celebrating, he's mocking. It is intensely bitter. It's his satire of Soviet triumphalism, and more than that, of anything optimistic. There is no victory, the music says, and yet there is no alternative except to pretend. The mood is desperate. Sarcastic, some critics say, but that isn't strong enough. It's like Shostakovich is marching around in exaggerated goose step, back and forth, showing his fake faith, his sham patriotism. It's horrible to play because it's so much fun. The chords are easy and loud, full of artificial glee.

Then comes the fugue. It is one of the most difficult pieces Shostakovich ever wrote. After a few years he himself gave up playing it. The key is Db major, so it already has five flats, and the theme itself uses eleven of the twelve notes of the scale. Every measure is crowded with flats, sharps, double flats, natural flats. It hurtles along at an inhuman speed. It is hyper virtuoso music, nearly impossible for anyone but the best, youngest pianists. It's just as unremitting as the prelude, but it's ultramodern, dissonant, and so rapid it's hard even to hear. Listening to it is like looking out the window of a train when another train is speeding by, and seeing nothing but blurs of faces and reflections.

Fugue 15 was Shostakovich's answer to the party line of the Prelude. It's the music he really wanted to compose, his anti-Stalinist manifesto. And yet,

it's not pure: shortly before it ends, the march theme from the prelude suddenly comes back. Its mindless hammering 4/4 chords drop in from nowhere, interrupting the frantic flood of dissonant notes. On the last page the prelude almost takes over, nearly ruins the fugue's rage with its distracted insanity.

These are bad dreams. Fugue 8 seems entirely different from the Fugue 15, but both are inhuman frames of mind, experiences outside of normal life. The first is an unhealthy torpor, and this one is like hysteria, like tachycardia.

People who knew Shostakovich said he spoke very quietly, and his voice trembled. His voice was like water, that's what his neighbor Piotr Alechinsky said. He put himself under tremendous pressure. He had to keep marching for the music censors. The government's dream of a perfect life had to be celebrated at every moment. If he had woken himself from that nightmare, if he had escaped from Russia, it would have been a tremendous relief at first. He might have gone to Berlin or Paris and composed mid-century modernist music like the people who disparaged him. But that would have been a worse nightmare because he would have become a simple modernist. He stayed in St. Petersburg, and the sharp edges of his enforced happiness cut into his life, shearing whatever he tried to create. If he had lived in Paris or Berlin, he might have written fugues that are easier to play and hear, and his preludes might have been genuinely happy. His days could have been relaxing and his dreams entirely normal.

If your life has gone so far from reason and come so close to a nightmare, then it won't help to try to make it normal, that will only make it worse.

Trying to wake up

Julius Weismann was twenty years older than Shostakovich. He lived in Germany, right through the Second World War. You wouldn't guess that from his work. He dreamed his way through the 1930s and 1940s. When he tried to think of new music, he heard only Bach.

Weismann's set of preludes and fugues is called *The Tree of Fugues*. It's scrupulously loyal to a composer who died exactly two hundred years before he did. The sad thing is Bach wouldn't have liked Weismann's music, because Weismann added tinctures of Schumann and Max Reger. He also wrote songs to lyrics by Strindberg. Bach would have been dismayed by those. But Weismann was utterly faithful to his ideal. Some of his pages look like photocopies of Bach's two-part inventions.

This is soft, harmless stuff. Placid and oblivious to the world around it. It's as if Weismann looked out of his office in the University of Freiburg, where a committee of National Socialist party members had made him a professor, and dreamed of horse-drawn carriages clattering by on the street.

His father was the biologist August Weismann, and when Julius was young, the house was often filled with cages of mice. Julius's father wanted to prove that animals inherit their appearance from eggs and sperm, and not from anything that happens during the animals' lives, and so he snipped the tails off sixty-eight white mice, and then he let them mate and raised another generation, and from those he chose sixty-eight and snipped off their tails. He did that for five generations of mice. Mice can breed when they are six weeks old, so August's experiment took less than a year to complete. It was a bloody year, requiring the deaths of over 4,000 mice, and the harvesting and preservation of 408 tails. In the end, Julius's father was delighted, because every mouse of the sixth generation had a normal tail. He celebrated, and then killed the entire sixth generation.

After Julius moved away to university, he lived a quiet life. If fugues are like dreams, Julius's are dreams within dreams. Once in a while he woke up, and wrote a thoughtful page of music, with hints of disquiet.

During the war, he went to a relative's home in the Alps to continue composing. Most of his music is uneventful, like his life as a decorated National Socialist composer. He began *The Tree of Fugues* a couple of years after he won the Leipzig Johann Sebastian Bach Prize, and he finished it in fall 1944, shortly before Allied raids destroyed his hometown.

Meanwhile, Vsevolod Zaderatsky was in the Russian gulag, writing his set of *Twenty-four Preludes and Fugues.* Bach wasn't much on his mind, but Shostakovich was. He also thought of Arthur Lourié, Alexander Mosolov, and Nikolai Roslavets, friends of his who had been persecuted under Stalin. The first half of the twentieth century was an amazing time for music in Russia. There were a hundred good composers, maybe more: conformists like Myaskovsky, Kabalevsky, and Khachaturian, traditionalists like Medtner, the Scriabinists, followers of Prokofiev and Stravinsky, and above all the avant-garde, the lost generation of modernists like Lourié, Mosolov, and Roslavets. Zaderatsky was among the most obscure. A few people knew Sergey Protopopov with his three magnificent and strangely boring sonatas. Some composers had heard of Alexei Stanchinsky, who had died young. Maybe a dozen people in Russia knew what Nikolai Obukhov was doing in Paris. One or two people remembered Leo Ornstein, who had left for New York in 1906 and then stopped composing altogether.

Zaderatsky was a special case. His name was erased from the roster of Soviet composers. He was persecuted more severely, and for a longer time, than any other musician of his generation. In the gulag he composed on the forms the prison used for telegraph messages. His work was never officially performed, never published or reviewed. Ostensibly his crime was his modernist music, but actually what he had done was much worse, so bad the judges never mentioned it: he had taught music to Czar Nicholas II's son Alexei, and for that, the composers' unions and the Soviet government pursued him for forty years.

Before the Revolution, he had married and had a son who showed promise as a pianist. When the October Revolution was imminent, he sent his wife and son to France to keep them safe. A few years later, he himself was arrested. In 1926 all his possessions, including his compositions, were burned. He was in a succession of camps until near the end of his life.

The *Twenty-four Preludes and Fugues* were composed in the Kolyma camp, one of the most isolated of all the Stalin-era prisons, in the far northeast of Siberia. Most prisoners there did not last longer than four years. Over a hundred thousand people died in the Kolyma camp.

The problem was how to express that degree of suffering. Sometimes the only way he knew how to put his anger and fear in music was by making it louder, shouting in chords and octaves. Both the preludes and fugues tend to ramp up as they go along, and by the end I am pounding both ends of the keyboard, thundering, hurting my fingers, trying to make the piano as loud as an orchestra.

The opening prelude begins ominously with quiet octaves in the bass. They trace a tentative melody. Then it explodes in hysterical high thirty-second notes.

The high notes rain down like a hail of silver nails, *ffff* to the very end, shrieking over the dimwitted melody in the bass.

Sometimes the only way Zaderatsky knew how to end a piece was by hammering more chords onto the end. Like Tchaikovsky, except that Tchaikovsky was celebrating and hoping for standing ovations. Zaderatsky wanted to make his music inhumanly fierce, like a person shooting an intruder over and over after he is dead.

It is exhausting to play his preludes and fugues, and it is hard on the ears. Every once in a while, he tries for a dreamy effect, but it doesn't last, and soon enough the pounding resumes.

Zaderatsky was trying to wake up from his nightmare life. Sometimes in nightmares you know you need to wake up, so you scream. But it's only screaming in the dream, so it doesn't work. It just fills your nightmare with yelling.

Weismann's dreams were deeper. He was asleep in another century, with no way to wake up. His preludes and fugues toss and turn under their down comforter. Occasionally they seem half-awake, but they aren't, they're fast asleep.

When Zaderatsky was released from the camp in Kolyma, it was assumed he would stay in the area. Kolyma is over a thousand miles from Vladivostok. Released prisoners were so poor they usually could not even get south as far as Magadan, a town on the coast that had no railroad. Zaderatsky was forbidden to live in most Russian cities, so he could not earn his way back. Years later he told an interviewer that when he was about to be released, a man spat out a gold tooth he had been saving and told Zaderatsky that he should use it to get back to his family. Eventually, he managed to get to Vladivostok, and from there to Kazakhstan, and then to Zhitomir in Ukraine, a small city west of Kiev, where he remarried and taught in a music school.

In 1952, shortly before he died, he risked being sent back to prison by sending letters to France to try to find his first wife and son. He discovered she had remarried. His son had been captured by the Germans in the war. The guards had mangled his hands to prevent him from pursuing his career as a pianist. Zaderatsky never saw his first wife or son again.

When Samuel wrote this book he was plagued by dreams, and also fascinated by them. He wrote about them, and even found photographs that matched his memories. It seemed to him the dreams were warnings, but people have always said that about dreams. When a dream warns you, it's supposed to be

telling you to change your life. The dreams Samuel had were trying to tell his waking self that it was asleep. That his days were nights, that his days were his dreams, that his nights were lucid and as close to reason as he would get.

Now I can see that the person who wrote this book was never fully awake. He was dazed and battered. Those nightmares of forests and fires were his mind's attempt to wake him up. But it's not easy to wake from a dream if your eyes are already open, and it's daytime, and it's your life.

Weismann's wife recalled his reaction to hearing that his childhood home had been bombed. "This place is lovely," he said, looking out at their view of the Alps.

Adela

I only use a couple of rooms in this house. Bedroom. Piano room, which is also the living room. Kitchen. Bathroom. Study, where I sat and read this book.

When Fina Hodges visits she seems out of place. She shops and spends time in the kitchen. She sleeps in the second bedroom. I look at her and I see a person, of course, but I also see a thing, like when I look at a piano or a tree.

She makes sounds and gestures that signify caring, happiness, or exhaustion. I can understand what she means without exactly attending to what she says. At the end of the month she will take me away to Cattaraugas, and I will no longer have my piano or my walks. She means well, but she is so far away from my life.

She tells me Steven will come up next Wednesday with a U-Haul to clean out the basement and the shed. She says they want to keep the snow blower, the chest freezer, pegboard panels, and the iron wood stove. She says please look around, make sure there is nothing you want to have with you when we move to Cattaraugas.

I hear her, but I don't answer. A person is a thing you look at, and it moves and makes sounds, but it's absent. It's not really there, it's in its own mind, thinking its own thoughts. It's been that way for years.

It was that way even thirty years ago, when I got Maschinka's letter telling me Adela had died.

I guess you may not remember me. I am Maschinka, you met me in Bratislava, I am the daughter of Adela's sister Ekaterina.

I am sure that Fina has given you the bad news. I am very sorry for you. Ekaterina asked me to write to you to tell you some things. Perhaps you do not want to hear. If so, please just fold up this letter.

Moja milá teta Adela became sick in the autumn. She complained about pains in her stomach and her back. We took her to the hospital and the doctor said she had gastrointestinal cancer. The hospital

wanted to begin a chemotherapy, but Adela refused. She said she knew about hospitals, and she had seen patients with her condition, they only get worse. In the autumn she stayed in bed all the time, and we had a woman who came to take care of her. She was very weak. She gave us Fina's phone number, but she said she did not know yours.

We planned a day to call. But then suddenly Adela was worse. She had very bad pain. She could almost not talk. The doctor gave her strong medicine, but she could not rest. In a week she was dead. We called Fina, I am sure you know this already.

I am sad to tell you that Adela did not die easily. I was there, and so was Ambroz and both their daughters, Barunka and Zofie, and also my mother and Stepánka and Jan. Adela was very medicated, and she did not really know what she was saying.

She yelled at us. She said "you will all die!" She grabbed my shirt in her fists and looked at me and shook me and yelled "*milá Mashik, zomrieš.*" It means Maschinka, you are going to die. Then she said "*sladká, naivná.*" It means, Sweet, naïve Maschinka. Later she asked for you. "*Kam išiel?*" she asked. Where did he go? Maybe she thought you just left the room. Then she said "*úbohý, beznádejný Samuel.*" It means poor, hopeless Samuel. In the last hour of her life, she yelled. We could not understand her.

Ekaterina also wants me to tell you that Adela Sklenárová is buried in the St. Nicolas Cemetery. It is Žižkova 1885, 811 02 Bratislava in case you will someday want to visit. Her family name on the stone is Tóthová.

That letter did not hurt me because it had already been ten years since I had seen Adela. It was more like when a doctor asks how you have healed, and lifts up your shirt, and there is the old scar you had forgotten.

As each decade has come and gone, quiet has settled over Adela. I used to wonder sometimes about her new husband. She appears in my thoughts now and then, wading in that stream, calling me from her mother's house, pretending to be interested in the lab, going on about her sisters in Bratislava.

I know what those moments once were, but I have turned down the volume in my mind. The scenes come and go without bothering me. You have to turn down the volume on words in order to be able to hear the music.

The place Adela once occupied in my mind has been taken over by Ivan Wyschnegradsky. He was the composer of strident dissonances. He wasn't satisfied with the twelve notes of the scale. He kept dividing them into smaller, less pleasant parts. His *Twelve Preludes in All the Quarter Tones* is an answer to Chopin and Bach, but it would have made their hair stand on end. Wyschnegradsky uses quarter tones, halfway between the notes on the piano. They make a kind of music that can be utterly normal and even sweet, but also unexpectedly sour, like when you're eating fruit and one is suddenly rotten. The ordinary notes of the piano are there, but in between them there is another set of notes, always exactly halfway between the keys. The two sets of notes, normal and exactly wrong, never mesh.

When Adela and I talked, it was like that: one of us spoke in the language of black and white keys, and the other answered between the first one's words, in harsh inaccurate tones. Her English was good enough, but always full of little mistakes and Slovakian loanwords, and each of them brought with it the sense of a deeper misunderstanding, a gap that could never be bridged. For me, the weird accents of her language, the *í*'s with accents instead of dots, the exotic-looking *ý*'s and *ž*'s and *č*'s, the *ů*'s with the little bubbles on top, were tokens of the strangeness of her thought. Anyone who can think in *í*'s and *ů*'s is not thinking in ways I know. Those accents remind me of Wyschnegradsky's weird symbols: a mirror-image flat sign for one-quarter flat ♩, half of a sharp sign for one-quarter sharp ♩, and three of those together for three-quarters sharp ♩. The best is the three-quarter flat ♩. It looks like a little heart divided in half, but it sounds just as awful as the others.

The new notes sound as wrong as it is possible to be. Precisely positioned between the notes of the keyboard, poised at the point of maximum finger-nails-on-blackboard dissonance.

This is how Adela and I were. In the beginning I suppose we mistook our mismatch for passion. We thought the abrasion was exciting. As we settled in with each other, we learned to keep the irritation at arm's length. It's not what she said that I remember, it's the way it grated, how it didn't fit with the way I spoke.

Of the composers I play, Wyschnegradsky is the most annoying. He forces me to re-tune my entire piano in order to play his pieces. I have to spend time with the piano lid up, leaning over the wires, screwing the tuning pins until the notes are just the right amount out of tune. The harmonies are sour, but there's also something about them I love. He felt things in his own way, and I can tell he needed someone to listen.

When I play passages like this, I feel like shivering. They give me a sliding feeling, they make me a little nauseous. The music is feverish, like a violinist who is trembling and can't hold to pitch. It's like you're sick, say you have

the flu, and you stand up too quickly and collapse onto the floor. You're surprised and alarmed, and you realize you're sicker than you'd thought. Maybe it would be best just to lie down for a while.

Talking to Adela was like that. I always thought I could manage it, but we exhausted each other. Like Wyschnegradsky, she felt things very strongly. He believed his emotions were too powerful for the usual twelve notes. He needed a special language. He demanded special tuning even though he knew it would keep most people away from his music. Adela needed someone to listen, but after a while I wasn't able to do that.

Wyschnegradsky has been my way to hear that peculiar dissonance, which is as far from harmony as it's possible to get and therefore oddly like a new kind of harmony, stronger than the ordinary one. I count myself happy that I no longer need a person to experience such a thing. Everything I want to remember about Adela is there in those backward flats and broken hearts. The music is entrancing, but it is bad for me. It's best not to play it, but to look at it on the page, and imagine its unnatural sound.

Love supposedly keeps us young, and that must be true for some people, but it also unravels us. Care damages the smooth working of life, it is like arthritis, care makes it painful to move around. I have removed love from my life, and it's calming. When an image of Adela comes across my mind, I remember what it was like to care for her, and my heart races. Then I remind myself she's been dead thirty years. The memory clears. I think of the music, and I am calm again.

Paths

That winter, Samuel was fascinated by paths. His own, and the paths of animals, planets, and stars. I'm still interested in paths, but only in music. For years I've been drawn to the orderly look of notes on the page, how they are always placed on the same five lines like clothing hung out to dry, like birds on telephone wires. Slurs and ties lead the eye from one note to the next, forming paths that guide me through the score.

I can see now that my interest in these patterns is the ghost of Samuel's. It's not supposed to matter how music looks on the page. The printing style isn't supposed to mean anything, and yet the shapes of the notes make a difference to my mood, their spacing on the page changes how I think about the music. Images of the scores stay in my mind, just like pictures.

Franco Donatoni's *Françoise Variationen*, which he wrote in the 1980s in Milan, has some especially lovely curving paths.

The slurs swerve up and down like a hummingbird flying through a forest. Or, slower—a gnat threading its way around blades of grass. Or the notes are like the saplings in the hyena's pen. Or like the forests in Samuel's dreams, and the slurs are his wandering paths.

Normally musical slurs do not double back, because nothing is supposed to go backward in music. Slurs slope forward. Donatoni's also go backward, because he wants to show the player that the notes are tied to each other in an unusual way. They are linked by elastic bands that loop forward and backward in time.

He makes the beams of the thirty-second notes straight and horizontal. The result looks like white train tracks seen from far above, or like a negative image of a musical stave, with white lines instead of black. The triple line of beams shows time moving straight ahead. The curved slurs are looped time, backwards-and-forwards moving time.

The first piece in the *Françoise Variationen* opens *ppp*. The first seven notes are easy, because they make an arc, down into the bass and back up.

I try to play the next notes, starting with the C♯ and the high A♯, so they sound entangled. The loops gather them, pulling them together into a single pattern, compressing them in time. Of course I play the notes in order, as they are on the page. But in my mind they're entangled.

This is not the way music works. Notes are not pulled back into the past or pushed into the future. It's how memory works, pushing thoughts back into the past, pulling experiences from the past up to the present. Memory tries hard to distort time, yanking and tugging and hoping it will collapse.

Even the title *Françoise Variationen* is illogical. It should be *Französische Vari-ationen,* in German, or *Variations Françaises,* if it's French. But it is neither, and they aren't variations anyway.

Whatever they are, they're beautiful. Like Wolfram Pichler's drawings of planets weaving against the stars, or just diagrams of something technical that I can't understand. I practice that last four-note group. The ribbon knots the top two notes to the bottom ones, ties the first note to the last, circles the high notes, and somehow makes the whole thing into an emblem, a picture.

Several of the *Françoise Variationen* are high up on the keyboard, which Donatoni writes as 8↑. These notes are like glass chimes striking all together at different pitches, and yet each one is a thirty-second note, all in order with no gaps. The slurs bind them into melodies, first four notes, then three, then nine. The *Françoise Variationen* move very fast, and I can't hear those groups, especially the long ones, but I can see them on the page. They sound like rushing water, gushing from a spout onto a metal roof. On the page I see wa-ter spilling and cascading.

Later in the *Françoise Variationen,* there is some harsher music. It's rapid and strident, and hard to play accurately. Perhaps Donatoni's ideal performer is a machine that can strike rapid rhythms interrupted by brief silences. A machine that can start and stop in a fraction of a second.

This music isn't intended to be pleasant. Some pieces are nothing but shivers, shaking sets of notes with brief silences between. Donatoni loved packets of music that sound percussively, that begin and end abruptly. The music lurches and jerks. Sometimes it sounds convulsive.

I don't know who this music is for. Music of the spheres, that's what people used to say about planets and stars, when they thought the orbits of the planets were related by simple mathematics. Donatoni wrote inharmonious music, a music of broken spheres.

Like my life, Donatoni's was divided into three parts. When he was a young composer, he wrote romantic music with touches of modernism. Some of it is lovely, but he felt out of place. He said Bartók and Stravinsky had done everything. His production slowed. In 1965 he stopped composing completely. That was the end of his first period.

He began again, after two years of silence, but his works sounded unfinished or inconclusive. He tried to make music out of fragments he found in

other composers. He discovered Stockhausen, Boulez, Cage, Babbitt. His music was widely performed, but he was unsure what to do, who to follow. For ten years he composed brittle pieces, fewer each year. Finally, he stopped for a second time. He was silent for five years, and during that period he didn't go to concerts or give interviews.

In the late 1980s he started composing again: his third and final period. That's when he wrote the *Françoise Variationen*. His music in this period is sure of itself, but hard to understand. Not so much cold or distant as absent. I think like me, absent from the world and yet still in it. Still in this house up on the Bruce Peninsula, at least for a few more days.

Donatoni said in interviews that music isn't supposed to be expressive. "I am no longer trying to express myself," he told a reporter. "This music exists just for itself." "Is that a satisfying way to write?" the reported asked. "Of course," Donatoni said. "I have never been happier."

The third period lasted fifteen years, until he died.

First period: nostalgia, the composer is like a child, discovering what he likes, lost in history. Second period: he tries to find his own style, but he can't manage it. Third period: he's replaced himself with a machine. He's happy at last. The pages look like diagrams. In the end, it's only pattern that matters.

I like Donatoni because he tried three times, like I did, as little Sam, as Samuel, as I am now. When my childhood didn't work, I fell asleep. I woke up as Samuel Emmer. That life was ruined, so I fell asleep again. Now I realize, like Donatoni did, that pattern and music are all there is.

In between the three periods of his life, Donatoni molted or hibernated, no one knows. He never spoke about the gaps in his life. Unlike me, he didn't leave home. He just wasn't himself. His wife said he spent most of the time reading the newspaper. She tried to get him to go to concerts, to talk to other composers, but he wouldn't. One morning she found him in his study writing music. She was overjoyed. He shrugged. *"Ecco qualcosa di nuovo,"* he said, Here's something new.

That is what happened to me, and it has divided me from myself. When you disappear like that, you return as a different person. You look back, and there's the person who once was you, far off in the distance, but you can no longer hear what he is saying.

Viperine's last note

Fina says it is cleaning-out day, Steven will be arriving with the U-Haul. Tomorrow she will drive me to Cattaraugas. She brought in another pile of sheet music from the piano. The living room has to be clear, she says, so the people from Key Impressions can take the piano. On top is Furrer's piece called *Voicelessness (The Snow Has No Voice)*. In it, soft sounds merge one over the other, as snow does. Whispering like Viperine did. *Voicelessness* is hypnotic, soporific. The score even looks like snowflakes falling.

But Furrer's snowflakes aren't random. Actually, the score is maddeningly complex. The left hand in the first line is repeated as the right hand in the second line. The left hand in the second line is repeated as the right hand in the third line. And so on.

In that way I'm always repeating part of what I've played before, but the repeated material is mingled, always in the same treble clef, with new material, so I can never quite be sure what I've heard before and what's changed. At first my right hand plays 11/4, and my left 12/4; and then it's twelve beats in one hand and thirteen in the other—and so on, even though that is impossible to measure when the beats are broken up into triplets and quintuplets. It is exact, but it can't be counted accurately. All I can do is try to approximate the rhythms the piece demands.

Voicelessness is like many people whispering together. I sense there are patterns in it, but I can't quite make them out. The overlapping sounds seem familiar. As if I have heard them before. And of course, I have: I've heard half of them, because whatever I played with my left hand the last time through the score, I'm playing now with my right hand, but I can't distinguish what's new from what's old because the notes are all on top of each other. They overlap, continue, and interrupt each other. My hands are together, one over the other, then under, my fingers interlacing to reach the keys. The music makes a single impression, but it is always gently divided against itself.

Voicelessness is soft like snowflakes, and also infuriating and disorienting. Like Viperine's soft voice, her intentions blurred, her breathiness cold and uninviting. At the time I thought she was the least comforting person it was possible to imagine.

Furrer did not write sets of preludes and fugues, but he did compose a piece called *Aphesis,* which is a ruined fugue. It begins the way a fugue always does, with a theme that's just a string of single notes, no pedal. The tune is unmelodic, as if the piece were written by someone who can't play the piano and has to pick out notes one after another. The listener is meant to wonder how such a theme could be used to make a fugue. At last, the theme stops and the left hand begins playing. It's the same melody, but the first few notes are missing, as if the voice that answers hadn't been paying attention at the beginning.

The word "aphesis" is used to describe the way the initial part of a word sometimes drops out, like when *around* becomes *round.* Furrer was interested in seeing how a fugue might destroy itself by cutting off parts of its own theme.

Soon the two voices are joined by two others, making four-part counterpoint. When the third and fourth voices enter, they are also missing the first notes. Furrer inserts those missing notes later on, in the middle of the theme. Each time the theme returns, it is in worse shape. Notes are missing and extra notes are inserted.

In clinical psychology, aphesis is a condition of defective memory, in which the beginnings of traumatic events are forgotten. The patient remembers what happened afterward, or recalls events in the wrong order. This disordered memory is a defense mechanism, to prevent the patient from fully experiencing the traumatic event.

Furrer's piece becomes increasingly complicated. Each time the melody repeats, it has lost more notes from the beginning and added them toward the end. The counterpoint becomes dense. After a time, the theme is unrecognizable: it is missing too many of its initial notes, and it has too many notes implanted in it. I can no longer tell when it begins or ends.

Aphesis is like a cancerous mutation. The theme is clear at first, when it plays by itself. When it appears again, it has been damaged: like a mutated

gene. It is truncated and interrupted by notes that don't belong. Like a cancer-ous cell driven by defective genes, *Aphesis* keeps growing, feeding on its own errors, making them more complex and longer. I wonder what it is trying to express, whether it is going to heal itself.

This is how Viperine was. Each time she spoke or wrote to me, she was slightly mutated. She became harder to understand, more perverse. It was her way to survive in my attention. The cancer cell manages to survive by mutating. It keeps the body's attention by changing and multiplying. The body's defenses are mesmerized, confused about what they encounter. When I play *Aphesis* I know I won't be able to follow all the changes Furrer has built into it. In a normal fugue I listen for the opening notes of the theme, to catch the moments when it is taken up by one voice or another. In *Aphesis,* I know I won't hear those notes, or if I do, they'll be in the wrong places.

Somewhere inside *Aphesis* the theme keeps struggling. I pick up pairs of notes I recognize: a Bb followed by a C, a repeated F. The melody is reduced to moments. Each note I recognize is flanked by sounds that are intent on hiding it.

At the end, Furrer lets a single voice play the theme one more time, in its most fully mutated form. That is when the whole composition makes sense, because the awkward theme is suddenly beautiful, a proper melody at last.

When I finally understood that Viperine really cared for me, that she was trying to help me, it was too late. At the very end of the year, she found me and sent me a message. In so many words she said that she had not been able to bring herself to say clearly what needed to be said. I should have replied. I told myself I'd missed someone who cared for me. But I never tried to find her, or anyone else I knew. It was too important to start again.

That was so long ago. Viperine would be seventy. A generation has come and gone while I have been watching the large field and the woods. You can only regret things that happened in your own life.

Vipesh

When the Danish composer Asger Gaarn heard that his mother died, he was in Lund as a guest conductor. The director of the orchestra told him he should cancel that night's concert and fly back to Copenhagen, but he decided to stay. He conducted the program that evening, and then he had his mother's body frozen so that he could remain in Lund and write a symphony dedicated to her. The funeral took place the following spring. Gaarn had the Danish National Orchestra play the symphony in front of her casket. Afterward, he took a two-year leave from his position in Copenhagen and composed another symphony, two string quartets, a choral fantasy, and two sets of *Twenty-four Preludes and Fugues,* all dedicated to his mother.

When his father died, he was in Frankfurt. This time he flew back, but the following year he spent eight months in a retreat in Finnmark, composing pieces in his father's memory. They include *Funeral Music for Seven Instruments, The End of the World* for solo flute, a study for double bass solo, a piece called √3 for violin and piano, *Symphony No. 3, Symphony No. 4, String Quartet No. 3, Concert Etude* for piano, the *Piano Sonata No. 1,* and *Twenty-four Preludes and Fugues,* all dedicated to his father. He arranged a special concert in Honningsvåg, the northernmost city in Norway, with the Danish National Orchestra and the Danish String Quartet. They played all the compositions dedicated to his father, and then he had his father's body driven seven hours to the North Cape, where it was transferred to a boat and towed out into the Arctic Ocean. Gaarn stood on an observation platform at the top of a one-thousand-foot cliff and played *The End of the World* for solo flute while the boat was set on fire. The compositions dedicated to Gaarn's father are opus numbers 50 through 61.

Gaarn's fourth wife died in 1980. He took a year off and composed Opus numbers 330 through 351: *A Great Mourning* for brass band, *Chôro Daniensis* for flute and clarinet, *Pollicino Quartet* for violin, viola, cello, and double-bass, *Cabaret Voltaire* for guitar, Æbeltoft Elegy and Fanfare for trumpet, *Trio No. 4* for violin, cello, and piano, *Shells from Martinique* for saxophone quartet, *Symphony No. 23, The Tragedy of Lady Day* for mezzo-soprano and big band, *Little Suite* for

piano, *Johanna the Seducer* for soprano, alto, tenor, and bass, *String Quintet No. 11, Copenhagen Suites Nos. 1, 2, 3, 4, 5,* and *6, Pyramid* for cello, flute, percussion, and piano, *Tsetse Fly* for flute, piano, accordion, guitar, and percussion, and *Twenty-four Preludes and Fugues,* all dedicated to the memory of his fourth wife.

Gaarn completed 693 numbered compositions before he died in 2010. Almost four hundred of his works are dedicated to people who died. Each time he finished a piece, he sent a copy of the score to the person's family, with a handwritten letter expressing his sentiments and explaining the composition in detail. The letters are published with the scores. He wrote in florid awkward prose, like Vipesh. And like Vipesh, he was overcome by the need to ingratiate himself.

"My dearest second cousin Ninke, it is with the utmost sadness that I gift you this composition entitled *A Sorrow Beyond Dreams,* dedicated to your latest husband. I never met Tim, nor any of the Dutch lineage of our fertile family. Yet I have no doubt he was surging with the blood of our common ancestor Barents Petrus Handke, vice-governor of the Copenhagen chapter of the Hanseatic League. I wish you many happy days without your husband, and please enjoy this composition entitled *A Sorrow Beyond Dreams,* scored for nyckelharpa and kettledrums."

Mourning and compositional mania were entangled in Gaarn's mind. The most compulsive of his achievements are his cycles of preludes and fugues called *Det tempererede klaver.* He began in 1964 with a set of twenty-four preludes and fugues dedicated to Hindemith, who had died the year before. The next sets were Op. 157 and 158, two of the compositions dedicated to his mother.

He kept going for forty years, writing complete cycles of twenty-four preludes and fugues, forty-eight pieces each. Most are dedicated to dead composers who wrote cycles of preludes and fugues.

Twenty-four Preludes and Fugues Op. 190 was written in 1971 and dedicated to Stravinsky. In his letter to Soulima Stravinsky, Gaarn explains that he had originally intended to write a set of *Twenty-four Preludes and Fugues* to the English composer Cyril Scott, who had died the year before, and he wanted to apologize for that, because he had remembered that Scott is credited with giving Stravinsky some ideas for *The Rite of Spring,* and he thought Stravinsky's

name should not be sullied by any further honor given to such an enterprising but clearly second-rate composer. "I hope these preludes and fugues are not tarnished by echoes of Scott," Gaarn writes to Soulima, "and I am delighted your husband lived one year longer than Scott."

Twenty-four Preludes and Fugues Op. 275 was one of the works he dedicated to his father.

Twenty-four Preludes and Fugues Op. 309 was dedicated to the radical composer Jean Barraqué, who died in 1973. In his letter to Barraqué's widow Gaarn explains that he had been torn between dedicating this set to Barraqué and to the Hungarian composer Alois Hába, who had also just died. "It was a difficult decision," he writes in his dedication. "Hába was one of the pioneers of microtonal music and wrote many preludes and fugues, whereas your husband did neither, but in the end your husband was the better composer, even though he was quite dry and generally unconvincing in terms of his music."

Twenty-four Preludes and Fugues Op. 320 was dedicated to Shostakovich, who had died in 1975.

Twenty-four Preludes and Fugues Op. 336 was one of the works Gaarn dedicated to the memory of his fourth wife.

Twenty-four Preludes and Fugues Op. 357 was composed in 1982 in memory of the Azerbaijani composer Gara Garayev. In his dedication, Gaarn thanks Garayev's widow for sending him the beautifully printed book of testimonials to her late husband, which includes such eminent names as Shostakovich and Shchyotkin. "I wish to add my paltry voice to theirs," Gaarn writes, "so that I may be associated, in however small a way, with their own wonderful assessments. I understand, too, that a metro station and an avenue in Baku have been named after your late husband. I can only hope for something similar for myself. If you know of any streets in Baku that are in need of naming, please let me know, thank you."

Twenty-four Preludes and Fugues Op. 409 was dedicated to the Polish composer Witold Lutosławski, who died in 1994. He had written four sets of preludes and fugues, all lost when he had to leave his belongings during the Warsaw Uprising forty years earlier. "Dear Danuta Lutosławski," Gaarn writes, "I know you are dead, because you followed your husband so quickly into the

grave. I am exceedingly sad you have not lived to receive my letter and this composition. I wanted to ask you if there is any chance your husband's preludes and fugues survived the war. It occurred to me that perhaps you took them in a suitcase and then forgot."

Twenty-four Preludes and Fugues Op. 420 were dedicated to Iannis Xenakis, who died in 2001. Gaarn's dedication is addressed to his daughter Akantha. "My dearest Akantha," Gaarn writes, "I solemnly dedicate this cycle of preludes and fugues for pianoforte to your father, who was without a doubt the most annoying composer of the last hundred years. By annoying I mean perplexing. I can hardly understand a note of what he wrote. Why didn't he write any preludes and fugues? Why did he baptize his works with incomprehensible names? I cannot bring myself to pronounce them. Why did he write such incomprehensible music? Please do not answer this letter."

Twenty-four Preludes and Fugues Op. 466 were written in 2006 and dedicated to György Ligeti, who wrote a piece called *Nyolc prelúdium és fúga* (*Eight Preludes and Fugues*) for organ. Gaarn completed his set in just six days after he heard Ligeti died. That's eight preludes and fugues every day. "Dear Mr. György Ligeti," Gaarn writes, "it is very sad to me you have died. I wonder if you ever got my letters. I wrote you three times. I asked why you only wrote eight preludes and fugues. Eight is a very unusual number. Twelve is common, as you know. I myself prefer twenty-four, the number Bach has given us. I wonder if Bach has asked you that yet now that you are in heaven. I suspect he will. It's very strange. I am sure he is curious. Why would anyone write eight? Please say hello to Bach for me. Yours, Asger."

Op. 470 was single prelude and fugue lasting four hours and twenty minutes, dedicated to Karlheinz Stockhausen, who died in 2007. Stockhausen never wrote preludes and fugues, but Gaarn was impressed by a transcript of a lecture Stockhausen had given in 1953 in the Darmstadt summer school. He had promised his audience never to write any conventional musical forms, including symphonies, string quartets, nocturnes, preludes, and fugues. "Dear Doris Gertrud Johanna Andreae Stockhausen," Gaarn writes, "I hope you are recovered from your husband's sudden death. I have written this long prelude and fugue in his honor and his memory. I could have met him. I walked back

and forth in front of your house many times, looking into your windows. My piece is as long as one of your recent husband's operas, and I have one hundred more compositions than him. Also, I am still writing, and he is dead. Thank you for your attention."

Gaarn's last set of *Twenty-four Preludes and Fugues* was Op. 638, finished in 2013, a year before he died. It was dedicated to Hindemith, who had died a half-century earlier. He wrote his letter to the caretaker of the cemetery where Hindemith was buried, Cimetière La Chiésaz, in the Canton of Vaud, Switzerland. In the letter, Gaarn expresses his regret that he had neglected Hindemith for so long. "He was, after all, the past century's preeminent master of fugal form. But I have been punished for neglecting him, because now I cannot locate any of his living relatives. Please station yourself by Hindemith's grave, and wait for legitimate heirs. I understand Hindemith was often unfaithful so inquire with tact, thank you."

Thirteen sets of twenty-four plus one for Stockhausen is a total of 626 individual preludes and fugues.

The letters Gaarn wrote are pompous and posing like Vipesh's, and his music also reminds me of Vipesh because it is hard to tell what he felt sincerely and what he composed because he thought he should. His music isn't sloppy, exactly, but it's made of echoes of other people's music. Some sounds like Bartók and Hindemith, some like Schönberg or Debussy. None of it is very compelling. He cared too much about what other composers thought. Will Soulima Stravinsky approve of me? Will the spirit of Ligeti shake his head? How will I look to the great composers of the past?

In his seventies, Gaarn continued to write music whenever he heard someone he knew had died. But there were so many people, and he wrote so much, that eventually he ran out of empathy. He dedicated pieces to Danish soldiers fallen during the German occupation, the Estonian War of Independence, the Korean War, the Gulf War, the Kosovo war, and the first and second wars of Schleswig. He wrote a series of pieces dedicated to people who died in disasters, including the 1897 Gentofte train crash, the 1853 cholera outbreak in Copenhagen, the 1919 Vigerslev train crash, and the two fires that destroyed parts of Copenhagen in 1728 and 1795. He wrote a song cycle of

eighty-six songs, one for each of the children who died when the Institut Jeanne d'Arc was accidentally bombed in 1945.

There are also pieces dedicated to his cats Muesli, Ask, and Embla. When his cat Embla died, he wrote an elegy for orchestra and soprano voice. The lyrics are an epic poem about the life of the amazing and beautiful Embla. At the debut, Gaarn came onstage and gave an emotional lecture about his cats.

Late in life he started writing pieces dedicated to dates and places: *Elegy for Tuesday the Eleventh of March, 1994; Fanfare for the Friis Shopping Center in Aalborg; Windy Day at the Flødeboller Kiosk at Ribe in Jutland,* for string octet and sandpaper blocks; *Fifteen Nautical Songs for Roskilde; The Wet April of 1998, for Women's Chorus; Roses of the Rex Garden in Førde,* for chimes, Tibetan bells, and marimba; and *A Sad Day for Minks* for male chorus. Gaarn's last composition was *Fifty-seven Songs in Honor of Poul la Cour, Captain of the Jylland, World's Last Surviving Screw-propelled Steam Frigate,* Op. 693.

I don't doubt Gaarn loved his mother, his father, and even his cats. But if your life lasts long enough, the deaths of people you know are no longer punches that knock the air out of the world. They're more like the little shock you get when you look at your bank balance and see it's lower than it should be.

Samuel Emmer

In 1941, when Rodion Shchyotkin was six years old, he used to go with his father to Shostakovich's second-floor apartment on the endless Nevsky Prospekt in Leningrad. His father worked for Shostakovich, transcribing orchestral manuscripts into parts for performances. Shchyotkin's father sat at a desk in the corner of the front room, and Rodion sat on a stool between the desk and a cabinet stacked with Shostakovich's music.

He was aware from an early age that Shostakovich wrote controversial music, that some of his work had been banned, that expatriate Russian composers didn't like him. Shchyotkin's father was a failed composer, but Rodion was determined to be a success. He made sure his own pieces had lots of popular appeal. His early composition *Carmen Suite* is optimistic in that way.

In the 1950s, when Rodion was a teenager, he and his father used to visit Shostakovich at his summer home in Armenia. On one of those trips, Shostakovich asked Rodion "if you had to go live on an island, and you could take only one score with you, what would it be?" And Rodion said, "Bach's *Well-Tempered Clavier*." Shostakovich replied "my choice is secret."

In 1973, a decade after his father died, Shchyotkin visited Shostakovich in his apartment outside Moscow. Shostakovich was in his bed. He was dying of lung cancer. Shchyotkin asked him if he remembered the question about going to an island and taking only one score, and Shostakovich said "of course," and Shchyotkin said "will you tell me now?" And Shostakovich said no. Shchyotkin told him he had changed his mind. He would take Shostakovich's own *Twenty-four Preludes and Fugues*. Shostakovich turned to face the wall.

Shchyotkin told that story to an interviewer, and explained that he had wanted Shostakovich to know that he'd finally realized that it didn't matter if Shostakovich was controversial, or if Russians abroad thought he was old-fashioned. What mattered was how intense and desolate he had managed to make his music, and that the most unbearable and therefore the best composition of all was his *Twenty-four Preludes and Fugues*.

Shchyotkin made a good career for himself, writing compositions that were played in Russia and occasionally in Europe. He wrote popular music, but he often thought about Shostakovich. He knew he should try to write something as strong as Shostakovich's *Twenty-four Preludes and Fugues*. Eventually he decided he had to try. He wrote his own sets of *Twelve Preludes and Fugues* in two volumes, one for the sharp keys and another for the flat keys. The arrangement makes them seem like Bach's or Shostakovich's, but many of Shchyotkin's pieces aren't really in any key.

When I play these, I can feel Shchyotkin trying to compete. He gathers his energy to write a strong prelude, a magnificent fugue. But he's jumpy. The music hops around without going anywhere. It seems he can't keep his mind on what he's composing. A couple of the preludes are only one page long. They're just mindless runs up and down the keyboard, trailing off, pausing, ending in faint chords.

He tries to think about what he's doing, to keep up his concentration and energy. There are echoes of Shostakovich's preludes and fugues, but Shchyotkin's are written without steady conviction. Thinking too directly about Shostakovich made him especially anxious, and he lost heart. Rodion Shchyotkin is like the brightest boy in the class, who can have a great future if only he can stop fidgeting. Like his model, Shchyotkin felt he was genuinely disconsolate, beyond help, but it was impossible for him to make music that responded to Shostakovich, because it was impossible to think clearly about his suffering.

I realize now that Shchyotkin is the remaining echo of what Samuel was in that year. I am attracted to Shchyotkin's inability to keep his thoughts together

because Samuel felt it once. I am sympathetic to his fear of feeling the world too strongly because Samuel experienced the same thing. I can understand Shchyotkin's ambition to write something as monumental as Shostakovich's *Twenty-four Preludes and Fugues,* because that was what Samuel was trying to do with his book, make his disastrous year into something stronger than it was.

When Shchyotkin wrote his sets of *Twelve Preludes and Fugues* he was trying to create something that would show he felt love. He knew what sorrow is, he knew what it means to be alone and look into yourself and stomach what you see. But his music is skittish and unfocused. He writes indecisive themes in jumpy rhythms. He can't find his pace. He changes his mind every couple of bars.

His music sputters and twitches. This melody moves around, trying out different registers. It falls into the bass. It shivers. It starts up again in duplets, like a sluggish march. Then it ends.

This is dispiriting, like Shchyotkin's father must have felt when he gave up his own composing and went to work for Shostakovich. It is pushed and pulled from one thought to another. It doesn't have time to listen to itself. The music wanders among wrecked feelings and thoughts.

Shchyotkin watched love and grief from a distance, the way Samuel did. His world was too much, it overwhelmed him. I am delighted my earlier self is gone. The world is much simpler when emotions can sit silently on the

pages of my scores until I decide to play them. It's amusing to recognize my earlier self in Shchyotkin, to realize that one of the reasons I keep coming back to Shchyotkin is because he is partly me. When I play his music, I hear Samuel's cold sweats and unsettled nerves, and I can feel his sense of slowly impending disaster.

Shostakovich was comforted by the monumentality of his suffering. He saw himself as a tragic figure, beset by Soviet officials and the composers who looked down on him. He had a grand, stentorian, moaning manner. He trumpeted his isolation. Shchyotkin didn't have that power. He wasn't trapped by Stalin. His relatives hadn't been jailed and executed. He couldn't think of himself as lost or forgotten, because he had won more awards than most of his generation put together. He won the Bavarian Academy of Fine Arts Prize, the Lenin Prize, the Hamburg Prize, the Baltic Star, the Tree of Life. He was a UNESCO ambassador, he was honorary professor at the St. Petersburg State Conservatory, he won the Russian State Prize, the Russian Order of Merit for Service to the Fatherland, Fourth Class, and finally, twenty years after Shostakovich died, he even won the Dmitri Shostakovich Prize.

And yet, he was alone in the worst possible way. He wasn't as good as Shostakovich. He couldn't feel in the way that was necessary to write like Shostakovich. He felt and wrote in fragments.

When he composes fugues he is trapped. He has to come up with five, six, seven minutes of music that coheres, that has real emotion. He knows perfectly well what that sounds like in Shostakovich or Bach, but he can't do it. He picks his way along, one tentative measure at a time. With silences between. His fugues don't come together, as other people's do, into a tapestry where all the voices sing. In this piece, the theme is marked *incerto,* uncertain. The music creeps forward a half breath at a time. At last, the theme is answered an octave higher, but then Shchyotkin changes his mind. It's not a fugue. It's just a hint of one. The music steps lightly across the page, as if the staves might give way and the music will fall.

At times, this uncertainty creates beautiful music for a moment or two. In this prelude, a melody suddenly appears, *dolente,* meaning sorrowing or pained. It ends a couple of measures later.

It's depressing to hear too much of this, and after a while I go back to Shostakovich. Shchyotkin's work is embarrassing because his suffering doesn't usually work as music. It's broken, directionless.

Prelude and fugue 20, from volume 2 of Shchyotkin's *Twelve Preludes and Fugues* is marked "for the left hand only." That is a common sort of piano exercise, made famous in the twentieth century by Paul Wittgenstein, the philosopher's older brother. Paul had his right arm amputated in World War I, and played music for the left hand alone. He got mixed reviews. His playing was good, but there wasn't much interesting music for the left hand. The Wittgenstein family was one of the richest in Europe, so Paul commissioned a number of famous composers to write one-handed compositions for him. Shchyotkin knew those pieces, and he knew that the instruction "left hand only" would make pianists think the piece is especially challenging. But his prelude and fugue are not virtuoso exercises. They are so gaunt they look like sketches. He needed an excuse to present them as a finished pair, so he labeled them for the left hand alone, as if he intended them as a technical exercise.

Again the notes are sparsely scattered across the rows of staves, like birds foraging in a frozen field. He starts with two voices, then adds two more, but still the staves look empty.

This is how it was in the year of zoos and nightmares. Each day was a succession of disconnected thoughts. Some days seemed about to collect themselves, form themselves into patterns, become meaningful, but then they just died away. The expressive marking is *morendo,* "dying." This is actually Shchyotkin at his best. It doesn't quite rise to the level of sorrow, but lives beneath it, looking up. Sorrowing for its lack of certainty.

In his forties, Shchyotkin was often ill. He spent days in bed with headaches, and he complained that many foods made him sick. In those years he also wrote fast compositions, crowded with repeated notes. He tried to purge himself of his anxiety by writing an *Homage to Stravinsky, Prokofiev, and*

Shostakovich, a piece scored for three pianos. The three composers scream at each other. That is Stravinsky at the bottom, with his trademark pummeling chords like the ones at the end of the *Rite of Spring.*

Prokofiev is at the top, leaping up and down the keyboard. In the middle is Shostakovich, the one who meant the most, the one who dogged Shchyotkin's imagination.

The piece is harshly regimented. The pianists have no autonomy. Shchyotkin sets the tempo very fast. I imagine the three composers playing. Shchyotkin forces them to keep exact time. Every note has to sound. No one can go out of step. Everyone plays like a machine.

This music sounds crazy, like a child grinding a music box at double speed, like drummers going as fast as they can on tin drums. The high notes on the top clef sound like a person rapping on their front teeth with a metal spoon.

A sixteenth-note of absolute silence runs down through the score at the end of the first measure. The pause lasts about two-tenths of a second, just long enough to hear. Each performer has to stop and start again at precisely the correct instant. The blink of quiet is the proof they are playing correctly.

I think Shchyotkin pictured Stravinsky, Prokofiev, and Shostakovich, the presiding geniuses of the previous generation, as prisoners in chains. Hobbled and then forced to run in exact formation.

"Take that, Shostakovich, you bastard. You felt so much, you had so many moods, you were so versatile. Look at you now! This is what you are to me, a slave, a music box."

It's funny and horrifying at the same time, this piece. Each of the three composers is compelled to parody himself. They are forced to enjoy their punishment. The piece is relentlessly happy.

"We are happy!" The enslaved composers shout. "We are all happy!"

"See how they march in step," Shchyotkin exults. "They have no souls. They are dead inside! Now watch what happens when one of them tries to sing."

The second piano, representing Shostakovich, finds a voice, a melody in eighth notes. It's playful, maybe even lyrical. It's trying to go somewhere. But this is an anomaly. It needs to be stopped. Shostakovich needs to be brought back in step. In a few measures, Shchyotkin beats him back down into place. The melody, which had nearly escaped, is captured by the wall of noise. Shostakovich gives up and joins the others.

Homage to Stravinsky, Prokofiev, and Shostakovich is a pleasure, because it's an unprovoked attack, and because Shchyotkin of course wins.

For a number of years, Shchyotkin was ill, I don't know what with, and finally he had a stroke. It was a massive hemorrhagic stroke, and he was in a coma for two days. Afterward, he struggled on, learning to talk and read again.

When he recovered, he wrote more hysterical compositions, some pointlessly loud, like a man standing in an alley screaming and banging garbage pail lids. His later compositions are uncontrolled shouting and raging. In *Silent Night*, written in 1988, the blare makes it impossible to think about what the music might express. Too much is happening.

There are a few quiet moments in the later music, like the one in the second line. There I can hear, as if from a safe distance, the real sadness that Shchyotkin had always hoped to express. But then he picks up speed and volume and ends with a crash of notes.

Six years after his first stroke, Shchyotkin had another. When he came to, he could write and speak, but his gait was uncertain.

He had a third stroke, and after that he used a wheelchair.

Two years later, he was sitting at home, and his wife Irina asked him what he'd like for lunch. He asked for an ambulance. She saw he was crying. He knew what was coming.

A day later he had another hemorrhagic stroke. He didn't live to old age. The fifth stroke killed him in his sixties.

That winter, Samuel was like a building that is full of fractures and weaknesses. It is scheduled to be demolished in a controlled explosion. The building is stripped and all the glass is removed. Charges are placed throughout the building. The neighborhood is cleared, and the building is imploded.

Furrer, Protopopov, Lachenmann, Shchyotkin, and Donatoni are the music of that year. These notes map this book, by an arcane and exact geometry, from words onto pages of sheet music. Music is exquisitely articulate and precise, and you can attend to it forever without needing to be anxious that it might start to mean something.

Wyschnegradsky's preludes give me the mood of talking to Adela. It doesn't matter what order I play them in, because they're not the story of our marriage, just the feeling of it. Furrer is the music of Viperine's weird insistence, her breathless voice. Gaarn's ridiculous compositions remind me of Vipesh. Protopopov brings back the crushing avalanches of experiences that rained down on Samuel and ruined him and drove him away from his job. These composers give me everything I can accommodate.

Shchyotkin is my way of feeling Samuel's anxiety, his uncertainty. Samuel wrote a congested book, sometimes frantic, contaminated with doubt. He worked hard on it, assembling photographs, recording everything. The book, and the person who wrote it, seem pathetic to me now.

The end of Samuel

There is something tremendously sad about sets of preludes and fugues, because they forget each other. Just the way each day pretends the night before never existed, and each night imagines the world has always been dark.

A prelude is a day full of distractions, but then the sun goes down and the stars spin up and hang gleaming in the sky. The night may be soaked in moonlight, or dim and moor colored. Inside the fugue it is hard to recall the lovely clouds and sharp colors of the day. Each night gnaws at the day before it, ruining its shape and sense. Night insists it is all there is, that there has never been such a thing as day. You stare at the darkened sky and try to picture the bright blue. Then when the night is over, the landscape floods with light. Each day ignores the mindless destructions of the night before. It's as if nothing happened. The sun gazes blithely on the fields.

That spring, Samuel fell into a fugue state. He had been on the edge, in the twilight. In the course of the winter the world stopped working the way it is supposed to. It was occupied by things that made no sense. He no longer knew what the world was. He lived in it, but he didn't recognize it. When he gave up his job, he fell. His life became weightless, as you do when you fall. He was like one of those divers who go underwater without oxygen, just holding their breath. They stand in the blue half-light, in twenty or thirty feet of water, their toes lightly touching the sand on the sea floor. They hover there, on the edge of an underwater chasm, the brink of an undersea cliff that could be hundreds, thousands of feet deep. Instead of swimming for the surface, they push off lightly and dive, in slow motion, an underwater swan dive, downward into the dark.

That drive into the arctic was the first of a series of falls that took Samuel away from his life, farther from the memory of what a day was, what air and light were like.

The diver follows the cliff face, arms out, like an arrow pointing down. He sees a ledge beneath him. It is nearly pitch black. He turns slowly in the water and stands on the ledge. He pauses a moment. It is very deep, and if he doesn't

start for the surface soon it may be too late. He pushes off again and makes another elegant dive, arcing up and out over the abyss, drifting more and more rapidly down and out of sight.

Fina asked me once about the end of that year, where I had gone, what happened, how I ended up living up near Mar. "I can't answer," I said. "I was lost to myself." "Look," she replied, "you were always lost, but most of the time we knew your phone number." She was angry, surprised I had moved so far north for no reason. "I'm back now," I said. "Sort of," she said, and then she added, "It's good enough, it's okay."

When I emerged again, up here on Route 6, the weather was fine. That's all that matters. It's just what they say about people who return home after years of wandering in a fugue state, that they don't really care, they aren't worried about where they went, how deeply they sank.

Now I see daylight differently. I understand the world isn't a puzzle, where stray occurrences are secret signs, where force of will and willed attention keep the fabric of meaning together. The world is not a graveled maze. It's not an impenetrable diagram, it's not a prison island, it's not pages of mathematics.

The thing is, there isn't much in the world. The stars and planets, clouds and rain, fields. If enough time passes, even the most vexed problems relax. They just stretch out on the grass and stare at the sky. Samuel would not have understood this. He would have been frightened by the emptiness of my life. Maybe we tell ourselves the world is rich and full to stop us from seeing how little is actually here.

The veery

As far as the county's concerned, the road that leads to my house is a dead end, but actually it continues on as a dirt track between fields. On my left, there's the enormous cornfield, the kind where you can't hear a tractor on the other side, and on my right, a stand of woods. The track leads to a farmhouse, and from there it's possible to walk along another track that goes left, around the cornfield and back to Route 6. When I first moved out here, I used to walk all over the peninsula. Sometimes I'd be out all day. Once, I went south on Route 6 to Shallow Lake and back, a fourteen-hour walk.

About ten years ago, I stopped doing those long walks. My outing shrank to the circuit around the cornfield: down the dirt track to the farm, left around the big cornfield, back on Route 6. The same every day, just like the commute in Guelph, down Cather and right on Lorck to the Water Department. My loop here took an hour and a half.

Now I can no longer walk that far, or I could, but it would be an all-day project and I'd come back with aches to last a week. Instead, I walk along Route 6, or else I set out toward the farm, and when our group of houses seems far away, it's time to turn back. Everything is faster than me, the clouds, the breeze, the beetles and grasshoppers I startle as I walk.

Some of the birds here are new to me. There are spruce grouse and northern goshawks. They belong more to the arctic than to the temperate woods that stretch from here back down to Watkins Glen.

The birds that sang in Watkins Glen have tunneled somewhere deep into my brain. When I hear them suddenly there's nothing in the world except me and the birdsong. The cardinal is one, with its rising call. The rasp of a blue jay. The three notes of a chickadee. But the ones I love most, that make the dry Ontario ground into liquid, so I sink away into the past, are the hermit thrush and the veery. They both hide in the deep woods. I never see them, but at my age it wouldn't be a great idea to walk in the forest anyway.

The hermit thrush sings only when it thinks no one is around. It prefers to sing in the dark, after the sun has set and the other birds are silent. The song comes from inside the forest like water pouring down a metal sluice.

Eliot, the poet, also loved the hermit thrush, and he put it into *The Waste Land*. He says it sings Drip drop drip drop drop drop drop. I love that because he does not try to write anything poetic. Just drip drop. He wrote footnotes to his poem, and in one he explains that he heard hermit thrushes in Canada. Some scholars think he wasn't serious, that he was making fun of the hermit thrush's "water-dripping song." But that is only what you might say if you have never heard one.

Olivier Messiaen, the composer of bird songs, preferred the wood thrush, a cousin to the hermit thrush. It sings four notes: something near a high A, then down toward F ♯ , up to D ♯ and down to C. After the four notes comes a thrum or trill. The song isn't exactly on any pitch. It is microtonal and there are hints of grace notes so quick they can scarcely be heard. Messiaen had an acute ear, and somehow, he heard other tones inside the four notes. He made the trill into a modernist chord, B D ♯ E G G ♯ A.

A wood thrush wouldn't recognize Messiaen's version, which transcribes the bird's celestial music into equal temperament and flattens its warbling sounds into the geometric tones of the piano. To me, the wood thrush, the hermit thrush, and the other birds I heard when I was young are not music. They are messages that come to me straight from the most distant past. It's as if they aren't singing in the forest off the farm road, but somehow they're in Watkins Glen, four hundred miles away, eighty years ago, singing to me from another lifetime, before there was a Samuel Emmer, when there was only little Sam on one of his expeditions in the woods behind the house. How do the songs reach me across those unimaginable distances? How does the past hide in a dark patch of woods in northern Ontario?

The most haunting bird in Watkins Glen was the veery. Like the hermit thrush, it stayed deep in the forest. It used to sing late in the evening, as soon as it felt it was invisible.

The veery's song is not like any other bird's. It sounds like two girls whistling. They harmonize in sixths or fifths, it is hard to say. They sit high up on a

limb where no one can see them, those two girls, and they look at each other while they whistle, the way human singers do when they sing a duet. Their melody is two threads of silvery falling notes, repeated four or five times. I play it like this.

It sings alone, but it seems like a double creature. Two girls, or perhaps two insects. Or a crowd of distant singing voices. There is a rasp to the sound, like the meow of a cat startled in its sleep, and there's something metallic to it as well. Like a Phasma flapping its brittle wings in a metal cage.

People have tried to transcribe the veery's song, but they haven't captured it. How could they, when the veery has its magical syrinx and all we have are notes with stems and bars? One author said the veery's call is a "weird reedy liquid whistle," and he drew a picture of the falling notes.

In a weird reedy liquid whistle

People have also tried to spell out what the veery is saying. One writer says the veery calls out *reiiay reeiiay riayah riayah rayoh*. Another writer gave up on musical notation and drew the veery's song, as a chain of hearts.

The veery is named after the sound it makes, and maybe that is the best language can do. Of course, the sounds it makes aren't a song. They aren't music, they can't be put on staves, spelled out in nonsense words, or drawn as a picture.

The veery is just something that happens in the forest, out of sight, when I walk quietly and am lucky enough to hear it.

This evening I started my walk late, well after dusk. I had been playing the piano after dinner, and as usual I lost track of the time. I started with Furrer. A few bars of that, and then samples of Shchyotkin's fugues. I went back into the study and fetched a pile of scores. Steven is coming tomorrow afternoon, so I thought this evening might be the last time I play the piano. I went through the stack of music, playing just a minute of music from each score. I recognize the emotions now. I realize I have been listening for echoes of Samuel's life, traces of his feelings. I stopped playing and looked at the score I had put up on the piano. It was a beautiful page. The notes stood silently, each in its place, waiting to be heard.

I heard the silence. A maple outside the window rustled in the breeze, brushing the glass with its pointed leaves. Whatever the night is in Cattaraugas, it will be different from the night up here, where there is the smell of corn and the intermittent hollow whine of wind across the flat land. I went out back to the farm track and along the woods. I walked carefully in the half-moon light, watching my shadow stumbling along the uneven ground. There was no sound except crickets and the shifting leaves in the woods. After five minutes, I had only gone a little way, and it was already far enough. Fina is right, if I stay here another year, I won't be able to walk at all. It is the end of this part of my life, the third of my lives.

The large faint image of the field in the moonlight was like an enormous ghost fainted across the land. I watched it billow in my mind's eye. And that's when I heard a veery, about twenty feet ahead of me, singing inside the woods. It was lost in darknesses, as if the shadows themselves were making that liquid song. It was all I needed.

My long lifetimes folded into nothing, and I melted back into the woods of home that I had left behind so long ago.

Little Sam

It's almost time. The piano is gone. Steven has been cleaning out the base-ment and loading up a U-Haul for the drive to Cattaraugas. He keeps bringing things up to me and asking if he can have them, or if he can throw them out.

He just found something even older than this book. It is a booklet of draw-ings little Sam made in grammar school. He would have been five years old or so. The pages are oversize colored paper, sewn together with red ribbons. Someone, I suppose my mother, wrote SAMUEL'S ALPHABET on the cover. Each page illustrates an animal and a letter of the alphabet.

The letter A is accompanied by an aardvark, drawn like a puppy with long ears. B is for bear, a black lump made by swirling the crayon around and around and adding eyes. C is a white cat, with curving claws and preposterous whiskers.

I looked through the booklet, hoping to remember what little Sam thought when he drew the animals. Or maybe I'd find intriguing similarities between his animals and the ones Samuel saw.

In some of the drawings the animals are in landscapes. The lion stands in front of a high building shaped like a triumphal arch. The sloth is next to a pair of scissors. Behind the monkey a broad, green shaft of light pierces a cloud. A toucan rests on a large leaf. Beyond and below them is an ocean. The sky is violet, lilac, gold, and rose.

W is for wasp, roughly made of impatient black and yellow stripes. I can imagine a child's small hand clenched awkwardly around the crayon. There is no X. Y is for yak, a shaggy dog perched on a snowy mountain. Z is zebra, of course, a wooden-looking striped horse standing next to a stick figure hold-ing a spear.

I told Fina I didn't want to keep the alphabet book. "It could have been made by any child," I said. She looked at me and dropped it in the garbage. "I still have the things I did at school," she said.

Little Sam has gone away, much farther than Samuel, and he took his entire world with him. Now I've left Samuel behind as well. He's evaporated, gone like the knotted concentration of the little boy who drew these animals. This is how memory disperses, how generations can pass within a single lifetime.

Proust wrote an optimistic book about memory, how it flowers in the imagination until your past swirls around you, pearlescent and welcoming. He was young, still woven into the cocoon of his childhood. If he had lived long enough, he would have wondered at the middle-aged man who spent so long cultivating his past. Memories do not wait forever. If too much time passes, they walk away. All that's left are books that no longer speak, like headstones scoured blank by the rain.

My hedge

Behind me, Steven and a friend of his are boxing things up. In an hour, this book will go in one of those boxes. Everything we leave behind will go to a landfill.

I won't be here, but things will go on as usual. In the hedge outside my window, one twig is maddeningly caught under another one. It wants to grow upward, but it can't. A single leaf is hooked under the stem of a leaf from another twig, like a man holding another man's head in the crook of his arm. The plant is tangled with itself.

In old age the world becomes stranger, because pieces of feelings and memories hide in it.

A spider has built a web on the outside of the windowpane. The breeze is buffeting it. It pushes and pulls at its web, as if to say, Stop, please stop.

A small caterpillar is making its way along a sprig, scalloping out mouthfuls of leaf. The ones it has bitten are disfigured. Their chewed margins are brown. They form a pattern like a child's drawing of ocean waves.

Is there a fourth phase of life, after the usual old age? Can a ghost die, and become another sort of ghost?

Years ago, in another lifetime, little Sam ran through the woods, listening and looking, seeing everything but himself. After that, Samuel Emmer ran through the world, failing to listen, failing to understand. Then came my life, the pleasant empty life of a ghost, who knew only melodies and no longer touched anyone. Now I'm noticing other things: these movements in the hedge, the sounds inside in the forest.

If I think of the phrase, *Viperine's voice,* I don't hear anything. It is unseasonably warm today, that's rare for the end of September. The sky is undecided. There's an irregular whistling sound up in the eaves. Inside that sound is the pitch of Viperine's voice. That's how voices are after so many years. They hide in things. That spider is struggling against the wind. It could be chattering in Adela's voice. It's nothing a human can hear.

I also sense voices of people I never heard. I can almost hear Monika Woodapple. Under the hedge and out in the strip of lawn beyond it, mice are moving quietly back and forth, keeping out of sight of hawks. They have their paths through the undergrowth, mouse-contoured tunnels in drying autumn grass. When they move, their tiny feet make minuscule padding sounds. Brushing softly by the grass walls of their tunnels with faint swishing sounds. Like Monika muttering to herself in German as she took notes.

Faces, too. Monika is hidden under her scarf and hood. But I can see her face in the scoop of afternoon sky that is cupped by the crescent moon.

If I think, *Viperine's face,* something indefinite comes part way into my mind, but it is not a picture. It's the feeling a picture gives you, the stamp it has, the way it faces you and says, Look at me. But there's nothing to see, my image of her face has gone.

The dead seasons are coming. Clouds are stretched out now over the plains, tumbled gray against gray blue. I can feel the strangeness of Viperine's stare in them. There's nothing out there that looks like her.

Author's note on the music

The music in this book does not have to be heard. Readers who have pianos can play the pieces while reading. Readers can also listen to audio files as they read.

The music can be performed for an audience. If that is done, the pianist or another person should read from the text that accompanies the music, and then play the music at least twice, with a brief pause between performances. The sheet music should be projected onscreen during the performance.

All the music in this book is modified by the author. None of it reproduces work by the actual composers. For that reason, it is not permissible to play the composers' original pieces. However, the pianist can improvise extensions to the music in this book, turning them into full pieces.